WITHDRAWN

THE

RANDOM HOUSE NEW YORK

KODAK PROFESSIONAL

THE

RICHARD AVEDON AND DOON ARBUS

SIXTIES

It was the best of times, it was the worst of times, it was the age of wisdom, it was the age of foolishness, it was the epoch of belief, it was the epoch of incredulity, it was the season of Light, it was the season of Darkness, it was the spring of hope, it was the winter of despair, we had everything before us, we had nothing before us, we were all going direct to Heaven, we were all going direct the other way—in short, the period was so far like the present period, that some of its noisiest authorities insisted on its being received, for good or for evil, in the superlative degree of comparison only.

CHARLES DICKENS, 1859

Twiggy, model
Paris

2

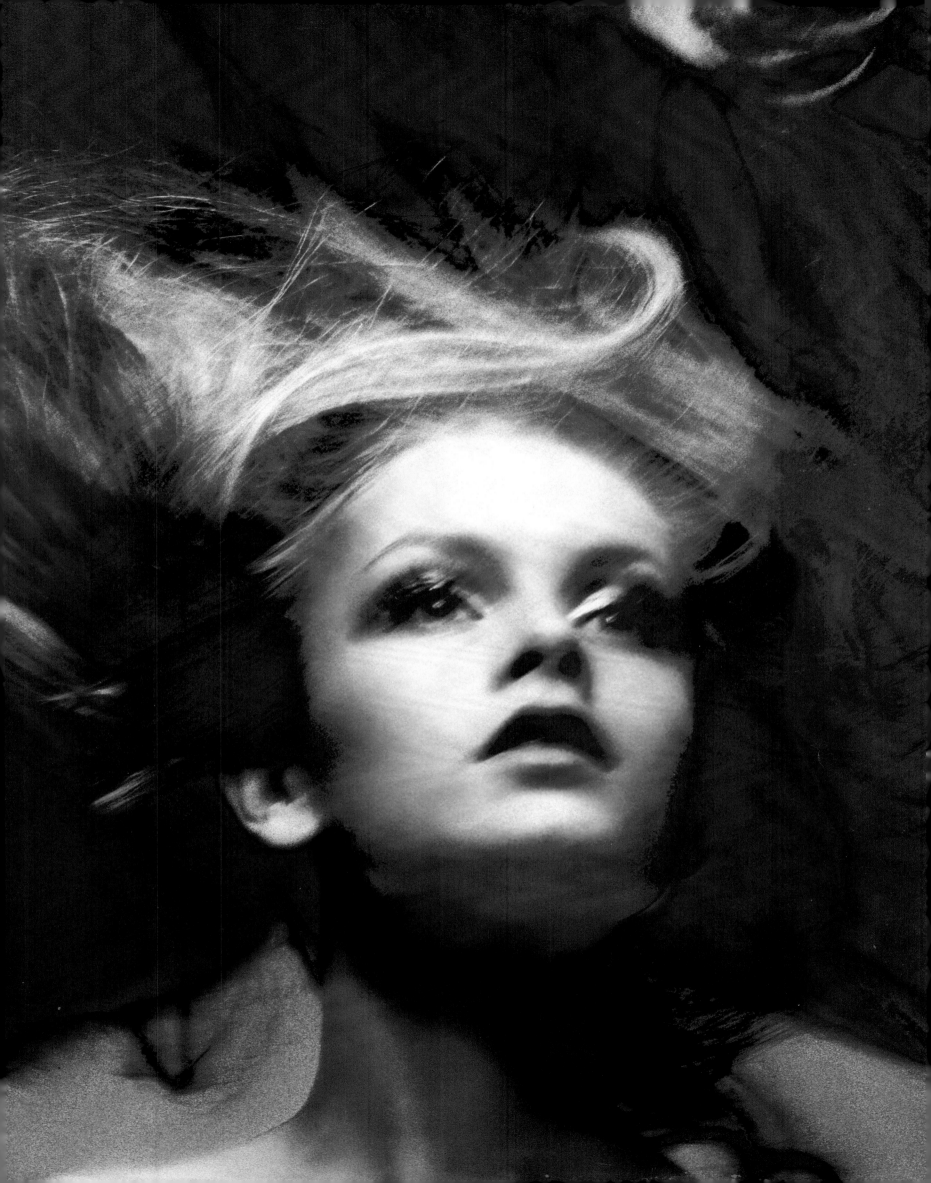

ABBIE HOFFMAN, Yippie
Chicago Seven Conspiracy Trial
September 25, 1969

Living in America I expect to get killed. I mean,...I've been
active for a long time. I've seen Mississippi and I've seen the
rest of the country turn into Mississippi. So going to jail or
dying or any of those things...I don't know...what's the
difference? Both times you're like—you're removed from,
uh...the streets. From what you feel you have to do.... Dying
is...I don't know. It makes a better movie but...what's the
difference?

Physical injury I've grown up with all my life, ever since...I
was a juvenile delinquent...football player. Death or the fact
that you might die at what you're doing is something
that...that I can face in my mind and deal with and...overcome.
I've overcome my fear of death. I've not overcome my fear of
jail.

I'm very much into survival. Survival is what I'm best at. I'm
a pool player and pool players, pool hustlers, they know how to
survive. I live on the Lower East Side, which is a jungle. I
live on one of the most vicious blocks in the country. I have
a plant that's been mugged.

Survival is where it's at. Survival and fightin'. 'Cause I
think we are at war. I'm not against the war in Vietnam. I'm
for the National Liberation Front winning. So I'm...I'm not for
peace there. Peace is a very complicated concept. When the lion
gobbles up the lamb and wipes his lips, then there's peace.
Well, I...I ain't for that peace at all.

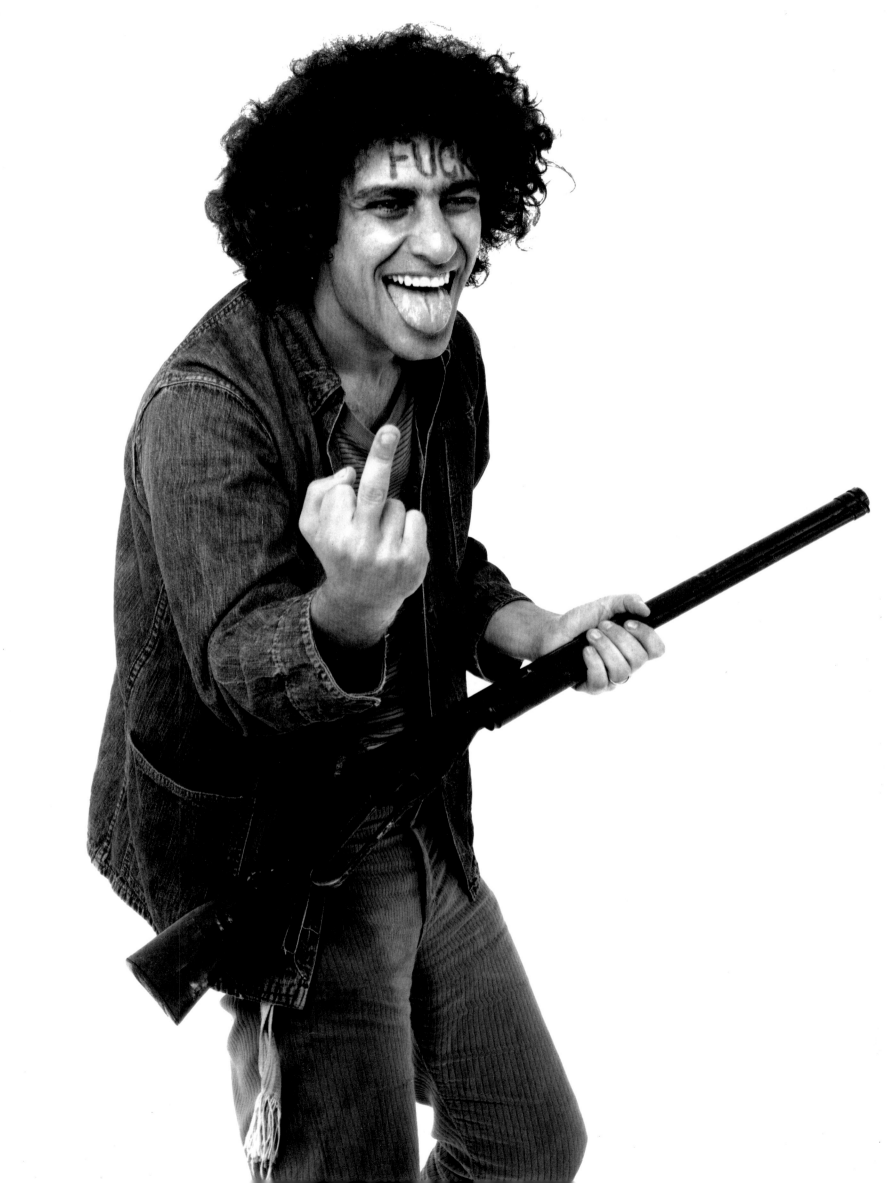

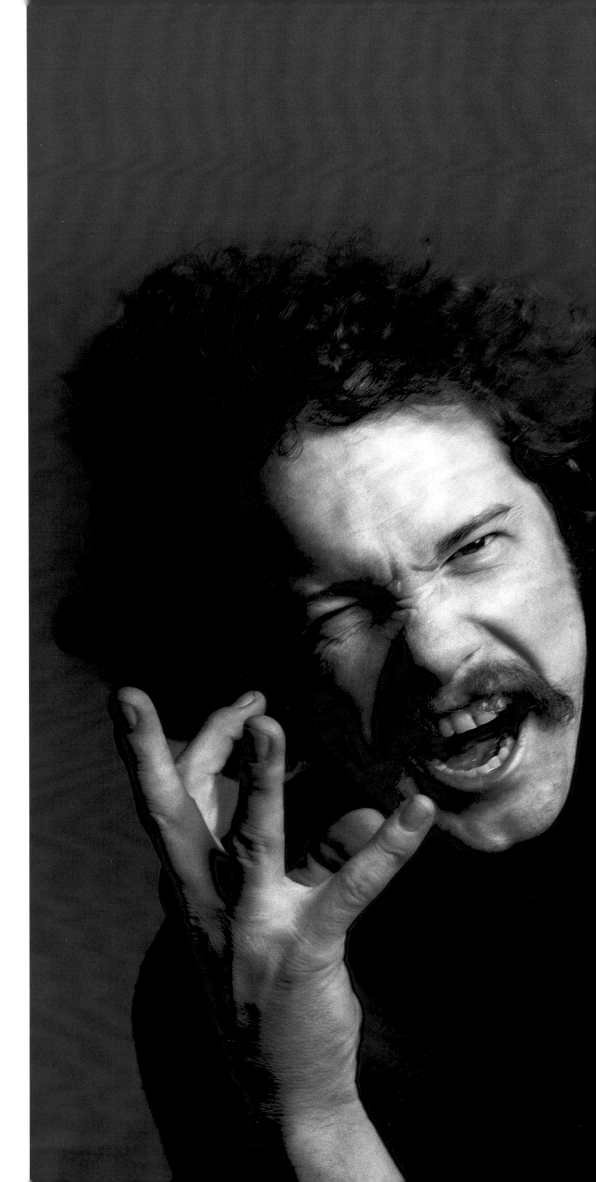

Ed Sanders and Tuli Kupferberg,
The Fugs, rock musicians/
political satirists
New York City

6

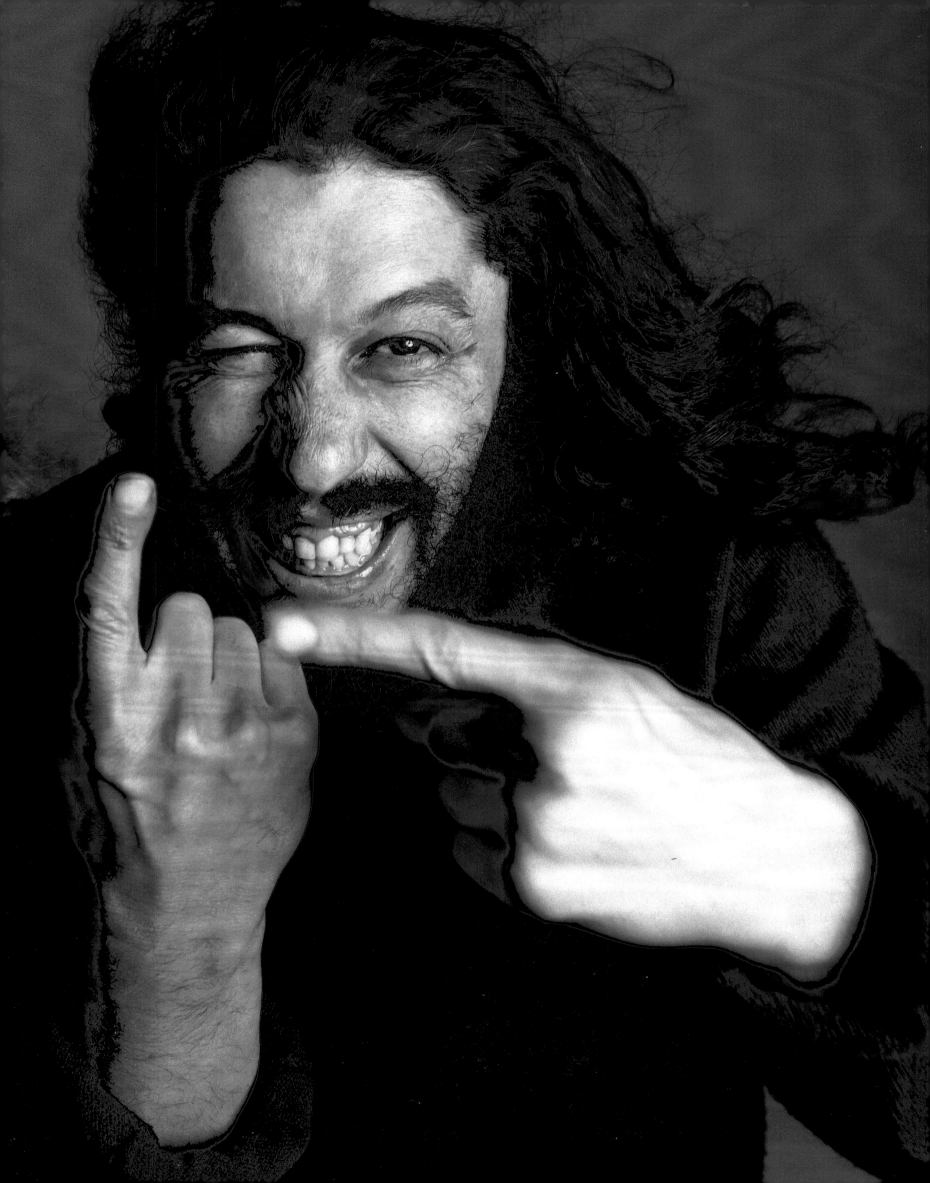

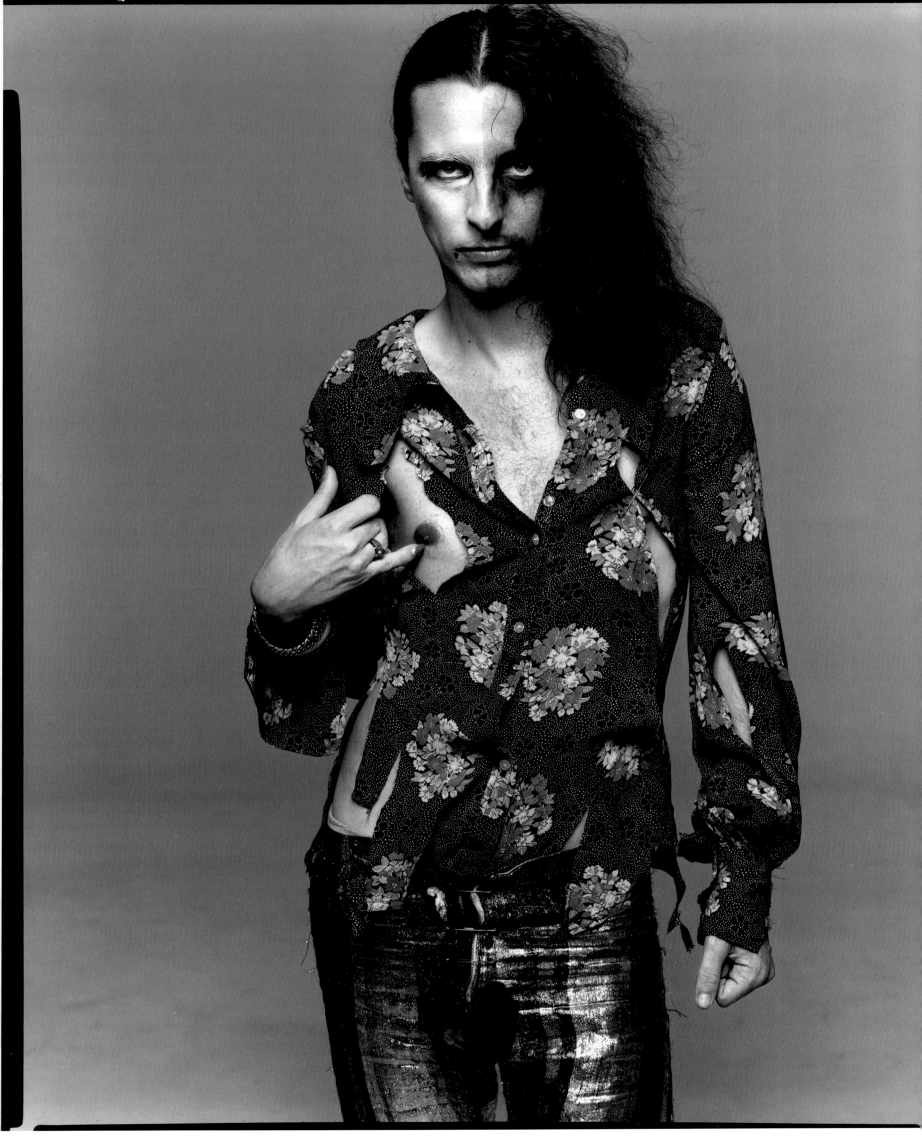

8 Alice Cooper, rock singer, New York City

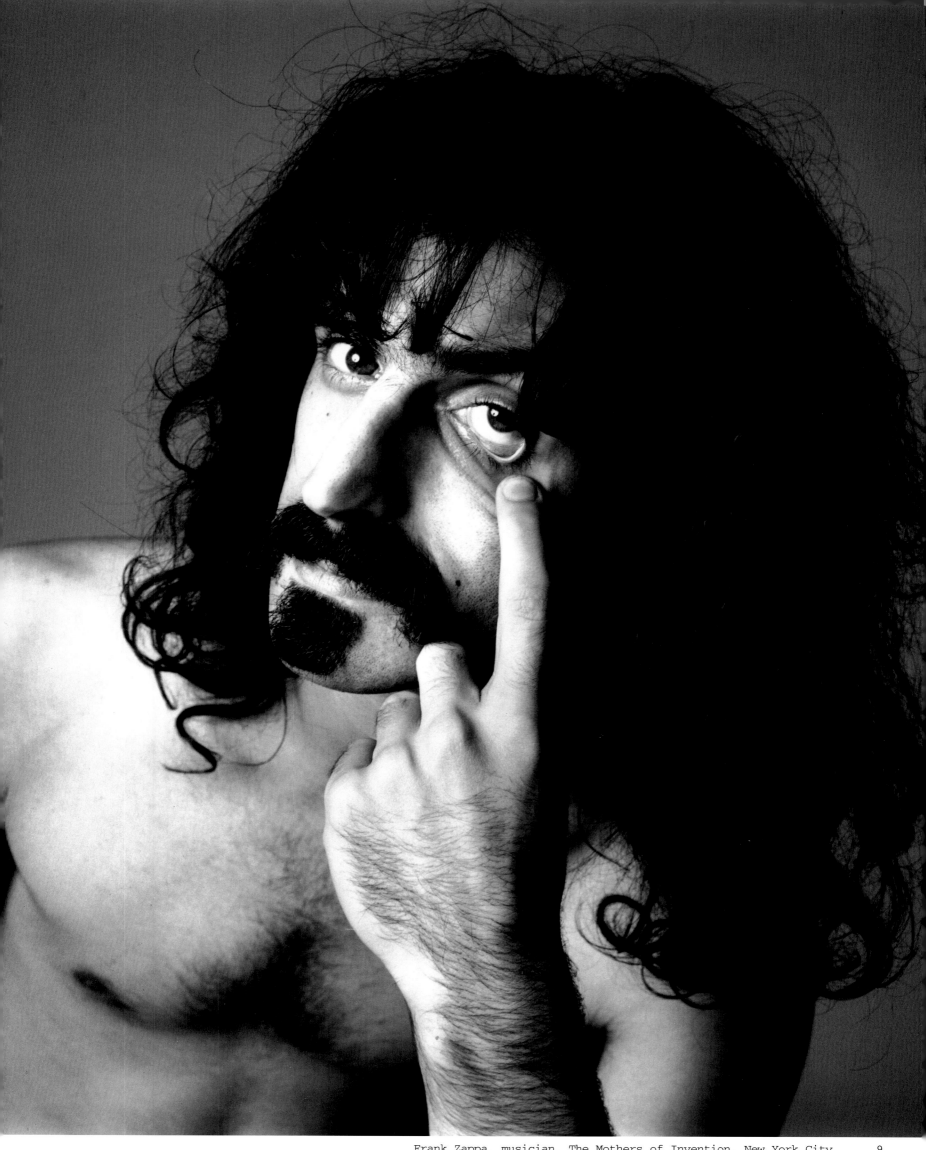

Frank Zappa, musician, The Mothers of Invention, New York City 9

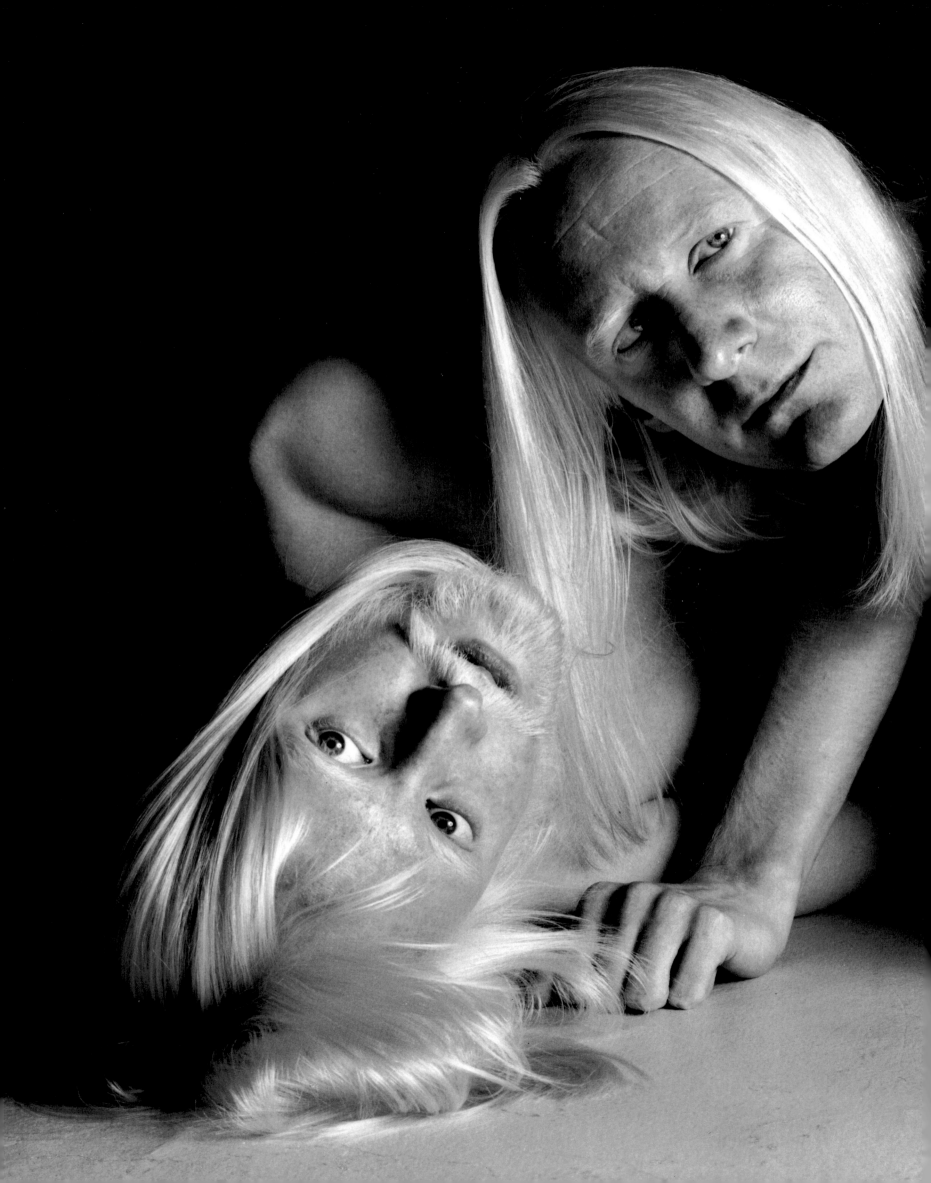

Edgar Winter and Johnny Winter,
rock singers
New York City

JANIS JOPLIN,
blues/rock singer
Port Arthur, Texas
September 3, 1969

I have like what anyone would call like, say, a loneliness,
a loneliness of my own. But it's just a private trip and
probably shouldn't be forced on other people that much, you
know what I mean? God, fuck it. Who cares how lonely you feel.
You just have to learn to deal with it like everybody else
does. Everybody has that, I think. Everybody. Even Christians.

I remember I used to think, goddamn it, it's because I'm a
chick or it's because I haven't figured it out yet. It's
because I'm not twenty-one. It's because I haven't read this
or I haven't tried that.... Well, I've done every fucking
thing and now I know better. There is no "because." And it's
not going to get any better.

My father.... See, my father is a very intelligent man and I
used to talk to him a lot because he reads and he's pretty
sensitive and I was a mixed-up kid and too smart for my age—
right? Anyway, so when I was eighteen, I ran away.
Well,...went to California. One day this thing comes along and
I learned something. It went *pfshutt* right in the side of my
head and I sat up...and realized something. I ran up and wrote
a long, long letter to my father all about how I'd felt
growing up was like climbing a hill and that sooner or later
you'd figure it out and it'd all come together and you'd level
out and it wouldn't be such a fucking struggle every day, you
know?... But then I realized there wasn't any leveling out, you
know? You have the same fucking problems—or more—when you get
old. I mean, you got more to deal with. It isn't gonna turn
that corner, man. It just keeps going right on straight
uphill. So I wrote my father and explained this whole thing.
Well, the next time I came home—my father has this friend,
another man who's also very intelligent—and my father had

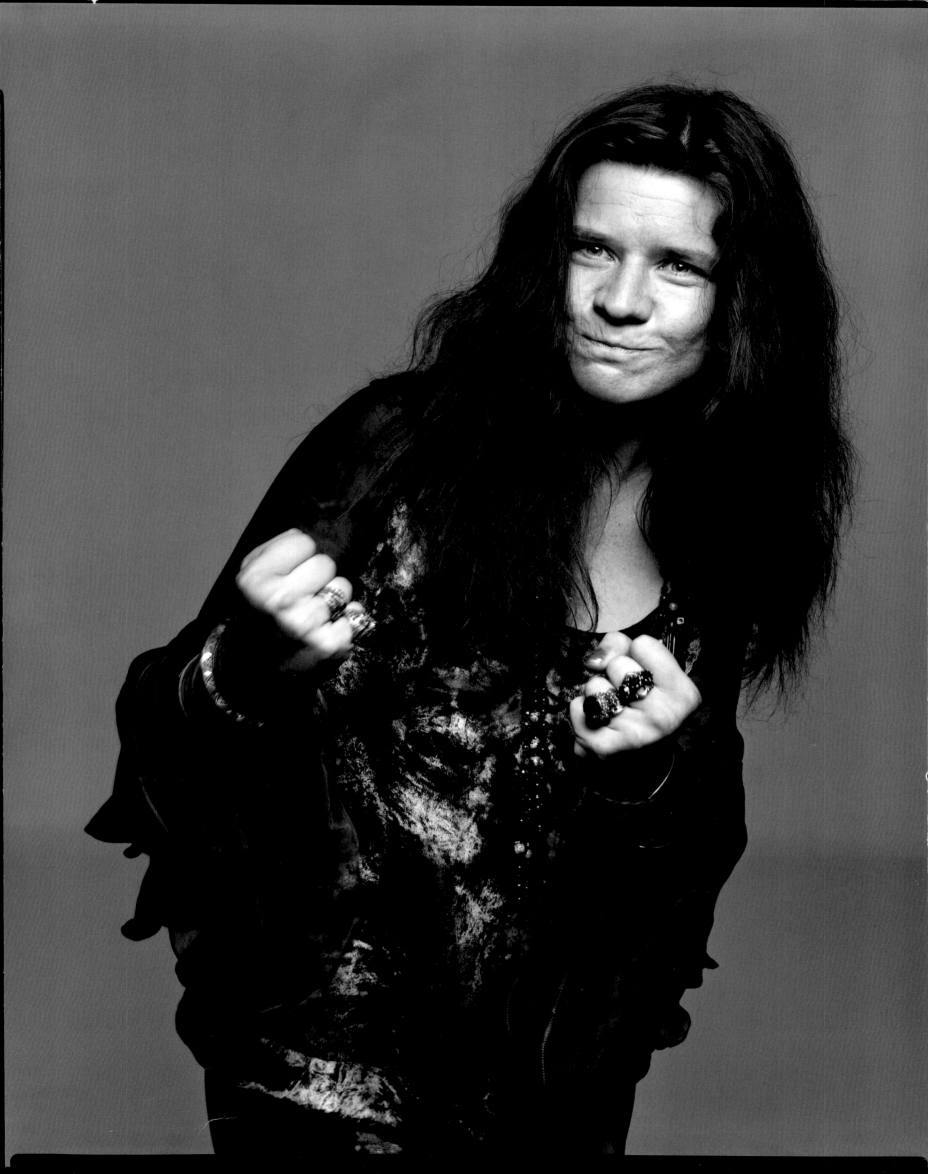

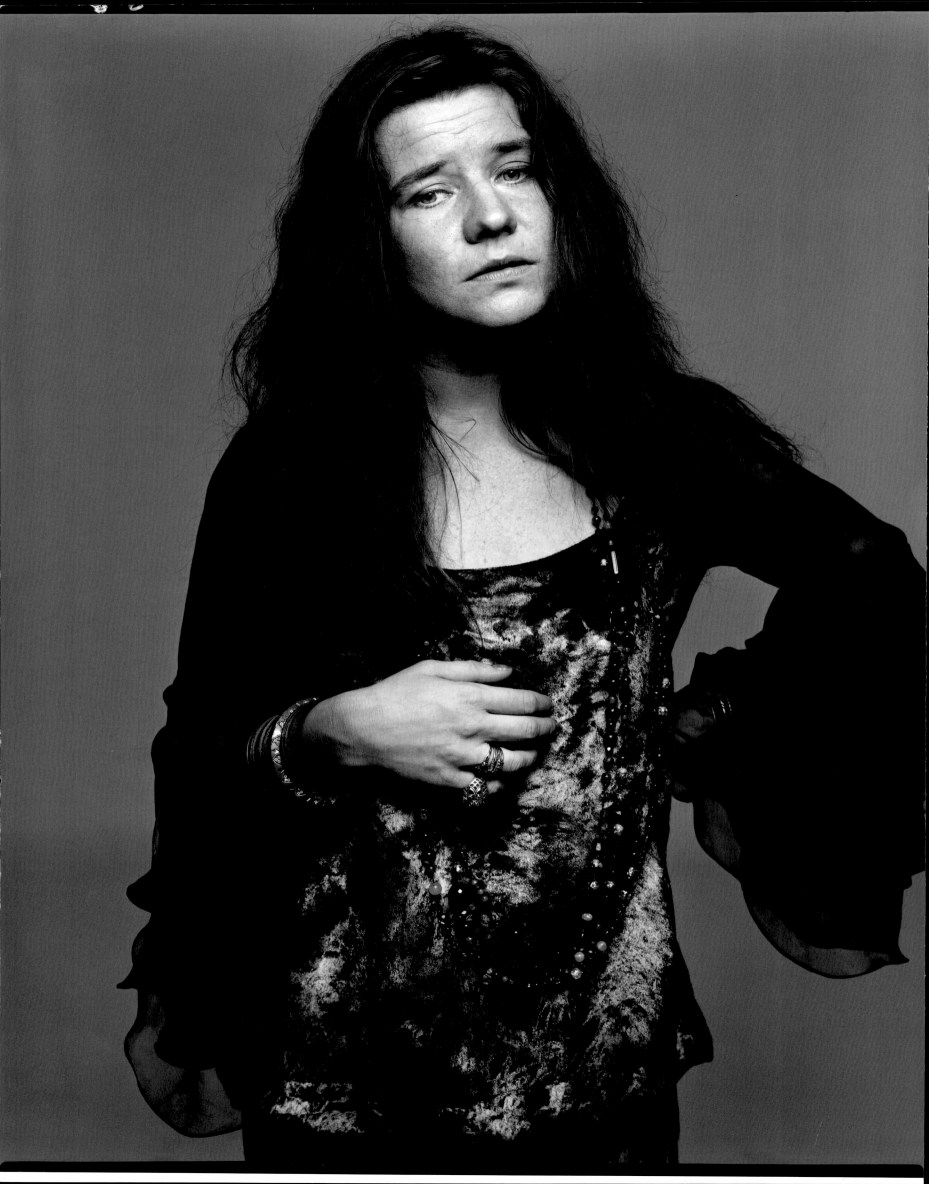

evidently let him read my letter. You know, "Look what Janis is going through." They were proud of me because I was a thinker and they liked that because they were thinkers. So when I got home, this guy comes up to me and he says, "Well, I hear you learned about the Great Saturday Night Swindle." That's what he called it.

The realization that there isn't going to be any turning point.... There isn't going to be any next-month-it'll-be-better, next fucking year, next fucking life. You don't have any time to wait for. You just got to look around you and say, So this is it. This is really all there is to it. This little thing. Everybody needing such little things and they can't get them. Everybody needing just a little...confidence from somebody else and they can't get it. Everybody, everybody fighting to protect their little feelings. Everybody, you know, like reaching out tentatively but drawing back. It's so shallow and seems so...fucking...it seems like such a shame. It's so close to being like really right and good and open and amorphous and giving and everything. But it's not. And it ain't gonna be.

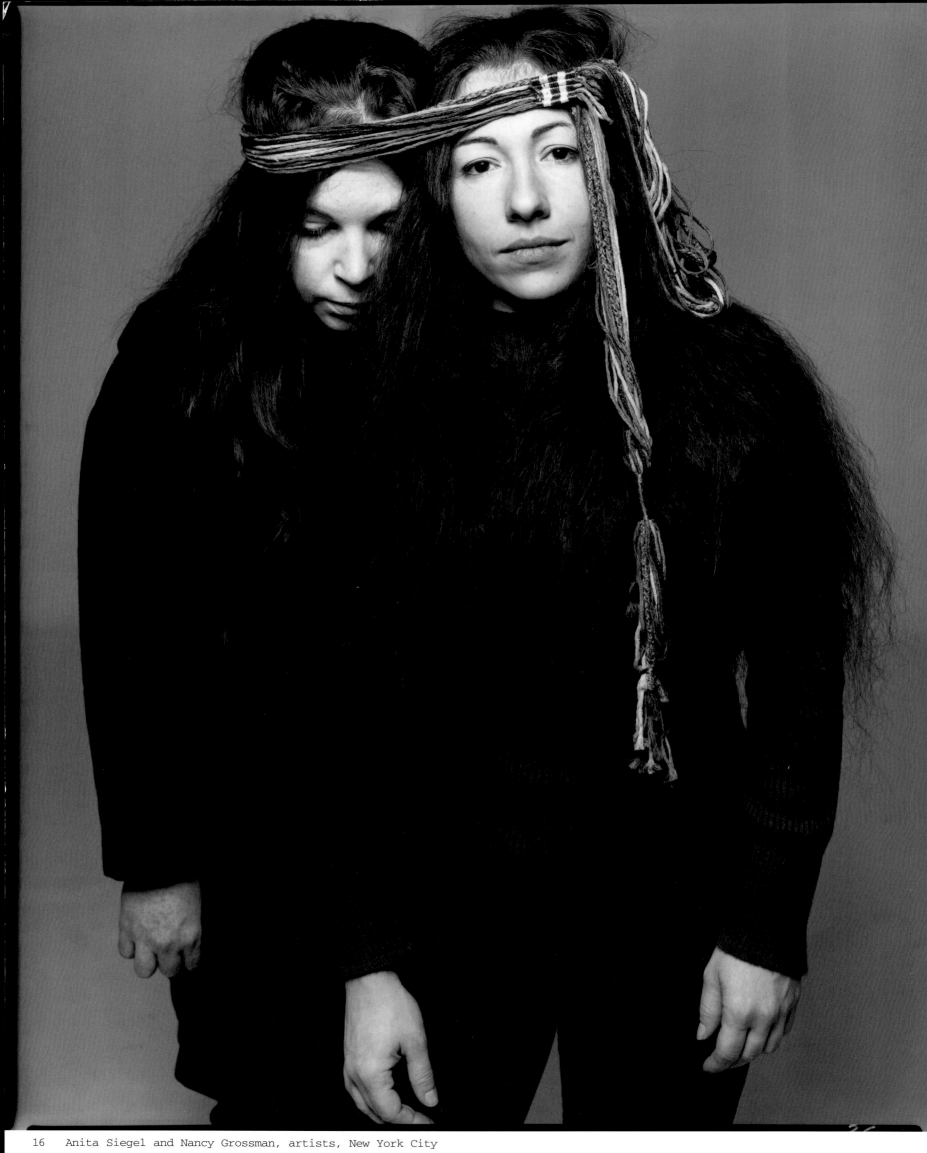

16 Anita Siegel and Nancy Grossman, artists, New York City

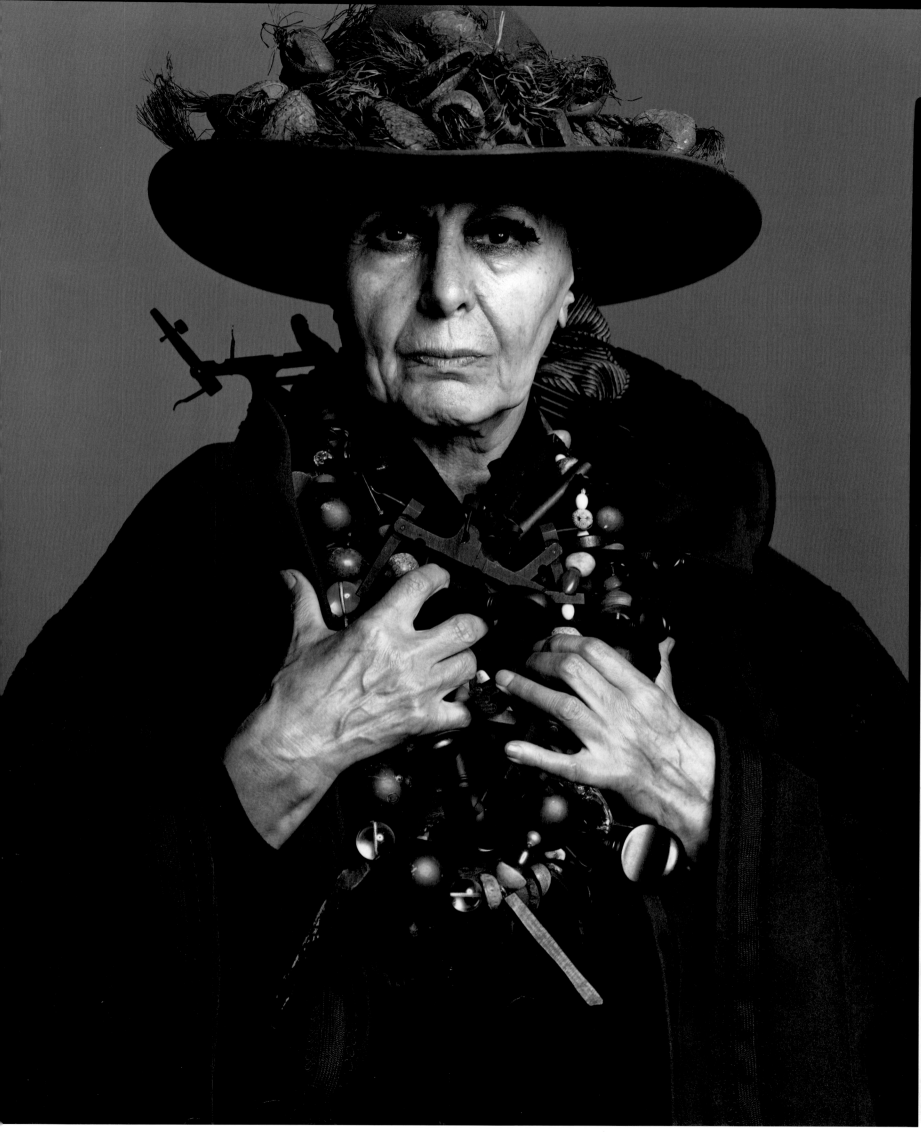

Louise Nevelson, sculptor, New York City 17

Times Square, New York City, November 22, 1963

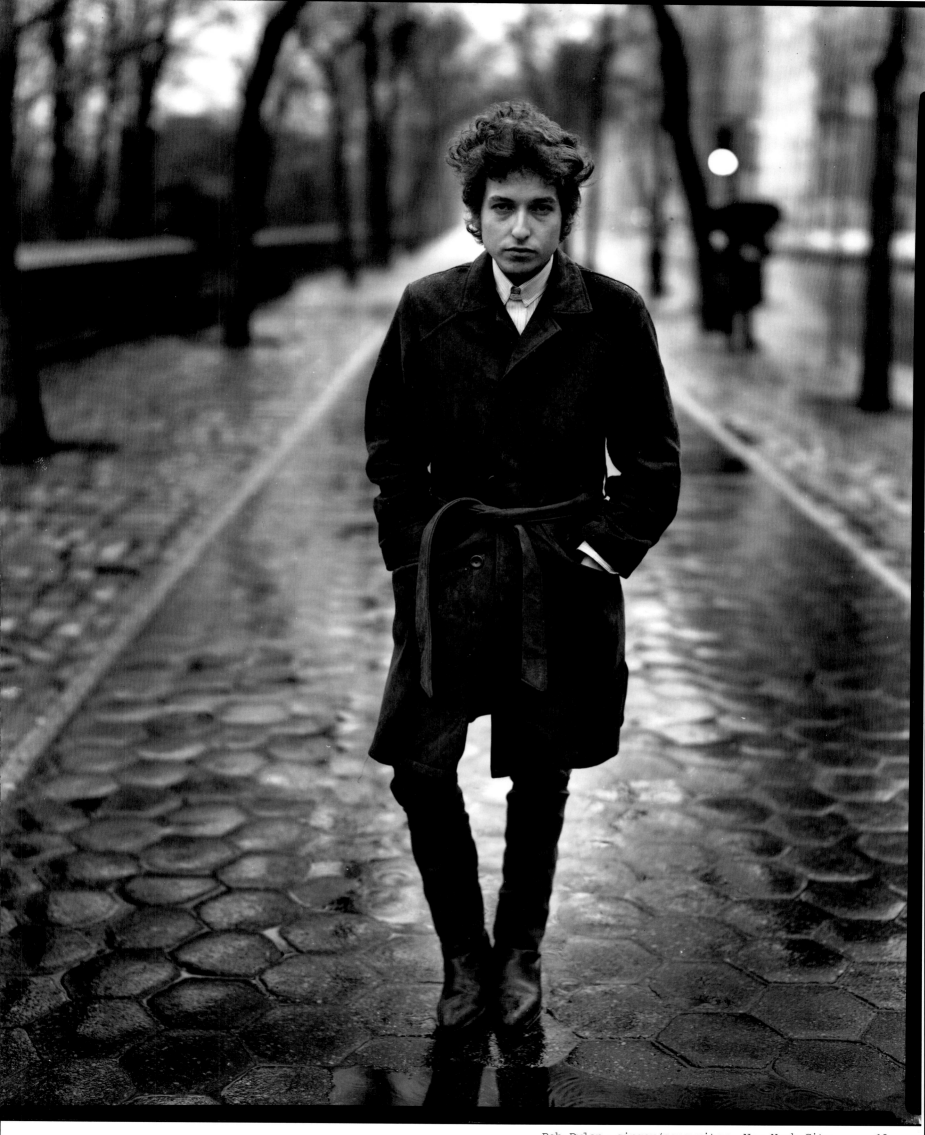

Bob Dylan, singer/songwriter, New York City 19

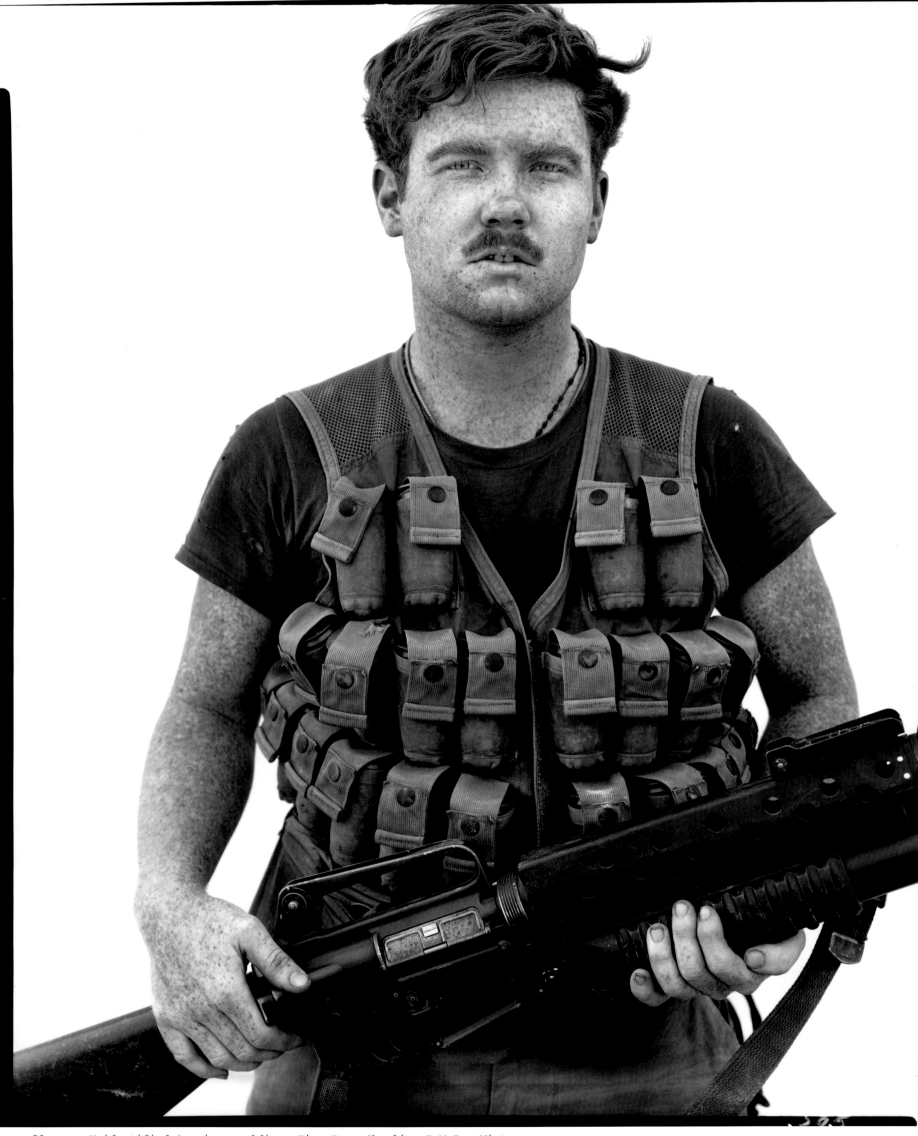

Unidentified American soldier, Fire Base Charlie, D.M.Z., Vietnam

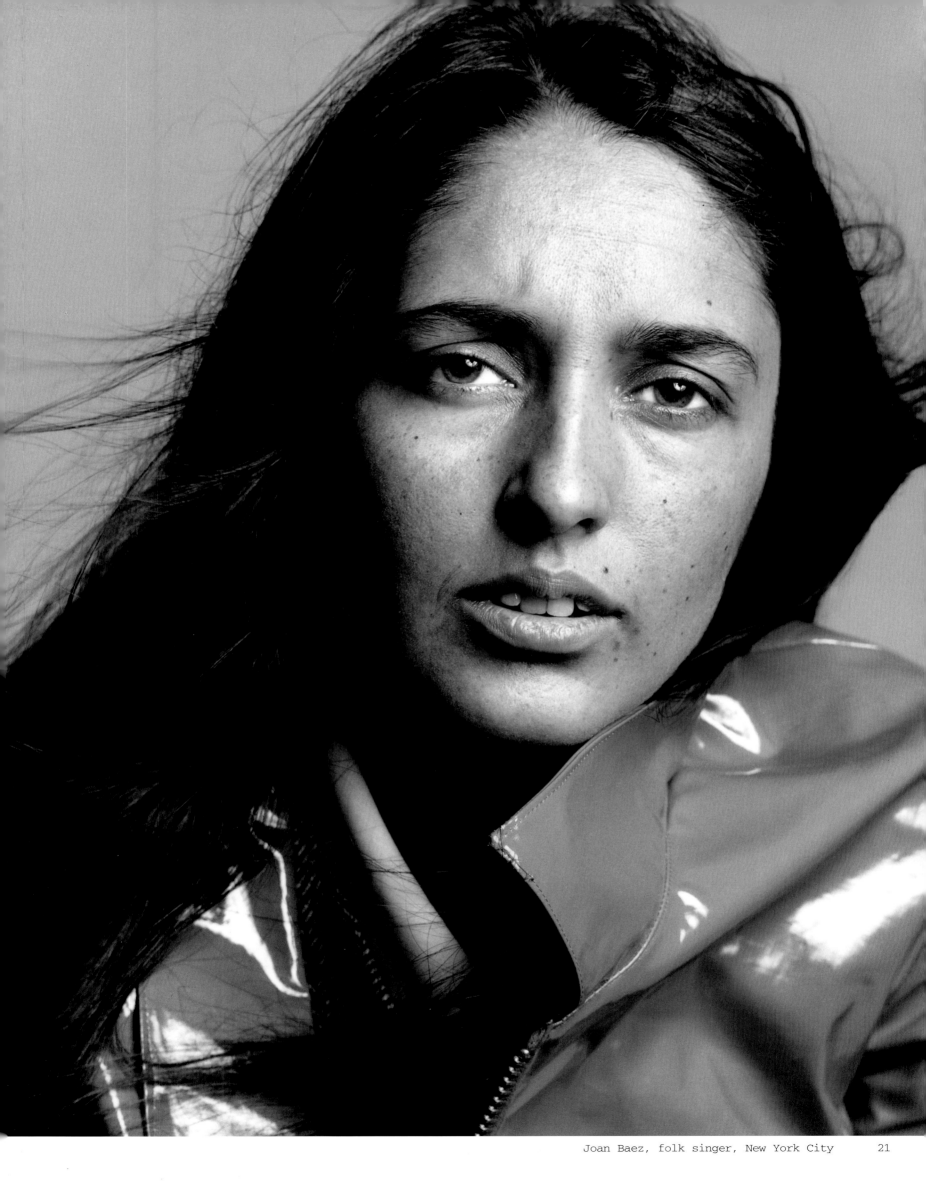

Joan Baez, folk singer, New York City 21

GLORIA EMERSON,
New York Times correspondent
Saigon
April 1, 1971

Vietnam is just a confirmation of everything we feared might happen in life. And it has happened. You know, a lot of people in Vietnam—and I might be one of them—could be mourners as a profession. Morticians and mourners. It draws people who are seeking confirmation of tragedies....

Once I got so desperate—the Americans had started bombing Hanoi— I ran to the National Press Center where they give the briefings...a forty-year-old woman running through the streets in the middle of the night...and I wrote on the wall in Magic Marker, Father, forgive. They know not what they do. And I don't even believe in God. Who is Father? Father, forgive, they know not what they do. But there were no other words in the whole English language.

If they found out it was me they would have sent me home. *New York Times* correspondents must not go running around at two o'clock in the morning writing, Father, forgive, they know not what they do. But afterward I thought how there's no way...no one, no one to whom you can say we're sorry.

DAVID McREYNOLDS,
War Resisters League
New York City
September 10, 1969

If you're gonna live in a city, you're gonna pass alcoholics by on the street. Or else you don't get to work. But that is to be brutalized and...it doesn't excuse what you've just done. That you've passed by someone lying in the gutter.... You know what I mean?... I have the feeling...that I really ought not to lock my door. But if I didn't, then I wouldn't have anything in the apartment, and I know I can't function on that level. Personally. So that is the function of this city.

That we lock ourselves in at night. We're all...we're all...voluntary jailers. It's really a very frightening thing we do. We have bars on the windows. I do, too. This is a very difficult problem for somebody who really would prefer...not to have his door locked.

I'll tell you when I gave up the whole business of trying to be saintly was way back when I was working...at the end of college...at a hot dog stand. I was living in Ocean Park, California, and I thought I would keep on working...you know, half the week at the hot dog stand and the other half, be radical. And I had just enough money to pay the rent. I didn't drink at the time. All I had was Seven-Ups and ginger ale in the refrigerator. And I'd come home and it would be gone. Because friends would drop in and drink them. So I left a note saying, you know..."I don't mind if you take these, but please...you know, I don't have any money. Leave a dime if you're gonna take them." So people would do that. And I would get home and there would be dimes and I'd be thirsty and there'd be no Seven-Up and I got pissed off about it and I said, "Look, if you want to take these...I come home tired and it's late at night and the store's closed" (I got home at three o'clock in the morning)..."drink it if you want. But replace it. Because one of us has to walk three blocks and it might as well be you as me. It's my refrigerator."

At about that point, I realized that poverty wasn't for me. If I was starting to write notes about how to deal with Seven-Up. So I left and got a job digging ditches, which paid me seventy dollars a week or something, and I could afford to buy whole cases of Seven-Up.

See, if when you don't have money, you start to daydream about it—which I do—then you better have a little money. If I don't have money, if I'm broke, I really start to daydream about having a vast fortune. I stop daydreaming about it if I have just enough to buy the Scotch...to have good food. Then I'm perfectly satisfied not to think about it. But I think that the...the problem is that you're always drawn to that image of...of uh...the teachings of Buddha. Abandonment. Nonpossession. Since you're all gonna die anyway. I think the real trick is to find out where you are without excusing where you are. Leaving yourself open to the fact that...you might become better than you are.

EDWARD ALBEE, playwright
East Hampton, New York
August 18, 1969

I used to be shy. Now I'm reserved.

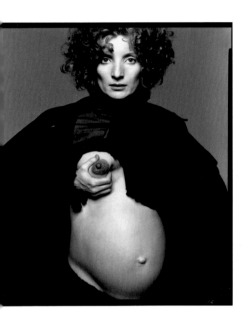

VIVA, actress
New York City
October 2, 1969

Whatever has changed, whatever I've lost of
myself, has been the bad stuff. I mean, now I
don't go into terrible states for six months where
I can't think of any reason for living, but at the
same time I can't think of any real reason for
dying so I just...like I've just laid in bed for six months.
Not able to move.... I don't do that anymore.

Not that I'm saying that's good. I mean I think it's great to
just lay in bed for six months. At least you're not making
things worse...I mean, all these active people, that's what
they do. I have a very black view of the world. Very very very
black. I say that anything that happens to it, it deserves.
But it doesn't affect my life so much now. I try to keep my
little part. To live sanely.

What I'd really like to be is rich. A mother. A capitalist.
Have a big house, a garden, everything else. Yeah, I would
really like to be bourgeois but I just can't seem to make it.
No matter how hard I try.

DR. BENJAMIN SPOCK, pediatrician and
antiwar activist, with his wife, JANE
New York City
September 18, 1969

My mother was a stern, dominating woman and my father a very
grave, quiet person. I was made to be a kind of goody-goody
boy who couldn't do what the other boys did. Why, even on
Halloween, when my friends would talk about turning over trash
cans, I would leave the group. I was so afraid of being bad
and being caught at it. My mother used to say to me, "All you
have to be is sure you're right and then nothing touches you,"
but if you think I was buying that in adolescence! I was
extremely conformist in boarding school and in college. Always
trying to be accepted.

When Jane and I got married and moved to New York, my whole
idea was to be a man of the world. I wore high collars and
suspenders and chalk-striped suits and did everything in my
power to appear...the distinguished man of the big city. I
thought I could throw off my mother's teachings.... I didn't
know then that you can't live down this kind of upbringing. It
was only gradually that I realized I'm conscience-bound. Always
will be. Then I spent the rest of my life finding how to live
enjoyably with my conscience. Accepting the conscience. Paying
any price. And by paying...getting permission from my
conscience to do the other things that are more fun.

This is like a marvelous solution for me. Why, if somebody
said to me now, "You're a has-been. The war's won. You don't
speak the modern language," I'd be terribly disappointed....
It's an ideal existence. Out in the open. Berating the
president of the United States.... In psychodynamic terms, I'm
free to thwart and torment the authorities—that is to say, I
can get out my hostilities—because I'm protected in my
conscience by the knowledge that what I'm doing is morally
right. I've never been so relaxed. I've
never been so happy.

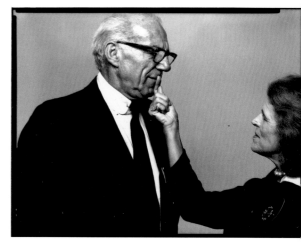

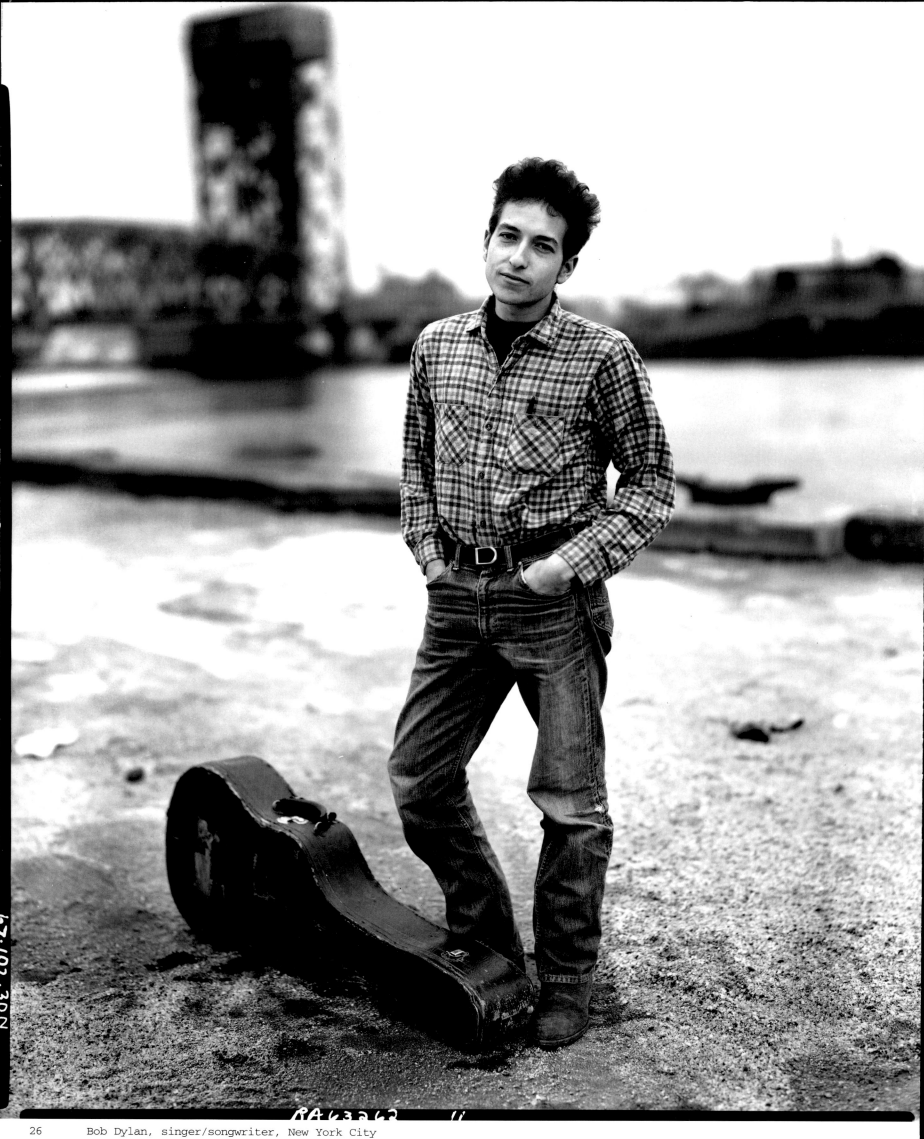

26 Bob Dylan, singer/songwriter, New York City

Paul McCartney, The Beatles, London 27

George Harrison, The Beatles, London

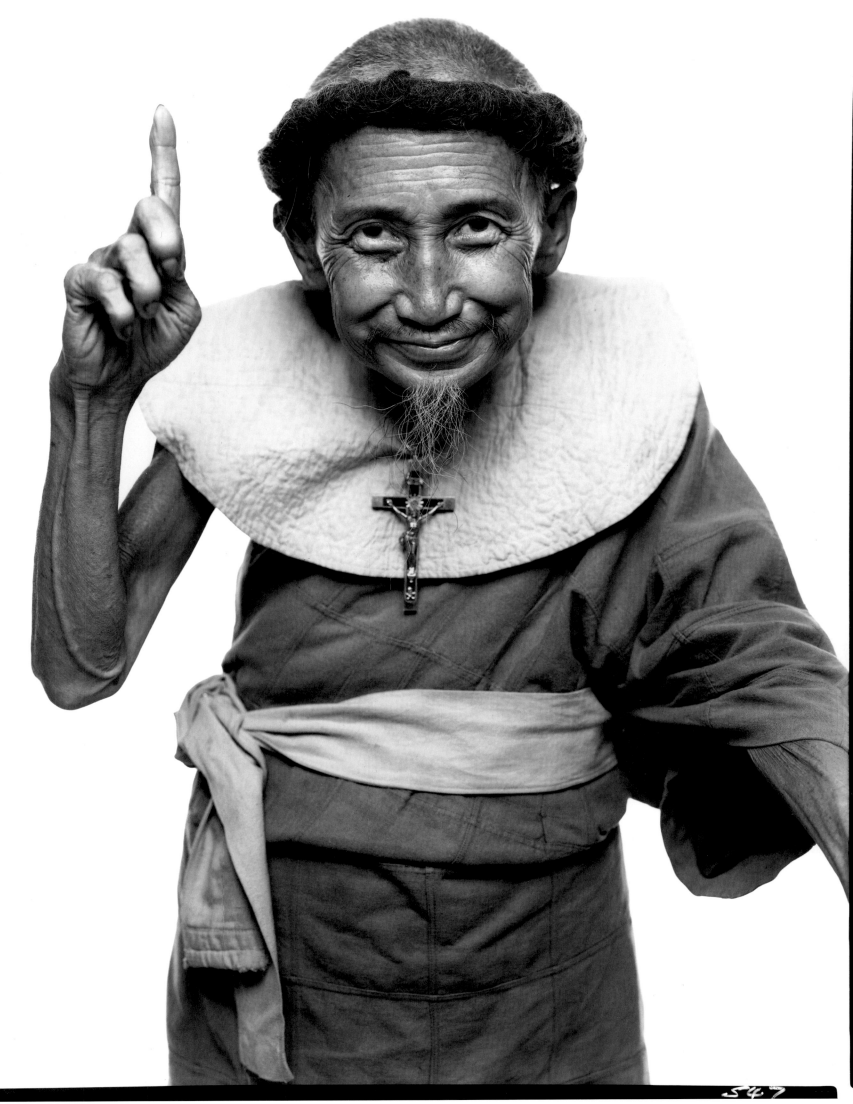

Dao Dua, "The Coconut Monk," Mekong Monastery, Vietnam 29

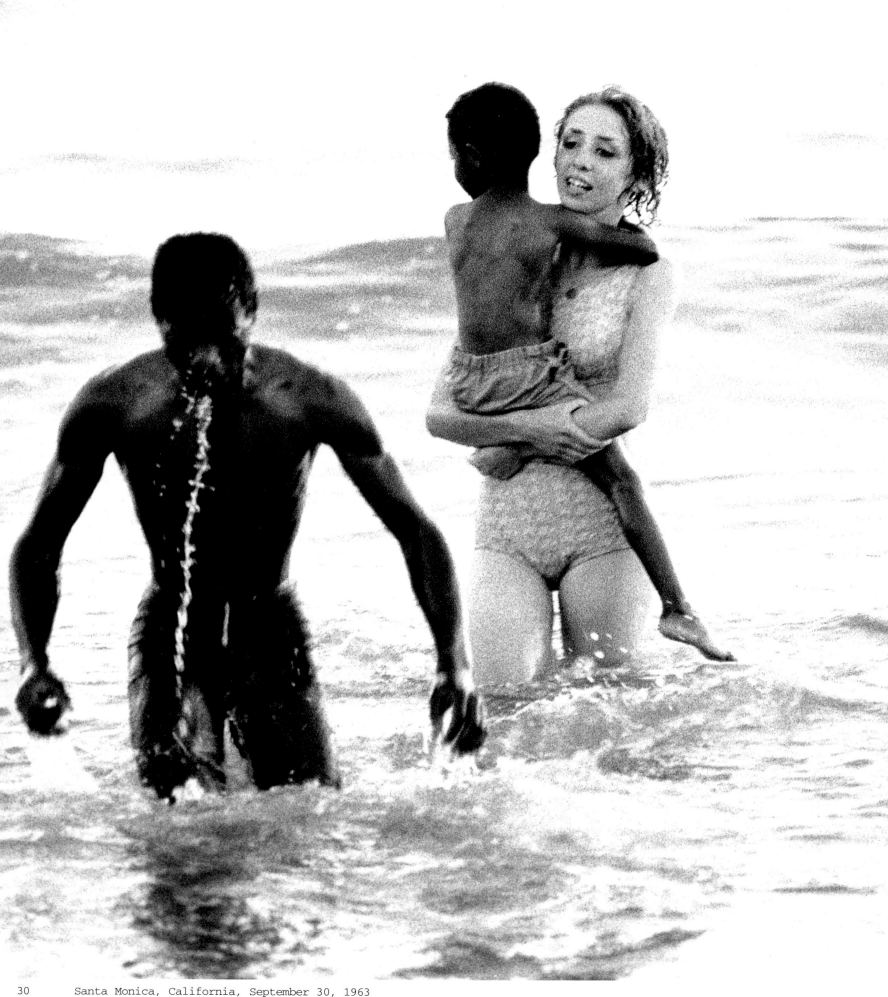

30 Santa Monica, California, September 30, 1963

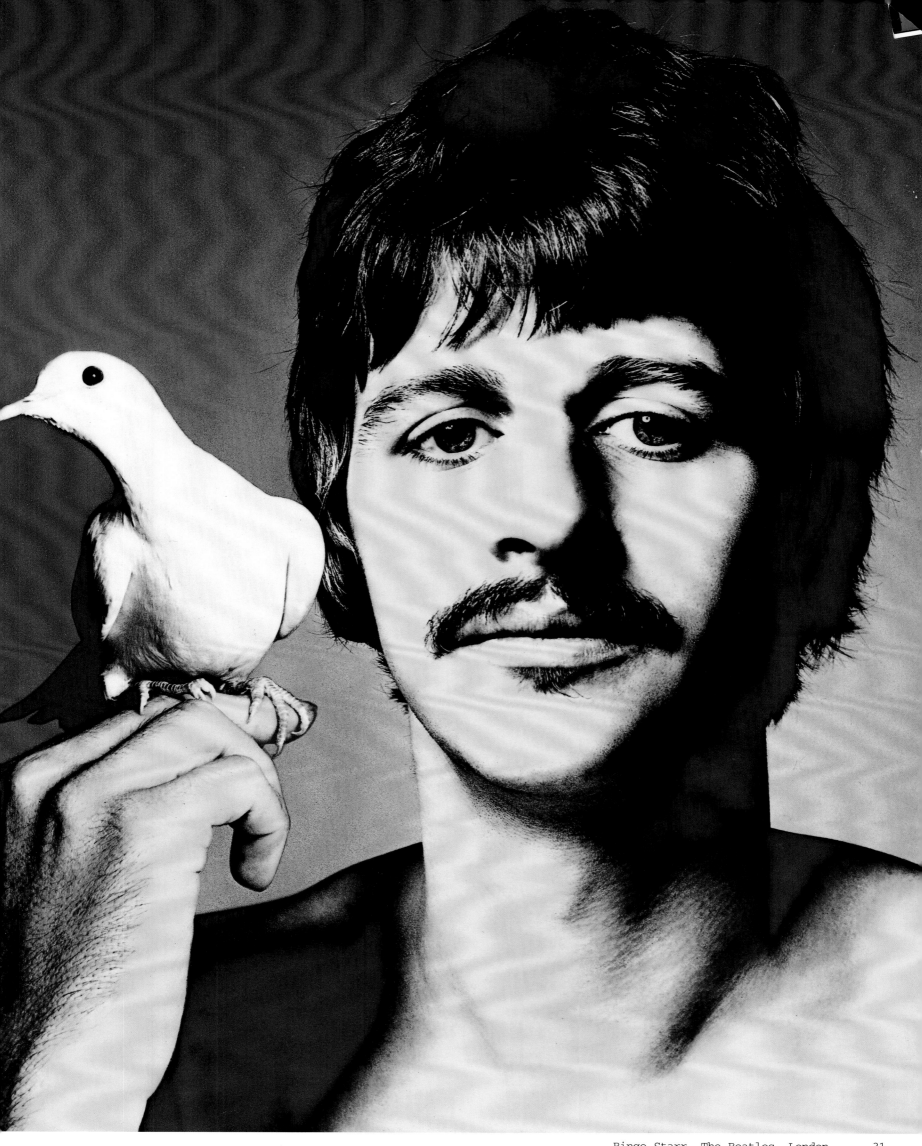

Ringo Starr, The Beatles, London 31

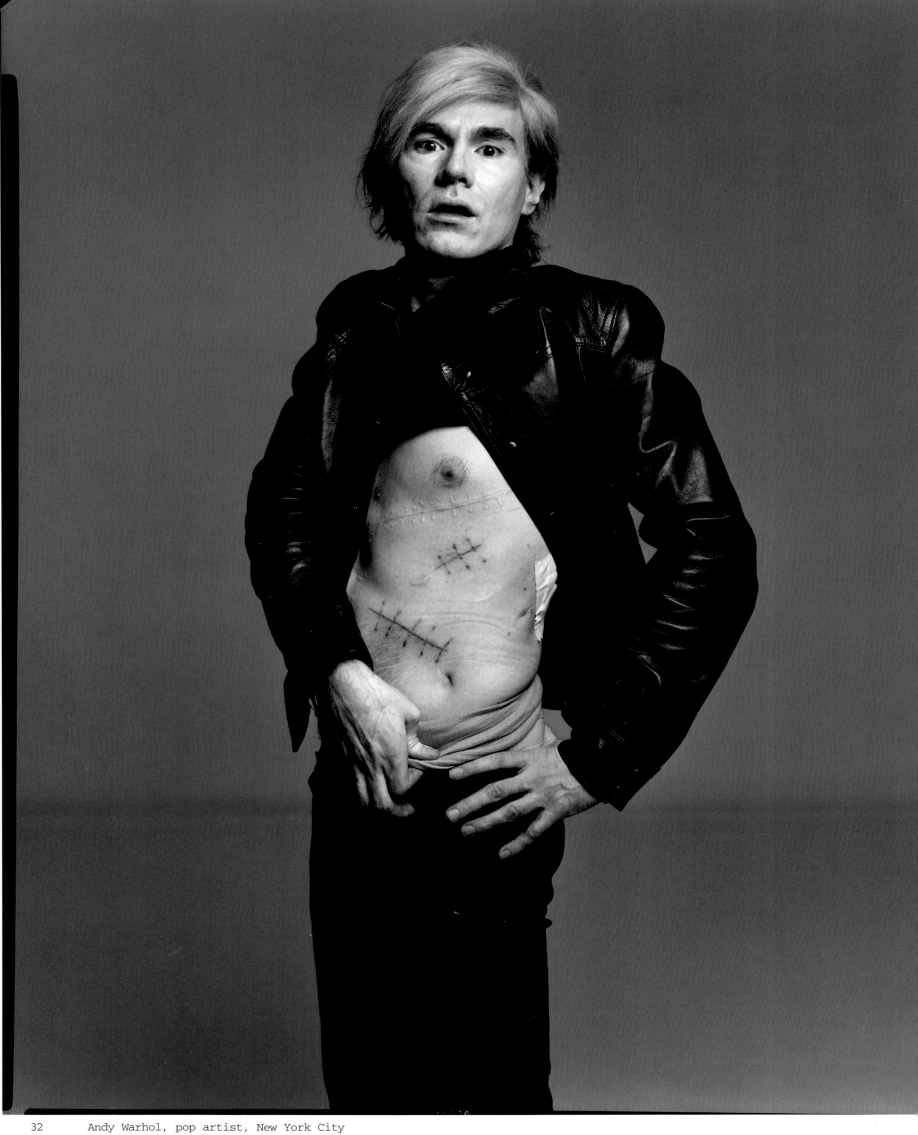

Andy Warhol, pop artist, New York City

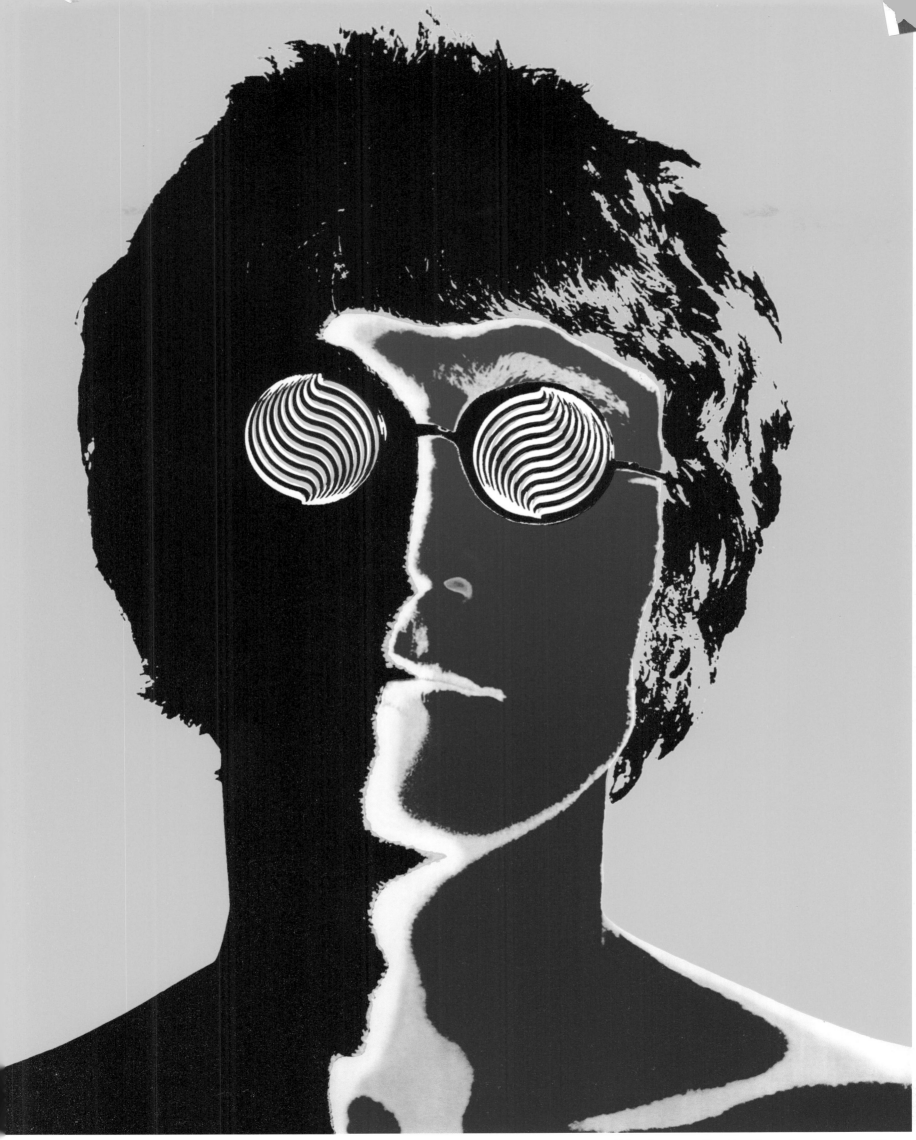

John Lennon, The Beatles, London 33

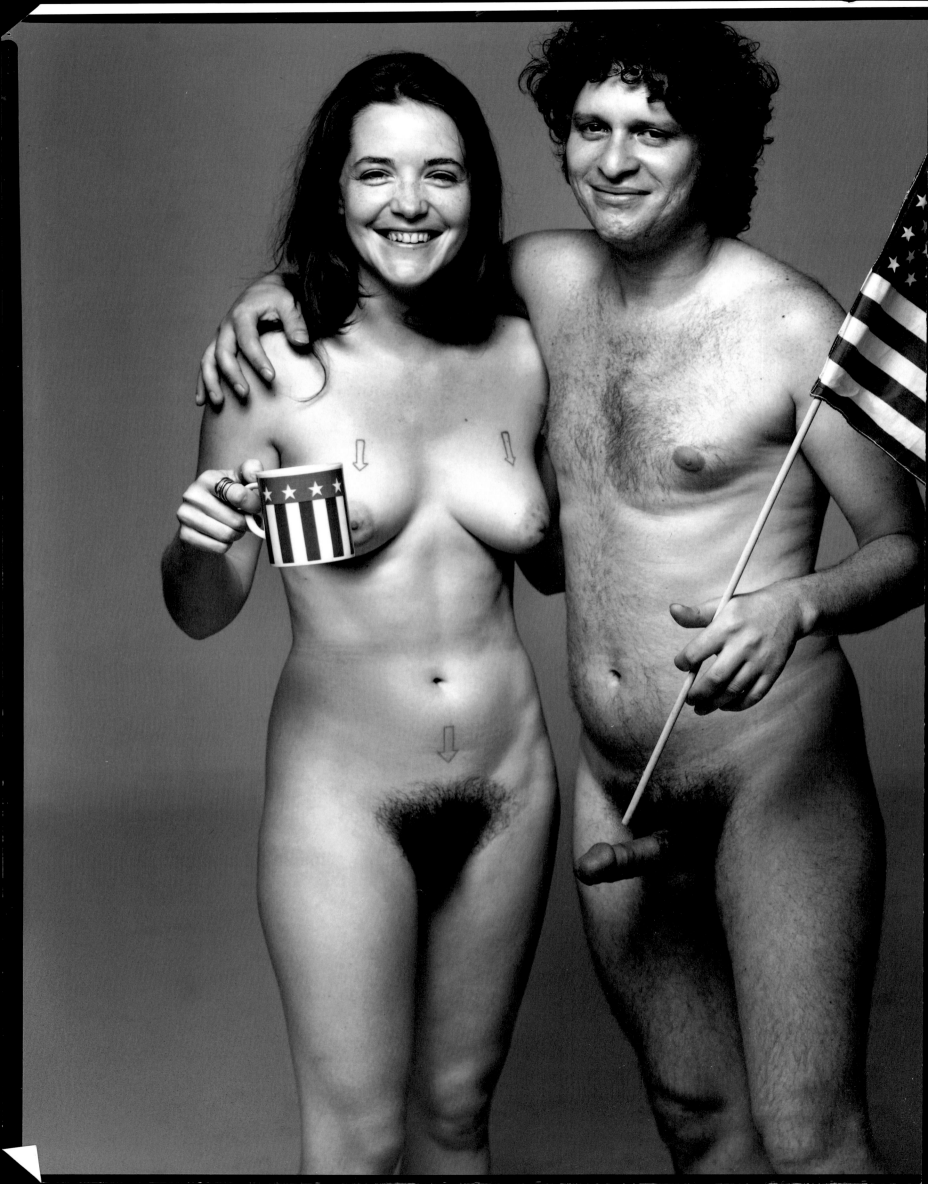

PAUL KRASSNER, editor
of *The Realist*, with JADA
ROWLAND, actress
New York City
August 8, 1969

You know how people are
always saying, "Taking
drugs should be a
religious experience
instead of just doin' it
for kicks"? But to me,
kicks *is* a religious
experience. When Ginsberg
talks about religious
experiences he's very
solemn about it. I went
up one time at the
Psychedelic Exposition in
Toronto, and he had just
done a whole Hare Krishna
and everybody was getting
very...holy. So I got up
and did the whole thing
about the real meaning of
Hare Krishna, Rama Rama.
I said it was about an
impotent Buddhist deity
and it was the plaint of
his wife. She was saying,
"Hurry, Krishna. Hurry.
Ram it. Ram it. Ram it.
Hurry, hurry, hurry,
Krishna." 'Cause the
words are just symbols,
and every symbol should
be able to withstand
being made fun of. And
that includes my own
symbols. Whatever
they are.

Allen Ginsberg and Peter Orlovsky,
poets
New York City

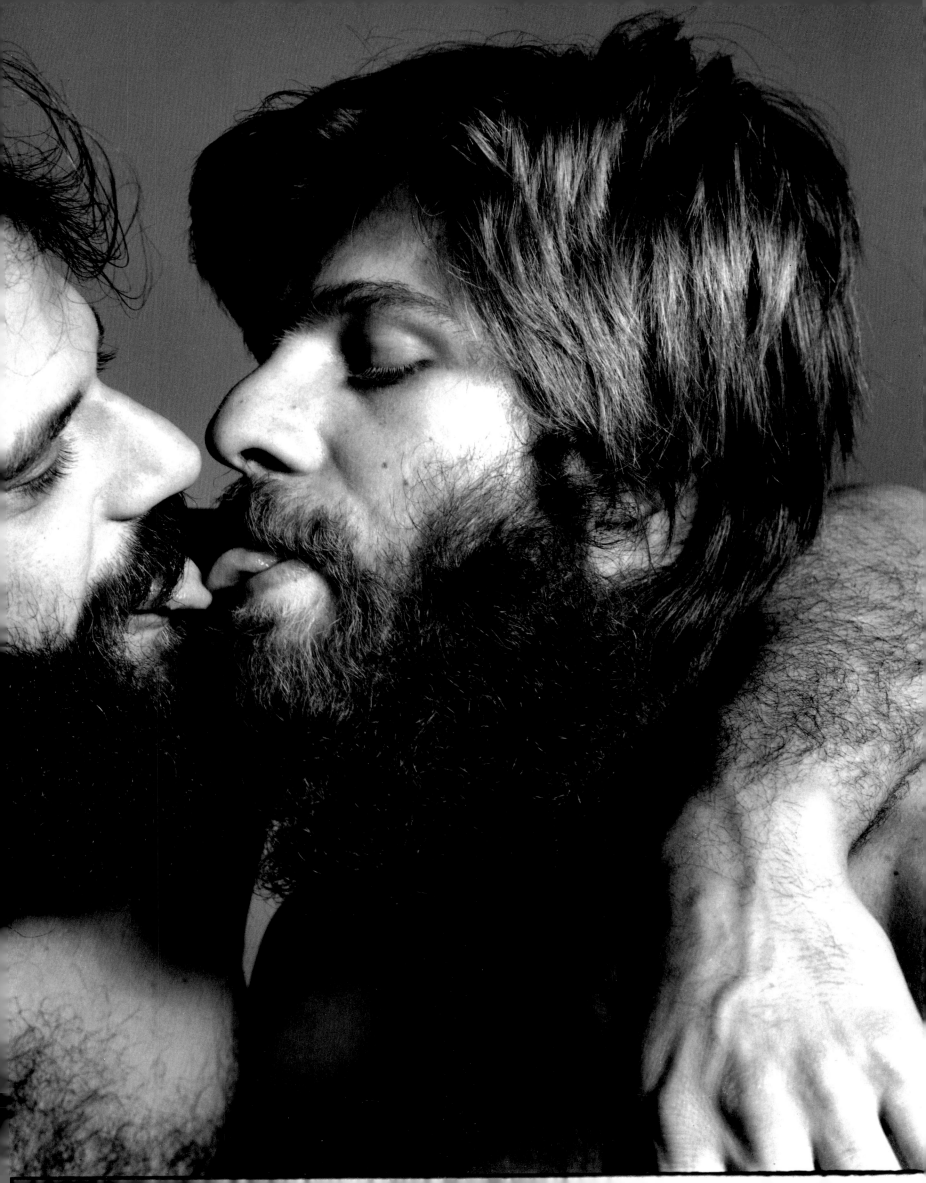

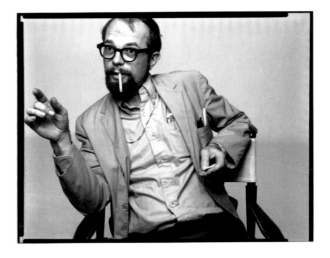

DAVID McREYNOLDS,
War Resisters League
New York City
September 10, 1969

This is the morning that I was gonna see how long I could not smoke. But I had one coming up in the elevator. I decided I really couldn't face it without a cigarette. Each day I see how long I can go...twelve-ten this morning, you know? My God, the terms one writes out for oneself...in blood. And the evasions that one finds in order to obey the pact.

I met a guy yesterday that hadn't smoked for a year. I said, "Well, do you still want to smoke?" He said, "Constantly. It drives me crazy." The only difference between the two of us is that I want to stop smoking constantly and he wants to smoke constantly. He's gonna live longer than I am but the tensions we have are identical.

I have a friend who gave it up immediately. Just like that: one morning, woke up, never smoked again. And my theory is that he's not committed to anything, including smoking. He's that kind of guy. He's never been able to sustain a marriage, a political conviction...a job.

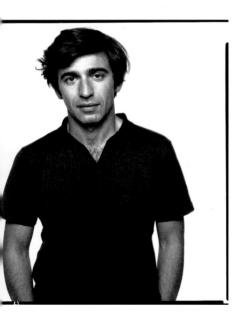

HENRY ARONSON, civil rights lawyer
New York City
September 1, 1970

I've often thought to myself, and expressed to friends, one of life's most awful moments is waking up next to someone you really don't want to be next to. That's really terrible. The Oh-my-God-what-am-I-doing-here. And yet being somewhat sensitive to other people's feelings and sense of self, you go through the motions of being a little bit affectionate, a little bit caring, but really you can't get dressed fast enough and out fast enough—or get them out fast enough, depending on where you are.

JANIS JOPLIN, blues/rock singer
Port Arthur, Texas
September 3, 1969

I live pretty loose. You know, balling with strangers and stuff.... A lot of people live loose, don't you think? Everyone I know lives incredibly loose.

Sometimes, you know, you're with someone and you're convinced that they have something to...to tell you. Or, you know... you want to be with them. So maybe nothing's happening, but you keep telling yourself something's happening. You know,

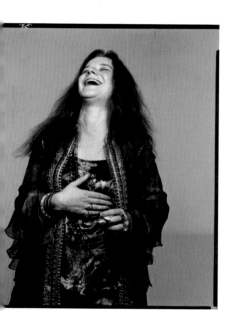

innate communication. He's just not saying anything. He's moody or something. So you keep being there, pulling, giving, rapping, you know. And then, all of a sudden about four o'clock in the morning you realize that, flat ass, this motherfucker's just lying there. He's not balling me.

I mean, that really happened to me. Really heavy, like slam-in-the-face it happened. Twice. Jim Morrison and Leonard Cohen. And it's strange 'cause they were the only two that I can think of, like prominent people, that I tried to...without really liking them up front, just because I knew who they were and wanted to know them.... And they both gave me nothing.... But I don't know what that means. Maybe it just means they were on a bummer.

Meeting somebody and balling them...means something, but it doesn't mean near as much as it used to. It doesn't mean, like, this is it forever. It means, Wow, I really dig you, let's get together. It just...takes it a step farther than, you know, talking on dates. Know what I mean? Really getting together. It just means you dig somebody and want to be with them. And that happens a lot, you know? You meet someone, you like them, and you...be with them, maybe for a while, maybe for a couple of days, maybe for a couple of hours, maybe for a couple of years.

LEONARD COHEN, poet, composer, singer
New York City
August 13, 1969

I don't know if you've had that feeling with grass but, um...I
used to experience it quite a lot. When you are smoking, say,
under the conditions that we are smoking these Indian cigarettes
now—with three people...and you're sharing a small space....
When one person goes away there's a bereft...when one person
leaves the room, just absents himself from the room for some
reason and suddenly...because the flows are so complete between
the three people...I mean, I've always felt that three people
make a...a very interesting number.... One is really extended
that way. I mean you really...something like, uh...of, uh...your
whole sense of...of charity and survival, you know...is
challenged with three people...if you're interested in
maintaining it all at the same time.... But it's hard. I found
it very hard. Well, of course, I was very hung up on...on
sexual, uh...uh...truth...in those days. I mean, I felt like if
any two people had any kind of sexual affinity for each other
they had to sleep with each other immediately, otherwise it was
a terrible...betrayal and waste, you know. I felt...well, I
spent a lot of time trying to decipher what
the feelings I had for somebody were...and
whether I had to sleep with them or not....
Fortunately, I'm relieved of those
obsessions now. It's really wonderful. It's
really wonderful not feeling you have to
sleep with everybody.

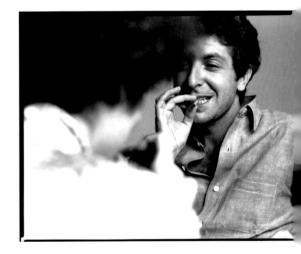

SUSAN BROCKMAN, artist, filmmaker,
with WILLEM DE KOONING, abstract expressionist painter
New York City
September 3, 1970

I guess I feel much more romantic with older men. I don't
suppose that's healthy, but maybe whether it's healthy or not
is irrelevant. Bill, for me, is just the personification of

that. I mean, I could just wrap myself up inside of him and...go to sleep forever.

Maybe that was part of the great fear. Someone once said to me—and this was someone I really couldn't stand, although in a strange almost mystical way they've affected my life—he said, "You can't grow with Bill." I didn't really take it seriously. I didn't even know what he meant really. I mean it was one of those things that just didn't get into me. But I sort of feel that if it hadn't been for that remark...Bill and I might still be together. I mean he gratified so much in me. I just wouldn't have to do anything. And because I'd be constantly gratified, I wouldn't fall down and get depressed and in a corner, where left to my own devices I might. And it was very painful to give that up. To this moment it hurts. It was a very deep attachment. I don't know if it was for the right or wrong reasons but...I mean, it was like...I could have died in his arms at peace.

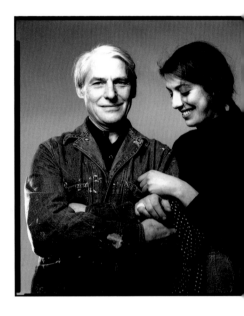

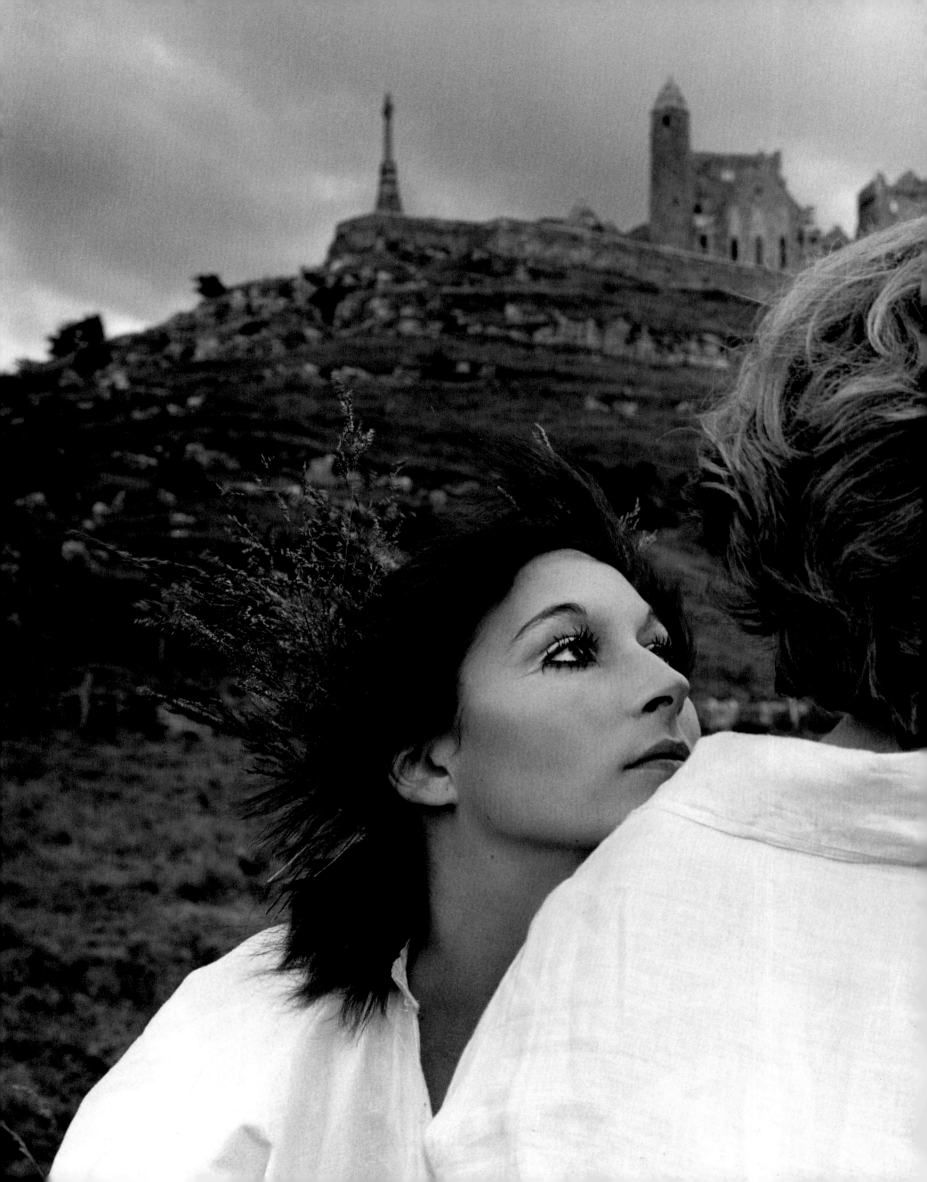

Anjelica Huston, actress, with
Harry Mattison, photographer
Menlough Castle, Ireland

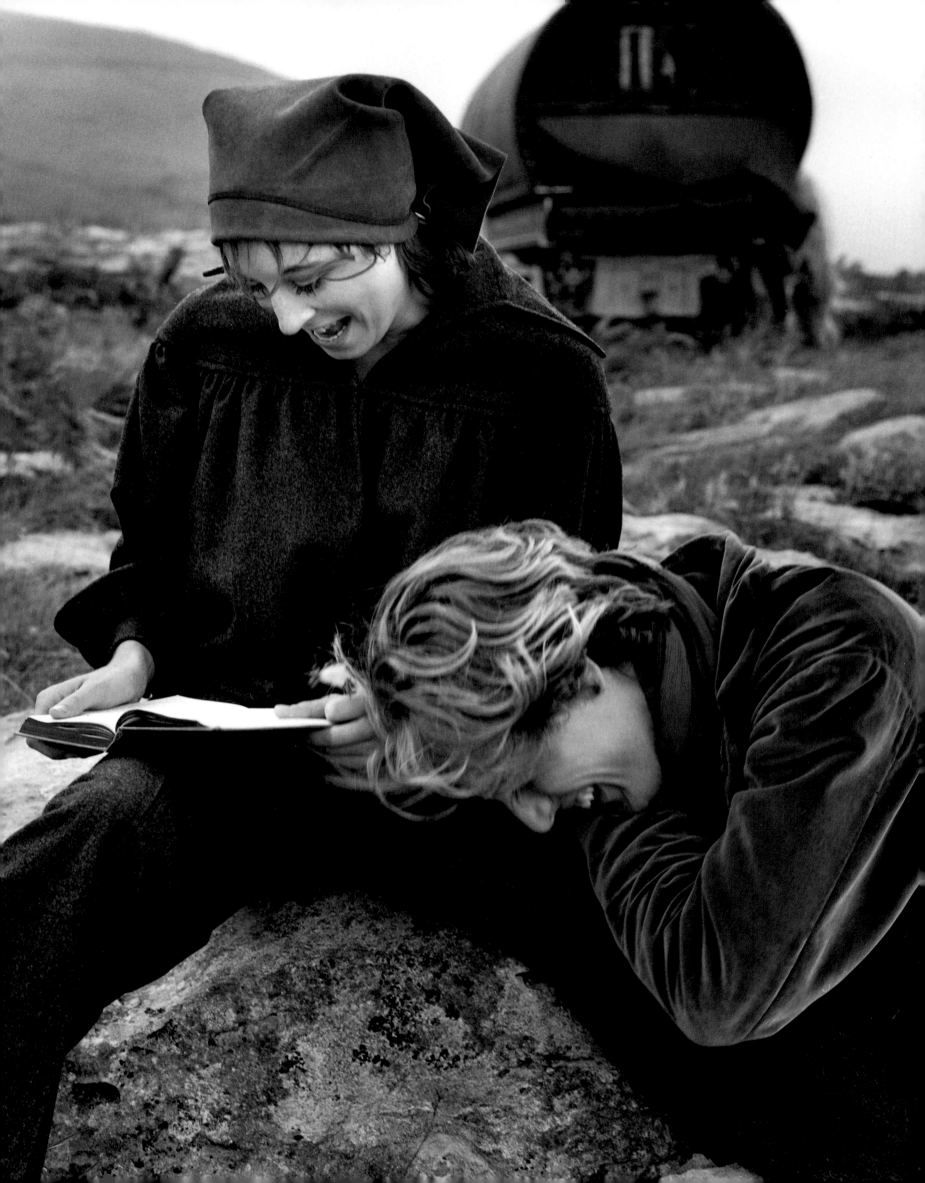

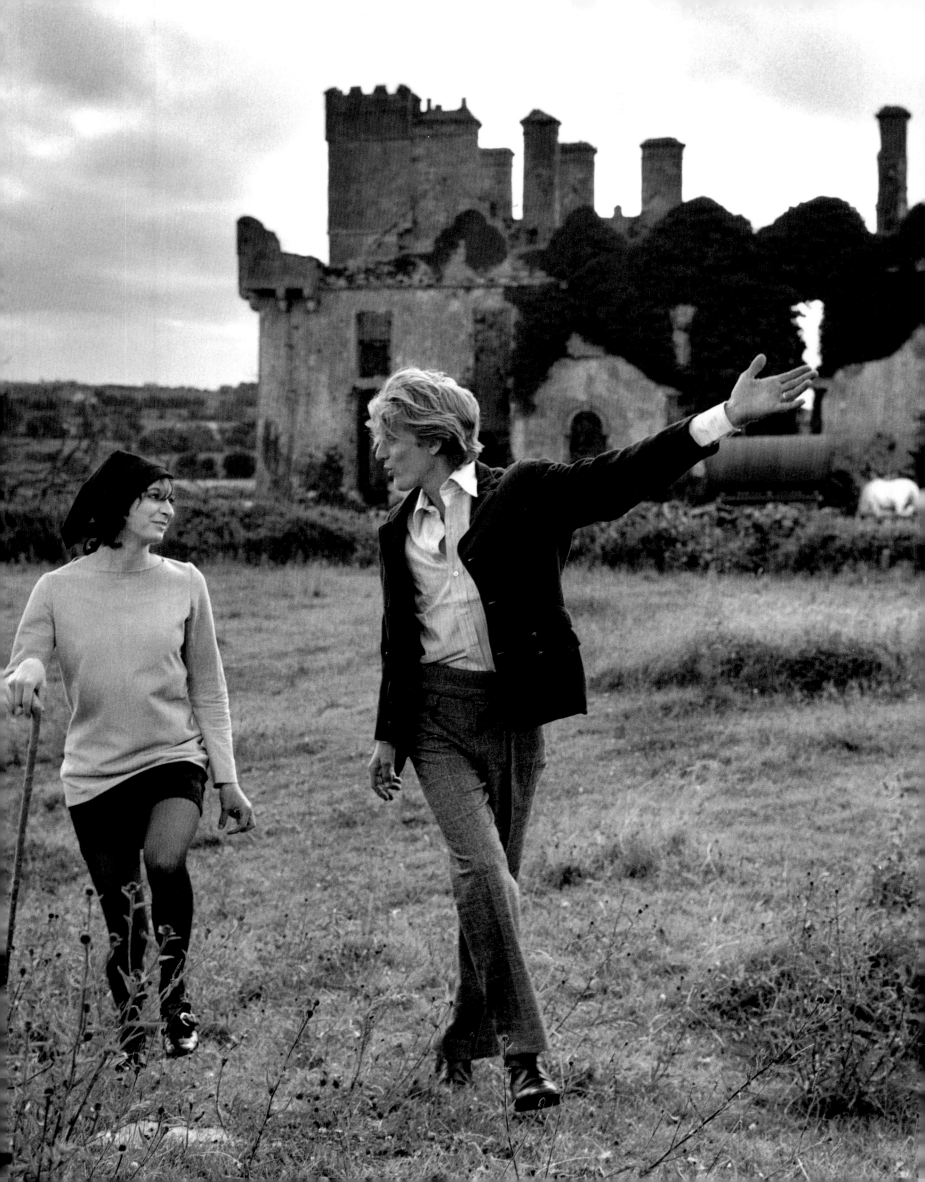

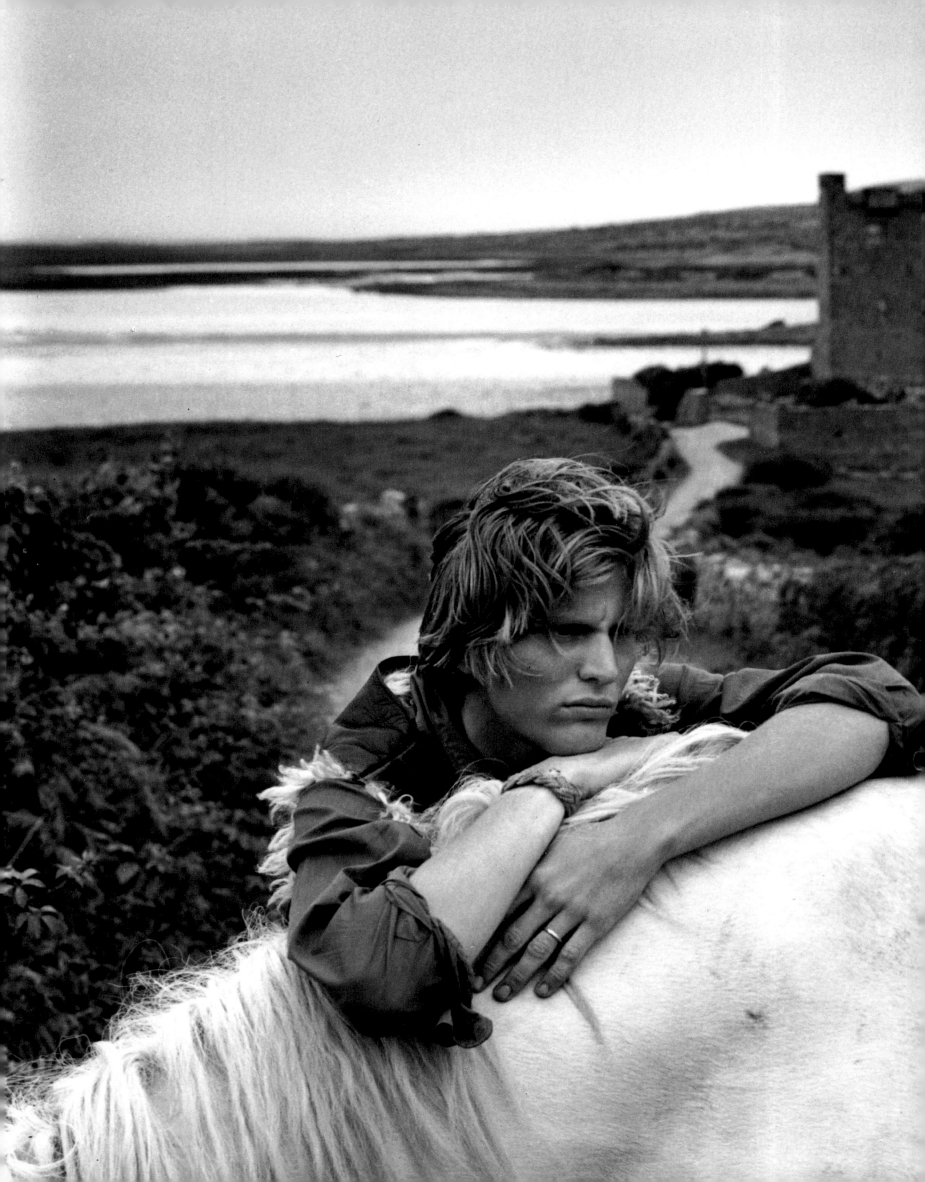

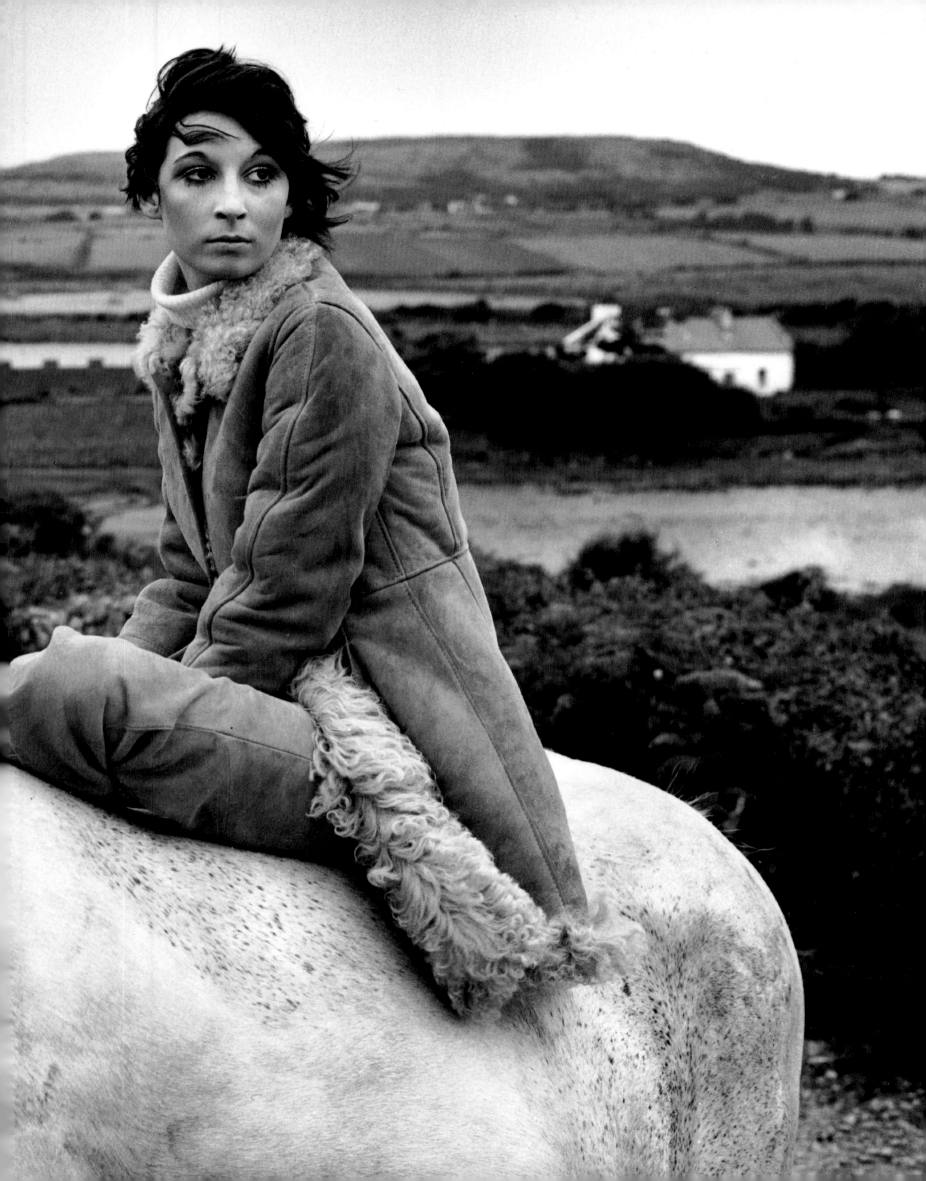

DOROTHY DAY,
The Catholic Worker Mission
Milwaukee, Wisconsin
September 24, 1969

Certainly the first time I
went to jail—when I was
eighteen—I felt a great sense
of desolation, a great
identification with all the
hopeless people around me. I
didn't have the faith. I
spent a couple of days
weeping and I just went into
a state of melancholy.

I never feel unsure in
prison anymore. I feel it's
a good place to be. You
know, a lot of the Catholic
Workers go up in the world.
And a lot of them go down in
the world—to jail. I must
say I have much more esteem
for those who keep trying to
get lower.... We must
continue to fill up the
jails. Breaking the law is
the only way of really
testing it.... There's an
old saying, "You cut off the
head of one tyrant and three
others spring up in its
place." The same way
with...you send somebody off
to jail and three others
come to take their place.
There's a constant...influx
of people in a movement of
this kind. And when someone
is taken off to jail,
somebody else has to go
ahead and assume

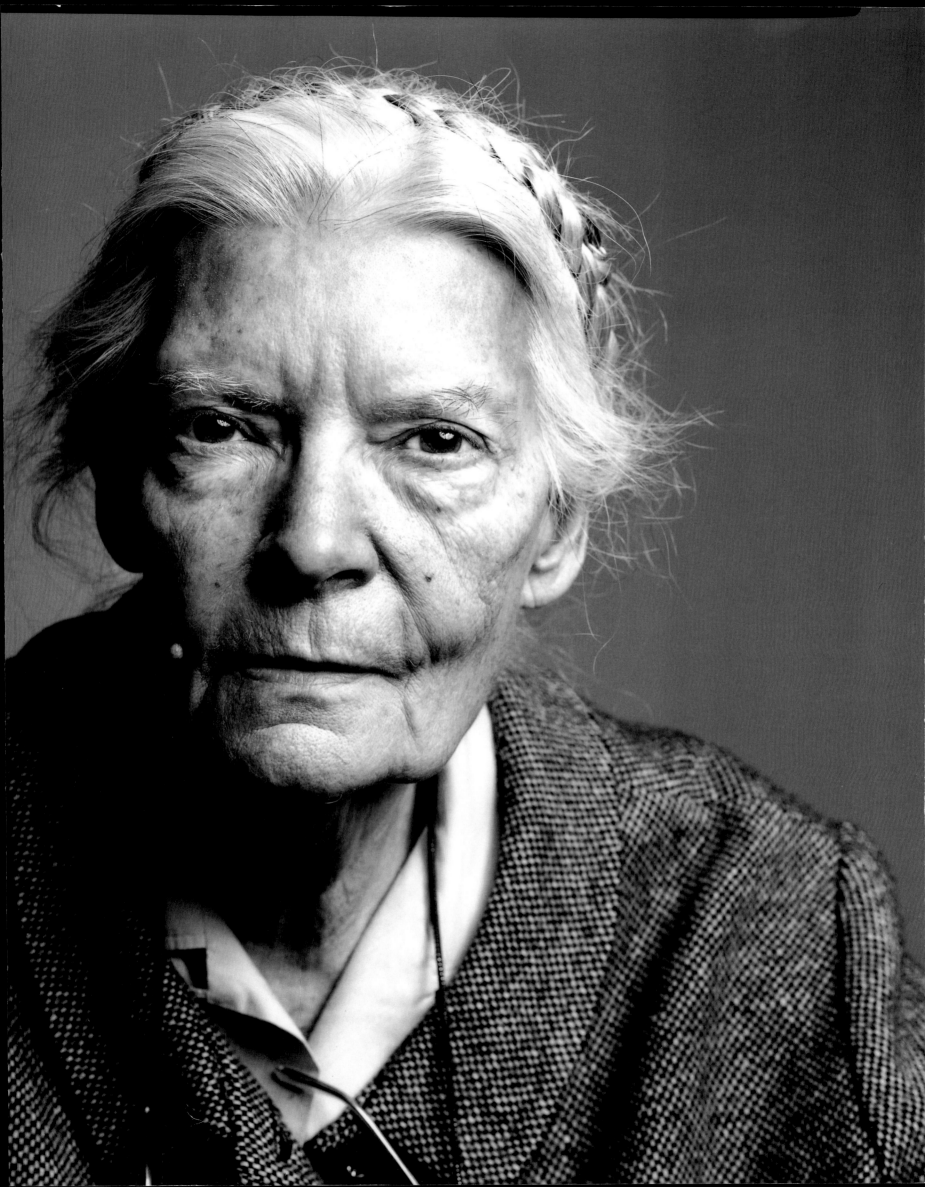

responsibility and do things they never thought themselves capable of doing...to keep things going.

I feel it's a very sure technique—working together with people and getting things done. A very sure technique of survival, too, in a time when people are losing their minds—practically. I think I'm absolutely sure of these things—the works of mercy and the nonviolent rebuilding of the social order. I think there has to be a sort of harmony of body and soul, and I think that comes about, certainly for a woman, through those very...the simple things of "feeding the hungry, clothing the naked, and sheltering the harborless."

Anne Schwerner, Fannie Lee Chaney,
and Carolyn Goodman,
mothers of three slain civil rights workers
New York City

50

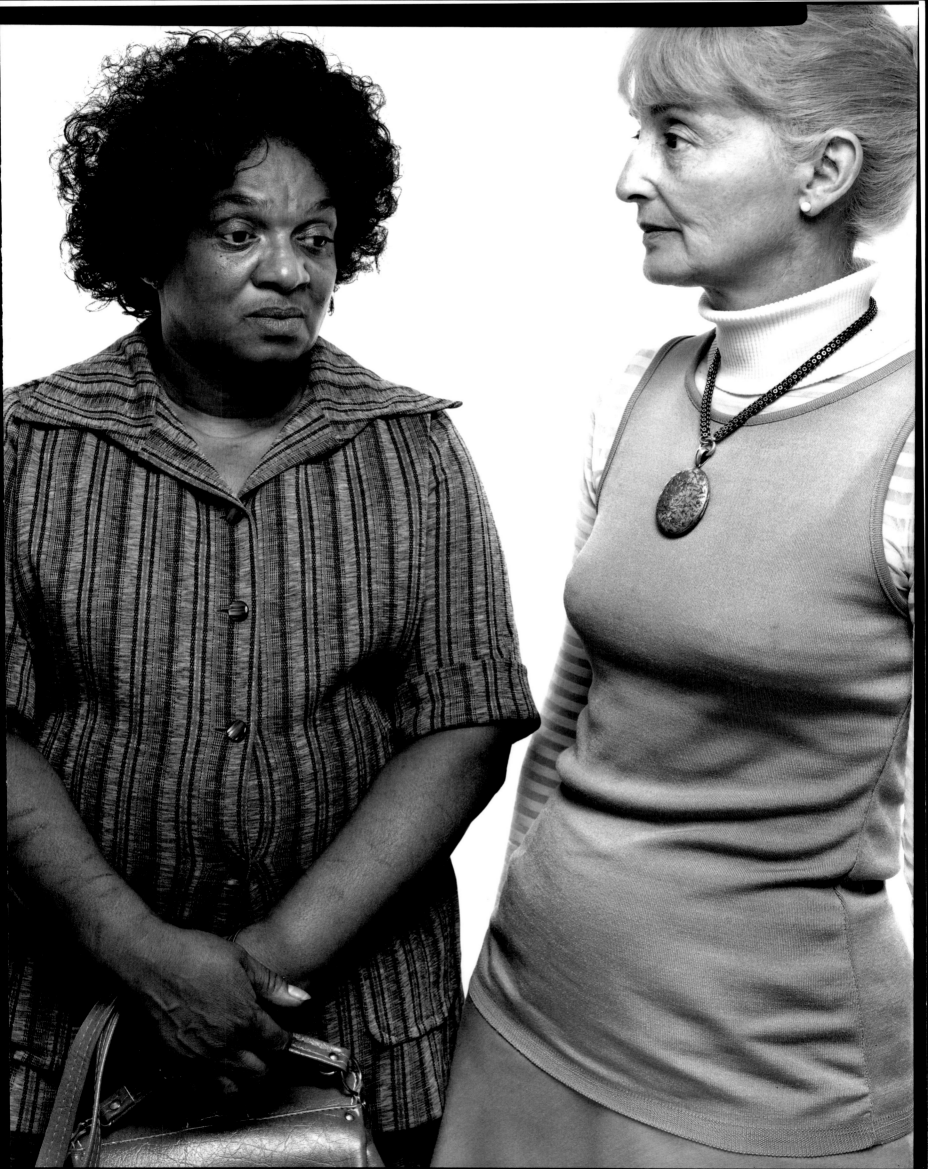

Larry Josephson, producer, WBAI Radio,
and Julius Lester, writer
New York City

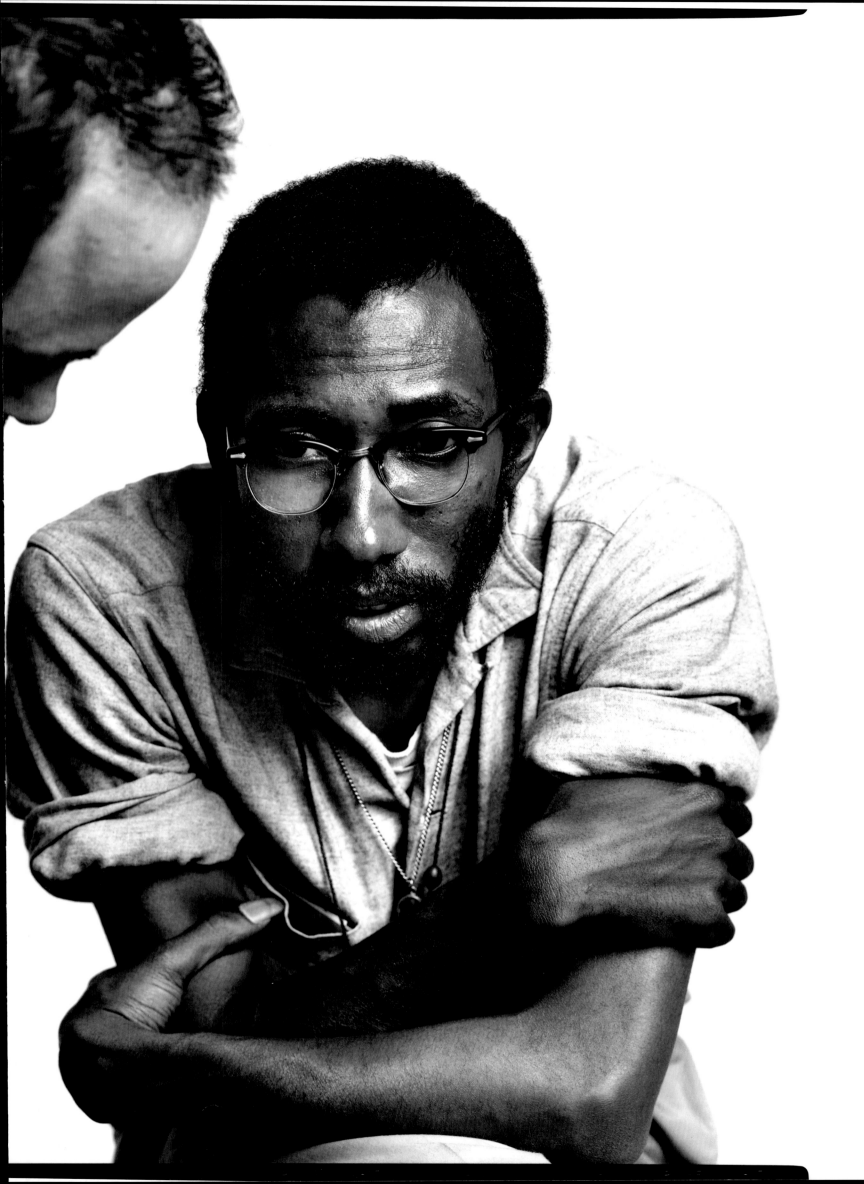

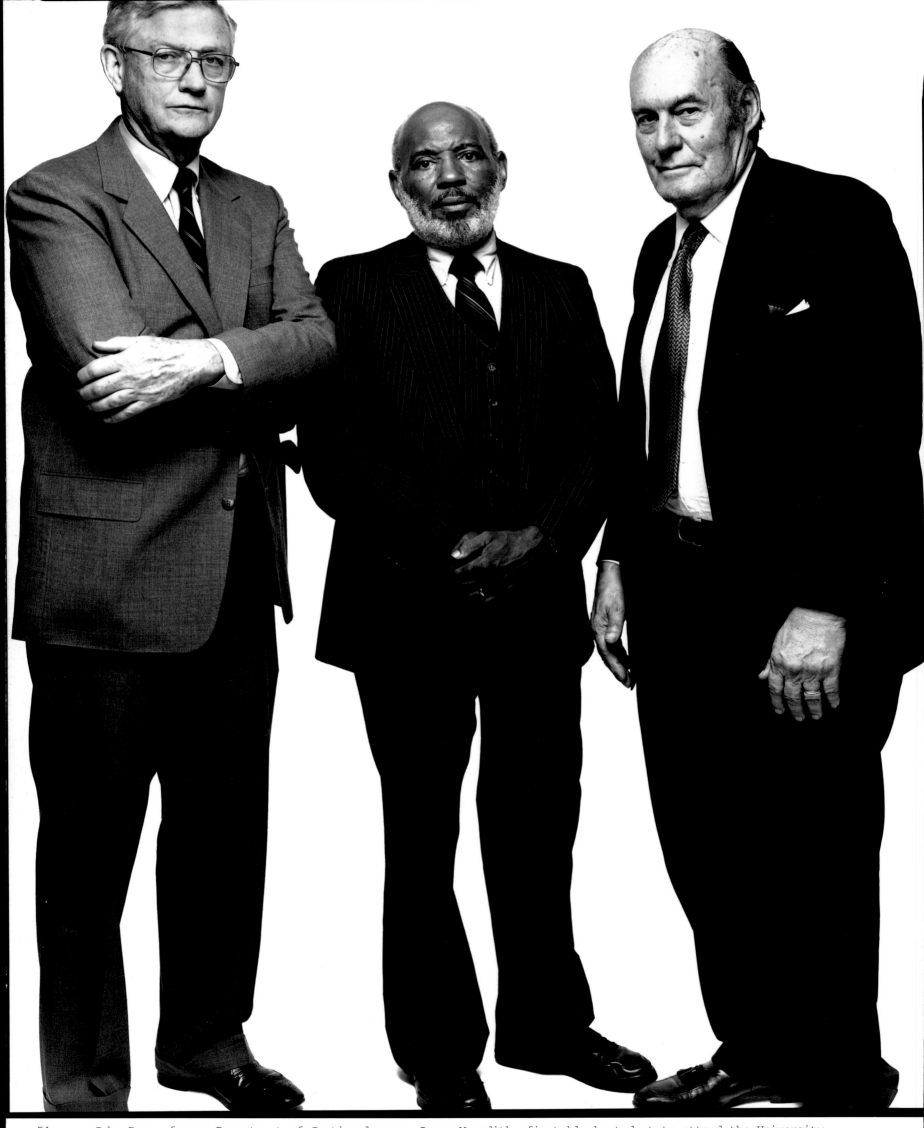

54 John Doar, former Department of Justice lawyer; James Meredith, first black student to attend the University of Mississippi; and Nicholas Katzenbach, former U.S. Attorney General, New York City, August 10, 1993

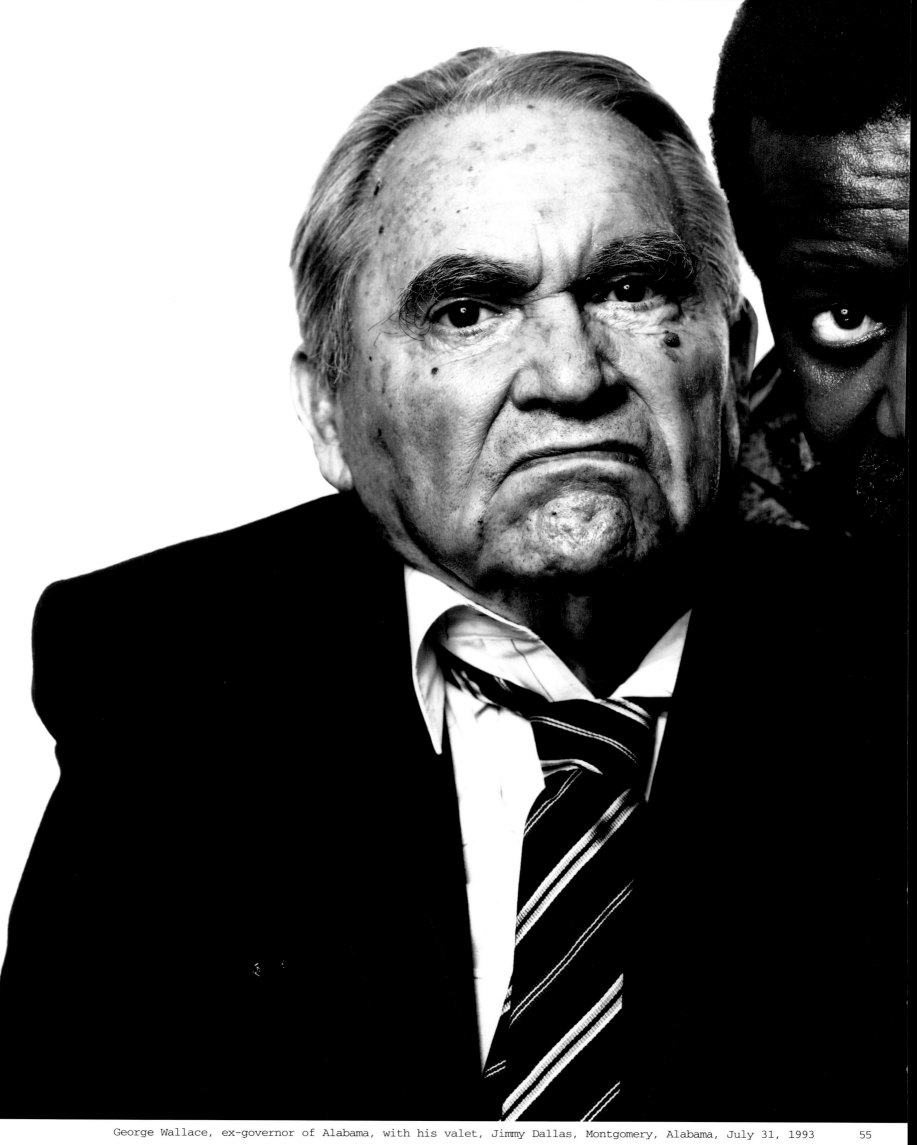

George Wallace, ex-governor of Alabama, with his valet, Jimmy Dallas, Montgomery, Alabama, July 31, 1993

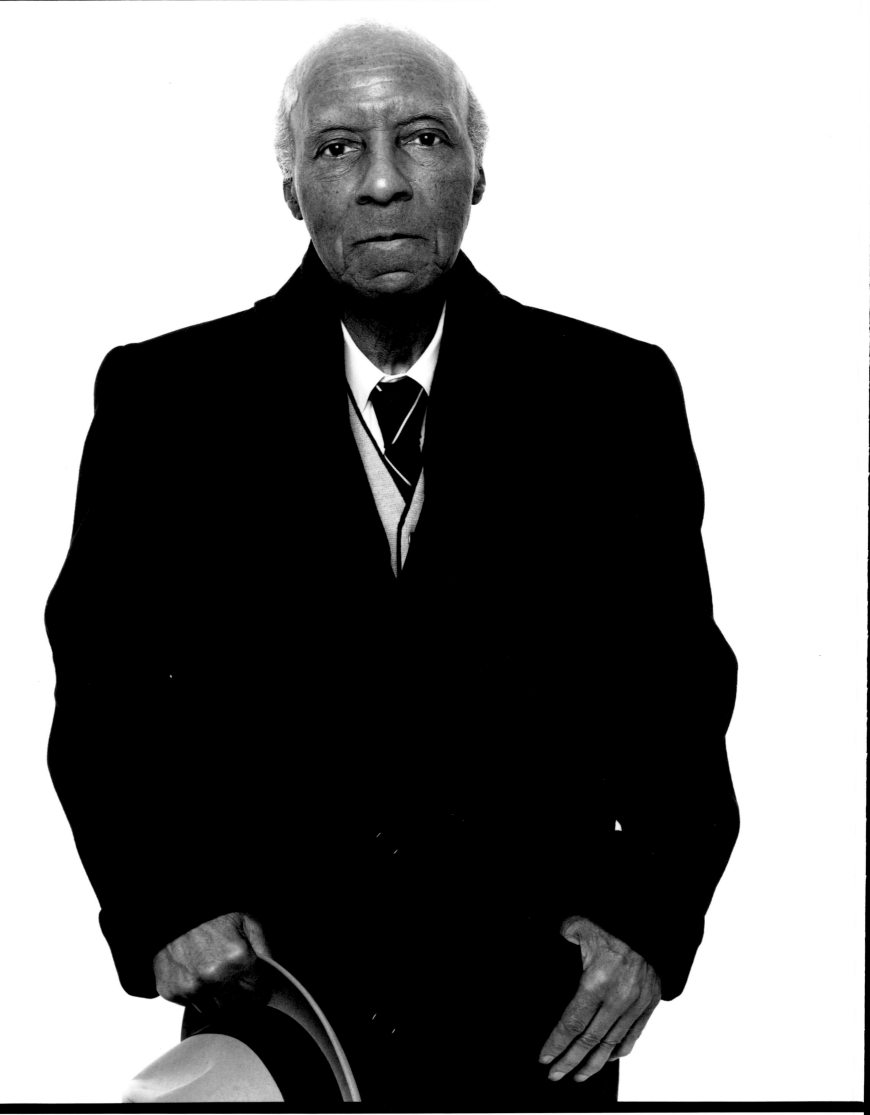

56 A. Philip Randolph, founder of the Brotherhood of Sleeping Car Porters, New York City

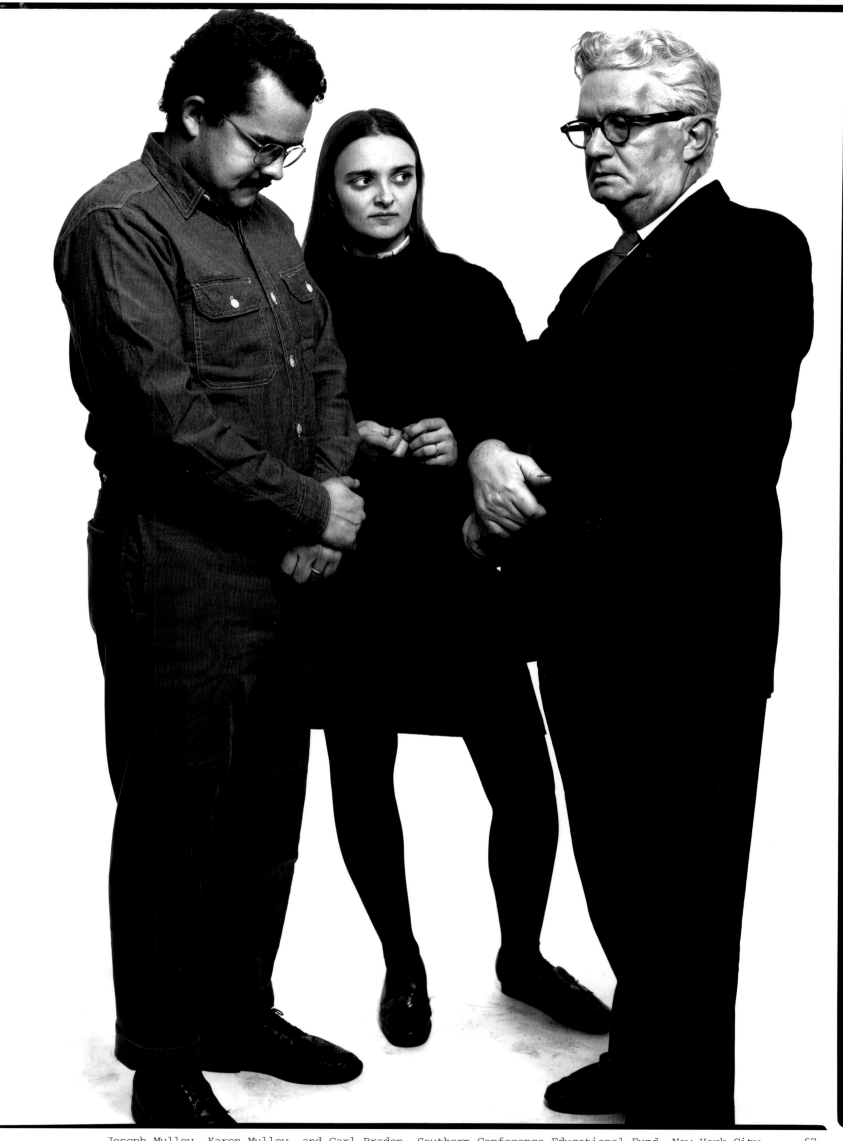

Joseph Mulloy, Karen Mulloy, and Carl Braden, Southern Conference Educational Fund, New York City 57

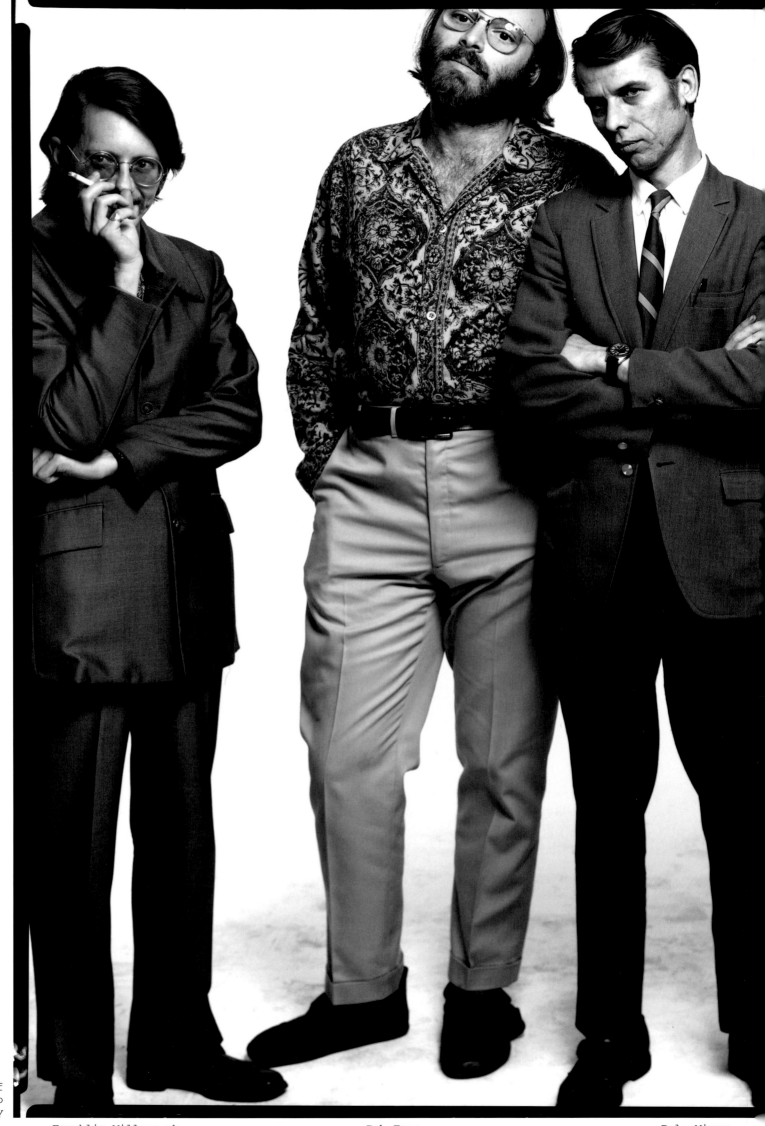

The staff of
WBAI Radio
New York City

Franklin Millspaugh Bob Fass Dale Minor

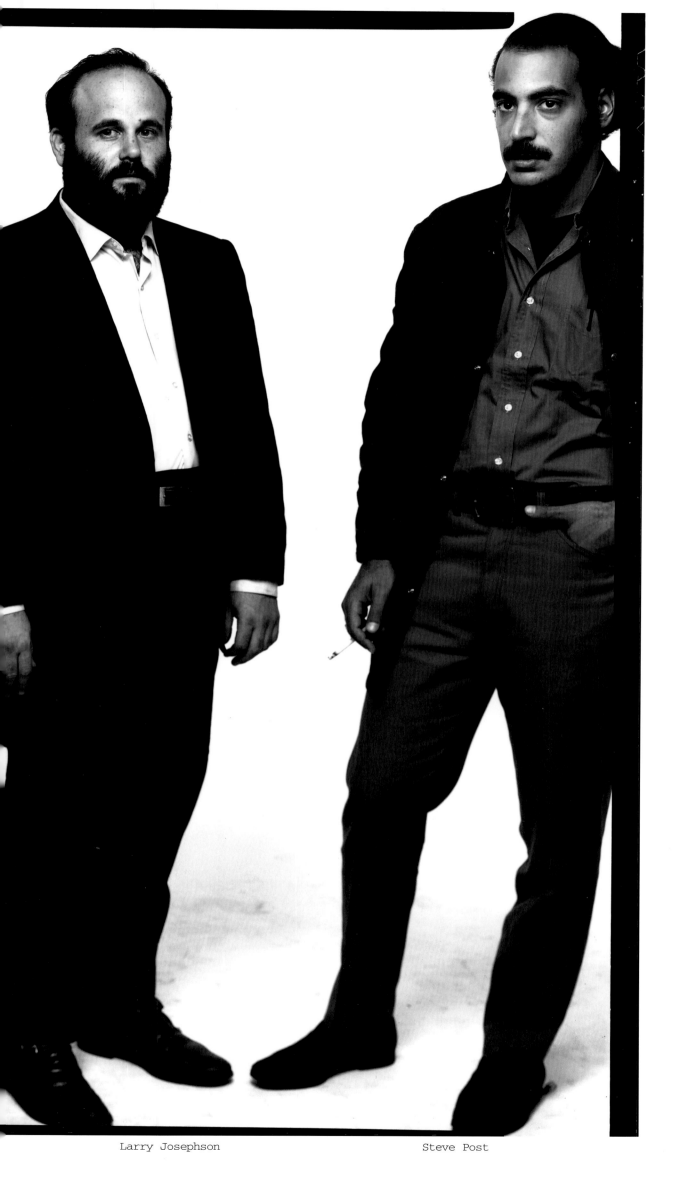

Larry Josephson Steve Post 59

Jean Genet, French novelist and
playwright, with an unidentified Black
Panther, Greenwich Village, New York

60

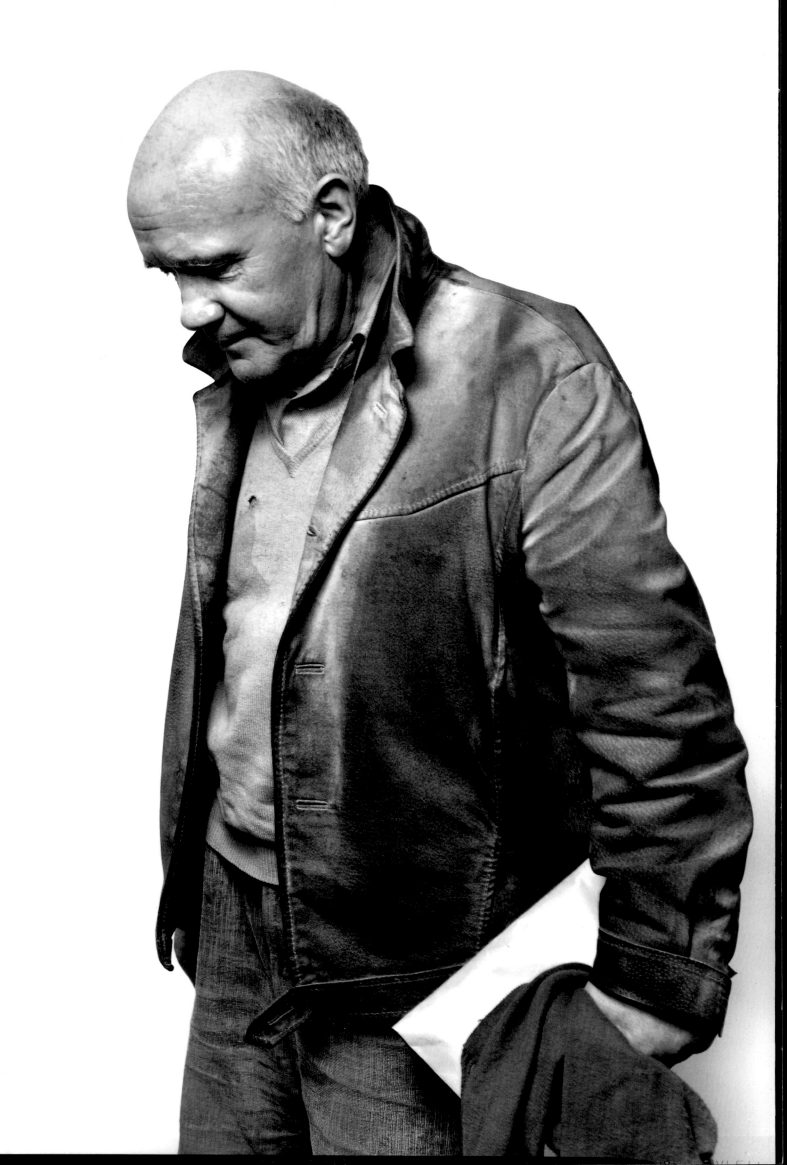

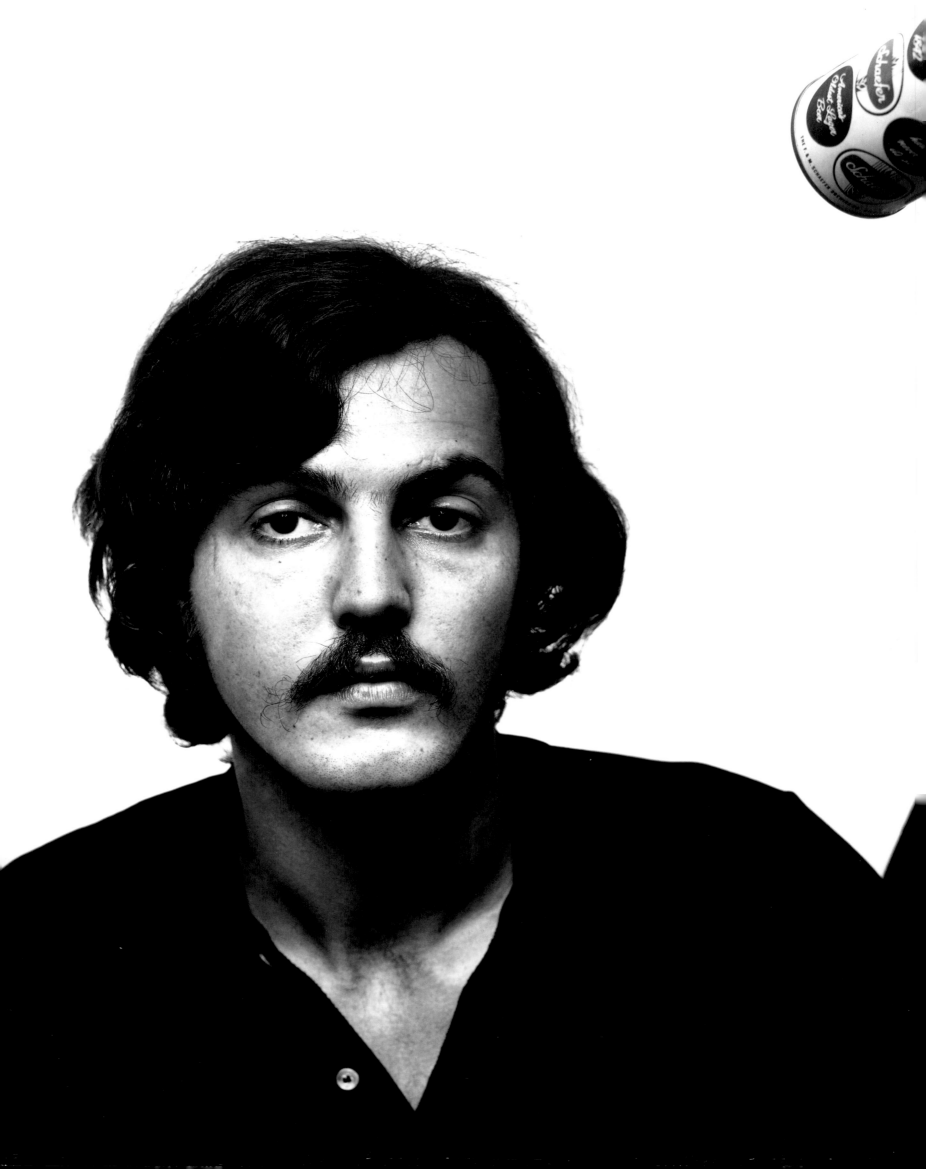

Gary Thiher and Jeff Shero,
editors of *Rat*
New York City

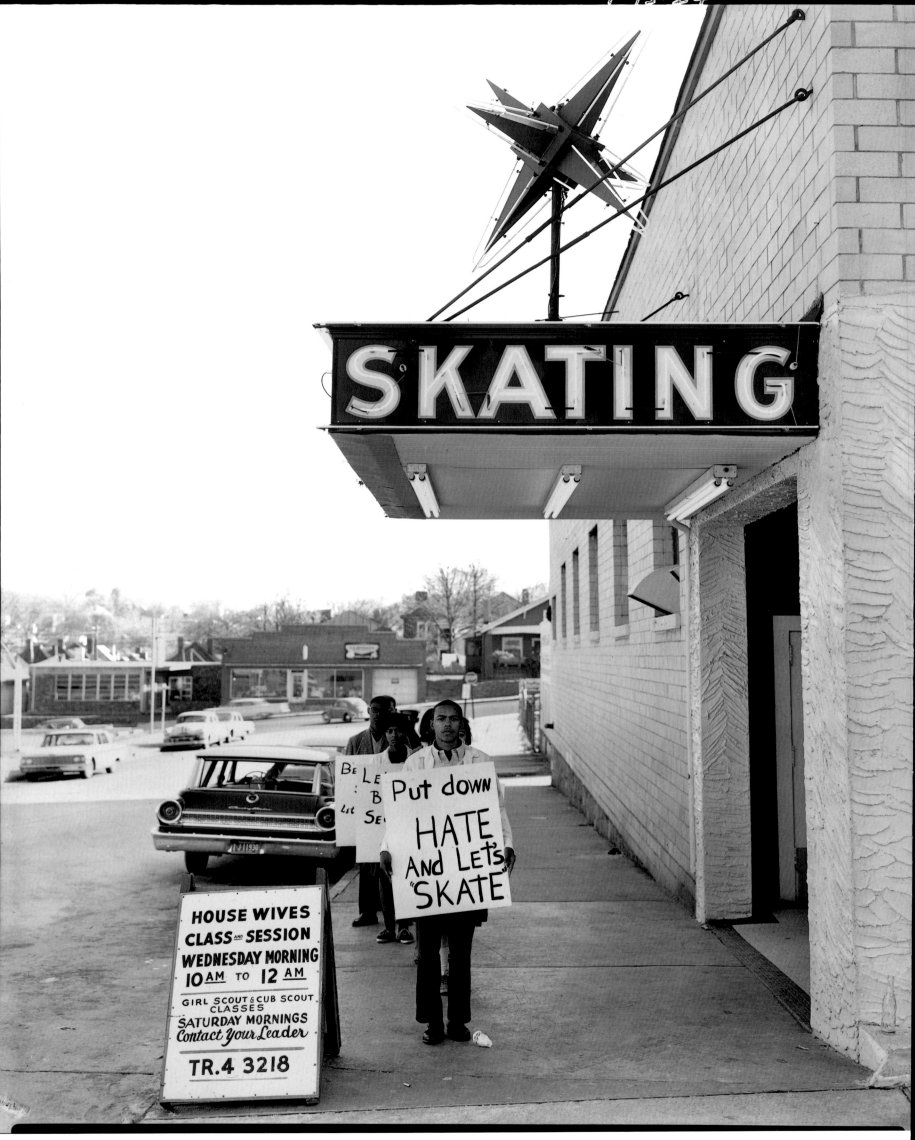

Civil rights demonstration, Atlanta, Georgia

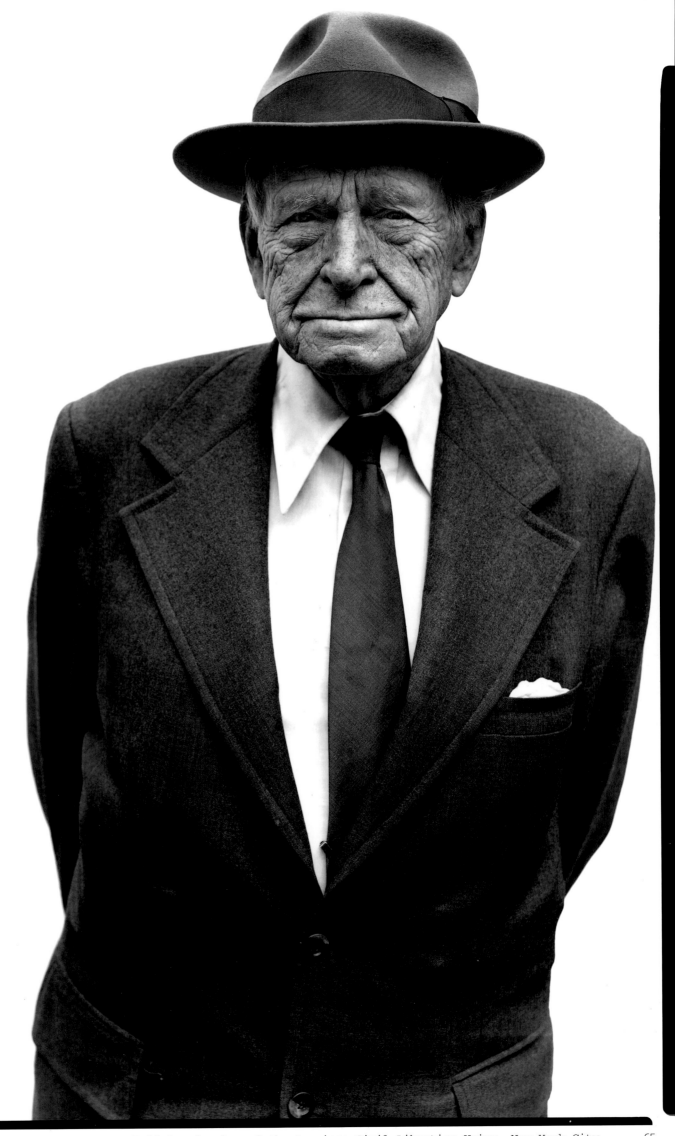

Roger Baldwin, founder of the American Civil Liberties Union, New York City

FLORYNCE KENNEDY,
civil rights lawyer
New York City
August 1, 1969

See, people call me a civil rights lawyer. I'm not a civil rights lawyer. Oh, when I was a little kid I felt that the law was one of the better ways to get justice and I went to law school thinking that I would go into the courts and I would defend these people and I would get justice for them. But then, you know, I started observing the way things were. I mean, to my way of thinking, the law is a hustle, see.... What I'm saying is that the courts are not the way to resolve conflicts once the conscience of the society has been made aware of the facts and it's still pulling the same shit. Then you don't try that way anymore.

People come to me with a case and I'll say, "This is not a case to go into the courts, but I'll form a picket line with you for nothing." So I use the law as a hustle and then I confront society in the way that it dreads most, which is to expose its phony hypocrisy, you see.... On the other hand, I object to being called a militant, because in a military society...sure, at a cocktail party where everyone is unarmed you can be a militant just by being rude to people...but in a military society you couldn't be a militant unless you at least had a plane, an aircraft carrier, a couple of submarines, and a little bit o' napalm.

I feel that in a society where there is institutionalized oppression the thing is to catch government and business in the grass—actually humping, you know. Forming a picket line or organizing a demonstration is not going to change the whole society, but there are cases in which it's the sort of thing one ought to do. Every so often one just has to put one's bucket down where one is. It's not a question of its being so important. I mean, if you're at a party and you throw a drink on somebody, you're not trying to drown them. You just want to indicate that you don't approve of them. Well, sometimes a person just has to prove to himself that there are certain things he's not going to sit still for.

Revolutionary doesn't always mean that you're cocking a gun. Revolutionary means that you go precisely the opposite of the way the establishment had you programmed. Those of us who are unimaginative, unskilled, untutored must do such routine things as putting our lives on the line. That's not real revolution. That's masochism. True revolutionary activity, in my opinion, is that which hurts the establishment without undue damage to the person who does the revolutionary act, you see....

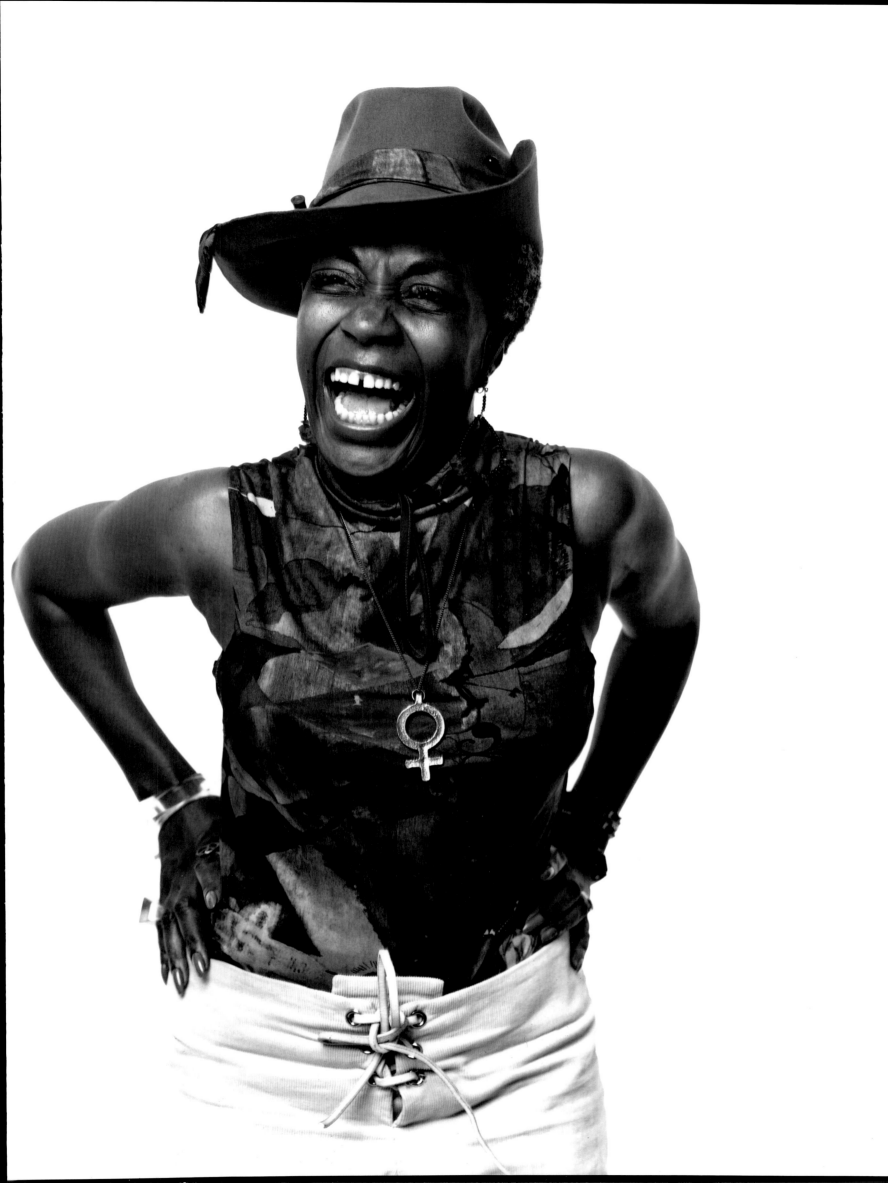

SHIRLEY CLARKE, filmmaker,
with her daughter, WENDY CLARKE
New York City
August 6, 1969

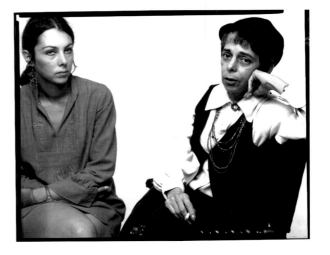

I guess we don't all have the same needs, but I have an enormous
need to find a barricade to die on....

DAVID BROTHERS,
deputy chairman, New York State chapter,
Black Panther Party
New York City
September 10, 1969

Black people in this country been dead four hundred years. In
any revolution, in any movement, in any war, you're going to
have death. Hell, I fought in the Man's war five years.
Didn't know what the fuck I was fighting for. Didn't question
about...I'm gonna get killed. The Man sent me a letter of
greetings. I went. Didn't say, "Well, man, I'm gonna die
if I go there." I was in the Pacific. We landed the first wave
in Iwo Jima, in Okinawa. We done tried to be good niggers. We
done everything the Man asked us to do. The Man don't give a
shit if you die as long as his interest is protected.

When I was marching with King down in Selma and Washington,
when the racist pig, the fascist cop, was beating me over
my head to the tune of "We Shall Overcome"—you see, had I been
politically educated, I would have taken that club, you see,
and beaten the hell out of him. I'm not thinking about myself.
I'm thinking about my people. Because I'm not persecuted as an
individual. I'm persecuted because I'm
black.

See, I love Huey P. Newton. I love Bobby
Seale. I love the Black Panther Party

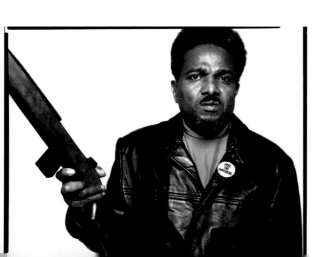

because it makes me tick. It gives me a sense of belonging. For so many years I've been caught up in this here false pretend of this here so-called democracy. And, like I say, it's only for the benefit of the few and not for the masses. This is why I'm willing to lay down my life—you see what I mean?—to get rid of this octopus.

I may not be here tomorrow. I may not be here next year. I'm willing to give my life to help the other. Because the fear of what will happen to me does not exceed the hatred I have for this imperialistic society we're living in. So the hell with my life. It means nothing.

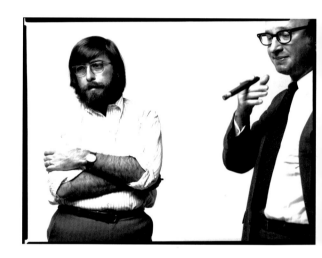

ROBERT SCHEER, editor of *Ramparts*,
with JULES FEIFFER, cartoonist, playwright
New York City
September 11, 1969

I used to have long arguments with the Panthers. I used to say, "Oh you're exaggerating. You're paranoid." I was with Bobby Seale before the FBI ripped him off. We'd just gone to a wedding, a nice pleasant wedding with the Panthers. Come out of the wedding and we're having a discussion on the street corner, you know. He's saying, "Oh, I think we're being watched," and I say, "Come on, Bobby, get off it. It's really not...that bad yet." We get in a car and we go around the corner and next thing you know thirteen FBI cars descend on us and there's fifty guys with guns drawn, each one with a gun at our heads and a shotgun in the air. You know, paranoia becomes the only really sane state of mind.

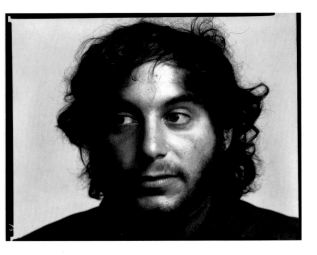

JONATHAN LEAR,
student, editor of *The New Journal*
Yale University, New Haven
October 1, 1969

 Three years ago I lived in Harlem with the
Vista program and I found it, um...very difficult to take...only
in the personal sense of...what the fuck was I doing there? I
went into it with a whole lot of notions that I soon found out
were absolutely wrong. The belief that you could be some small
help.... You realize when you get there, you know, you realize
there's nothing to be done. There's nothing you can do. And to
try is just...I mean, absurd. No one wants your help.

But I can accept the fact that I'm fucked up and I'm gonna be
racist for the rest of my life. I think that's something you're
gonna have to accept if you're gonna be honest with yourself.

JULIUS LESTER, writer
New York City
August 7, 1969

I look at white people sometimes and I'm looking at a two-
thousand-year-old ego. See, everything's political. My being
black in this country—when I walk down the street, it's a
political act. Because if I walk down the street, you know,
ditty-boppin', then folks are gonna get uptight. If I walk down
the street and I talk in my normal volume, which is loud, and I
talk with my normal vocabulary, which is "motherfucker," that's
political. So long as I breathe—even when I'm dead—I'll be
political.

But, see, like one thing that's happening to
the Movement now is that people are becoming
so rigid.... Like I've lost a lot of friends
in the past six months over my political
beliefs. There are people who won't talk to
me because I don't like the Panthers. But
hey, man, I could be friends with an FBI

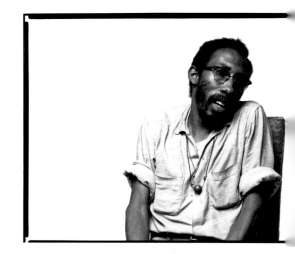

man, you know...I mean, it's like something Kazantzakis once said about...yeah: "one must be a lamb among the lions." You know? That's what it all comes down to for me. And if you don't start to learn to live that now, then you won't live it after, you know, the revolution comes...or whatever.

You see, as far as I'm concerned, the revolution...it has to mean creating political, social, and economic institutions which will create the possibility that people can love each other. I mean, like Che's phrase, which is to create "The New Man."...You know, you think differently, you feel differently, you look at things differently.... And if that doesn't happen, then you can have everybody well fed and well clothed and well housed and still not have a revolution.

FRED GARDNER,
founder of the G.I. Coffeehouses
New York City
September 12, 1969

When we started this work, the attitude of the Movement toward soldiers was...let's say, naive. I actually saw a little old sweet-looking Women's Strike for Peace lady cursing at guys at the San Mateo Induction Center. She called this one kid—this eighteen-year-old draftee reporting for induction—she called him Eichmann. Her sign—or, you know, her sister's sign—said Bring Our Sons Home. So I started talking to her and I said which of you has sons in Vietnam. And they all had sons in graduate school—if they knew where their sons were at all. Now that's just a parable. It was obvious that there was a class basis to the peace movement in '65 and '66.

Soldiers are not the enemies of the Movement. They're potential allies. They're more than that. Soldiers are the only people in America who are paying a stiff price for this war. Everybody else profits. Soldiers are the ones losing their lives, losing friends, having their lives disrupted. The real victims of American imperialism are its soldiers.

It's understandable why this country doesn't produce revolutionaries. Anyway, revolutionary is an accolade that can only be used in retrospect...for people who made the revolution,

right? This country is not on the brink of revolution and to
pretend that it is...is arrogant. 'Cause we haven't done our
homework. What does it mean today to say Tom's a revolutionary and
Rennie isn't? What does that mean? You can tell...afterwards. On
the eve of the revolution, then you start distinguishing who's
going all the way. When we get there—if we get there—then we'll
see who's a revolutionary and who's not.

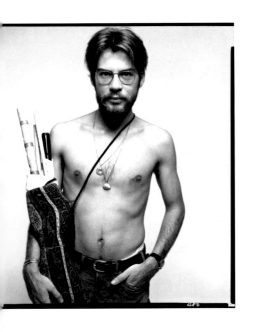

JOHN STEINBECK IV, writer
Saigon
October 2, 1971

All of us go around the world trying to see where
somebody else is at and measuring themselves against
it. Your idea of me, my idea of my brother, my
brother's idea of me.... The more people are around other
people, they get to know them so much better in so many ways,
but they also depend on their own concepts and lock those people
into being just what they expect them to be all the time. It's
inescapable. What I'm trying to talk about is the irony that
nobody will ever know the way another person thinks. I could tell
you the way I think, if that interests you, but it just doesn't
come. The words aren't the way you think.

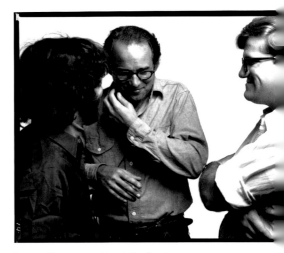

JONATHAN LEAR, student; **WILLIAM SLOANE
COFFIN**, chaplain, Yale University; and WILLIAM
TURNAGE, student, New Haven, Connecticut
October 1, 1969

I suppose we all have...images of ourselves. And often I think
that it's not so much that we love virtue as that we love the
image of ourselves as virtuous people. It's not so much that

we like to give; we like to prove to ourselves and others that we have something to give. You know, one's motives are all mixed up.

But I do think that for myself, there are certain things that you can't let go of. That's one of the things that I'm kind of a confessed Christian about, that...ah, if you don't stand for something, you'll fall for anything. Certain convictions are terribly important, not only because they're right, but because they also psychologically keep you sane.

I mean, this country is rampant with evil, it's just awful, you know, and we haven't a clue as to how bad things are. I don't think most people have a clue. We're lucky if twenty years from now, first of all, the world's still around. If we even have a democracy in this country, we'll be very fortunate. And some people will have done some terrific things to make sure we still have it. The danger is that the lover's quarrel can degenerate into a grudge fight. A lot of blacks now are just damn good haters. A lot of radical students are just damn good haters.

But you cannot be a human being in America today without taking on these issues in some fashion, because they are invading the privacy of everyone's life. To deny them—to deny their existence—is to deny one's own humanity.

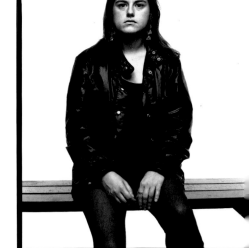

BERNARDINE DOHRN,
Weatherman
New York City
November 10, 1969

It's still on the level of guilt a lot. Kids are becoming more and more conscious of what it means to be white Americans in 1969—that they're only six percent of the world population and their country's losing. I don't know how you ever exactly get past it because the guilt is real. I mean, it has a real basis. But you can't be operating out of guilt all the time or else your main purpose is just to cleanse yourself. You gotta get on top of it. Or put it into something. But you never get rid of

it. You don't rub off your white skin. Another part of it is that people are being attacked every second by an apparatus which kills people, and you get angry and the anger puts another dimension into the guilt. I remember being in the Hilton demonstration a couple of years ago and being pushed up against a barricade and this cop saying to me—you know, really totally out of the blue, I didn't ask him—he just said, "Look, lady, it's a job. I've got a family to feed." Well, that's true. Up to a point. But there's going to come a time when people will have to say, "In 1970, there is no way in which people who really want to be people can put on a uniform in America." And that's legitimate. Killing a cop just because he's a cop, that'll happen. And that should happen. And there's nothing inhuman about it at all. It's survival. It's the most human thing in the world.

What matters is what the people who are fighting are feeling and thinking about. And their humanity. Trying to grapple with the way in which the necessities of revolution—you know, organization and discipline and an army and guns and fighting and killing—don't brutalize people but release people to a higher stage. And people fight for that, you know. The least imaginative people around the Movement fight for that. Fight for it to make sense of who they used to be and where they are now in relationships and loneliness and fear and being tough. And how much of the toughness is bravado and how much the bravado makes it real. But, I mean, it's a fight. Every second.

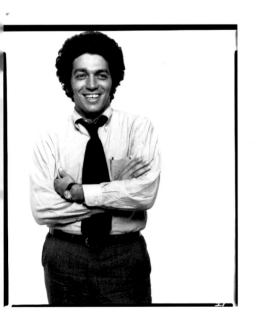

GERALD LEFCOURT, civil rights lawyer,
Trial of the Panther 21
New York City
October 6, 1970

There's an anxious kind of activity in your body and your mind when you're building for something that you've been looking forward to for a long time and over periods of weeks. And that tension of being so wide awake gets to you. I mean, it's like adrenaline constantly being pumped through your body.

It's fear, too. You know, you're afraid of people going to jail. You're afraid of going to jail yourself. You're afraid of what they could physically do to you. We've received threats by the

tons. Everybody's homes are being bombed. The judge's home is being bombed. The district attorney is under armed guard twenty-four hours a day.

Some people crack. It's not callousness, but you have to be able to laugh an awful lot at an awful lot of very serious things. I think the happy-go-lucky attitude is essentially the one that's going to save you in the long run. I'm not sure I have it, but I think that many people do and I think it's what keeps them going. It's not courage. It's an attitude. It's very different from courage.

DR. LOTHAR B. KALANOWSKY,
electroshock therapist
New York City
May 5, 1970

A patient with hallucinations who hears voices, he believes in those voices. They are real to him. If I tell him there are no voices, he will become quite angry. Or take the example of a severely depressed patient who makes one suicidal attempt after another. If there is something that really should bring him into a depression—a death in the family, the death of a husband or a child, for instance—this is not what produces the depression. They get them out of nothing. You see? They have no reason to get depressed. Usually they tell you, "I was the happiest person in the world, but then I suddenly realized something, that I committed this sin...twenty years ago I did something which I shouldn't have done and I committed a sin," and twenty years later this sin makes it impossible for them to go on living. The law provides that patients of this kind can be hospitalized for treatment because they do not understand that they need help.

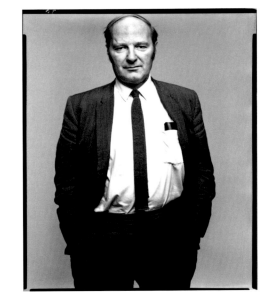

DAVID DELLINGER,
pacifist,
Chicago Seven
Conspiracy Trial
September 25, 1969

It was during the pre-World War II draft. I must have been in
my twenties. I had been in jail maybe six or seven months at
the time for draft resistance and we were getting into
increasing trouble with the jail system. We couldn't go along
with the way they were treating not just ourselves but other
convicts. Black people not only were segregated but really
received a very rough deal. People who were so-called criminals
had obviously lost all of their rights as human beings. And so
we just kept getting in deeper and deeper with the prison system
through our constant protests.

Anyway, one night—it was in the middle of one of our strikes—
somebody came in and shined a light in our eyes in the middle of
the night, took us out. They never told you where you were
going. And we ended up in an office, conferring with the
director of the Federal Bureau of Prisons. He started out as
some kind of a liberal intellectual and we discussed issues and
so forth. But after a time it was clear that we weren't going to
abandon our solidarity with the other inmates or end the strike.

I remember it was the most chilling experience of my life.
I mean, I've been at the point of death or in danger many
times since then but this...it really just sort of sent a
chill over my whole body. There was the director of prisons—in
the middle of a war in Europe against fascism—and he said,
"Dellinger, you have called the American prison system
authoritarian and fascistic. I'm to tell you that it's the most
authoritarian system in the world. And unless you stop this
nonsense, the whole weight of that system is going to come down
upon you." He then went on to make it very clear that unless I
stopped my activities, I would not get out of prison alive.

It wasn't at that very moment—because life doesn't work like in
storybooks—but maybe two weeks later, after I went through a few
days in solitary confinement without food and a lot of other
things, that it became clear to me that if I continued on this
path I would not get out alive. And I just faced it and
decided—not to sound heroic because I wasn't heroic—that I
couldn't back down. That I would die there.

Well, I didn't. But ever since then somehow...again, I don't
want to sound heroic, because I have been afraid many times, but

basically, although I've received bombs in the mail and I've been trailed by people who've told me that I wasn't going to live through the day and, you know, all kinds of things. But basically, having...having died—it's the only way I can express it, I died psychologically and spiritually in my prison, solitary prison cell and—it just doesn't seem to have that much effect on me anymore. It seems to be kind of an acting-out of a drama that I made a decision on a long time ago.

ED SANDERS, poet, musician, political satirist
New York City
October 30, 1969

It's hard being nonviolent. If you have a high metabolism and you're very energetic and your political positions are passionately held, then you naturally...violence is an easy thing to get into. Sometimes I...sometimes I slip. I haven't been in a fistfight in a long time, though. Nineteen sixty. Somebody beat me up at a New Year's Eve party.

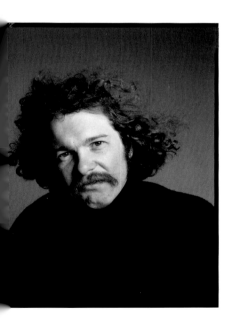

I'm not totally sure that you can change the nature of American civilization through...through peaceful means. I know that a lot of things have to be changed and changed quickly before the United States gets into outer space to ensure that the whole Milky Way doesn't become a big violent hate thing.

Up to now the human race is acting just like an incipient case of leukemia. Sending up spores. Conquering. Leaving behind dead and inert plastic matter. Tin cans and beer cans. Plastic cancer. Malignant universal melanoma.

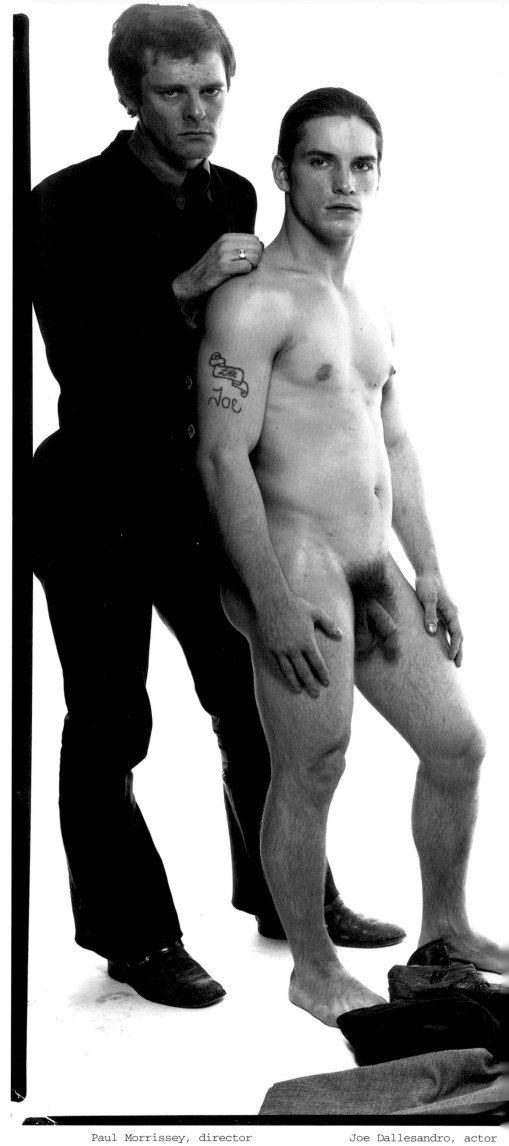

The Warhol Factory
New York City

Paul Morrissey, director Joe Dallesandro, actor

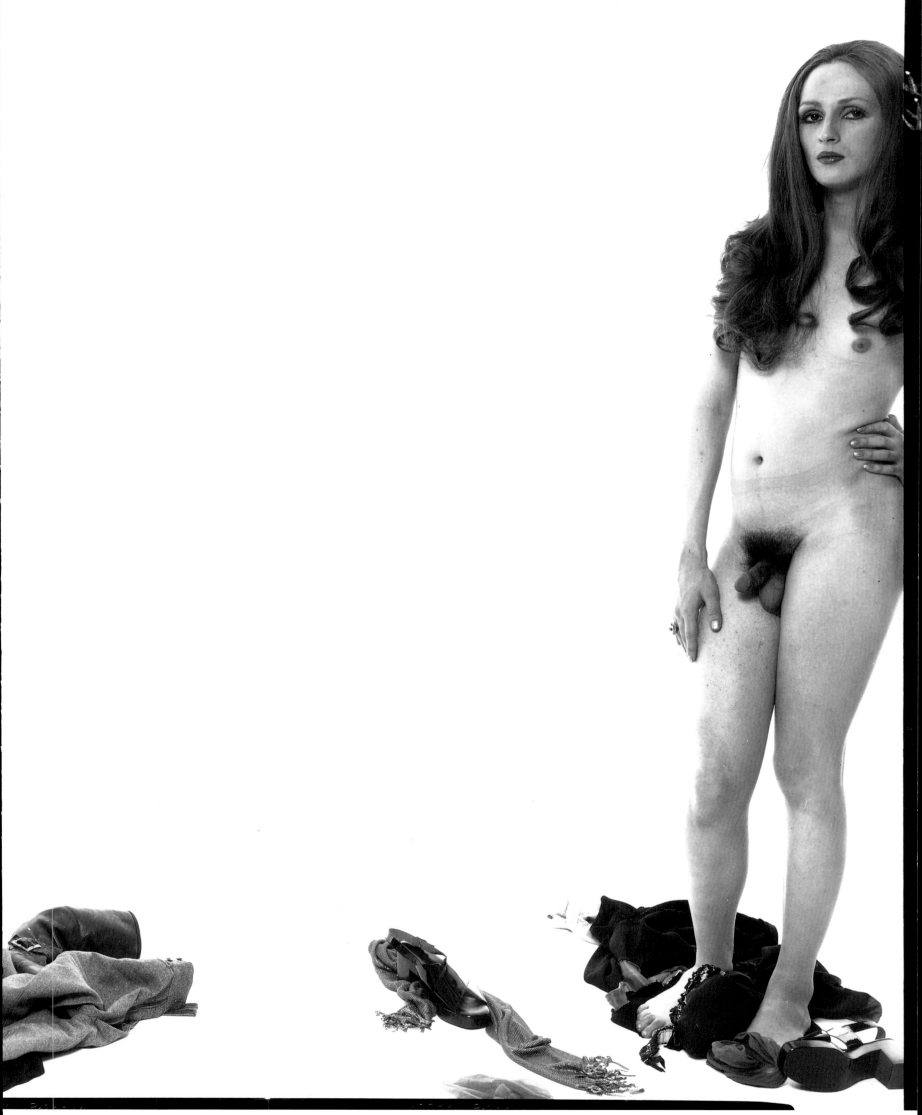

Candy Darling, actress 79

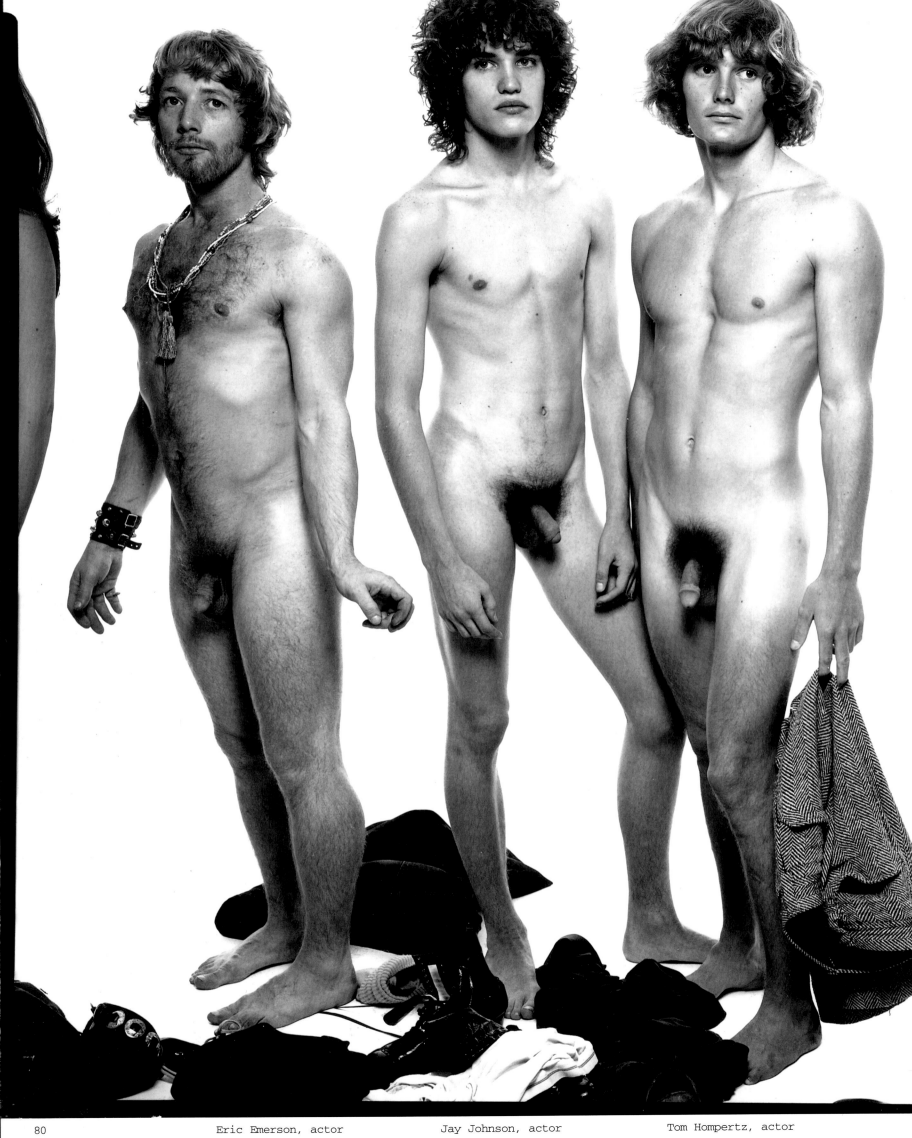

Eric Emerson, actor Jay Johnson, actor Tom Hompertz, actor

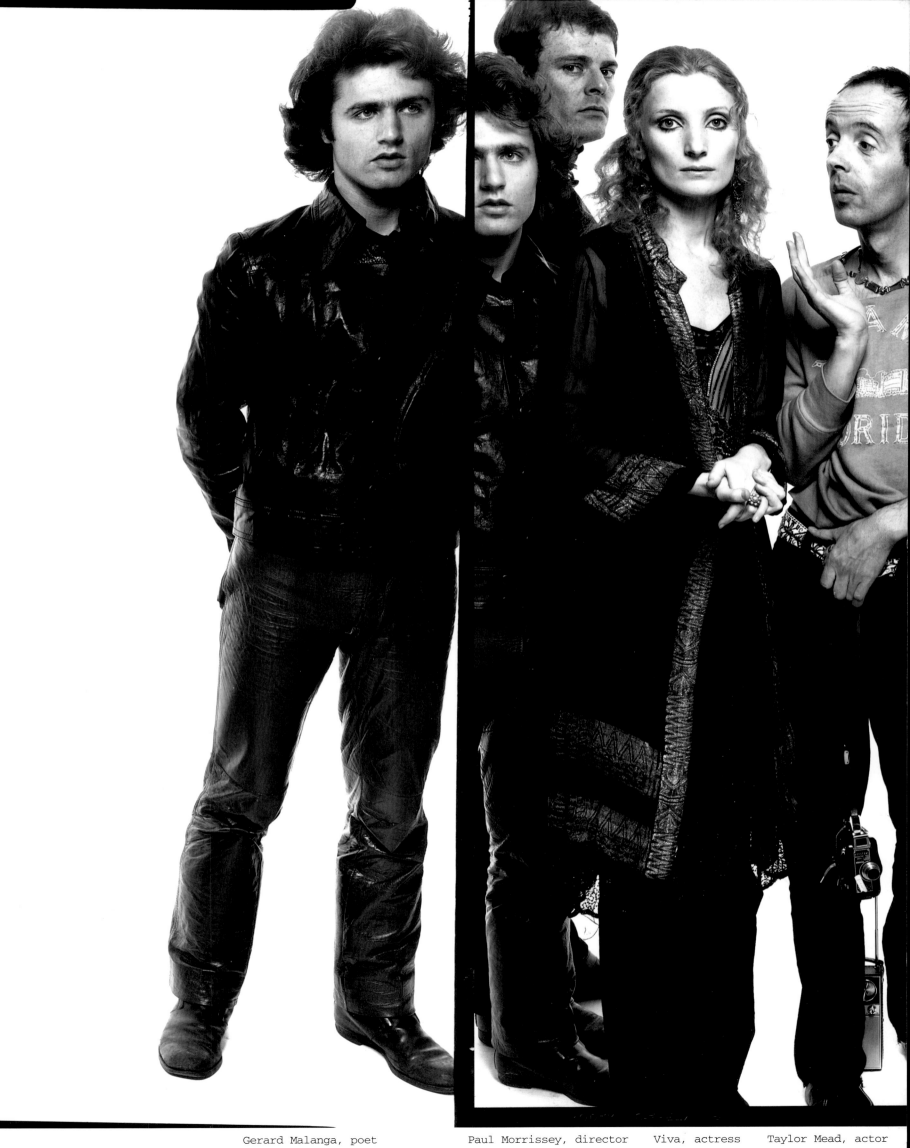

Gerard Malanga, poet Paul Morrissey, director Viva, actress Taylor Mead, actor

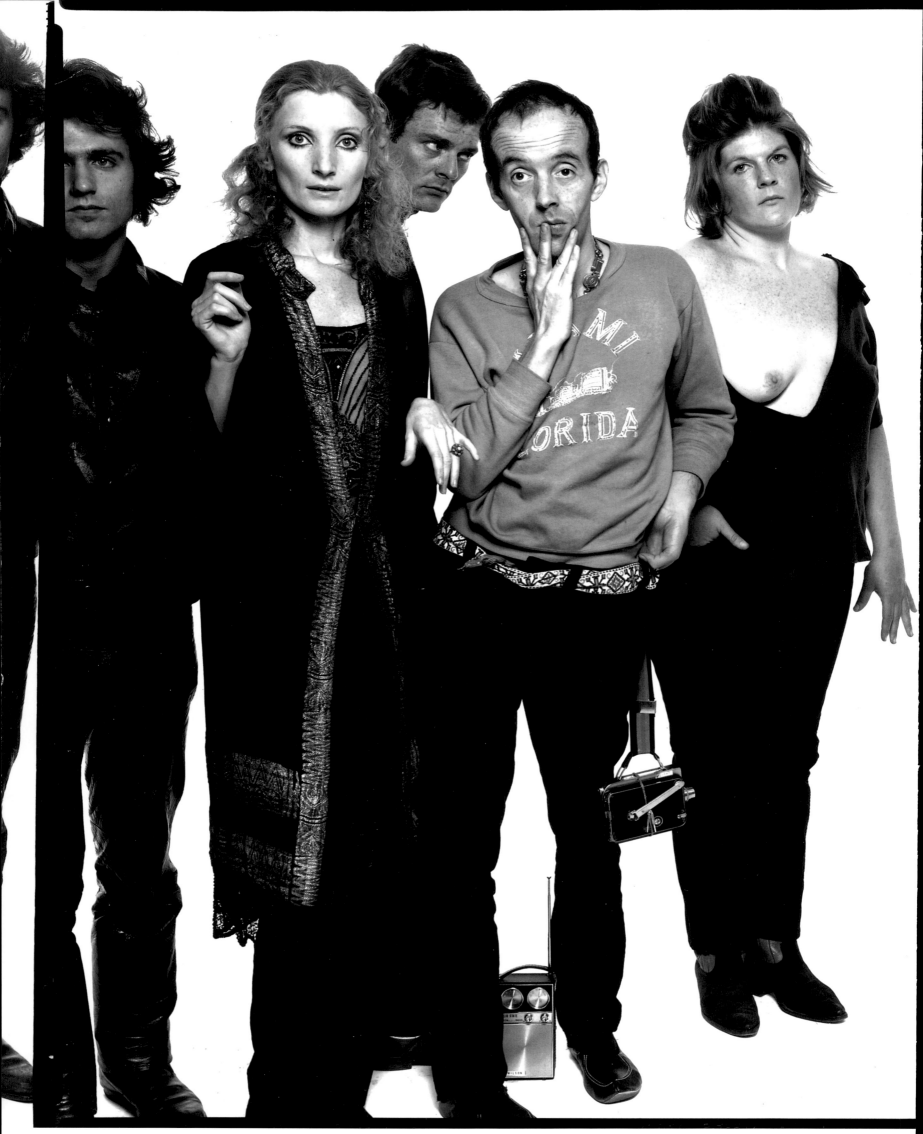

Gerard Malanga, poet Viva, actress Paul Morrissey, director Taylor Mead, actor Brigid Polk, actress

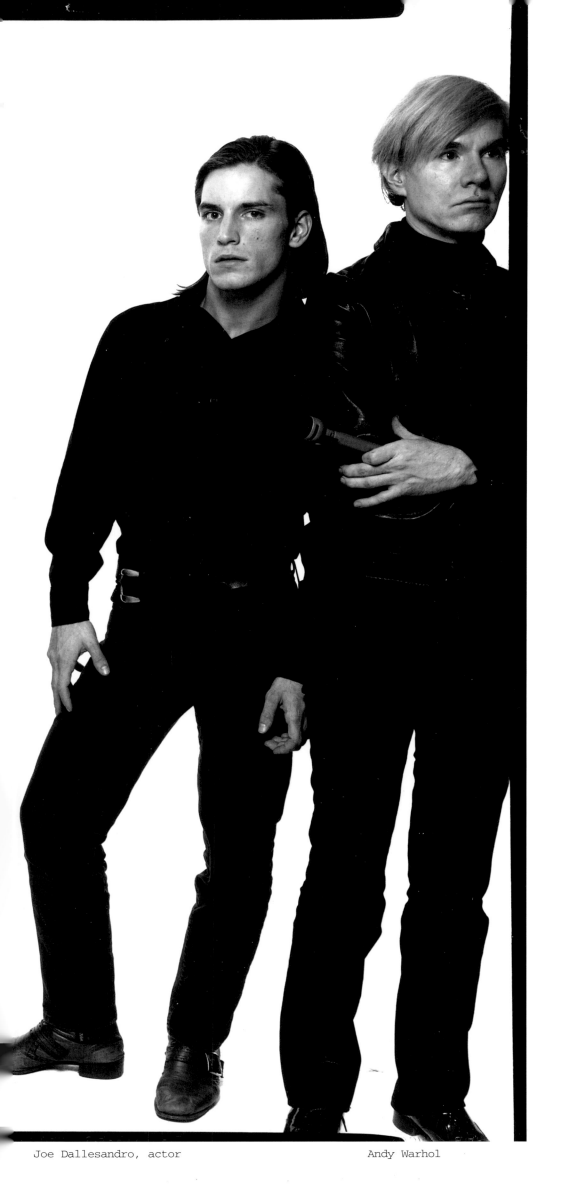

Joe Dallesandro, actor Andy Warhol 83

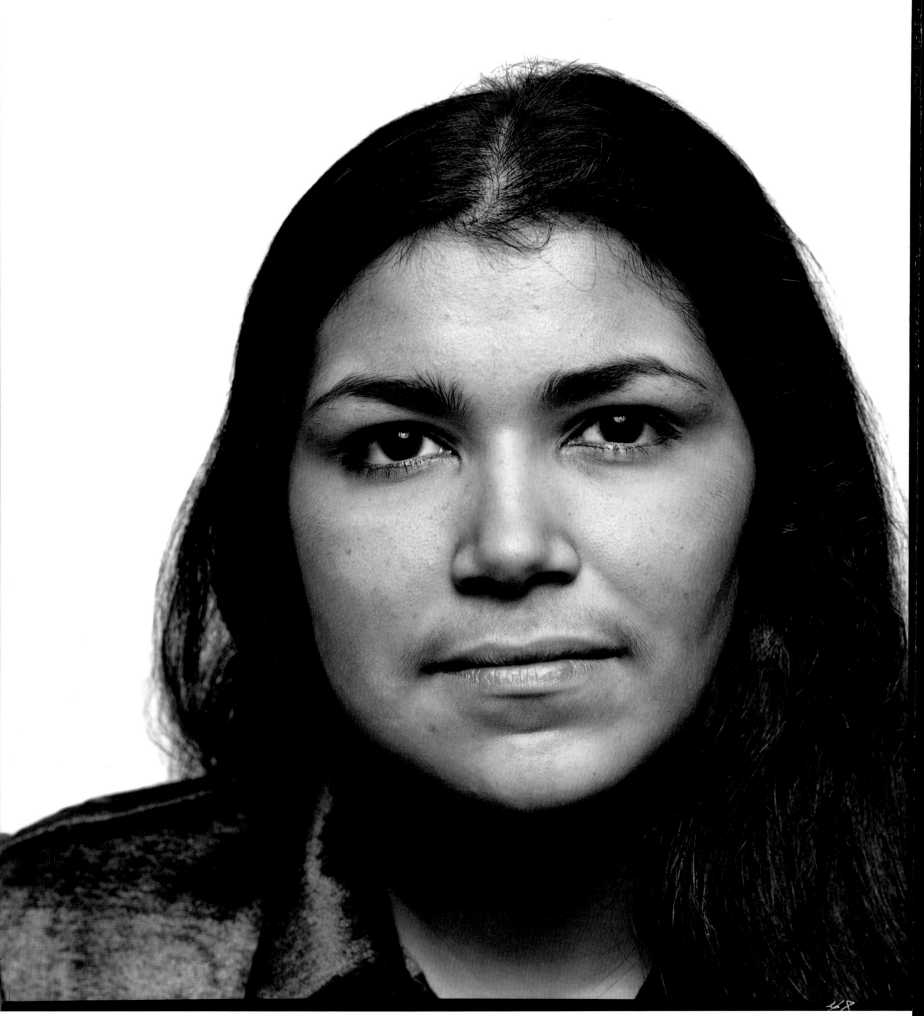

84 Gloria Gonzalez, field marshal, Young Lords Party, New York City

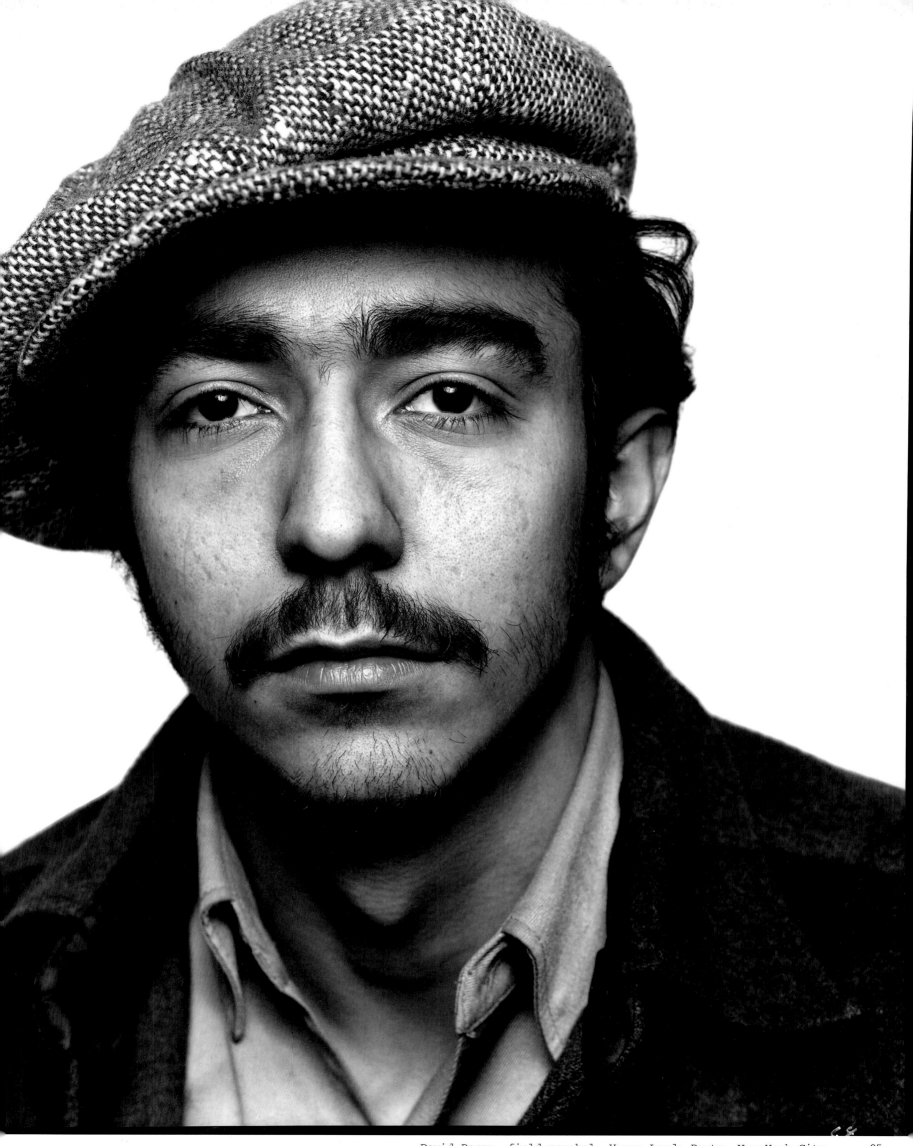

David Perez, field marshal, Young Lords Party, New York City 85

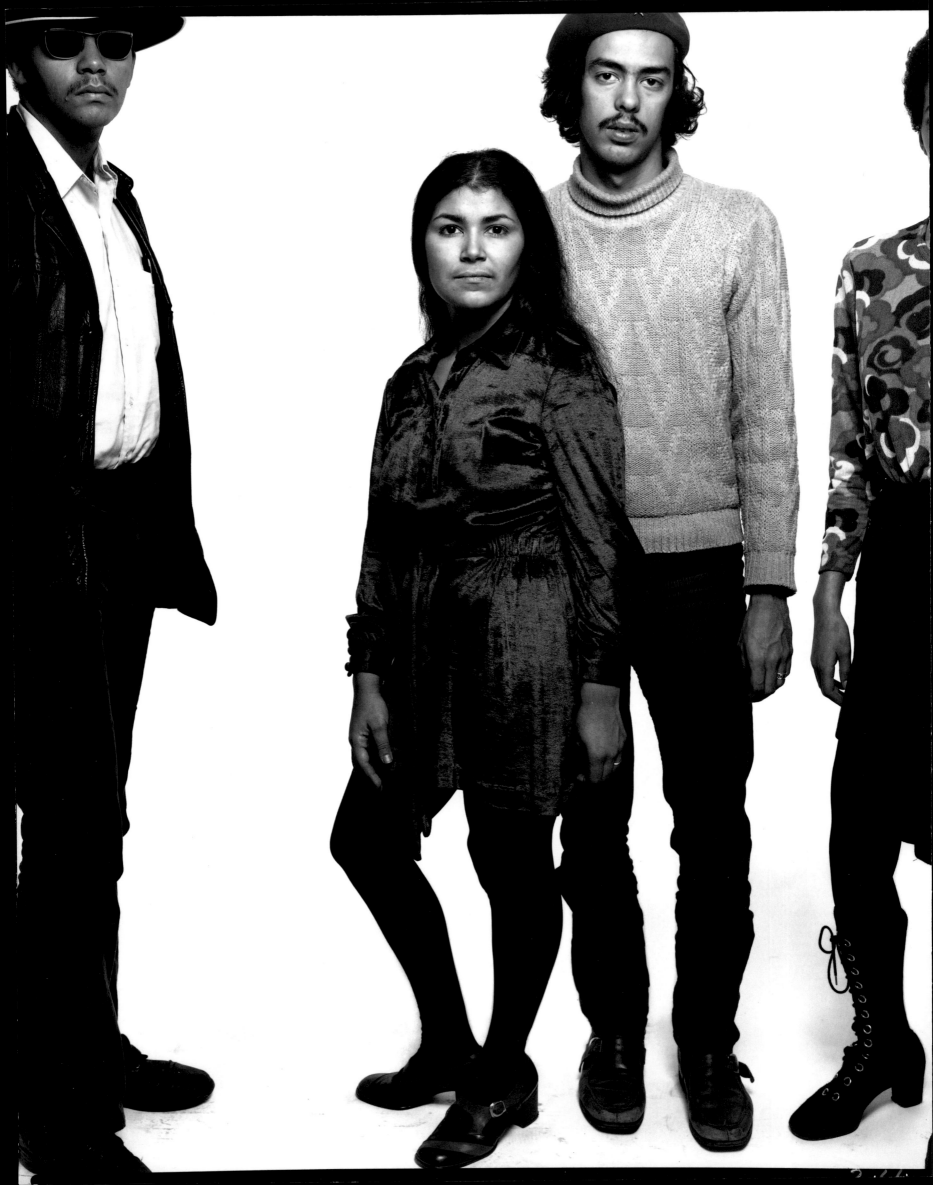

PABLO GUZMAN;
GLORIA GONZALEZ, field marshal;
JUAN GONZALEZ, minister of defense;
and DENISE OLIVER,
members of the Young Lords Party
New York City
February 25, 1971

Gloria and Juan Gonzalez were married last year. They had a revolutionary wedding. During the ring ceremony, they spoke these words to each other:

"If I go forward, follow me. If I stand still, push me. If I go backward, kill me."

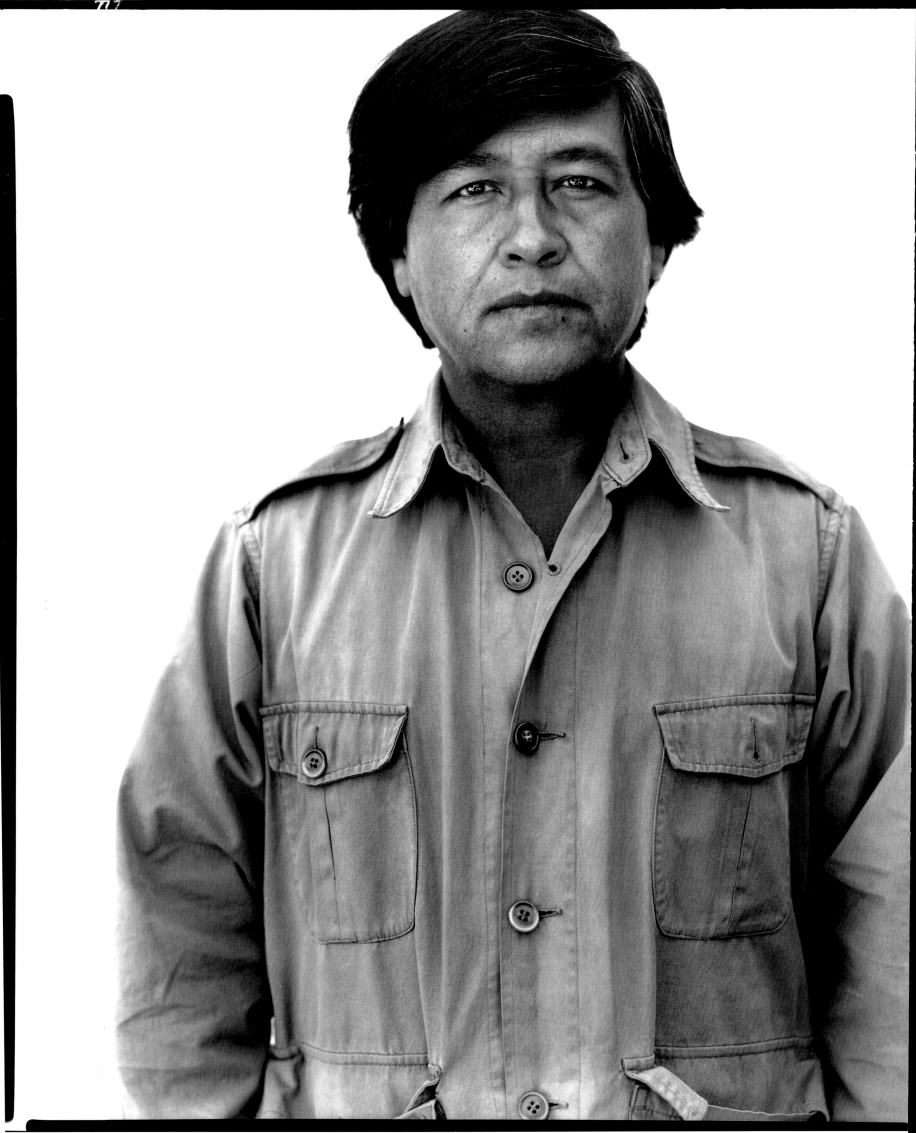

88 César Chavez, founder of the United Farm Workers, Keene, California

Members of the American Nazi Party with their leader, George Lincoln Rockwell, Arlington, Virginia

James Baldwin, writer
Harlem, New York, 1945

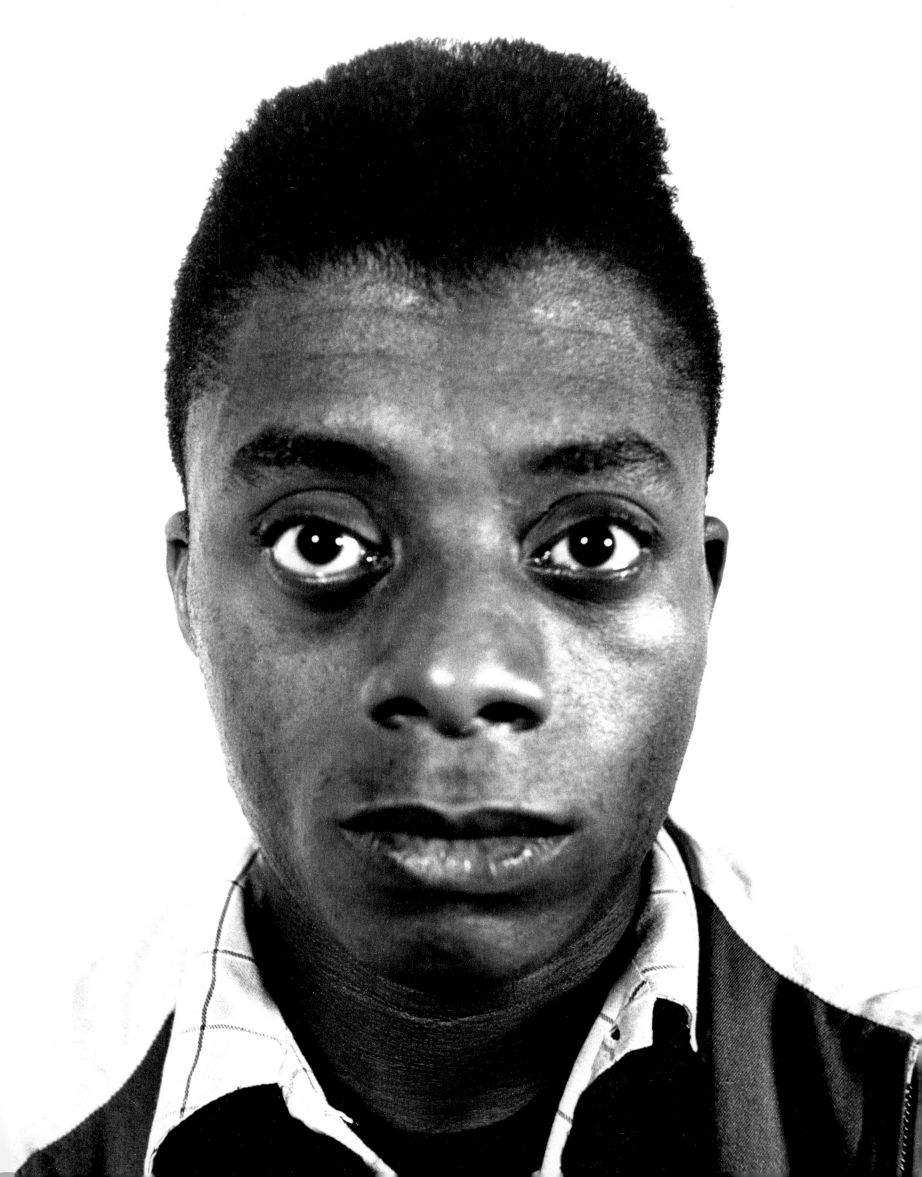

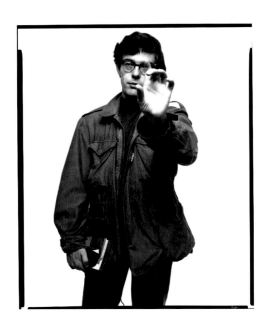

RENNIE DAVIS, antiwar activist, co-founder of SDS,
Chicago Seven Conspiracy Trial
September 25, 1969

The only thing that isn't explained to me is why everybody
isn't like me. That's the only thing that I can't comprehend.
'Cause I grew up in Four-H and on a farm. My father was a
liberal and, uh...I wanted to be a farmer and then a
writer...and then a teacher. Things like that. And...well, you
know, I'm very, uh...all-American. Always have been. Still
consider myself to be...very indigenous to this country. And
when I say this country I don't mean New York or Berkeley. I
mean the Midwest, Virginia, someplace like that.

I think that when I was young I had a sense of...decency that
I, uh...treasured. Worked on. Thought about. Was conscious of.
And that vague sense of...being a good guy...has taken on a
certain sort of maturity. The global sense of a new man in a
revolutionary society—that is genuine for me. Real to me.
People that destroy each other at meetings, people who attack
each other personally,...people who become bitter enemies
because of ideological struggles...upset me.... Yet the other
dimension of it is...how the environment toughens you and,
uh...turns you into a fighter and also sometimes makes you
bitter toward people that aren't where you're at. Ordinary
people.... You meet a man who's a working man, who's on the
police force and who's assigned to follow you for three
weeks...and when he first meets you he, uh, he strikes you as
being a decent guy, somebody you could actually have a
conversation with. But his whole...experience makes him want to
kill you.... Or, it doesn't take very many times to have—you're
lyin' in a room with a girlfriend—to have a policeman come kick
the door in, throw you up against the wall and haul you into
court for marijuana or somethin' that's not even there—or, you
know, put a shotgun at your head, cock it, pump it once,

and...and say somethin' like, "Don't move, motherfucker"...to make you...to make you feel great hate.

If you see Vietnam...when you see Vietnam, you feel great hate for Johnson and Nixon, Westmoreland, McNamara, Abrams, LeMay.... You want to kill those people for what they've done. Not just the lies. It starts out that you're outraged—you're naively outraged—because the government lies. In 1967 we only hit steel and concrete, they say. Then you go there and you see the schools and the hospitals and the population centers and...the use of antipersonnel weapons—the steel pellet bombs that are absolutely useless against the steel and concrete targets they claim to be hitting. The bombs that when you drop 'em on the cities take all the people's lives and leave the buildings intact. When you read about that, you're outraged...but when you see it, when you see it, when you're underneath those bombers yourself and you huddle with Vietnamese in roadside bunkers or shelters while American pilots bomb and strafe over your head...and the Vietnamese are there to protect you...to put their bodies over your body...and you think about that—as an American—then you...you want to do some killing yourself....

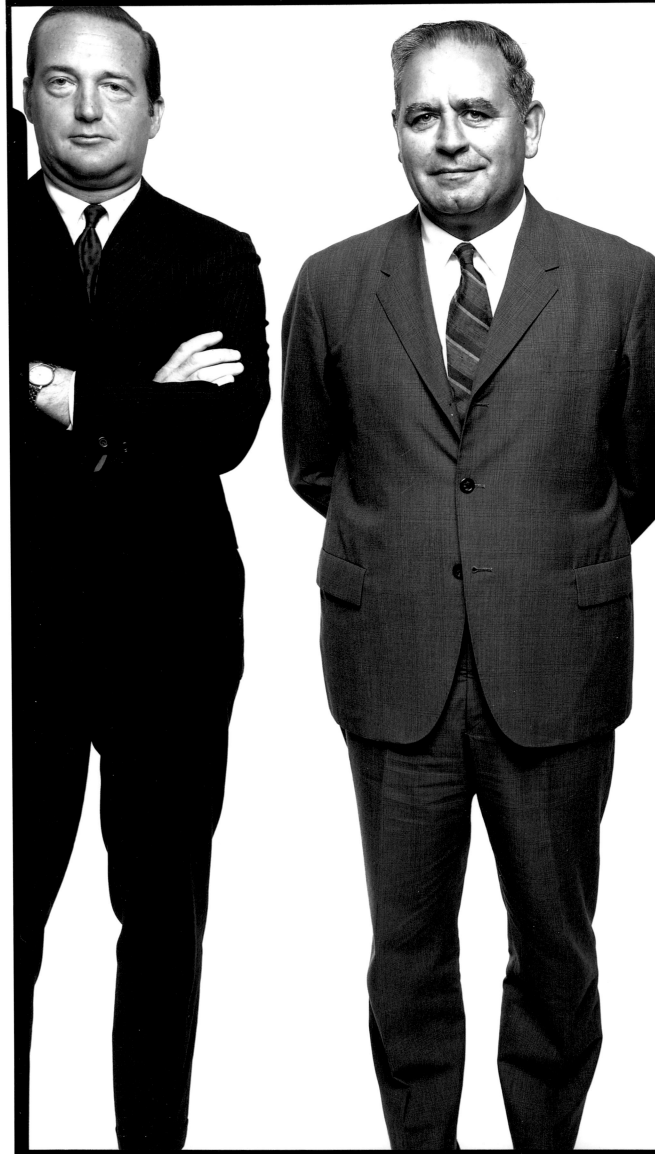

The Mission Council,
Saigon, Vietnam:
Hawthorne Q. Mills,
mission coordinator;
Ernest J. Colantonio,
embassy counselor for
administrative affairs;
Edward J. Nickel,
minister counselor for
public affairs; John E.
McGowan, minister
counselor for press
affairs; George D.
Jacobson, assistant chief
of staff; Gen. Creighton
W. Abrams, commander U.S.
Military Assistance
Command, Vietnam;
Ambassador Ellsworth
Bunker; Deputy Ambassador
Samuel D. Berger; John R.
Mossler, minister
director, U.S. Agency for
International Development;
Charles A. Cooper, minister
counselor for economic
affairs; and Laurin B.
Askew, embassy counselor
94 for political affairs

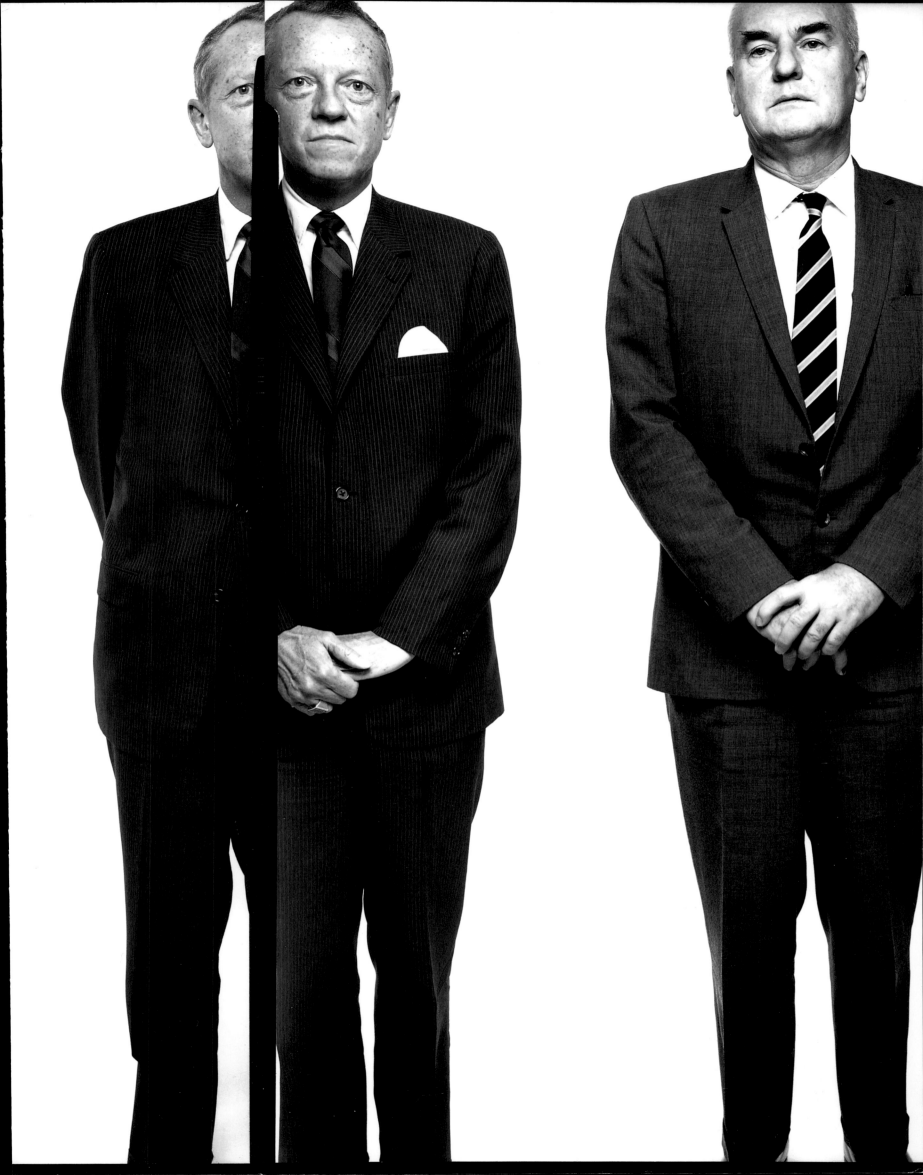

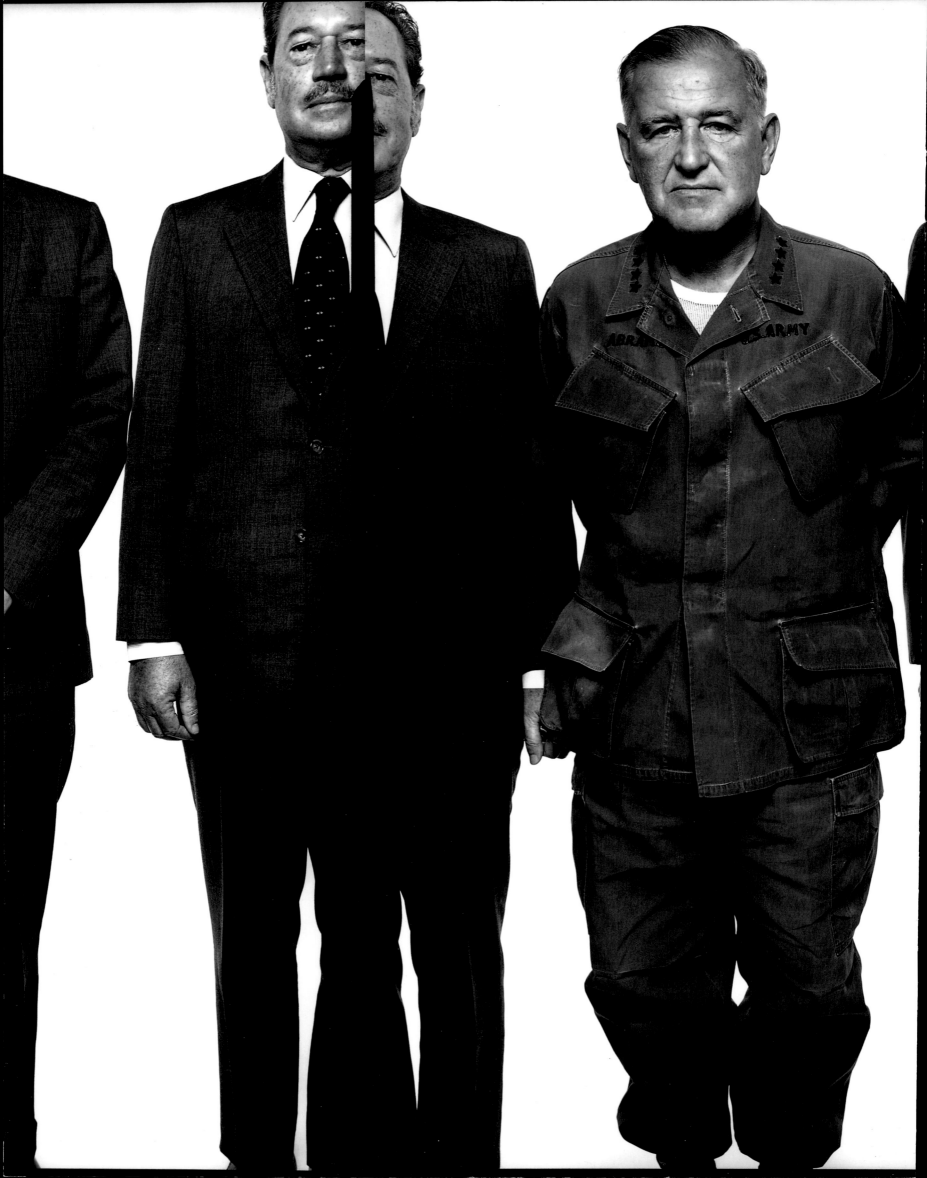

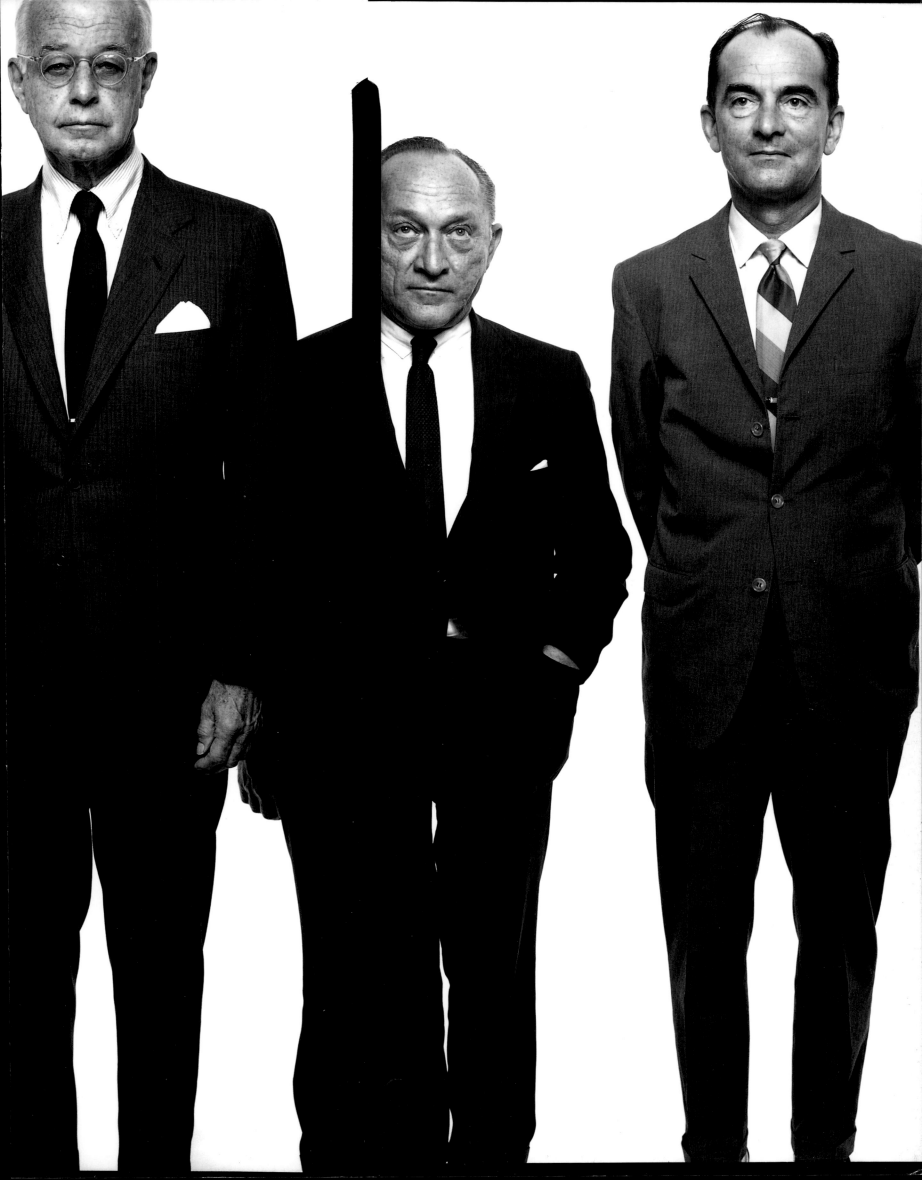

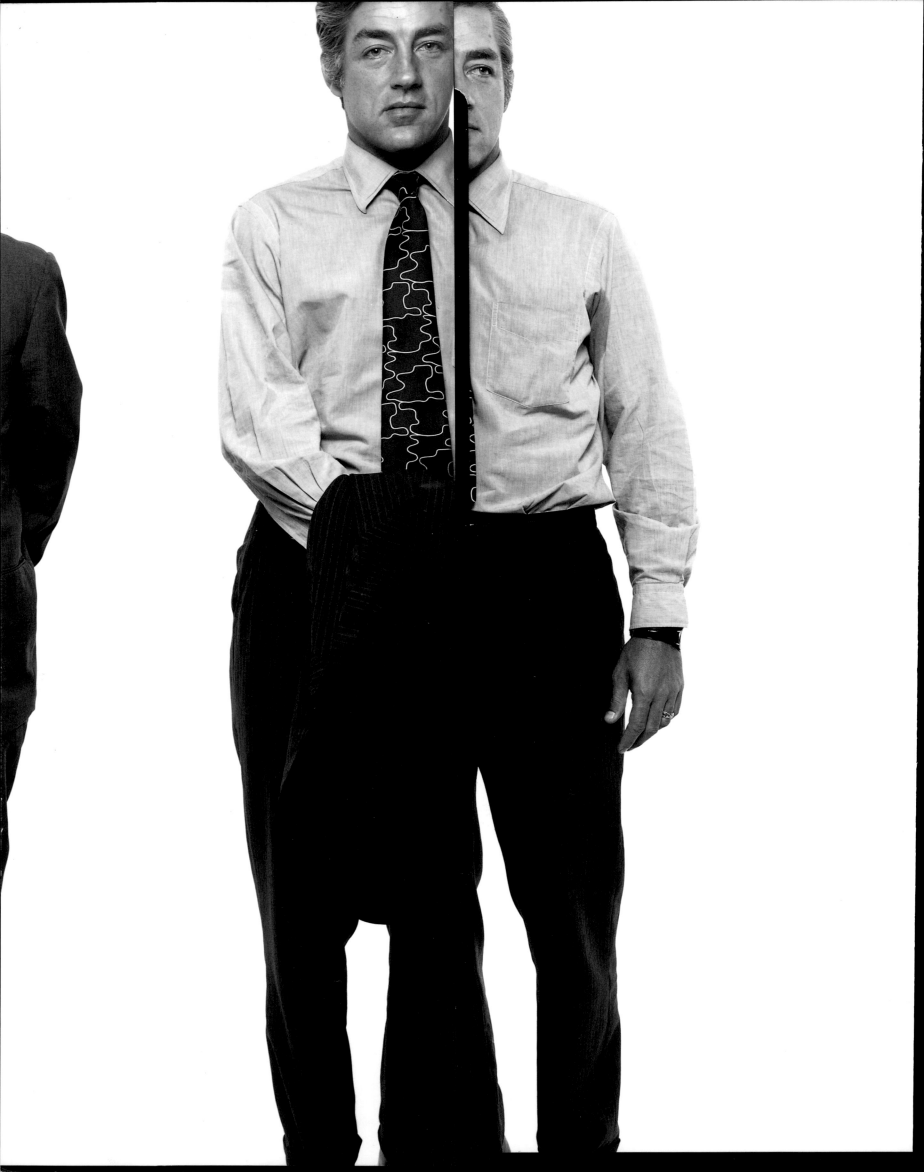

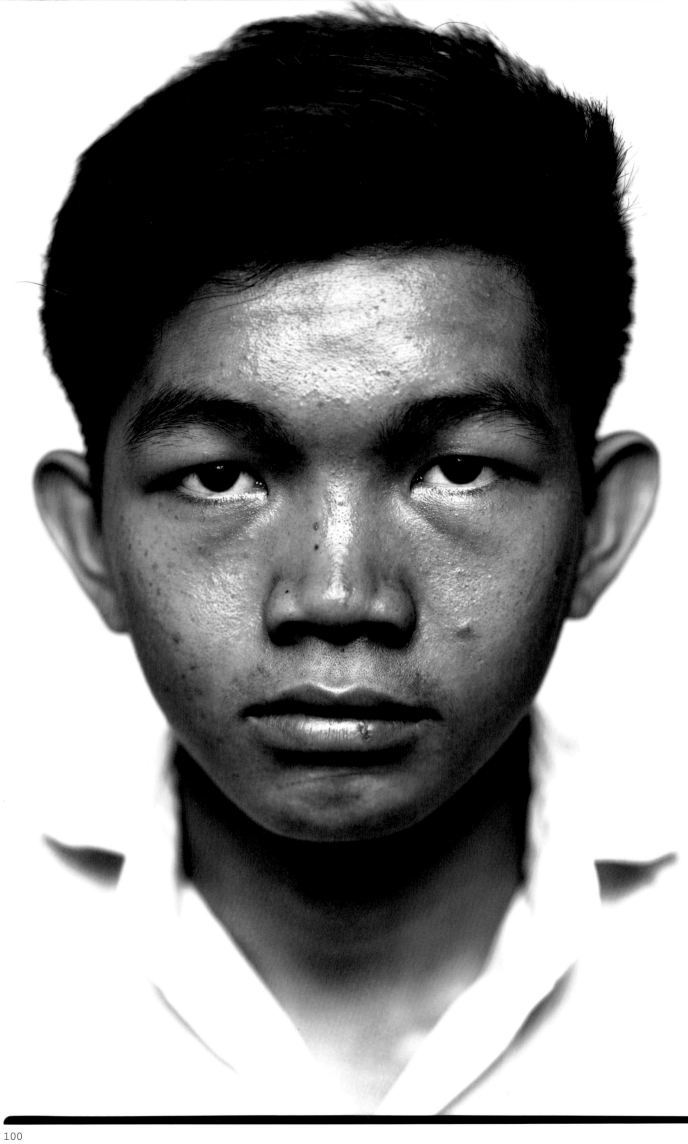

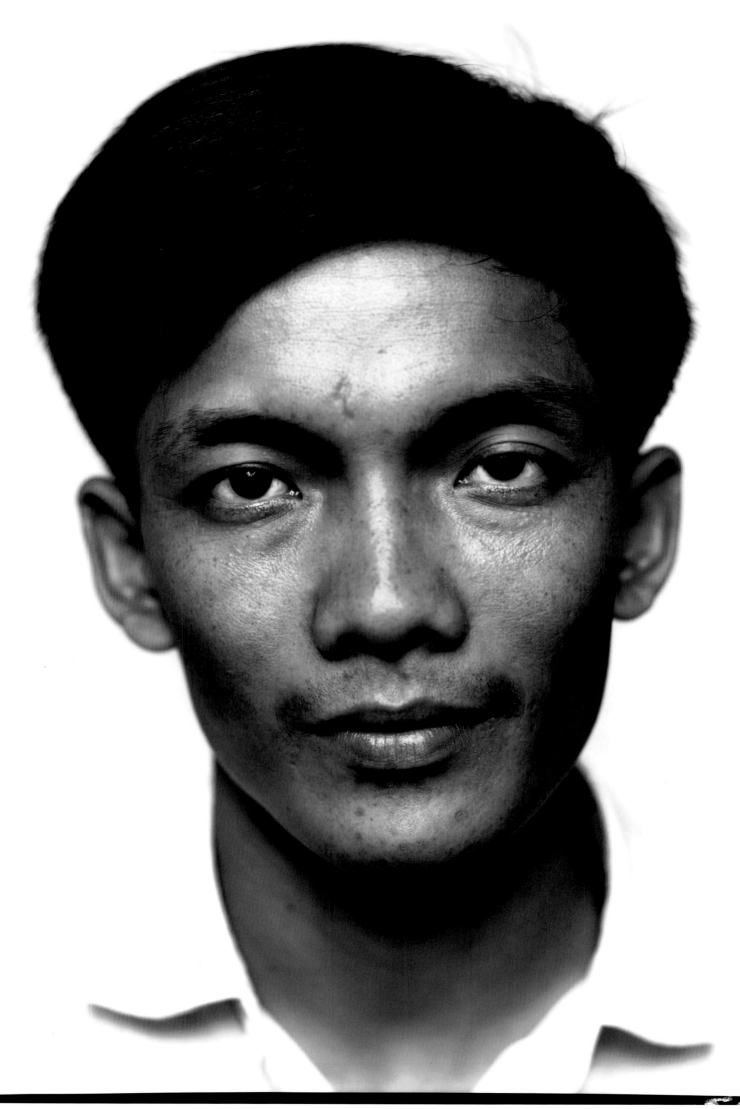

South Vietnamese student activists, members of the underground antiwar movement, Saigon

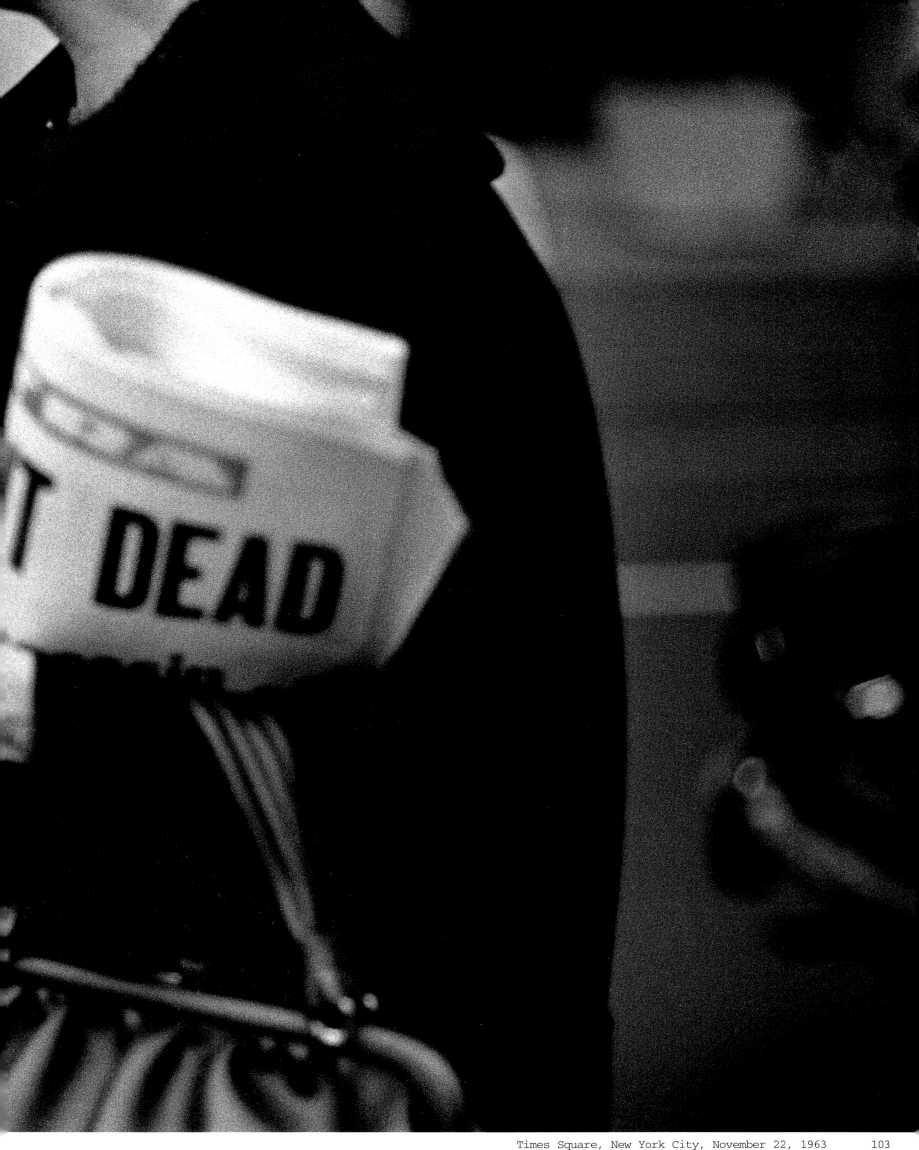

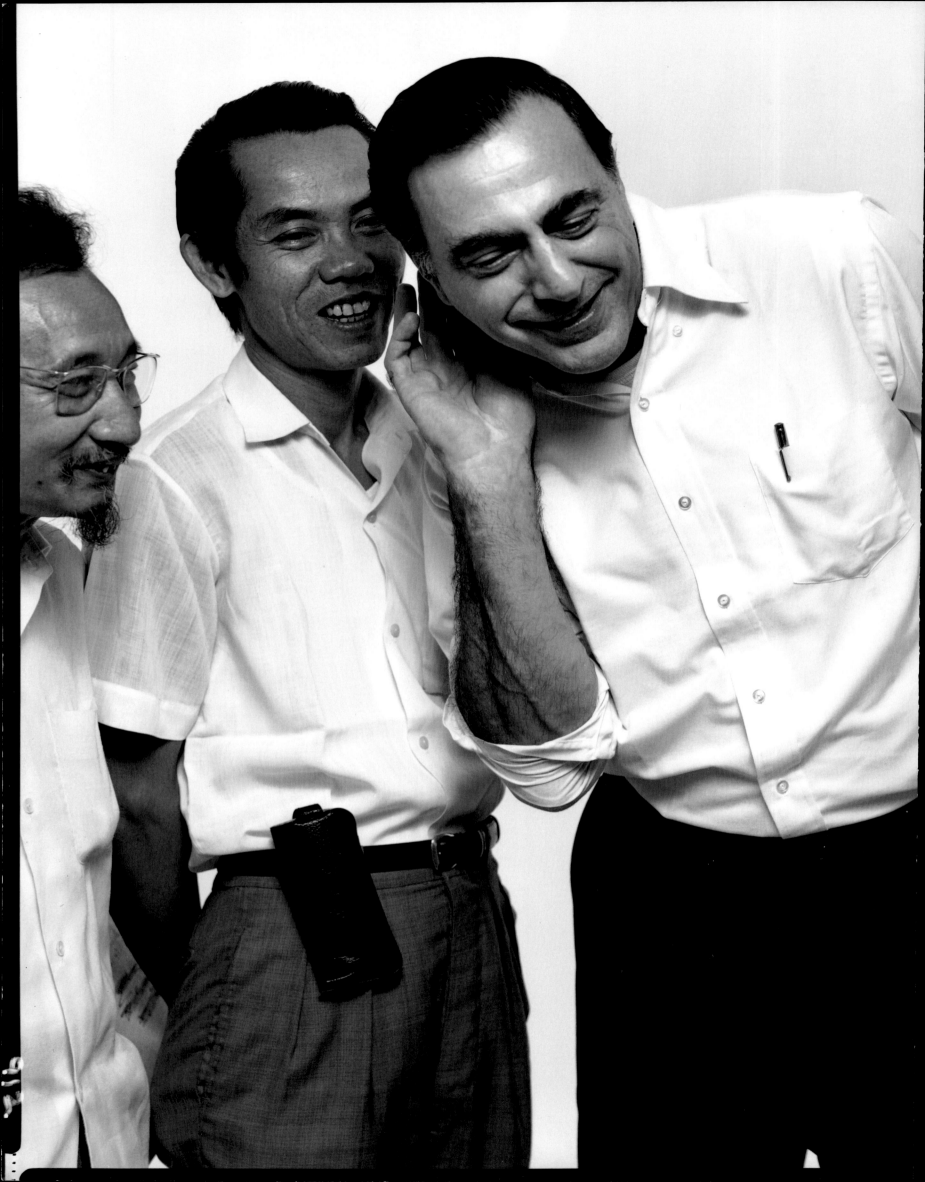

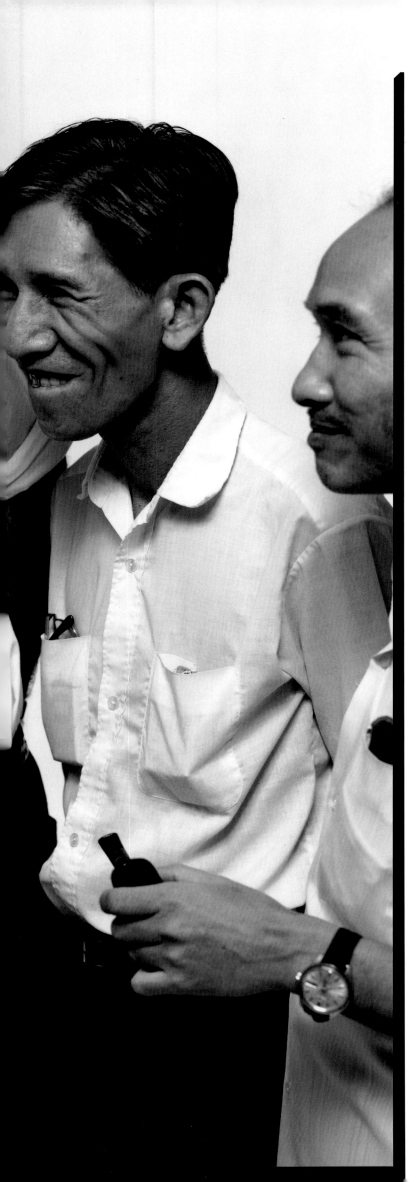

CAO GIAO, *Newsweek* correspondent;
GENERAL PHAM XUAN AN, *Time*
correspondent; **ROBERT SHAPLEN**,
The New Yorker correspondent; NGUYEN
HUNG VONG, *Newsweek* correspondent; and
NGUYEN DINH TU, *Chin Luan* newspaper
Saigon
April 17, 1971

I always liked the place. When I
first got here in '46 there were about
twenty Americans in town and hardly
anybody back home knew where Vietnam
was. A lot of Americans today have
heard about Vietnam and talk about
Vietnam and still don't know where it
is on the map. But, literally, in those
days, nobody had ever heard of what
the struggle of 1945 here in Saigon
was about. That a little fellow with a
beard called Ho Chi Minh had set up a
republic up north and was trying to
capture Saigon. And all the Vietnamese
names are so long and complicated and
the people—to use that overworn
phrase, the inscrutable Asians—are far
more inscrutable than the Chinese, and
the revolution that was going on here
at the time...nobody knew or cared.

Coming from a kind of political
background, social democratic background
—which is very unfashionable
nowadays—I thought Vietnam was
important because China was obviously
going to go Communist. It was obvious in
'45, '46 to most of us who knew
anything about politics. Vietnam was a
smaller cradle of the revolution—what I
call virgin revolutionary territory. It
was a place that was contestable, if
you're going to talk about whether it
was going to go Communist or not.

This thing has bounced back and forth
so much through history. I think there
is a potential contest between Hanoi
and Peking for control of Laos and
probably Cambodia, too. But you're now
talking about the Communists. I don't
think the average politician—let alone
the average man—in Saigon wants to
take over Cambodia, wants to take over

Laos, no. I just think he
wants to be left alone the
way most people do. He's
been tortured by war for
twenty-five years now and
he, he wants every foreigner
to just get the hell out of
the place. Including the
North Vietnamese.

If you're asking me do I
feel my age—which is
basically what you're asking
me—the answer is, yes. I'm
fifty-four years old and I'm
getting bloody tired of it
all. But I'm hooked. Every-
body's hooked in Vietnam.
The place—it grieves you, it
eats you up. It devours you.
It does. And once you're
hooked by it, you're hooked.
It's like pot or booze or
anything else. Or politics.
It gets into you. The
politics of it has gotten
into me.

I think everybody who's
been here thinks inevitably
about dying here. You think
two things, oddly enough.
You think you're not afraid
to die here and at the same
time you think what a
foolish way to die in such
a far-off place. But it's
not a far-off place because
it's really become such a
signal part of American
life...significant part of
American life. You might as
well die here as die in
America. Every year I go
home—I've been going home
for a month or so almost
every year—each time I
almost flee from America
back here. I'd rather die
here than die in America.
It's a better place to die.
Means more. Shouldn't mean
more but it does. There's
more reality to it.

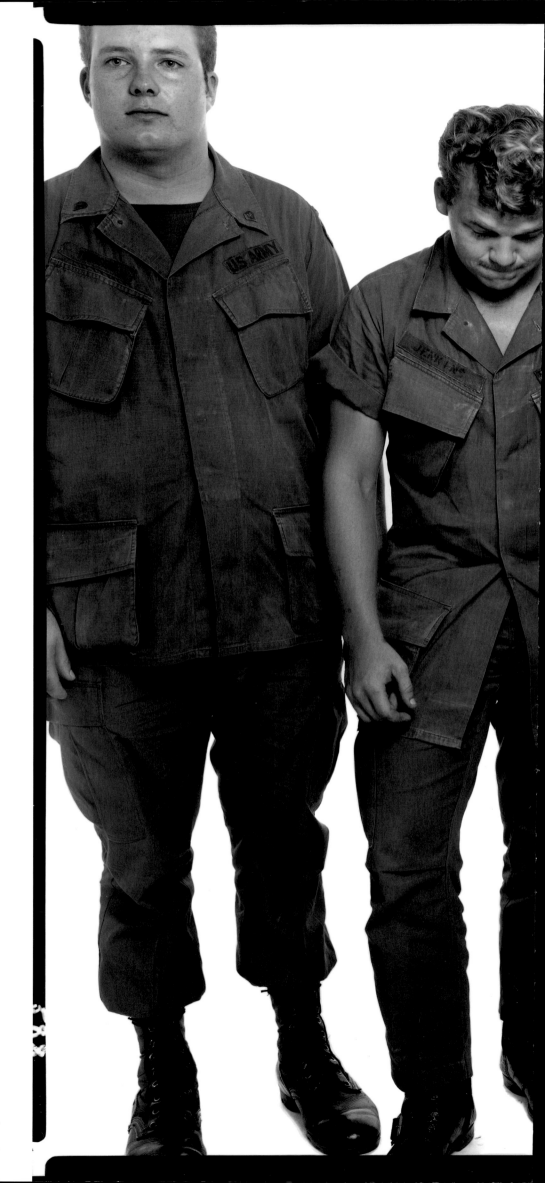

Jay Townsend, Frank E. Jenkins, and
Richard D. Honeycott, U.S. Army,
with Vietnamese women, Saigon

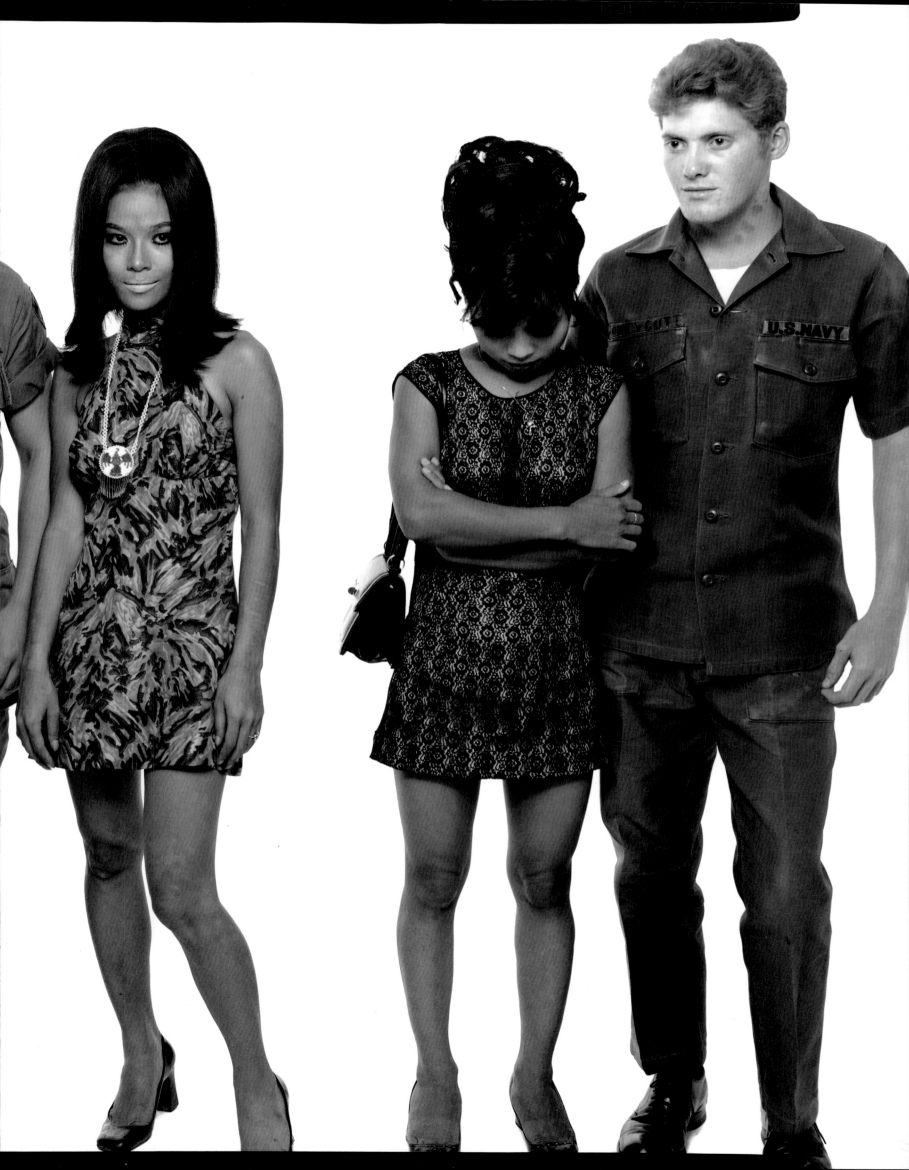

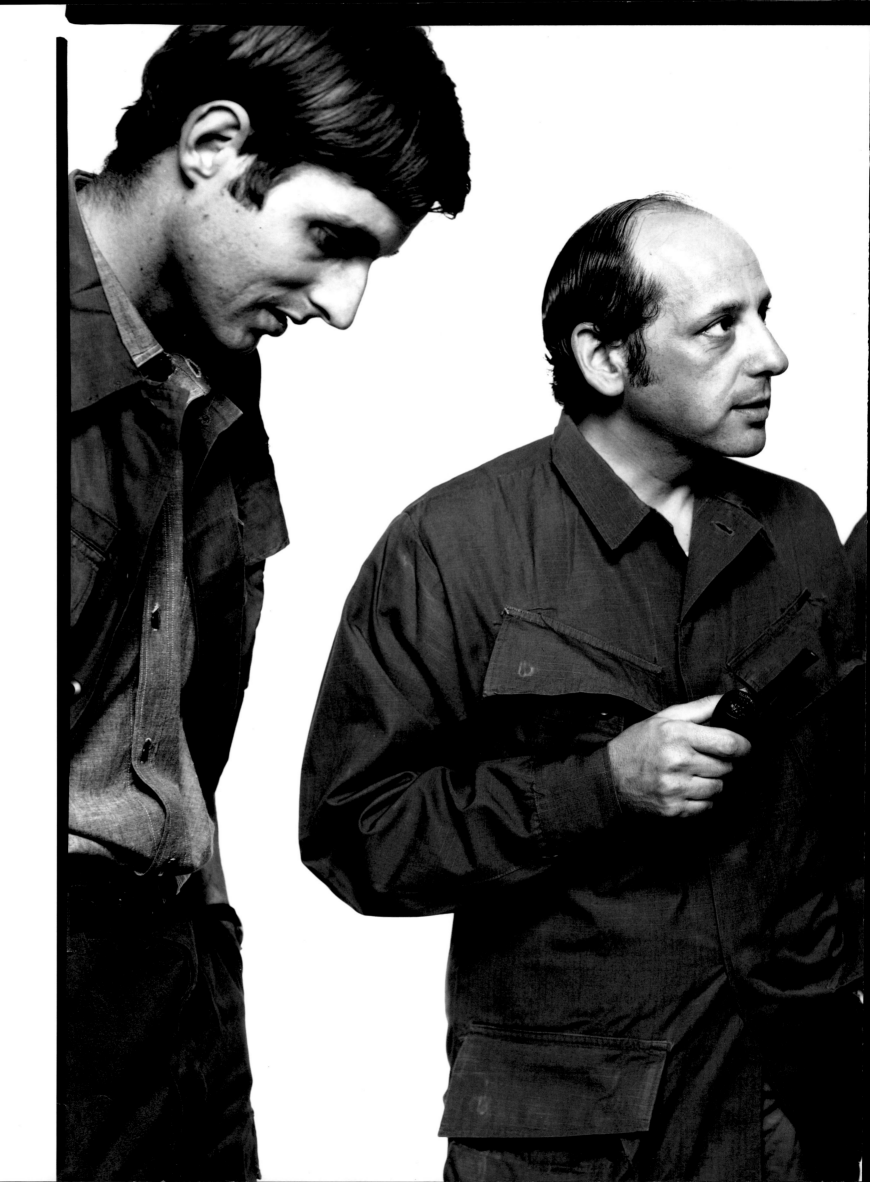

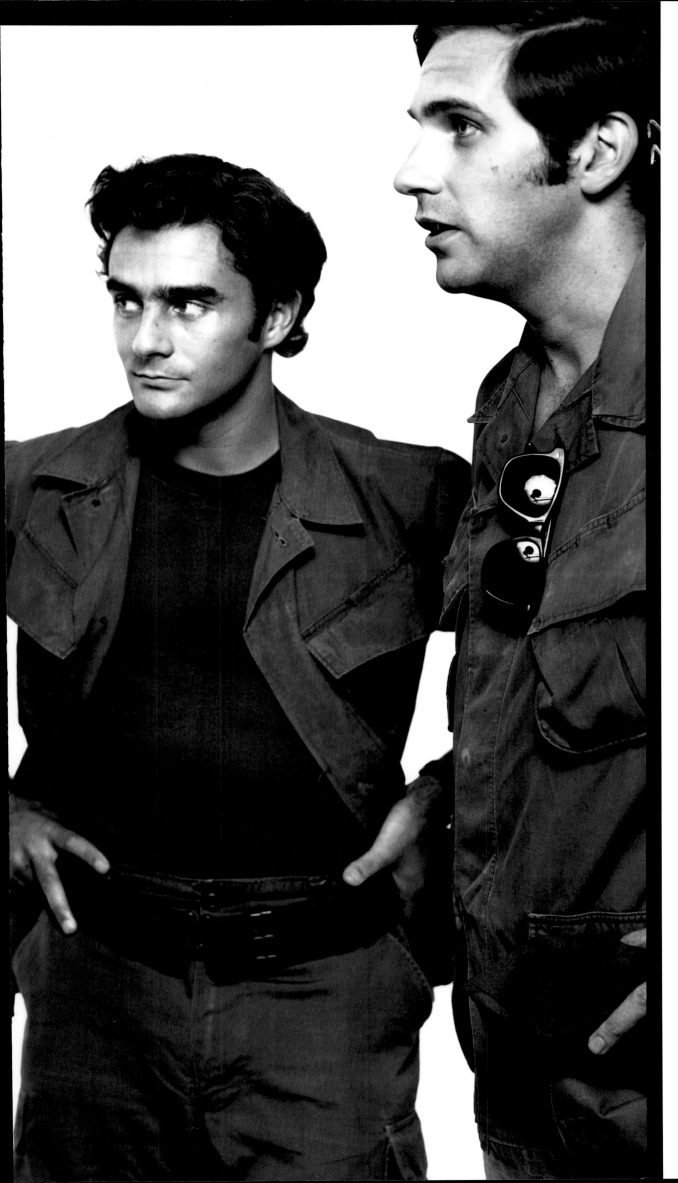

Saigon bureau chiefs:
Peter Jay,
The Washington Post;
Alvin Shuster,
The New York Times;
Jonathan Larsen, *Time*; and
Kevin Buckley, *Newsweek*
Saigon 109

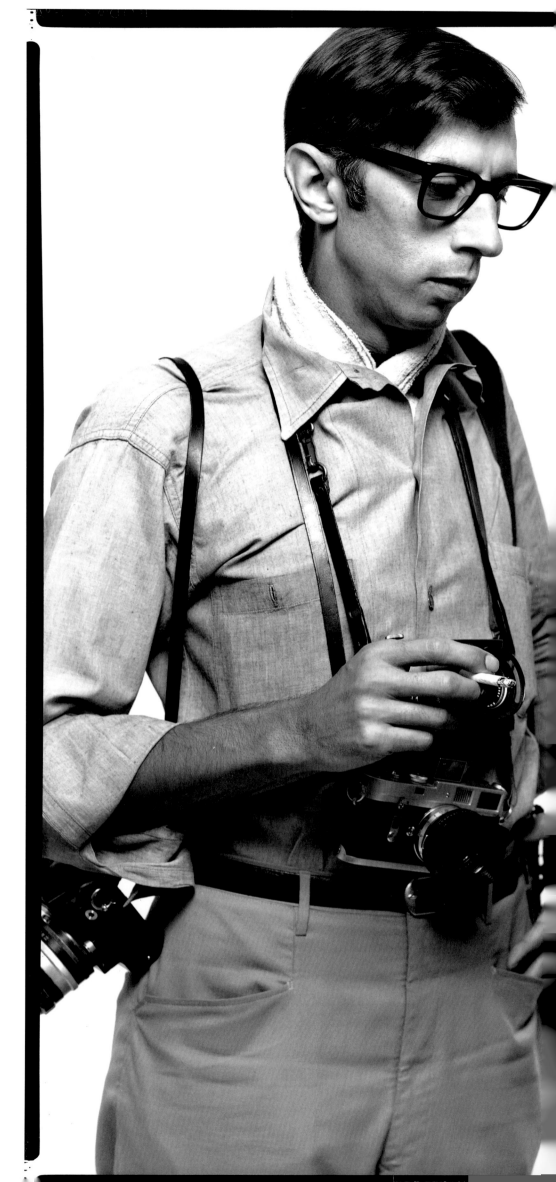

GLORIA EMERSON,
New York Times
correspondent, with DENIS
CAMERON, photojournalist,
and NGUYEN NGOC LUONG,
interpreter
Saigon
April 1, 1971

The odd thing is, I think
maybe the reason I'm so
close to Denis is because
we have seen so many people
who were caught up in this
war and didn't have a
choice. And we had a choice.
We were coming and going,
we'd be leaving, and we
kind of shared this guilt
feeling about that. Maybe
good friends have to have a
little bit of common guilt
between them about a larger
situation. Denis and I know
who we've left behind.

Did I talk to you about the
time we went past the
checkpoint and they opened
fire? Denis and I were
driving back because he had
a girlfriend who'd come to
see him in Phnom Penh and
he was very upset because
he thought a very smart
English correspondent would
take the girl away. I don't
know who he cared for most,

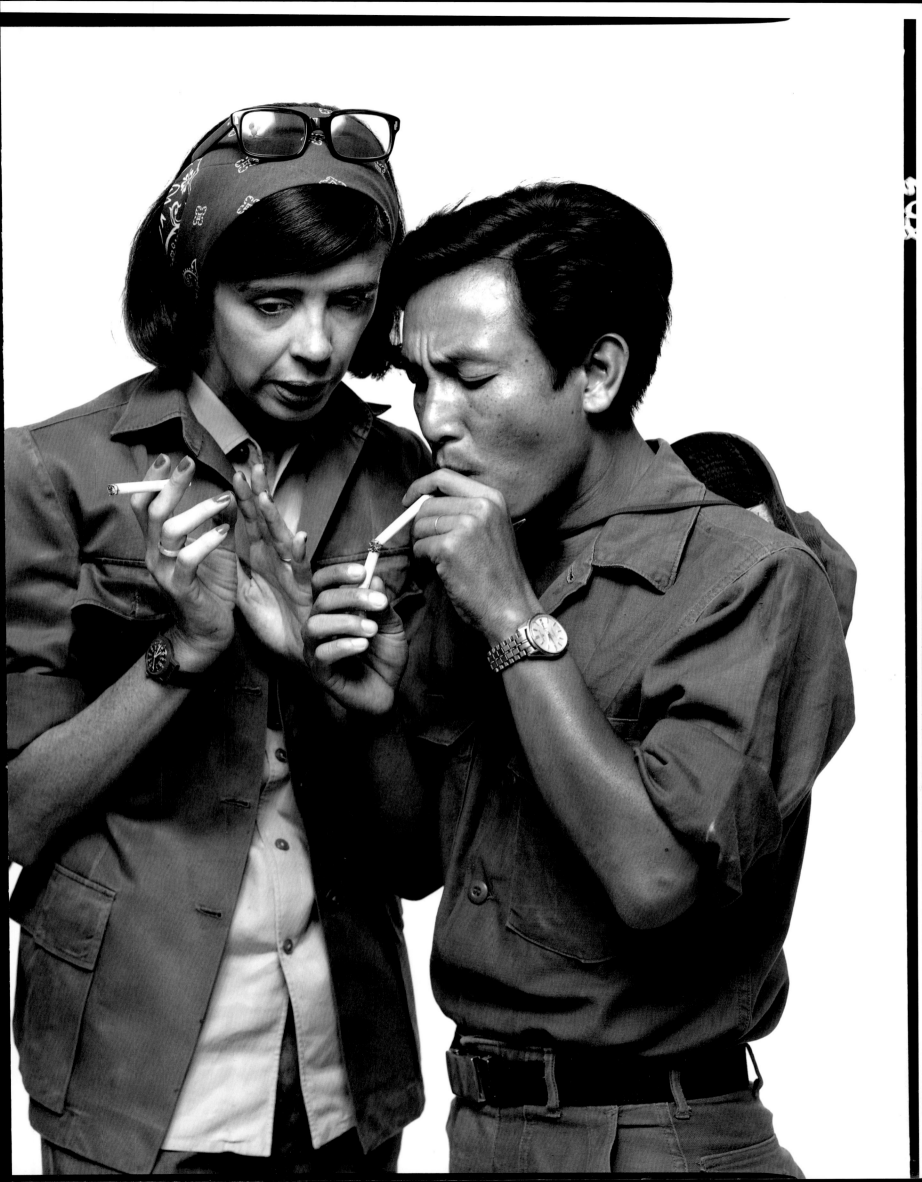

the English correspondent who suddenly loomed up as a rival who he adored as a friend, or the girl who was very decorative and rather a famous English debutante who'd come to Phnom Penh in the midst of all this war. His own particular anguish over two friends in Phnom Penh who might have been, what?...holding hands in an opium den together...was so great he risked our lives. We drove past a checkpoint and I was very cross. It was dark—the North Vietnamese were all over the country—and he slowed down. And then the Cambodians opened fire. The car turned over and Denis and his interpreter got out and started running to a rice paddy to hide. I was slower and tripped and I got caught and I couldn't find my handbag and the firing went on. Finally I got out of the car and thought, "It is simply too late. I won't catch up with them." And I looked and Denis had waited. He'd crawled a few feet and turned around and waited for me to come. And he had his hand out.

That was so extraordinary. He had waited. He was furious I took so long but he had waited. We crawled a bit and sank in all this God-awful mud and Denis said something about, "You had to go back for your fucking handbag," and then this splendid noble moment was over. We shouted that we were Americans and the Cambodians said in French they were sorry, they hoped we would forget the little incident. But I never forgot it. Because he waited. Not many people wait for many people, do they?

I think one of the great things that you can see someone do is reaching out literally to save you. To show you the way. I'll never forget this long arm going out to me. That may be love. I don't know. Then, again, it might be better than love, don't you think?

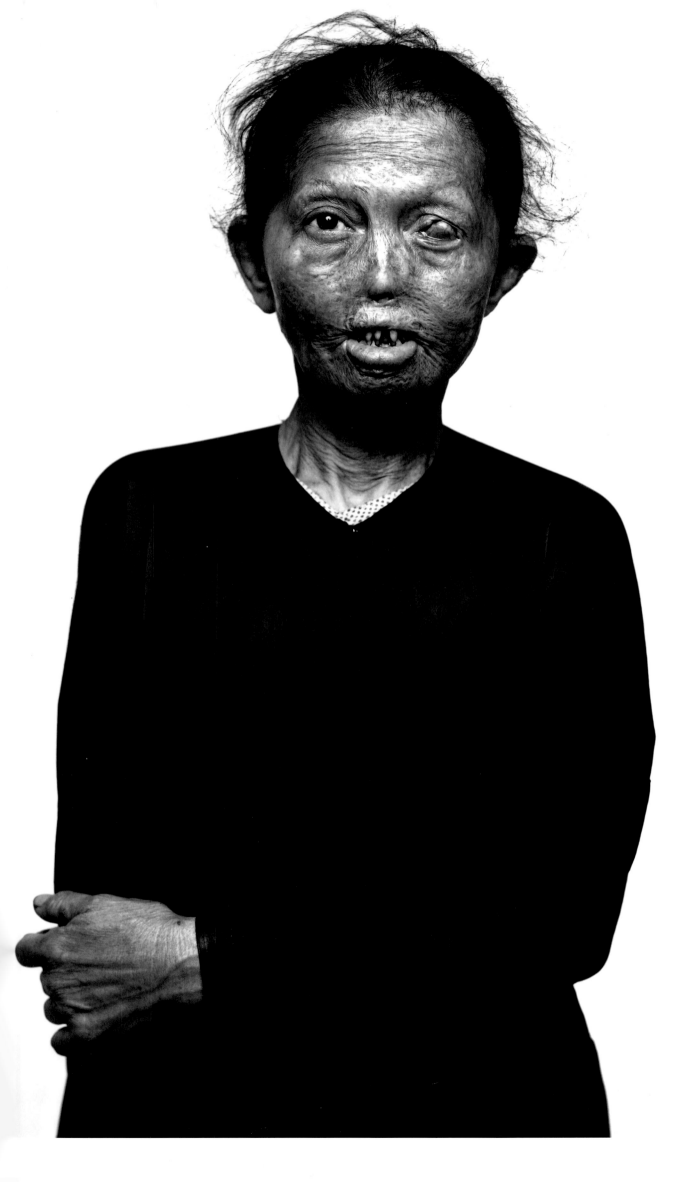

Napalm victim, Saigon 113

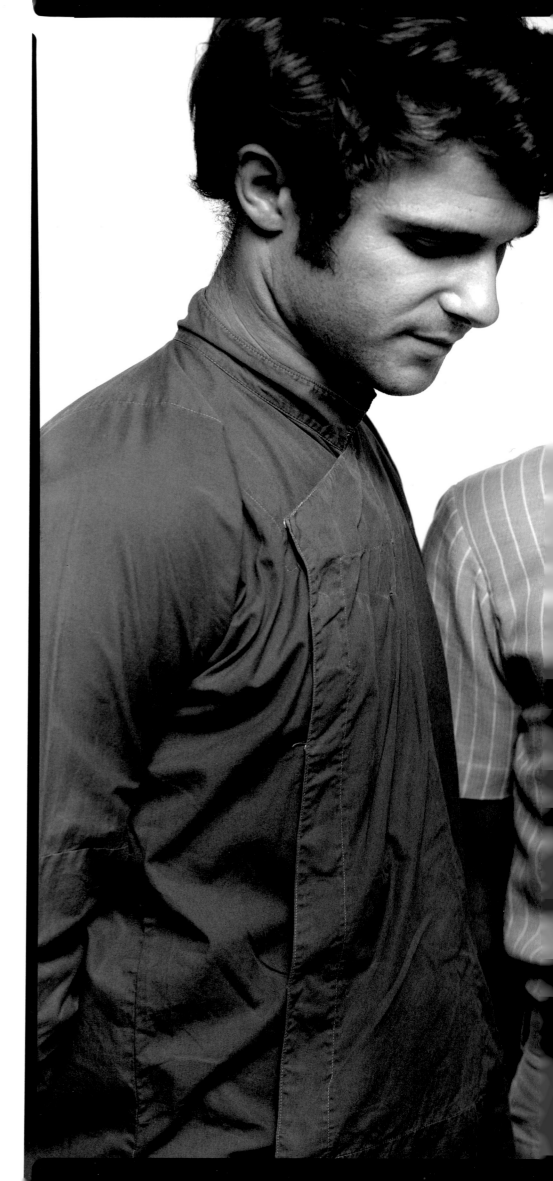

Tom Fox, Jerry Berge, and Don Luce,
antiwar activists, Saigon

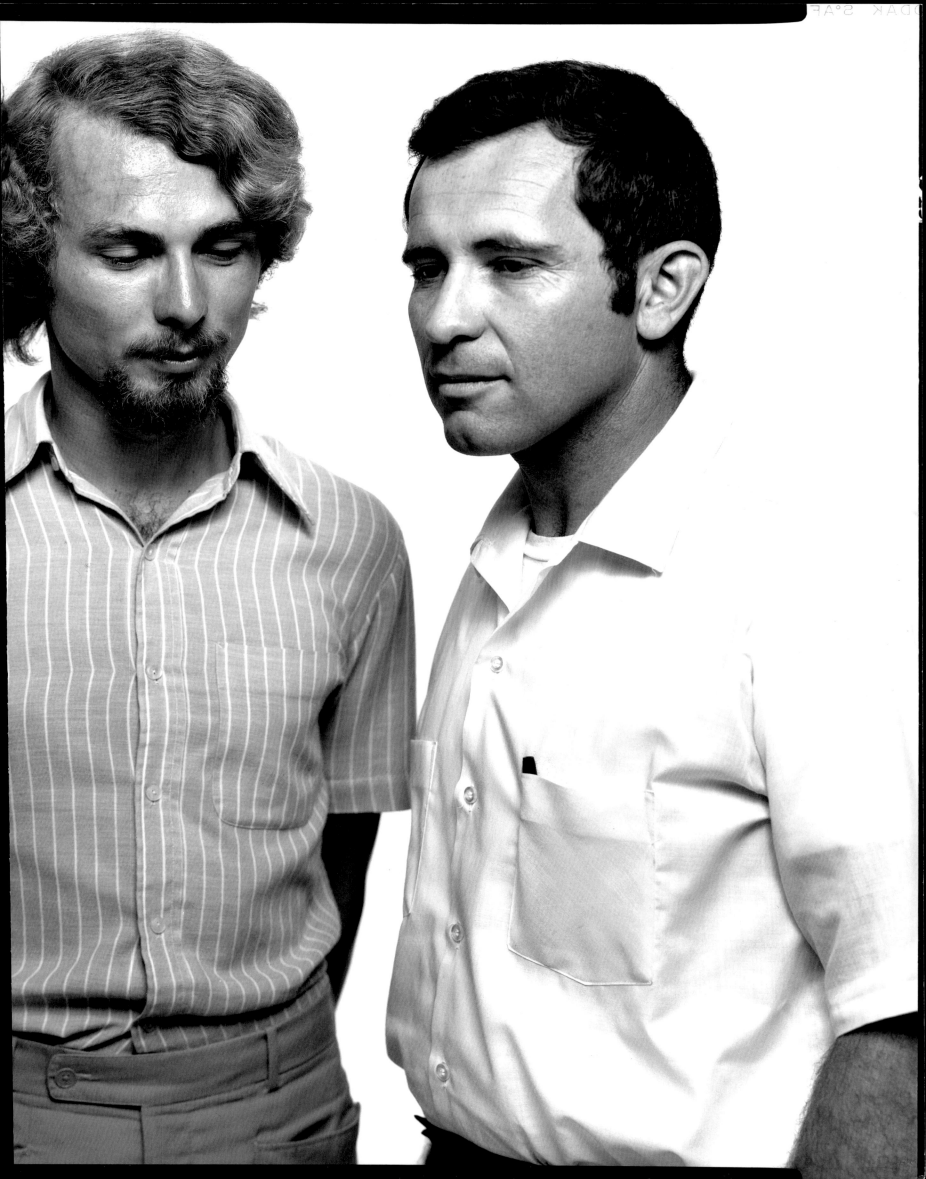

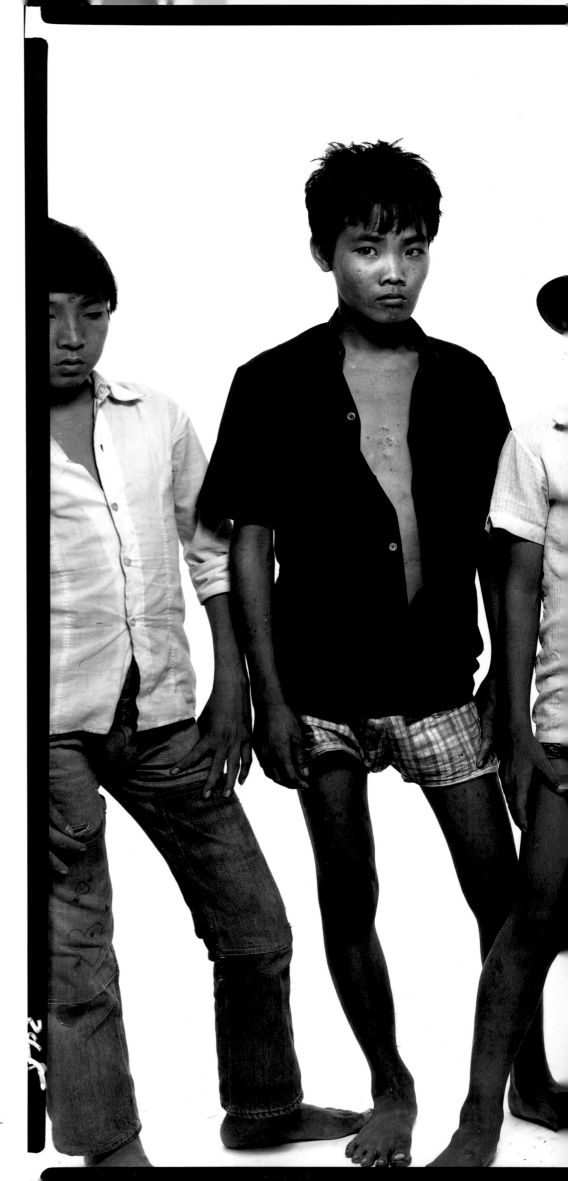

RICHARD HUGHES,
social worker,
The Shoeshine Project,
with Vietnamese street boys,
Saigon
April 1, 1971

It's very funny, you know,
because you get into these
things for all the wrong
reasons. That's the irony
of it. You know, the
Christian ethic, the social

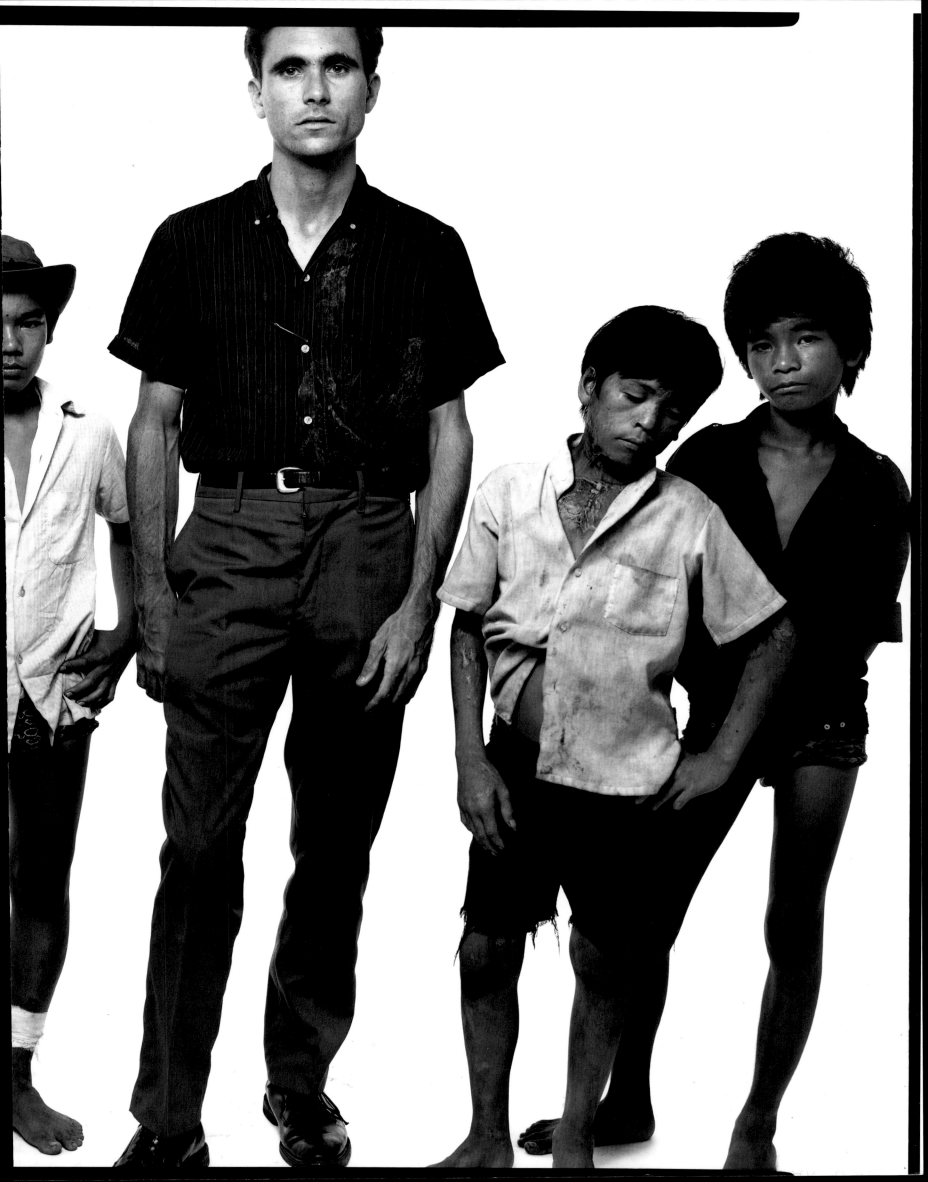

work ethic, ego, and your own image of what people need from you. A lot of my values have changed. Good work has been done but I did it for all the wrong reasons.

I thought—like everybody's impression in '68, from the idiot box, you know?—that if you're doing social work here, you're going to be carrying a stretcher and have three little Vietnamese babies under your arm, one American G.I. over your shoulder, and you'll be running somewhere, and you might get hurt. You'll do this for six months or a year and then you'll come back and tell everybody what Vietnam was about.

The first day I got here I met this guy sitting there looking like...who's the character in *Faustus*? The devil, I guess, who says, "Hey, Faustus, want a nice house?" or something. And I went over and he started talking about the street kids. In the beginning I was involved in a lot of different things. Involved with Buddhist monks and taking care of people in hospitals and traveling with Marines and finally zeroing in, after about six months, right in on the problems of the kids.

Most of them come from the provinces, and have some sort of family who has come to the city for some sort of economic Shangri-La, and found it pure hell. The kids escape into this carnival-like existence. It's incredible. It's like listening some night to music and every fifteen minutes you turn it up louder.

The first thing is for them to recognize even the possibility that there's a future. They'll tell you in sort of very unguarded moments, "Don't go to so much trouble, I'm not worth it." And they mean it. They're all a walking lie, a contradiction. And you're very attracted to them because they're wonderful to be with. They have that tremendous culture—I don't mean Vietnamese culture—they have this basic relaxation and you're amazed at their ability to be so blasé and removed from things. And you try to assimilate that. And then, one day, a kid just explodes and it all comes back into perspective and you say, This is very serious.

The first kid we lost, who was a beautiful person, when that happened a year ago I reacted with a tremendous amount of license and indulgence. But this time, with a boy who just recently committed suicide—he tried it twice before so it wasn't a case of he was going to put on a display and he goofed and died—even though it was the same anguish at not being able to salvage that kid, it was also a repression of many things exploding inside you the whole time. And with other recent events in the house—dying, almost dying, car accidents, knifings—where all the kids were reacting very violently, tremendously high tensions, it becomes a matter of attrition.

So when, an hour after somebody dies, a kid comes to you and says, "Well, we lose one more boy, huh?," you can say that kid's in a lot of pain. You can say a lot of things. But you just have to acknowledge that it's not a groovy thing and take his challenge and direct it right back at him. And then he'll pick up the cue. 'Cause these kids are really swift. As long as they know that you are willing to go that distance with them, that you're not going to fight against the reality of the thing, that you're not going to be a typically alienated American, then they'll pick up the cue from there and they'll say something about school or work or something like that.

See, it's very dangerous, psychologically, to be an American here. Because an American can intercede and save somebody's life in an incident with a policeman or get a kid out of jail or get away with a traffic violation. It begins to sink in after you do it so many times that you have this sort of power. Recently, in these four days, while I was constantly in and out of hospitals and graveyards, I realized from the reactions around me—totally from their reactions, when they ceased to notice me—that I was no longer the "good American" or the "freaky American" or the "idealistic American." I had ceased to be an American at all, which is an incredible thing. I was nothing more than any of them.

See, I think one of the big crises now is that there aren't any Vietnamese. I don't mean that their culture has been so destroyed—far from it—but as I watch people in the neighborhood for a long period of time, there's not this underneath "we're Vietnamese" type thing. There's tremendous, it's terrible to say identity crisis, but there is sort of an identity crisis. Living in this type of society and guilt about the reaction to it and things. They are really not together with each other. So in a crisis they will grab each of their individual things and pull back and pull their feelings back. They don't act as a neighborhood. They don't act as a group and this nation doesn't act as a nation. Perhaps a lot more people will have to die in a lot of Saigon hospitals before the Vietnamese do what they want to do with their own people.

You begin to see that these kids can't beat the system and you can't beat the system with them. And even though it's a very despicable ugly moral situation—talking just about the war— you've got to swallow and take a breath and say, How am I going to help this kid? How am I going to help these kids? The dead are dead. Save the living, you know?

There's barely a moment to register and reflect. And when you take the moments to relax, you take it with them. And you no longer feel the need to justify and resolve. It's a marvelous feeling in a way but it's such a total feeling, or such a deep feeling—I don't know which or both—that you know

essentially who you are. You may not be able to say, Well, if I define myself, I'm this, but emotionally you know you've landed somewhere.

When you begin to lose a couple of people that you were very much committed to...very slowly, your approach to death changes. You stop planning when you're going to leave. You prepare yourself for death. And you take your cue in a sense from the kids. They really can't afford to lose time grieving, you know. I mean, that's what's behind a lot of it. Not that their reactions are necessarily realistic or the way one should "react to death," but you begin to see that in many ways they're ahead of you. Because there are in fact billions of people in the world and there are people dying in Saigon every day. From that perspective, maybe life isn't that valuable and perhaps you do have too high an opinion of your own life, and you begin to question even those values that make you get emotionally involved.

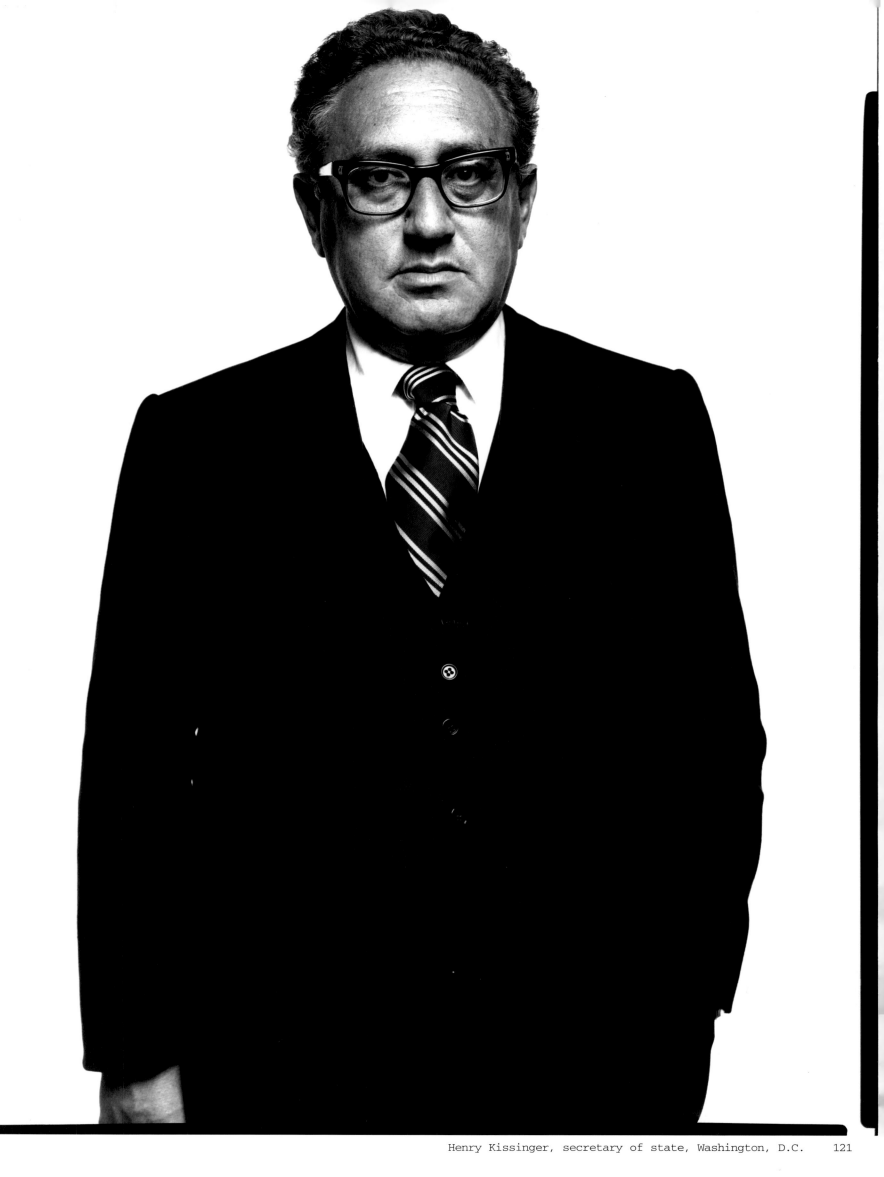

Henry Kissinger, secretary of state, Washington, D.C. 121

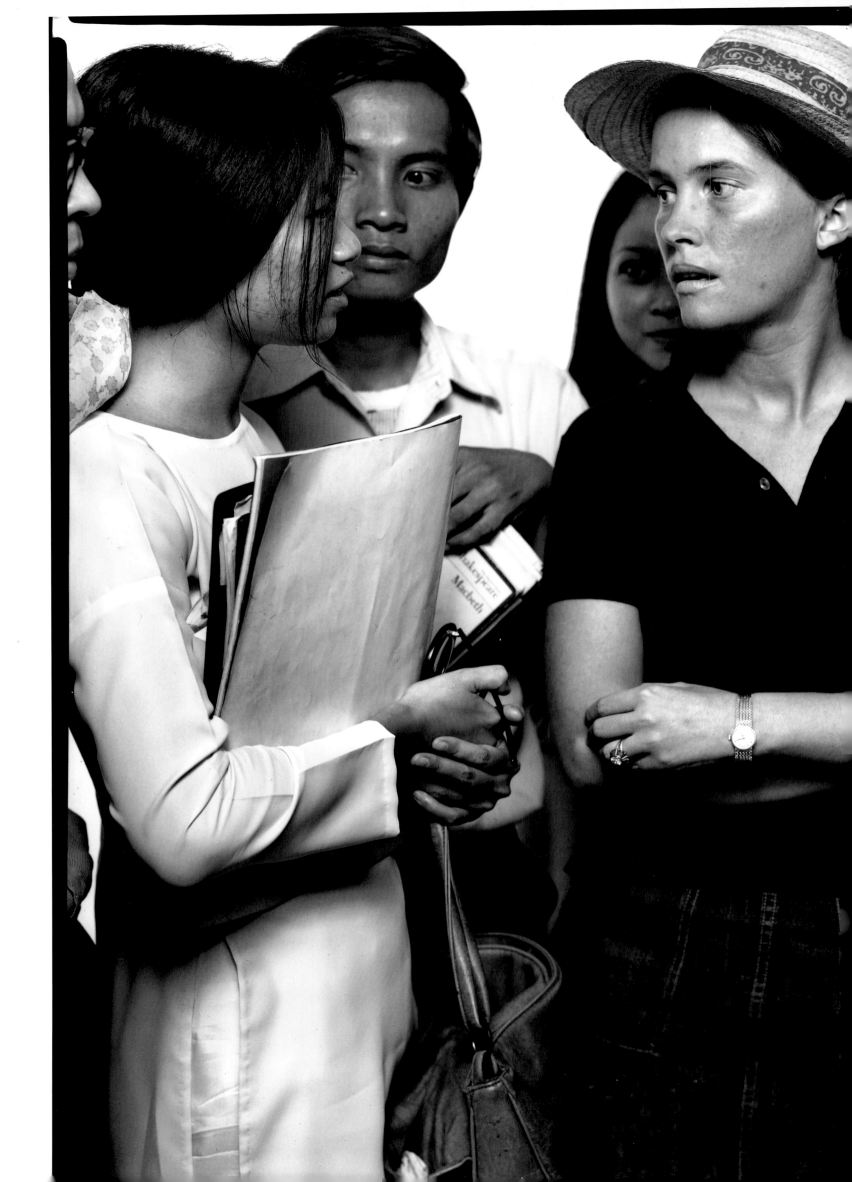

Wendy Wilder Larsen,
poet and teacher, with
her students at the
University of Saigon

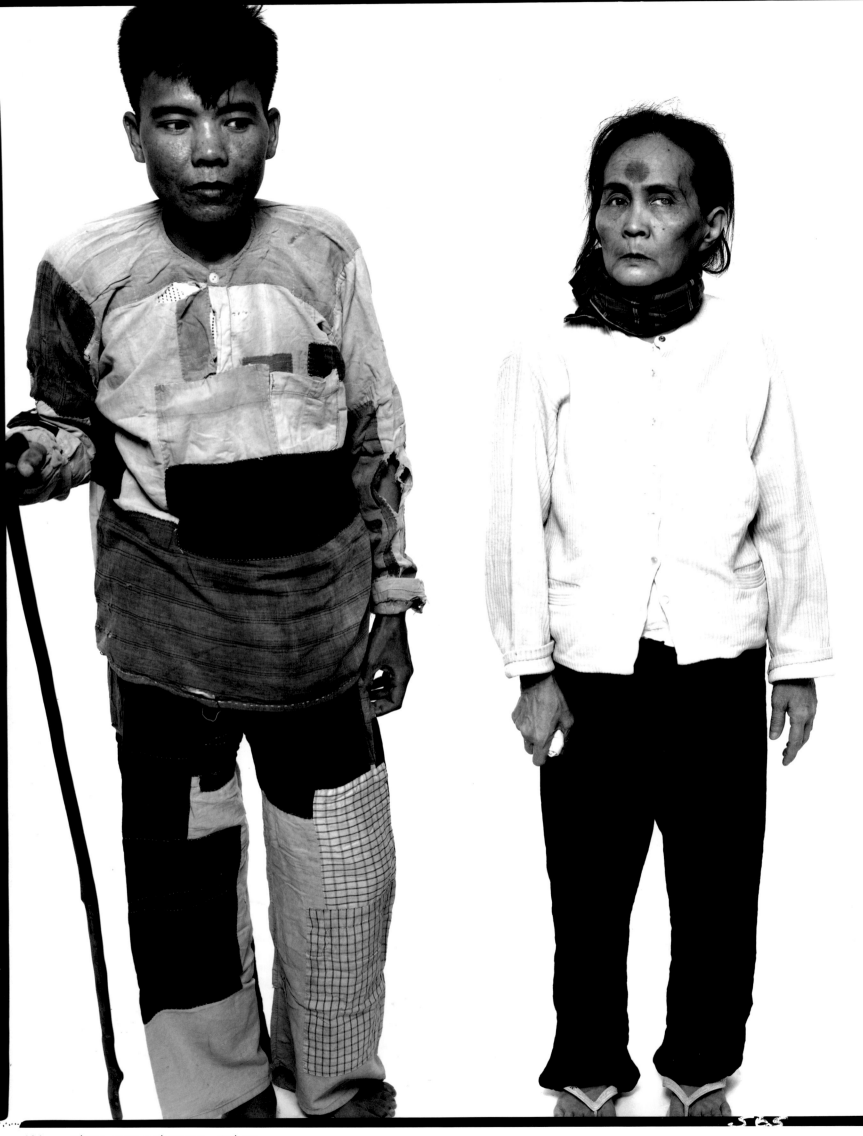

Tiger-cage prisoners, Saigon

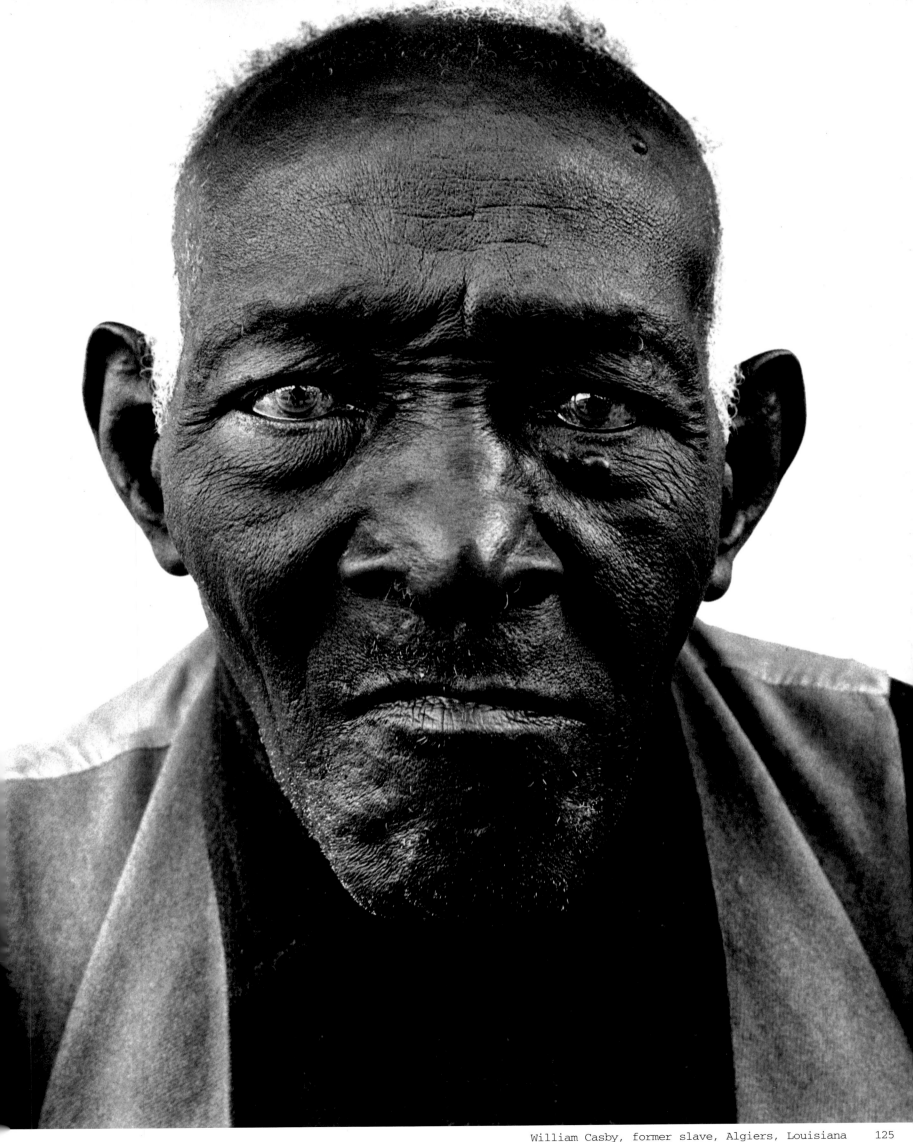

William Casby, former slave, Algiers, Louisiana 125

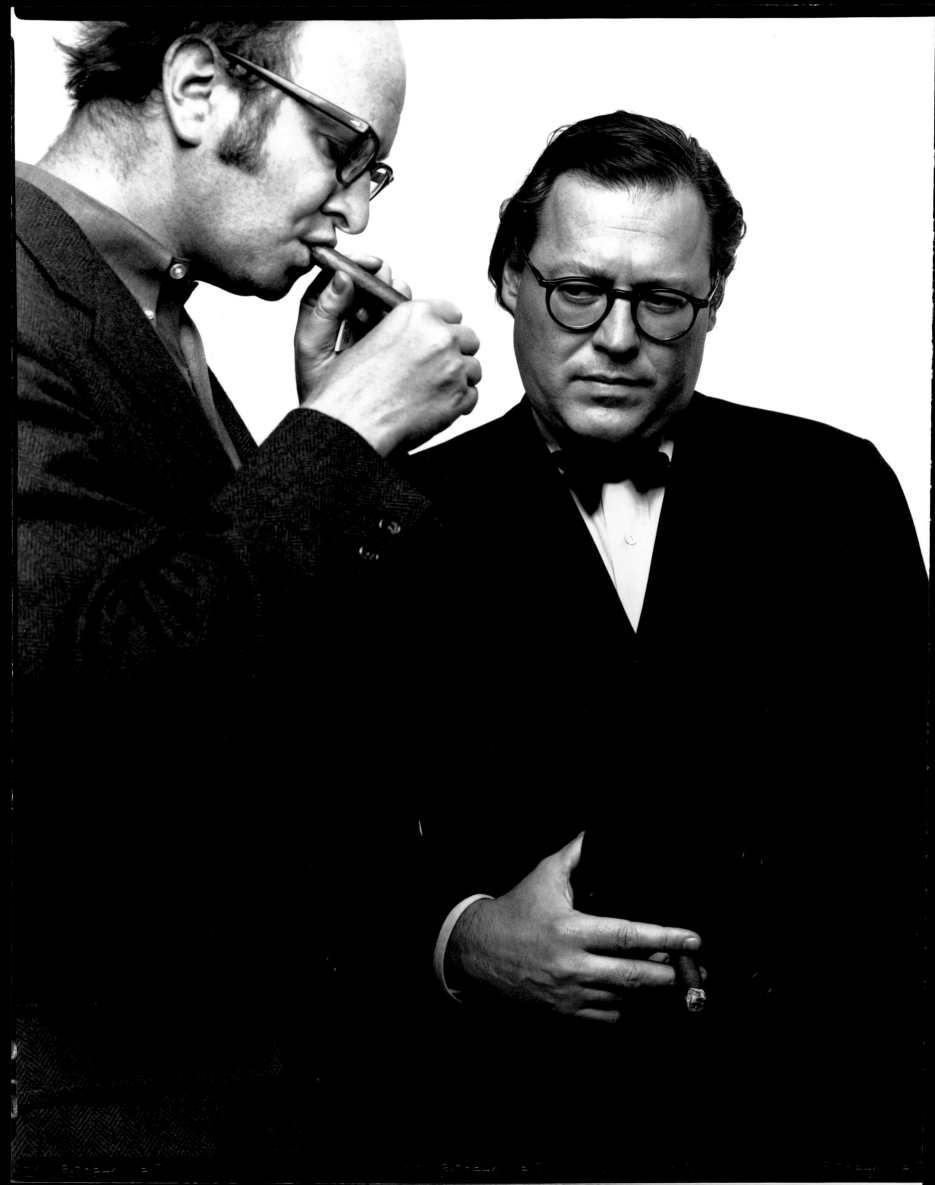

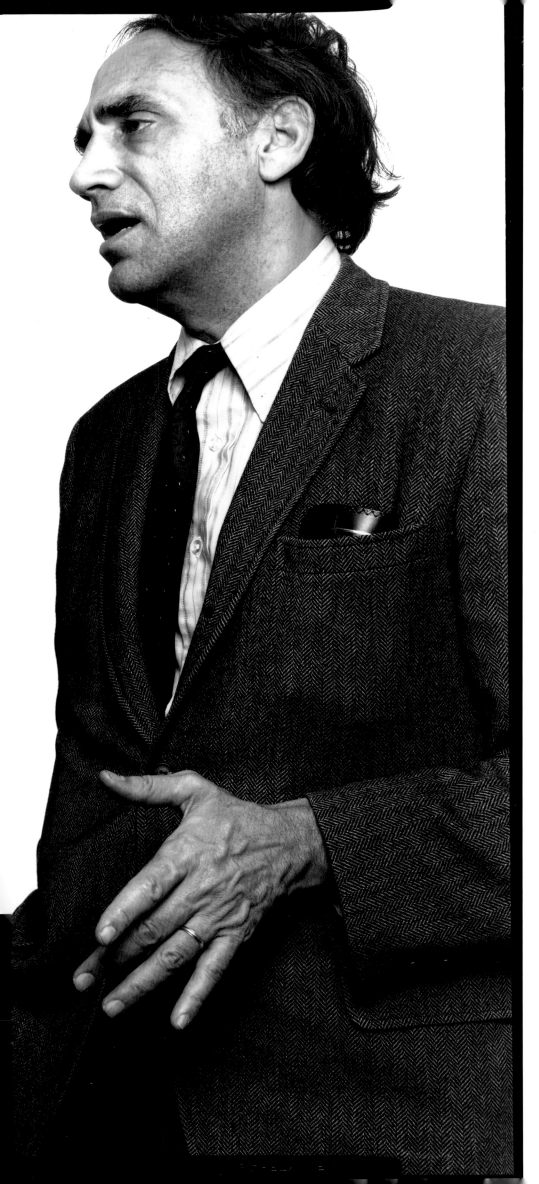

JULES FEIFFER, cartoonist, playwright; **JASON EPSTEIN**, editor; and WILLIAM KUNSTLER, civil rights lawyer, Chicago Seven Conspiracy Trial November 4, 1969

The courts are the last thing left in this country that people seem to have any faith in at all. And when that faith goes, I don't know what kind of community we have left. There's been a process, it seems to me, in this country for a long time—maybe since Kennedy turned sour...which was almost immediately upon his inauguration almost—in which the government has broken faith with the people over and over. And when that happens, you can't put it back together again. It's like what happens in a marriage that goes sour, or a friendship. You can't get it back. Ever.

The defendants are under great pressure. It's a terrible time. Some of them are frightened. I guess they're all frightened—who wouldn't be frightened in a case like this. It's awful to have to be told to be in a certain place every morning at ten o'clock and sit still until four-thirty and be told by people that this is necessary and to play a game that you know is rigged against you. It's very corrosive. You're gonna go nuts after a while.

Some of them are obviously in pretty bad shape. Worse than others. They're all a little distorted from what they used to be. Abbie seems to be holding up pretty well. In a funny way he seems to be getting a new lease on life. Abbie's extremely tough. He once said, "You can't like anybody unless you're ready to die." I think he needs that. I'm not sure that's a good thing to need, but maybe it is. Tom was very tense in the beginning of this but he's gotten a lot looser.

Rennie seems awfully nervous. All pulled in. And with a really hard determination to win this thing. Which obviously creates some kind of tension between him and, say, Abbie. I mean Abbie wouldn't mind winning either, but I think Abbie is ready to die and I think Rennie probably isn't. Tom believes he's going to get killed. He's said that. And maybe this accounts for the fact that those two—Abbie and Tom—emerge as the strong people, the leaders.

It's the defendants against the government, and the lawyers are sort of caught in the rush. Neither Kunstler nor Weinglass are especially radical themselves. Kunstler comes out of the civil rights thing. And Weinglass is just a good boy from Newark, a good lawyer, good middle-class guy who happened to know Tom. But the lawyers are almost innocent bystanders while the defendants and the whole government whack at each other with baseball bats.

LEONARD WEINGLASS and
WILLIAM KUNSTLER, civil rights lawyers,
Chicago Seven Conspiracy Trial
November 4, 1969

I think what happens is that you develop some very strong idealistic positions—which I had from...from the fourth grade to the eighth grade. Superimposed on that is a lot of formal education, and you're projected off into another direction. And then an event comes up in your life, or a person, who,

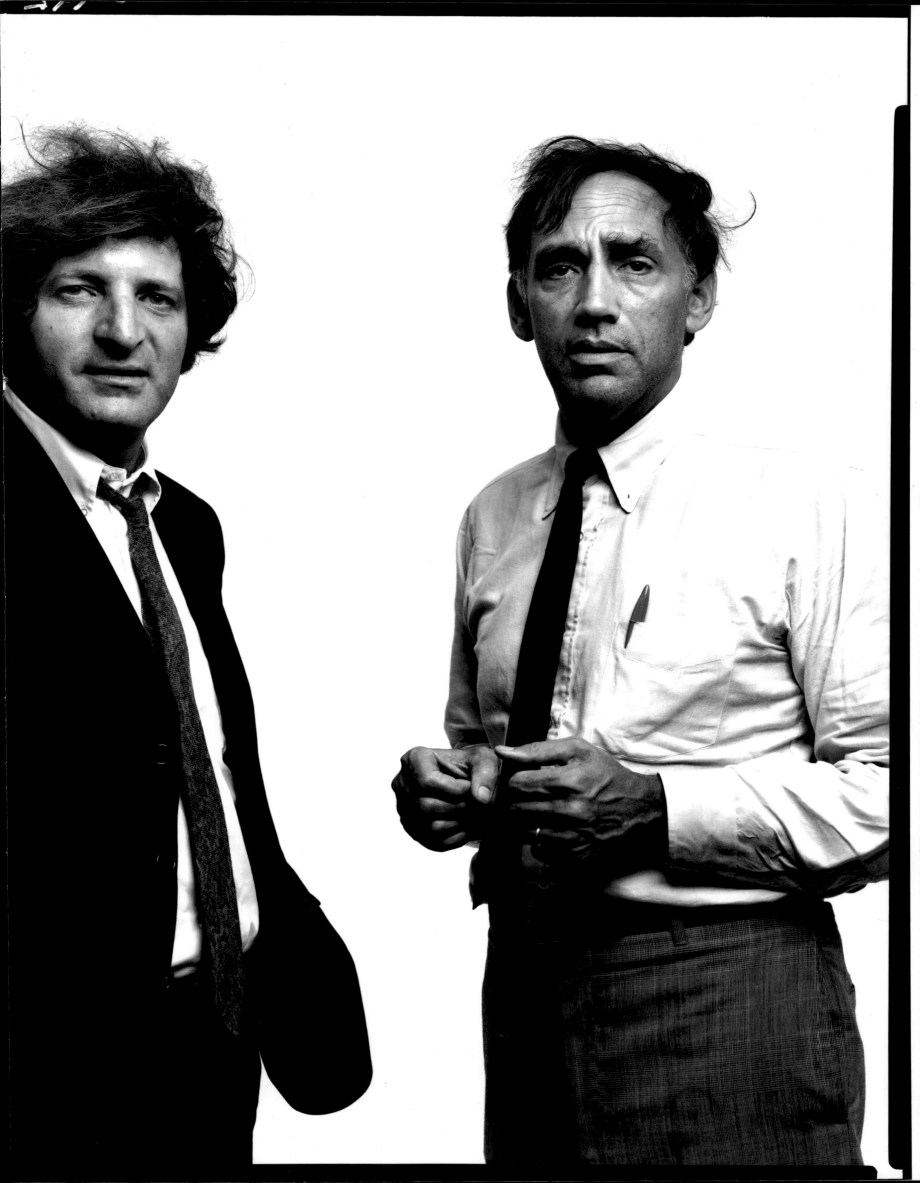

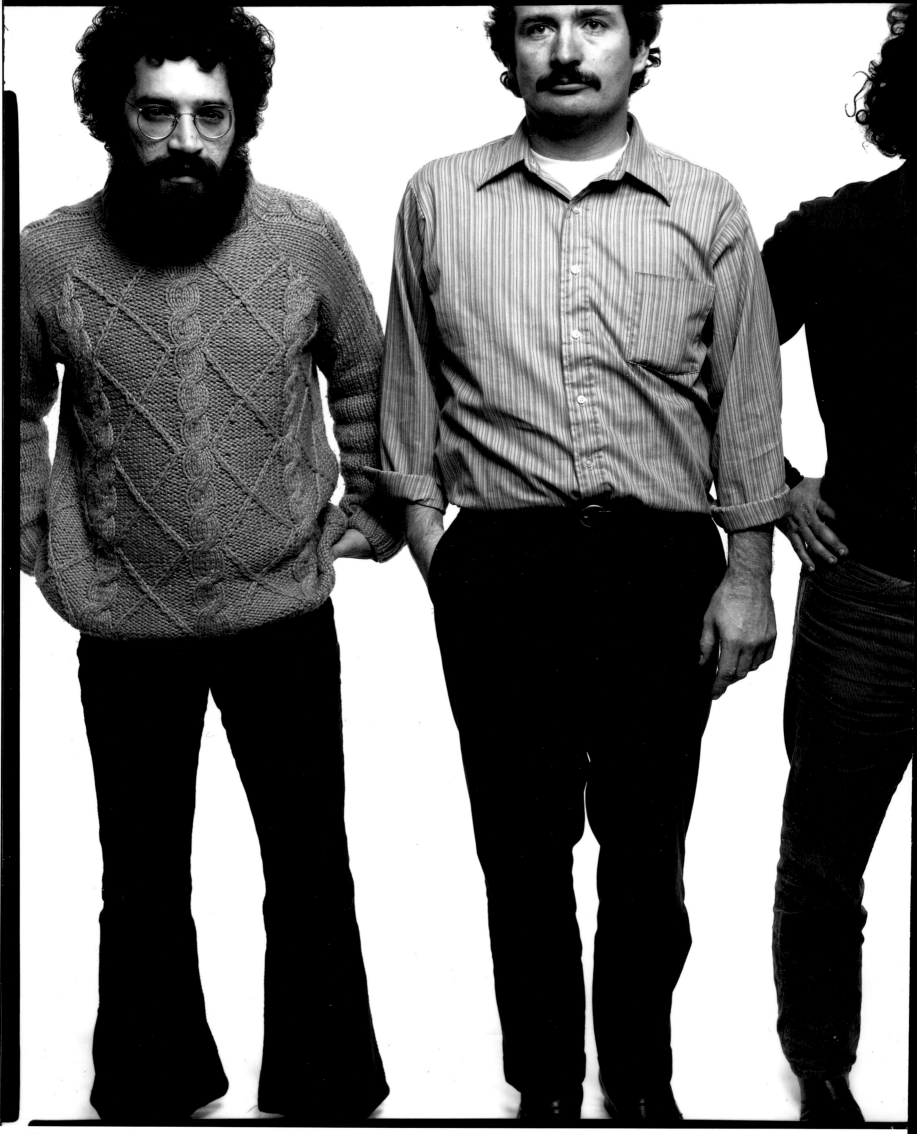

The Chicago Seven: Lee Weiner John Froines

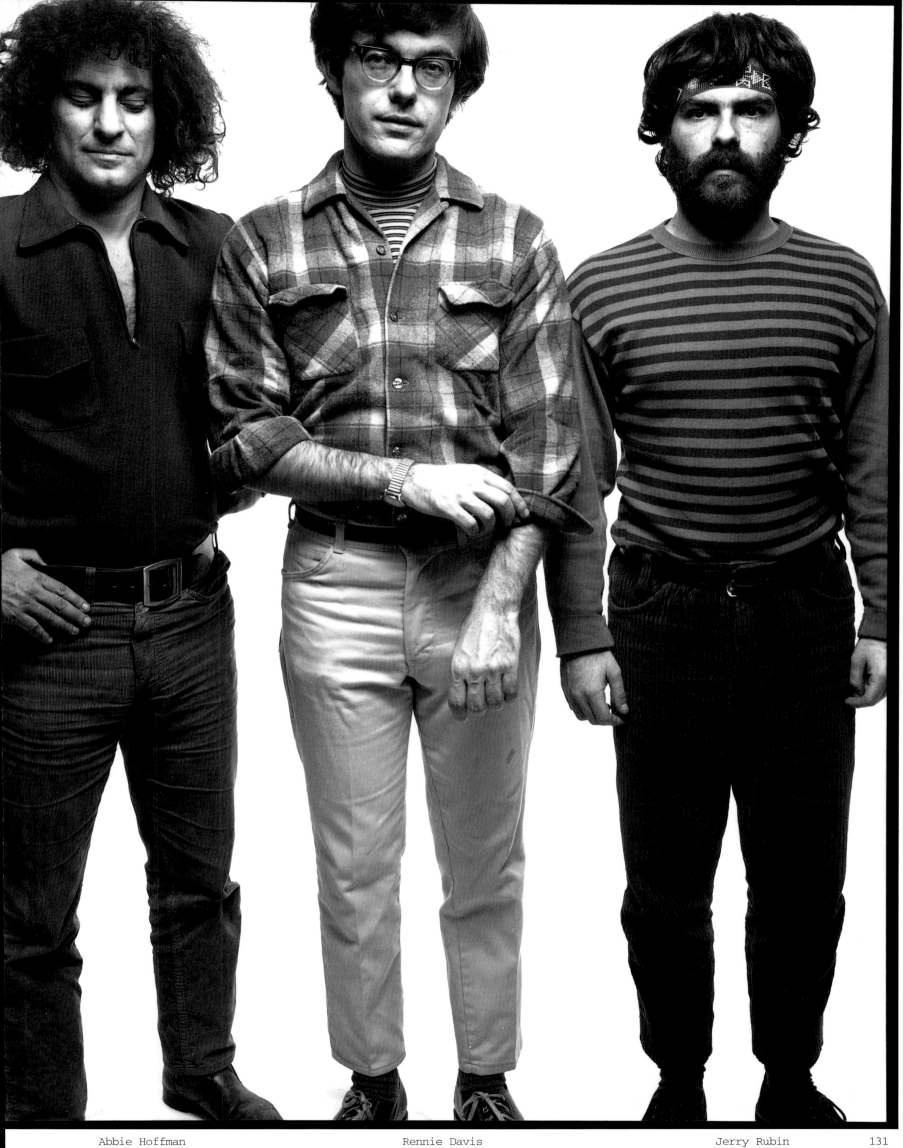

Abbie Hoffman Rennie Davis Jerry Rubin 131

Tom Hayden

Dave Dellinger

uh...gives you the strength and encouragement to go back to some of your original premises about life. That's what I would say Tom did for me. And really, when I think back, I was never too comfortable, uh...during...during the years of diversion. I feel much better now.

Tom has changed my understanding and attitudes about a number of things. I've learned a lot from him. Nobody knows anything about Tom's personal life or even his personal feelings. He and I have spent hours talking about children, marriage, things of that nature that I don't as a matter of course talk about and I think he probably never does. He has a long personal history that I won't go into, and I don't know very much about him—you know, Freudian stuff—but he's built up his own defenses. In his work he's confronted a lot of jealousies, a lot of antipathy. A lot of people are afraid of him. I think most of them just try to figure out who Tom is and then try to conform to it. And he has, I think, a certain amount of contempt for that. He really forces a lot of people back into their own insecurities. And...it's very hard to deal with someone like that.

But...I liked Tom right away. He's one of the strongest men I ever met, and I just believe very much in his integrity as a human being. I have a lot of respect for his ability to analyze and reach a correct conclusion and follow through on it. You meet one person like that and it's worth fighting for. He's worth fighting for. I personally think that it's very important that he not be in jail.

TOM HAYDEN, antiwar activist, co-founder of SDS
Chicago Seven Conspiracy Trial
September 26, 1969

Well,...the kind of life that you have grows. It's not one way or the other. It grows...through experiences. In the late 1950s I was kind of a...dropout...already. My hero—the person I identified with—was James Dean. That kind of individual protest became...more political in the 1960s. It became possible to conceive of a collective revolutionary struggle instead of just a personal withdrawal—or emigration. I changed with that.

But I don't want to defend myself or explain what makes me live the way I do. These are very large, personal questions that I take very seriously—within myself or with people that I'm...intimate with...but I'm not sure they are of any value to...larger numbers of people. It trivializes these kinds of questions for me to...just give an answer into a tape recorder. I'm not going to do that. I am involved in a process and whether I'm happy or unhappy about it seems...so far removed from what I face.

I think it's a typically American confusion—the attempt to study an individual's biography in order to understand the revolution. That's a very great mistake. It opens up the idea that people should join the revolution on the basis of whether or not they're attracted to it. For people who are caught up in a process where they really have a very genuine need to liberate themselves, the question of whether they're attracted to the need to liberate themselves is irrelevant. They in fact have to.... So if you see yourself as political, then you try to encourage people to think about something else. Not about you.

WILLEM DE KOONING,
abstract expressionist painter
East Hampton, New York
August 18, 1969

I have to be too careful speaking...because I know
it is recorded. I don't like to go on record too
much. I don't want to be...talked into something.
Most people put words in your mouth—you know, the interviewers.
They say, "Don't you think so?" and then they start telling you
what you are thinking.... Things in print are so different from
when they are said. I mean, the flavor of...the mood of speaking
is so different from when it's printed.

Philosophers, literary people, you know...they say
things...inside their heads. They will come to the point that
the thing is really the thing. Like they say, "the chair"—
there's a chair over there. They really have just a social
condition that they know what a chair is...but it has nothing to
do with sight. They really cannot see it.

I think it's a little battle—a little private battle I have
with thought. That thinking has a lot to do with taking certain
things for granted. And it's difficult to really see
something.... Like if you're looking at me, after a little while
it becomes kind of a...you are experiencing something in a flash
but...you almost have to focus on the little highlight on my
nose.... You almost have to look through me to see me, you know?
There is no way of really seeing me.

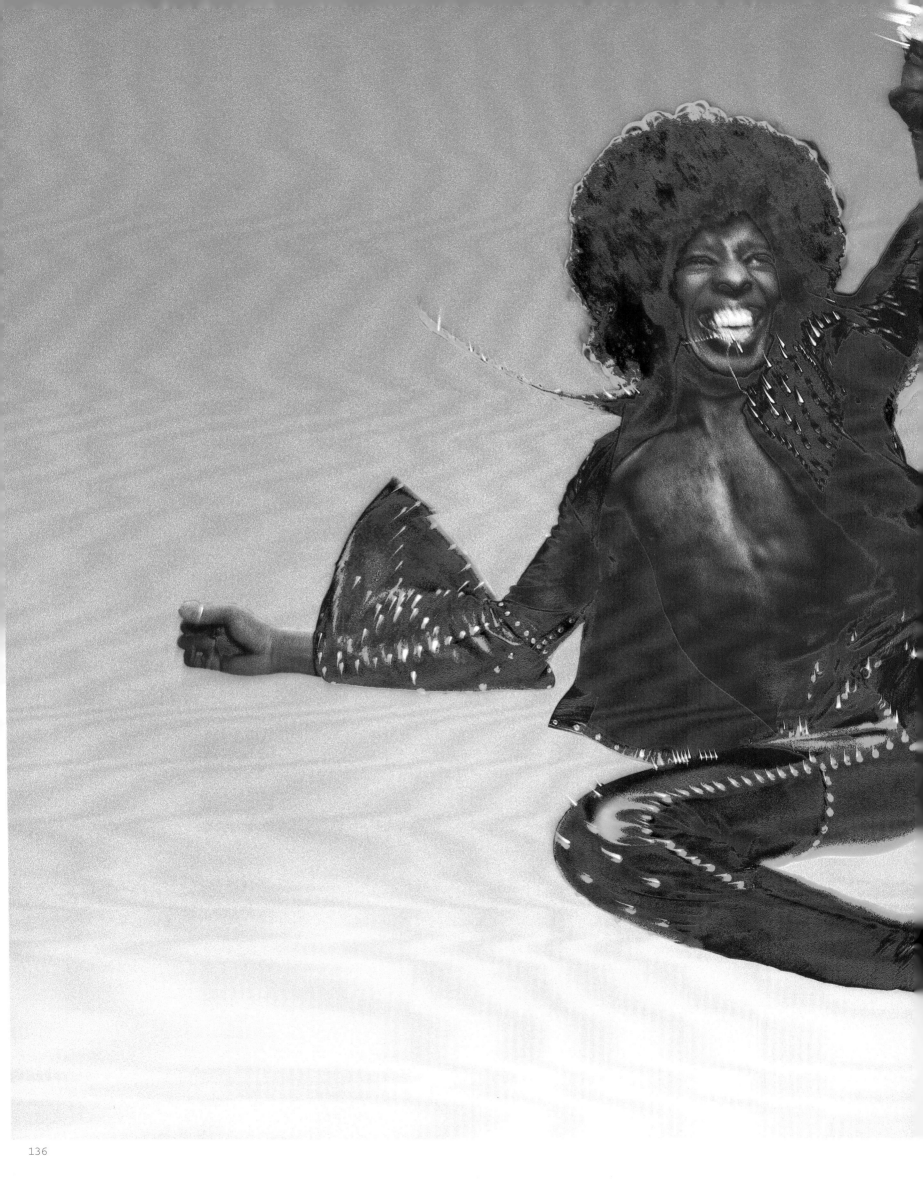

Sly Stone, rock musician, New York City 137

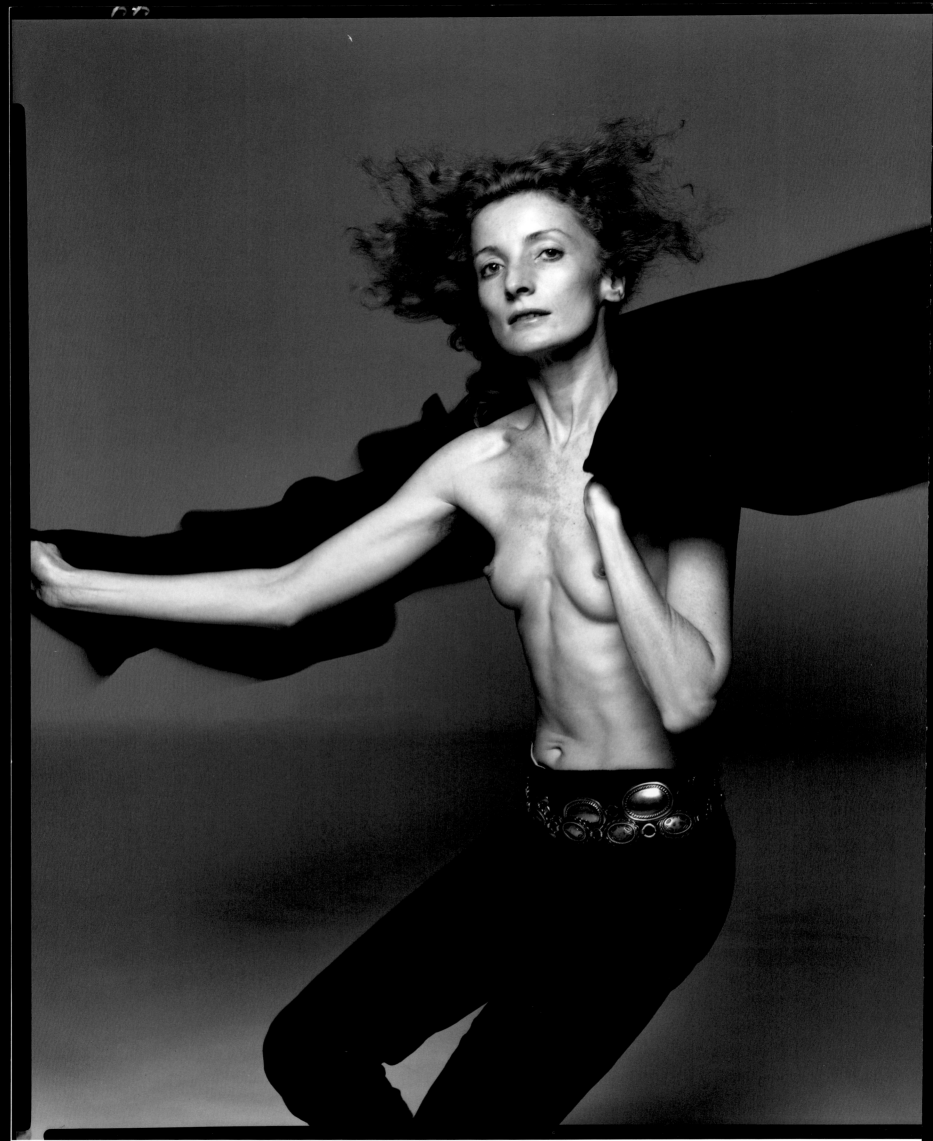

Viva, actress, New York City

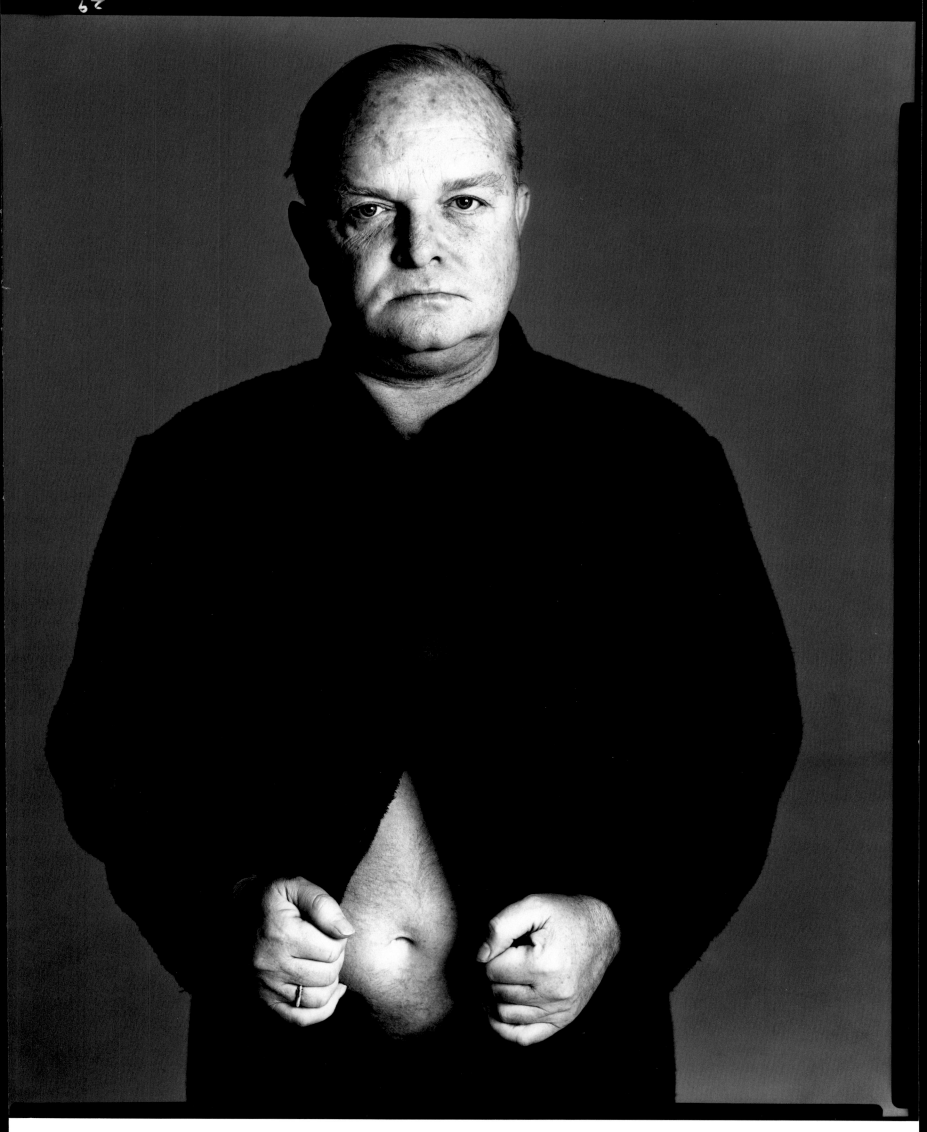

Truman Capote, writer, New York City 139

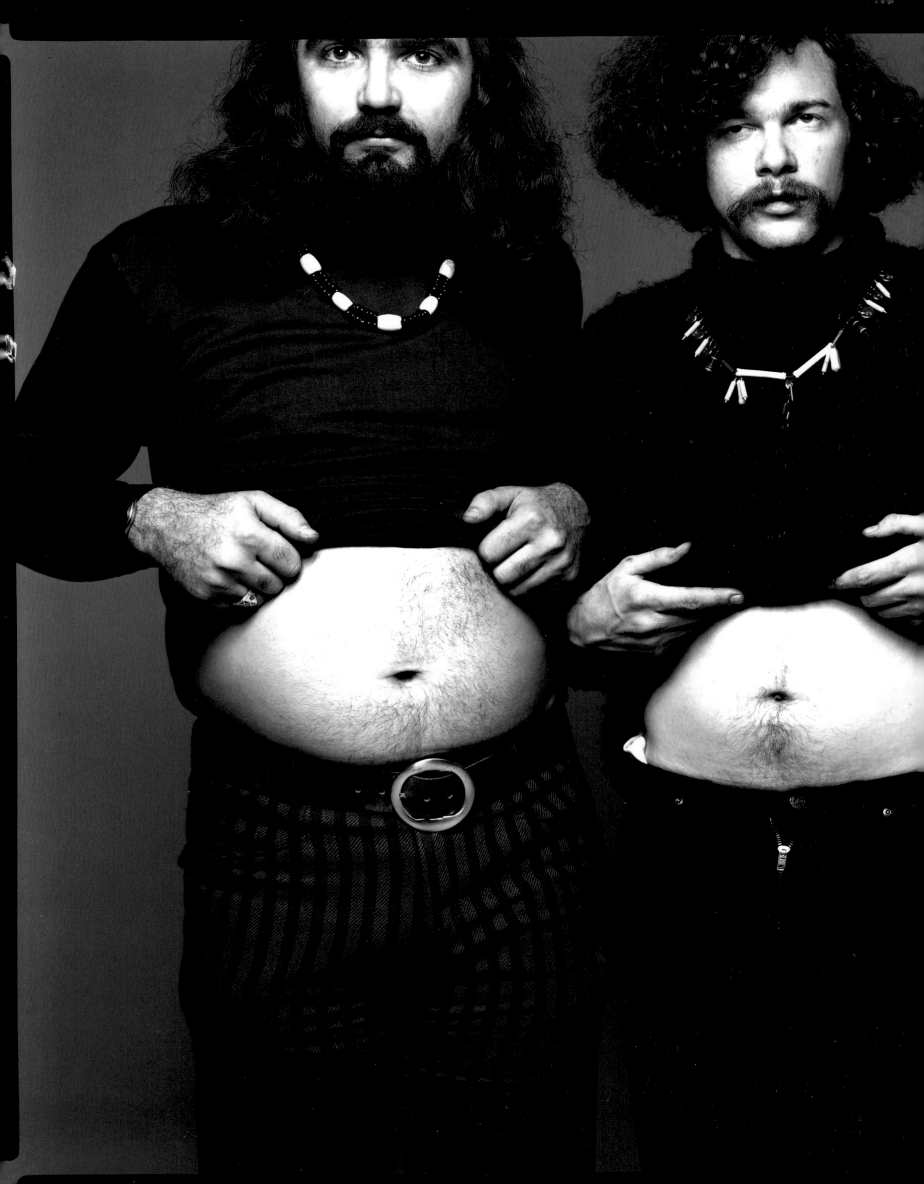

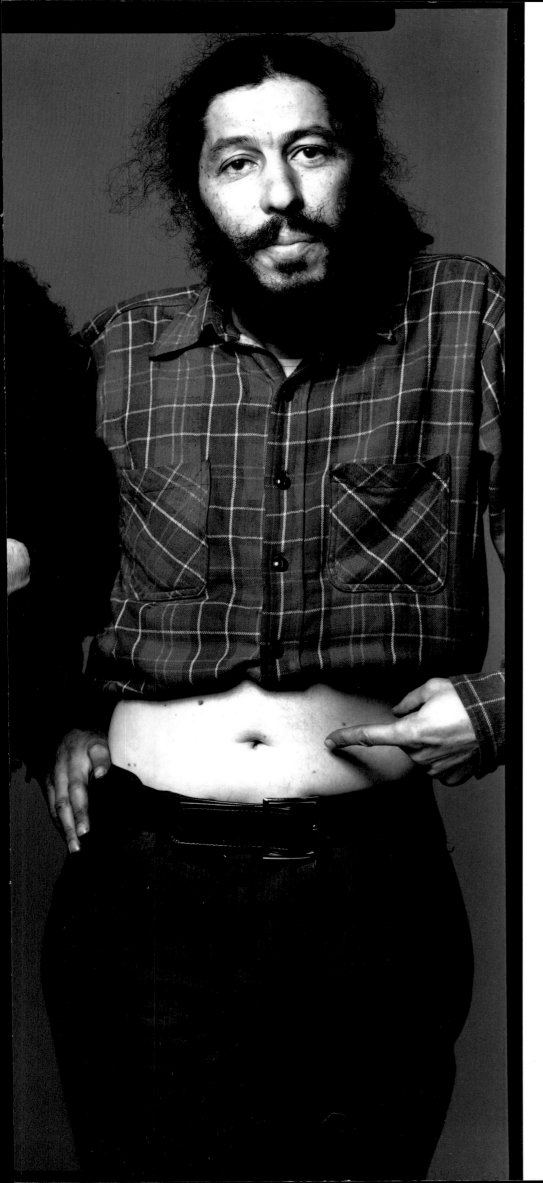

Ken Weaver, Ed Sanders, and Tuli Kupferberg,
The Fugs, rock musicians/political satirists
New York City 141

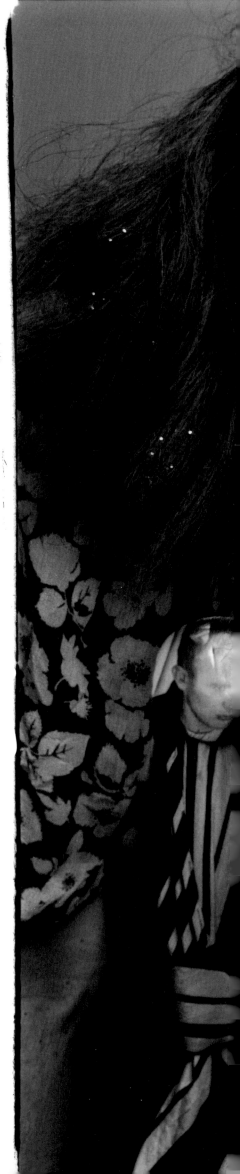

Jackie Curtis, Holly Woodlawn,
and Candy Darling, drag queens
New York City

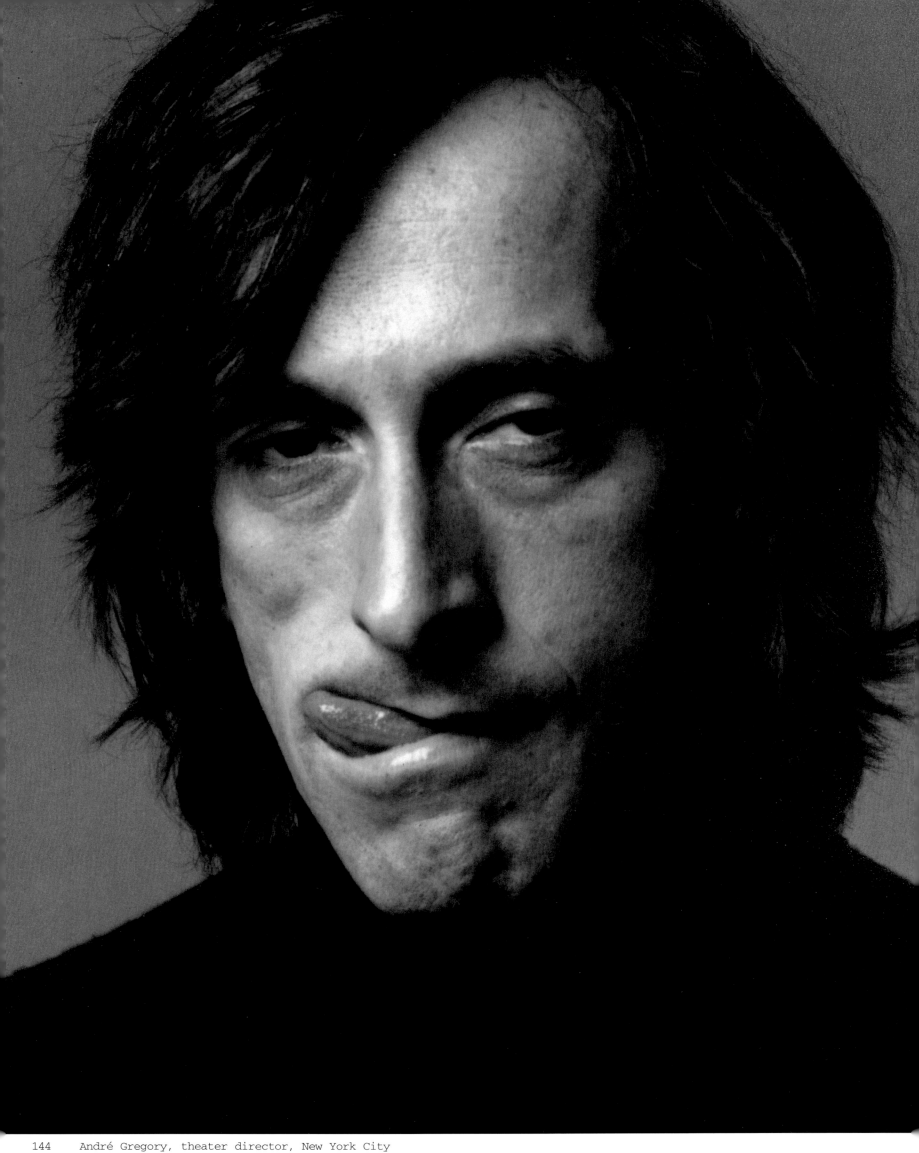

André Gregory, theater director, New York City

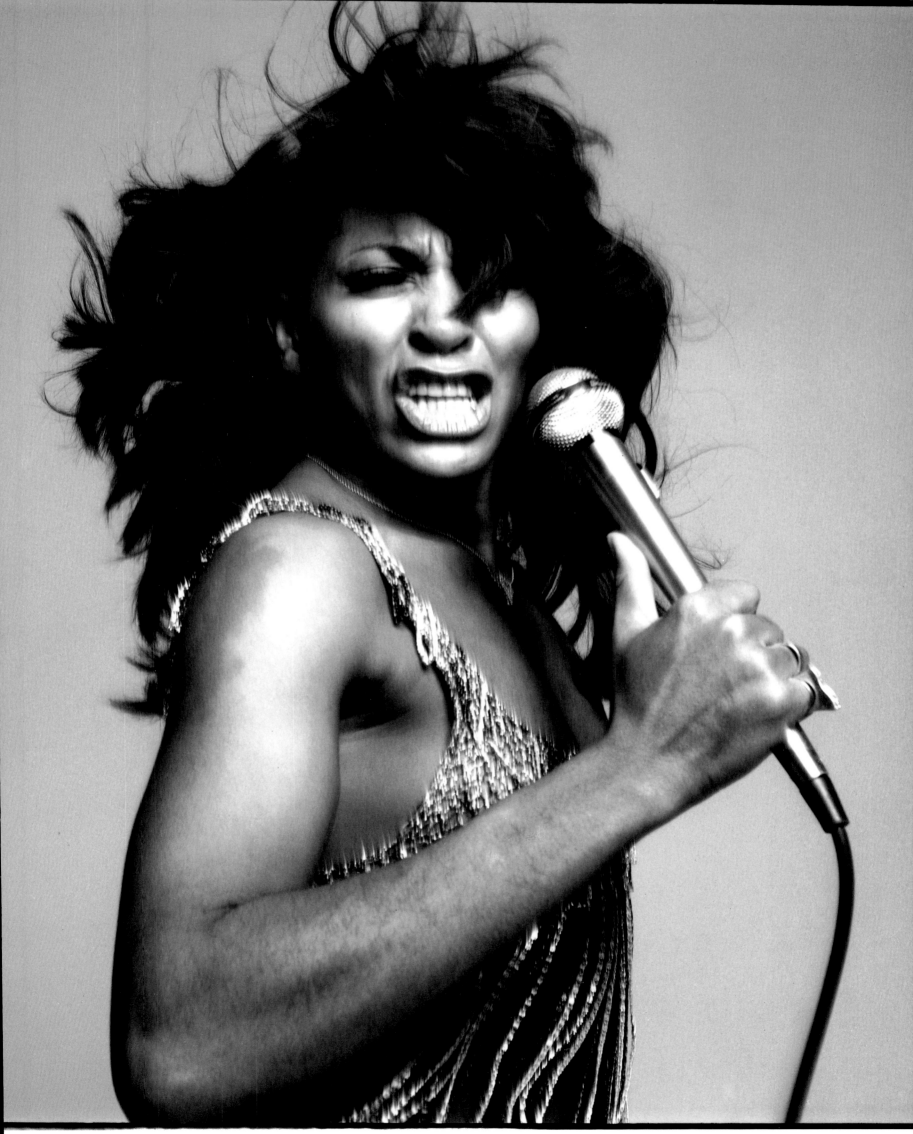

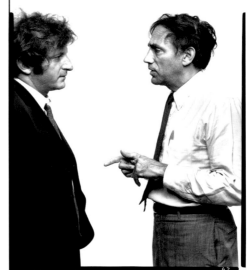

LEONARD WEINGLASS and
WILLIAM KUNSTLER,
civil rights lawyers,
Chicago Seven Conspiracy Trial
November 4, 1969

I was always a rough competitor.
Even as a child. My main sport was
swimming and I really enjoyed
getting into the pool and turning to watch where the other man
was.... In the water, you can see bubbles coming from fingers,
and you can spot where your opponent is. If you swam very hard,
you became sick at the end. Even if you won, you might be
puffing your cookies in the gutter, but you had this tremendous
exhilaration—you even enjoyed being sick, because that meant
you had exerted the last bit of energy. I guess, always, my
whole life has been personified by competing with someone. My
father. My brother. My friends.

It's just part of me. It's...the ego quotient. You know,
competing with the...the philosopher. All of us when we get a
few drinks in us, we can sit down and say, "My God, this is
ridiculous. What difference does it make if I really won the
swimming meet? Or wrote the book, or won the case. A week later
I won't even remember the swimming race, the court case, the
book, or anything else." But while you're in it, it
seems...painfully desirable. So we, you know, we fight for what
we need, even at the same time decrying the reason for needing
it and the importance of it to us.

I am a driver, you know. And drivers either get hanged, or go
to glory. I don't really think there's any middle ground. People
who don't have this drive go down the middle ground...somewhat
bored, but somewhat contented. I'll never be bored. And I'll
never be contented. And that's about the best explanation I've
ever given of myself.

JANIS JOPLIN, blues/rock singer
Port Arthur, Texas
September 3, 1969

When I was twelve or thirteen, you know, there'd be the chicks
who'd let the boy sitting two seats in front of 'em do their
homework for 'em. Me, I'd always say, "I can do it myself, man.
And better than you." I think these things get formed in a
person really early.

I always wanted to do my own fucking number but I didn't
really have any person to be or anything to build my trip
around. So this music thing came along. It was just...it was
everything I needed. It was something to do with all the
feelings I had without changing. You know? It was something to
believe in, something I could love and that would love me. It
was all there.

I think it creates distance for men, though,
just because...you've already got something. It's
like already having an old man—do you know
what I mean?—and then trying to have a sincere
affair on the side. There's just something in
the way. For me and them both. That I don't really
need them.

Like, I would want to need them. I would really
dig it if I could need a cat that much. I think
that would be just a wonderful feeling for a
woman. I know it: that's what women are for. Take
acid and you realize that's what women are for—to
need and be with a man and bear children, that
whole thing. But I got another trip going.

Well, maybe it's like the grass is always greener,
you know?—it could be that. "I'd be much happier
if I just had a home in the country and an old man
and three kids." Who fucking knows. But I think that is
basically a chick's trip. I know that whenever I really have
been in love and really just wanted to be with that cat, that's
the happiest I've ever been.... Well, except for those few times
on stage.

HENRY ARONSON, civil rights lawyer,
with unidentified G.I.
New York City
September 1, 1970

I've traveled a lot. Kind of a lot. I've been miserable in Paris
and I've been as lonely as anyone's ever been in Istanbul, and
on it goes. One of the real down moments of my life was...within
the last, I don't know, ten days, I guess, and I thought—in
this down moment when I was feeling so terribly disconnected
from everything—there was nowhere in the world that did a thing
for me, if you can understand that. All the stuff, the bullshit
posters, the guy and gal swinging down the Seine or surfing in
Hawaii or Bermuda or the Caribbean or wherever. I knew there
wasn't anywhere in the world that I could go that would make me
feel one whit different.

This act of going to Saigon and getting heavily involved in
defending guys in courts-martial is in many respects a huge,
huge extension of disconnectedness. It's a severing of all
moorings that are around me. Leonard called me. Leonard
Weinglass. Secretary said Leonard was on the line. I said my
chirpy, "Hi! How are ya?" And from the other end came: "You're
gonna get killed." And I said, "Uh, what're you talkin' about?"

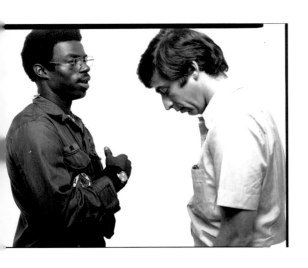

"You're gonna go out there and get killed." I
said, "Leonard, you've got a much better
developed sense of conspiracy than I do, and
rightfully so. What're you talkin' about?" And
he said, "One of those Oriental undefined
faces in the crowd..." He says, "Thieu and Ky
or the CIA—you're just gonna get it." With a
lilt in his voice, very good-natured. But damn
serious. Spooky.

I've often said of my life, even though I have
minimal complaints about what I've done, I
still don't think it's begun. You understand
that? I guess my fantasy is much more about a
different compact, sort of a personal life,
and less about professional life. It's really
the stuff of little houses in Vermont and ten little Indians
running around. And saying that, maybe, if one is to—in their
own little humble way—begin to deal with what this world might
be like, if you could create an entity—call it the family—in
other words, a smashing entity, if lots of people were to do
that, maybe the world would begin to look a lot different.

BERNARDINE DOHRN, Weatherman
New York City
November 10, 1969

The woman thing freaks out the pigs more than
anything. At my trial, one of the police who
arrested me was testifying, standing right next to
me, and the judge said, "Can you identify her for
sure?" And he turned around to look at me and I turned around
to look at him, and we got locked into this staring thing. I
hated him so much. And we just got locked into this thing and
him looking at me was totally sexual and my looking at him
was...was wanting to kill him. A lot. It just got into this
thing and the whole courtroom got quiet and finally the
prosecutor looked at the judge and said, "Your honor, the
policeman has just turned to stone."

RENATA ADLER, writer
New York City
July 31, 1969

Mmmm.... Well, I guess I always wanted to be a writer.... Well,
not always. Off and on always.... I wanted to be a doctor...or
nothing. Mainly nothing.

What does that mean? Being nothing.

Well, it means different things at different times.... Mainly it
means not.... Living sort of a family life,
not...I mean, sometimes it's beaches...sometimes
it's...other things.

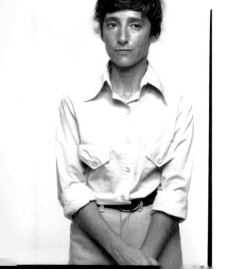

EDWARD ALBEE, playwright
East Hampton, New York
August 18, 1969

The terrible thing about the Davis family, who had
this house.... The wife was up in Boston and they
used to come here only for the summer. The husband
about fifteen years ago was in a small private
plane and the door blew open and he fell out. And
she never came back. She put the house on the market—didn't put
it on for a number of years, but finally she did—and I took the
house. It was all overgrown. Weeds up this high. But I just
walked around the corner and saw the ocean and the hill and knew
I wanted it.... This is the only highland on the south shore of
Long Island. You know, the rest is dunes.... It's very nicely
protected from the storms and the hurricanes.

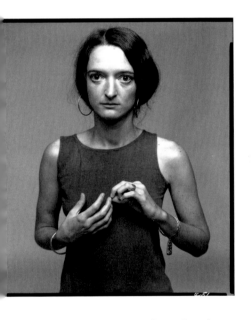

LOUISE STONE,
widow of photojournalist Dana Stone
Saigon
April 19, 1971

On a number of occasions people have wanted to
interview me because they wanted a story about a
wife whose husband is missing and what she has done
to try to find him. I've always avoided it because
I feel it can only endanger me.

See, I'm really playing a game with this. With the Americans, I
have to give them the attitude that I think the dirty Commies are
a bunch of rats that are holding my husband. On the other hand, I
have to deal with the North Vietnamese who don't even admit to
being in Cambodia and therefore could have nothing to do with
Dana or any of the other journalists that are missing.

But if you want me to talk about Dana.... I met him first in
'62 in San Francisco. He immediately attracted me because he was
the kind of person that if there was something he wanted to do,
he did it. He was never held back by the normal conventions that
were—especially at that time—keeping me from doing many things

that I wanted to do. I feel that if I hadn't met Dana I would have led a very normal and frustrating life.

So we immediately formed a relationship and we were constantly breaking up. He has a very violent temper and I was not used to being around someone who would explode the way he did. Since we've been together it doesn't bother me in the slightest anymore. In fact I think it's a much better way to live than the way I was before—keeping things bottled up and then holding resentments. But because of his temper we were constantly breaking up and at one point we were separated for two years.

In the meantime Dana had come to Vietnam and realized the only way to really see the country was to be a photojournalist. He told me the first time he was ever in a firefight that it was so horrible—because of his own fear and the fact that people were actually dying all around him—that if he had had the money to leave, he would have. But he didn't so he stayed on.... I came here in January of '68 and Dana and I met in Bangkok and we got married there.

We were always clinging to each other and hanging on to each other and holding hands. I can see him walking—he's got very muscular legs and he's short, very short, and he walks quickly. I see him walking up a hill with me behind, dragging along, Dana pulling me—and this image changes from place to place—we're holding hands and he's pulling me up the hill. And that's why I refuse to give up on this.

A lot of rumors have come out about what happened to the journalists, but it's impossible to separate the rumors, you know. This very good friend of mine told me the other day that he believed Dana and Sean were dead because he heard back in April that they had been crucified.

It's so embarrassing to go around and ask people if they've seen, you know, Caucasian American civilians when all the civilians in this country are just being destroyed. Their homes are being blown apart, their families separated, and lots of the members are missing or dead and I have the money and the time to go around and look for my husband and they don't.

The first month or so was the hardest because I didn't know what to do. I couldn't really see much reason, I mean selfishly, for myself...I just felt, well, why not get it over with, you know. Kill myself. I could die and I wouldn't have to worry about it anymore. Without him it's just...not that it's not worth living because I know that it is, but with him in this situation it would be very cowardly for me to commit suicide, not knowing whether he is alive or dead. When I feel that in order to survive I have to quit doing this, then I will. But I don't think it will ever stop.

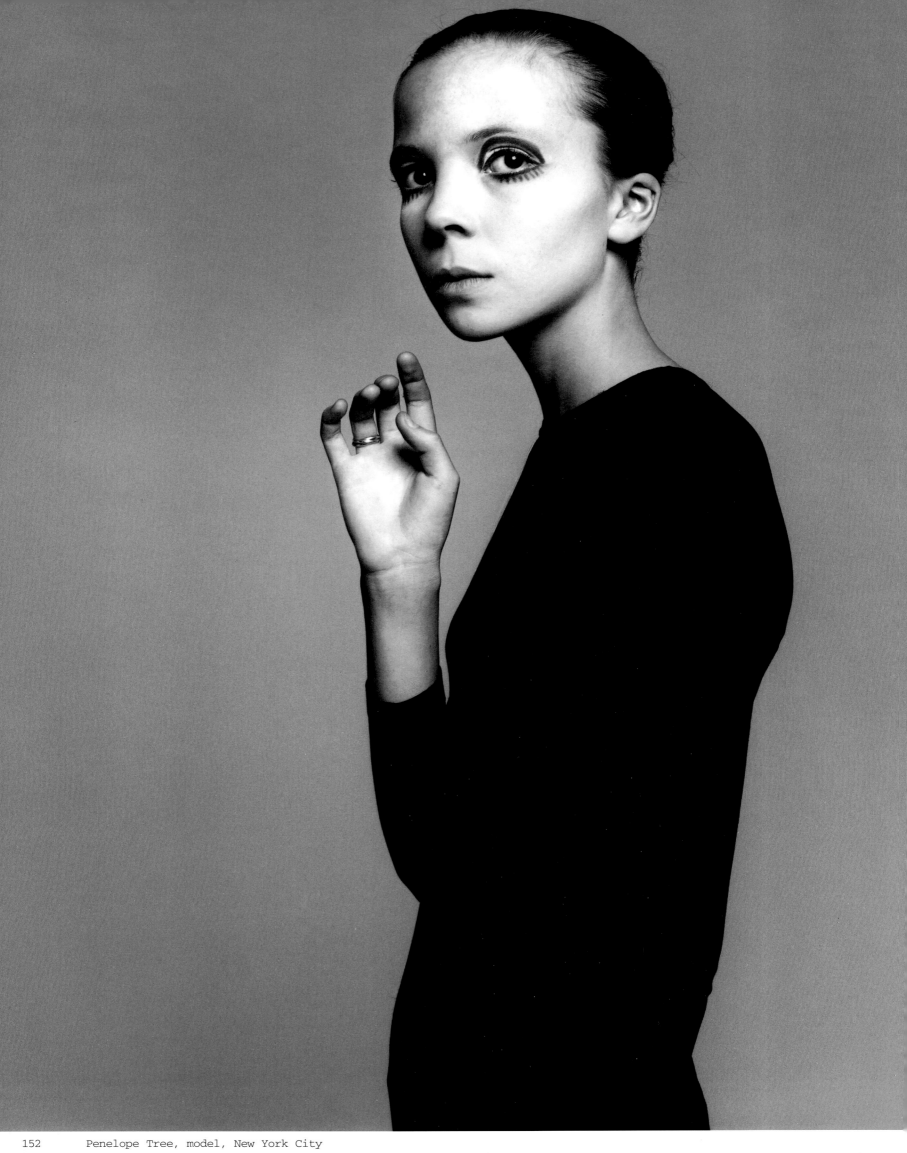

Penelope Tree, model, New York City

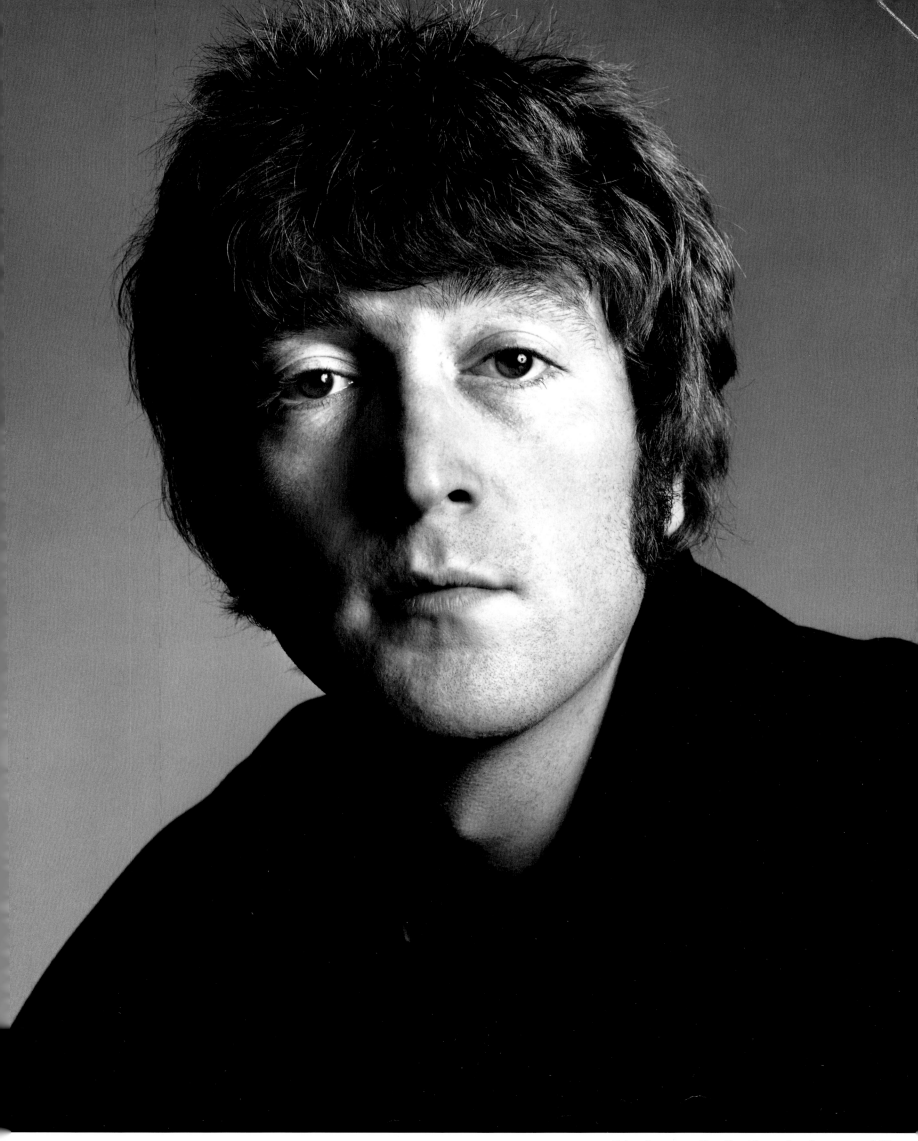

John Lennon, The Beatles, London 153

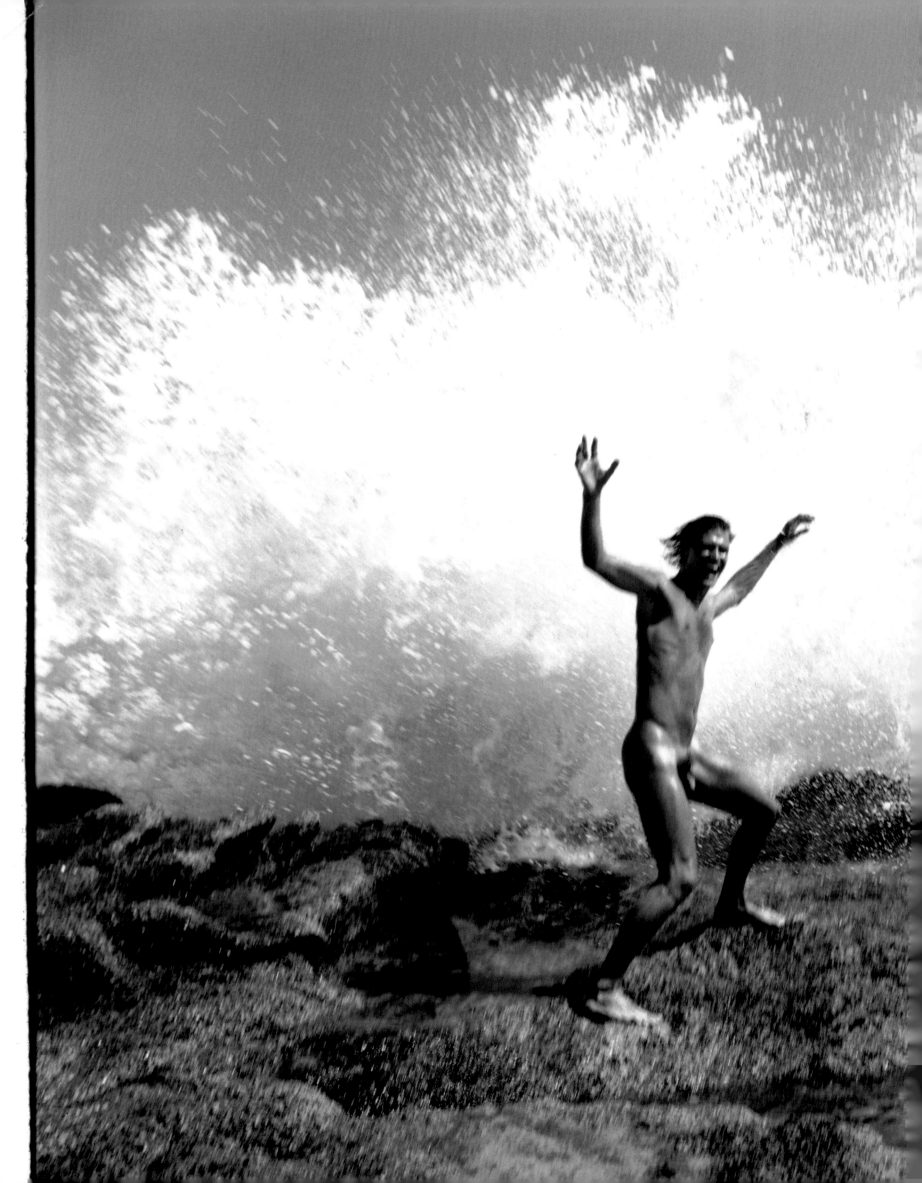

Baja, California

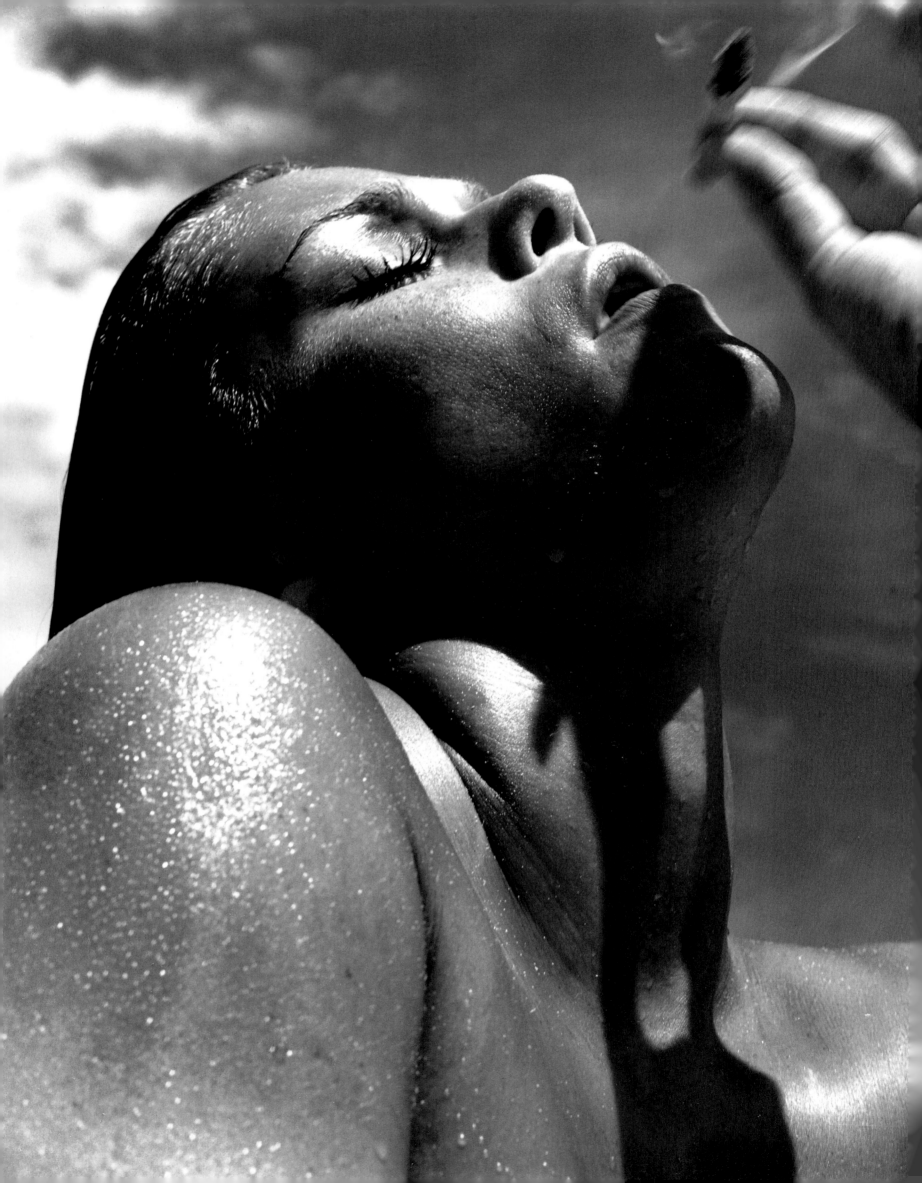

Lauren Hutton, model
Great Exhuma, Bahamas

Luchino Visconti,
film and theater director
New York City

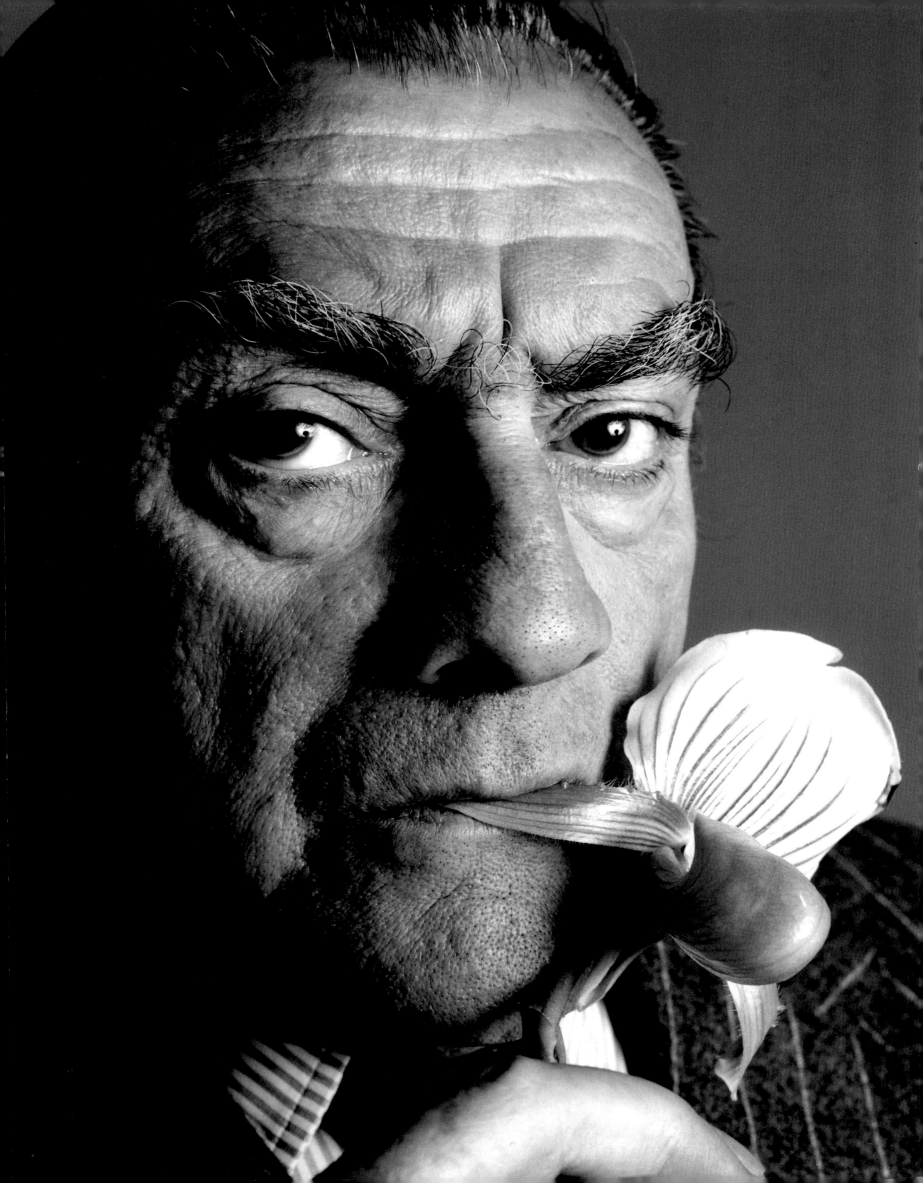

SAUL STEINBERG, artist,
with SIGRID SPAETH
East Hampton, New York
August 18, 1969

No matter how you turn it, you can't escape
being yourself and being an autobiographer and being a
contemporary of yourself. It's a series of revelations of what
you are.... What you do is like one of those Arab fairy
tales...where you inevitably—or a Greek tragedy—"what the gods
have decided for you to do." You can't escape it. You can't
escape it.

JOHN STEINBECK IV, writer,
with his wife, CRYSTAL
Saigon
April 2, 1971

I'd smoked some heroin. Crystal asked me whether I had and I
said no. I was horrified because that's the one criteria I use
to myself for just what a junkie is. Or someone who's in
trouble with the drug. Who has to lie about it.

One of the most interesting things about smoking heroin is you
smoke it and you get addicted. And then there's the question,
after you're addicted, whether you can play around with this
drug again now that you've withdrawn, whether you can smoke it
and play with it. I always knew that if I stopped smoking it I
would smoke it again and see what was what.

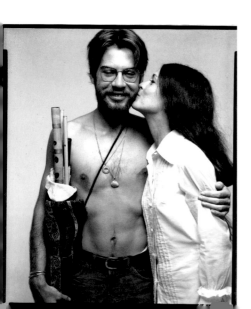

So when someone says to me, "You're standing in
front of an avalanche," the high drama of that
terminology in some ways is meaningless because I
feel like I've been in an avalanche since I was
six years old. And that's how I've tried to make
myself a Superman, by dealing with avalanches. You
know, psychologically and emotionally.

All I'm saying is that I planned to do this. It
was not as compulsive as all that. It may be a

master plan to destroy myself, but doing it was no big surprise to me. You shouldn't get too excited or be too concerned like I've just had a relapse. I don't think.

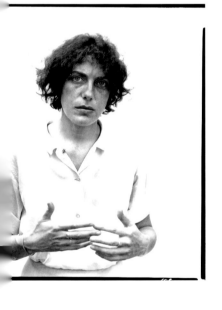

EDWARD ALBEE, playwright
East Hampton, New York
August 18, 1969

There are some basic problems with... The most serious I suppose is you can never tell if you're kidding yourself or not. Whether you are being corrupted, for example...by money. By success. By...all sorts of other things. You can never know. You make the assumption every time you sit down to write that you're writing for an audience of one: yourself. But then,...if the self has changed....

SUSAN BROCKMAN, artist, filmmaker
New York City
September 3, 1970

I watched the tennis matches on television. Terrific. It was Margaret Court Smith, a big Australian, full-breasted but lanky, too, and blond with a kind of boy's haircut. And just awkward enough to be elegant, you know? A beautiful athlete. She's been the ranking female tennis player, you know. You just have to watch her for a second and you see why.

She played this girl, Patty Hogan, from California. Patty's sort of fat and a little bit awkward, and she was always

tugging at her underpants under her tennis dress. And she has black hair and the part's sort of crooked and she's just incredibly sloppy and fidgety.

Well, they played the first set and it was clear that Patty had had it. She knew it. Everyone knew it. Because Margaret was just up there doing her number. Then all of a sudden in the second set something happened. It wasn't visible right away but after a few minutes you could see that Patty had changed her game a little bit.

Margaret was still cool and Patty went right on cursing and pulling at her hair and twirling the racket while she was waiting to serve. You know, nervous. But she had a shot that no other woman could make, some kind of hard backhand twist. Incredible. And she just kept lobbing things in and forcing this beauty, this real beauty, to make a mistake. It was just the biggest tennis upset.

And watching, particularly on television where you can see the whole thing and get a really clear picture of the game, I really saw how you have to adapt and move and change and move well. Because Margaret was a champion, you know, an aristocrat. And my mind was blown to see how she was sticking to her thing. But Patty was in there with another style and out to win on anything. And with that style she was able to throw a champion.

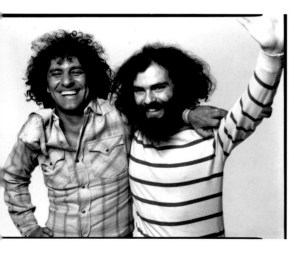

ABBIE HOFFMAN and **JERRY RUBIN**, Yippies
Chicago Seven Conspiracy Trial
November 8, 1969

I'm very egotistical. Don't forget that. I got a very big ego. You know...that's the main, uh...main motivating factor which you have to learn to control—to direct along political lines.... I don't know what the reason is but ever since I was a kid I wanted to be, uh...to have a big historical role. I don't know why. I just always wanted to do something historical.

It was always my goal to get revenge for what was done to me as a kid...in such a way that the government would have to retaliate. So now it's retaliating. So that's, you know... So the trial is great. I mean, just think about it. Wouldn't you want to be indicted by the government for a high crime? It's a great thrill. It's an honor. It's a compliment. It's a thrill. It's fun. I'm enjoying every minute of it.

I just think in many ways it's all an accident. Just one big accident...I mean, some people live to be ninety. Nothing happens to them. Other people, you know, die at twenty-five and have fantastic lives.

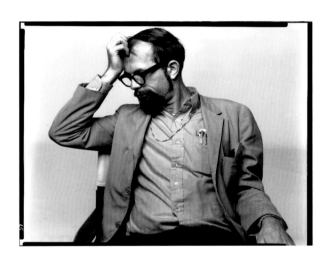

DAVID McREYNOLDS,
War Resisters League
New York City
September 10, 1969

I saw Norman Thomas last in the hospital...on Long Island. I saw him when he was a shell out on the bed. It was very depressing. In fact it cured me—almost—of my fear of death. Norman made it all the way through to the end. He didn't get shot. He didn't get run down. He didn't die of a heart attack on some overextended journey. He made it through to the end. And the reward was that. He was trapped in a bed waiting to die. And it was very...painful...really very painful. Much better to go quickly—to be assassinated—than to lie at the end...withered, pale...partly paralyzed...almost totally blind...partly deaf. He was still alert and alive. And he was upset politically—he'd made some mistake with the Socialist Party and, you know, he was still very political. But, uh...the other thing I decided...I hadn't even bothered Norman politically for about six months, because he was sick. Others had bothered him, which I found contemptible. But they were right. They were right.... Because not being bothered when you're sick and in bed...I should have tried to use him for factional purposes because...it would have helped him.... Anyway, there's no victory in living to eighty-two.

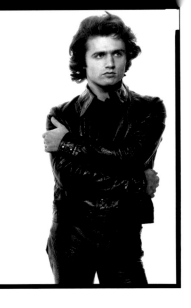

GERARD MALANGA, poet
New York City
October 20, 1969

I wouldn't want to grow old by myself. I'd want to
be with someone. I guess there've been a few
people in my life that I would have liked to have
grown old with. But...I don't know, like...when
you search for something and you find it...it no
longer holds the magic or the mystery it once had for you.

JONATHAN LEAR, student,
editor of *The New Journal*
Yale University, New Haven
October 1, 1969

It seems to me that one of the really scary things that's
happening—I guess it's the function of any advanced
technological society—is that it destroys a human being's
sense of awe. You know, like..."Hey kid, that's just the moon.
We've already landed there. Nothing to get excited about." It's
just drummed into your head that...nothing is awesome.... When
I was camping out in Colorado, it was the first time I'd
really lived outside and been away from...everything. I'd look
up at these mountains, you know, and they're just incredible.
And I was living as part of that. The daylight. The trees.
Everything. I'd say that really the toughest thing is...I don't
know, just, uh...understanding what it is to be a human. To
live and to think and to feel. And in that sense...I think
everybody's oppressed.

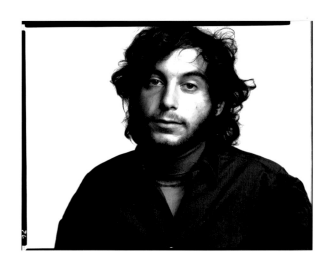

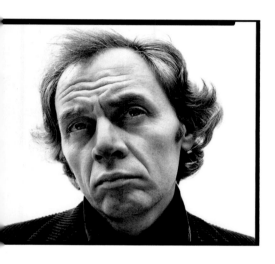

R. D. LAING, psychoanalyst
New York City
October 6, 1972

There's a sort of deadness that goes with the
sort of normalcy that's taken to be sanity.
Really a physical and mental sort of
flatness. I've seen some people who turn a
corner in their mind and suddenly they're out
into a very crazy space and they're pretty
mad by other people's standards and might be
sort of suffering, or not, but there's a
vitality and also a looseness. Really flying. But I pride
myself on having had those moments without having to be crazy
to get them. I don't envy madness. And I wouldn't recommend it.

FATHER JAMES GROPPI, priest
Priory of St. Boniface's Church,
Milwaukee
November 6, 1969

I'm no romantic. I think I've gone through that
stage. And protest for me is a sheer burden. I
don't enjoy it. It's...it's tiring. It's something
that I continue to do because I believe that it's
necessary, it's effective, and it's also my role as a priest.
It's a prophetic role. A preaching role. I look upon the picket
line, the march, even civil disobedience or going to jail, as
gestures in a sermon. Part of my priesthood, see.

But we're living in a totalitarian state. That disturbs me no
end. I'm getting more and more pessimistic in terms of what one
can do to bring about change in this country.... My God, you
can't give a talk anywhere—they'll nail you for inciting.
Really. The government's getting more repressive. You can't do
anything. They got you boxed in. So I don't know. I don't
know. I don't know where we're going.

Prison was a touch of hell.... I don't want anyone to go
there. I don't care what he's done. I found it extremely

painful.... The separation. The isolation, the psychological pain was—to me, almost unbearable.... When I was in prison I felt dirty. I couldn't wipe it off. I would read the Scriptures. Read other books. Very helpful books. But it was still this constant effort to clean myself. I mean you were fighting the bars. It was like all of society pointing their finger at you: "You're no good. That's why you're here." It makes you feel dirty. Imprisonment to me is a violent, sadistic act...of revenge...on the part of a morally sick society.

But the fact that you're in jail...is saying something. It's saying something to society and it's saying something to the Church. It's saying, "I refuse to approve of this through my silence," you know. And that gave me, at times, a kind of clean feeling. Because silence speaks.... And it amounts to toleration.... And, my God, you begin to realize that your place is in jail. Because you have to fight it. To tolerate it is to justify it.... Man, I don't know. It's terrifying. What can you *do*?

Malcolm X,
African American leader
New York City

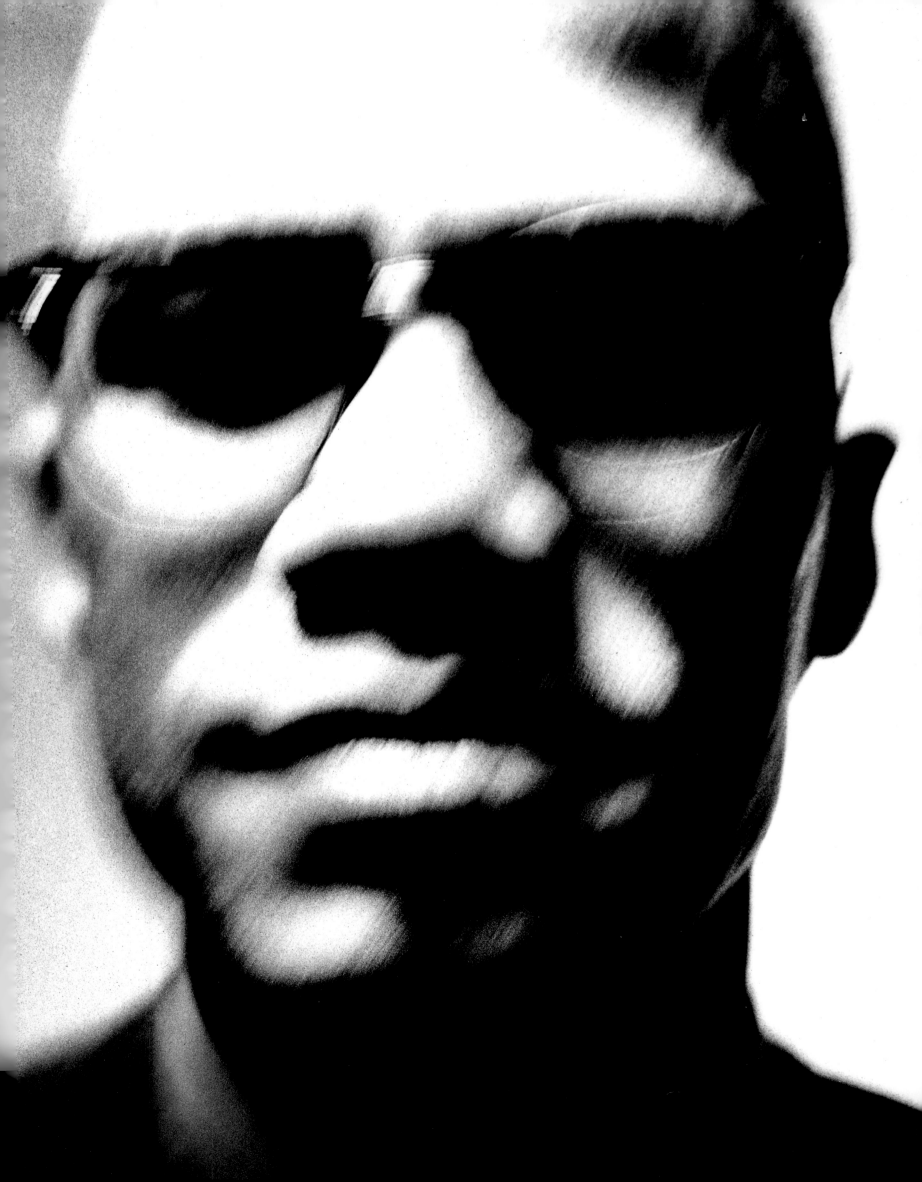

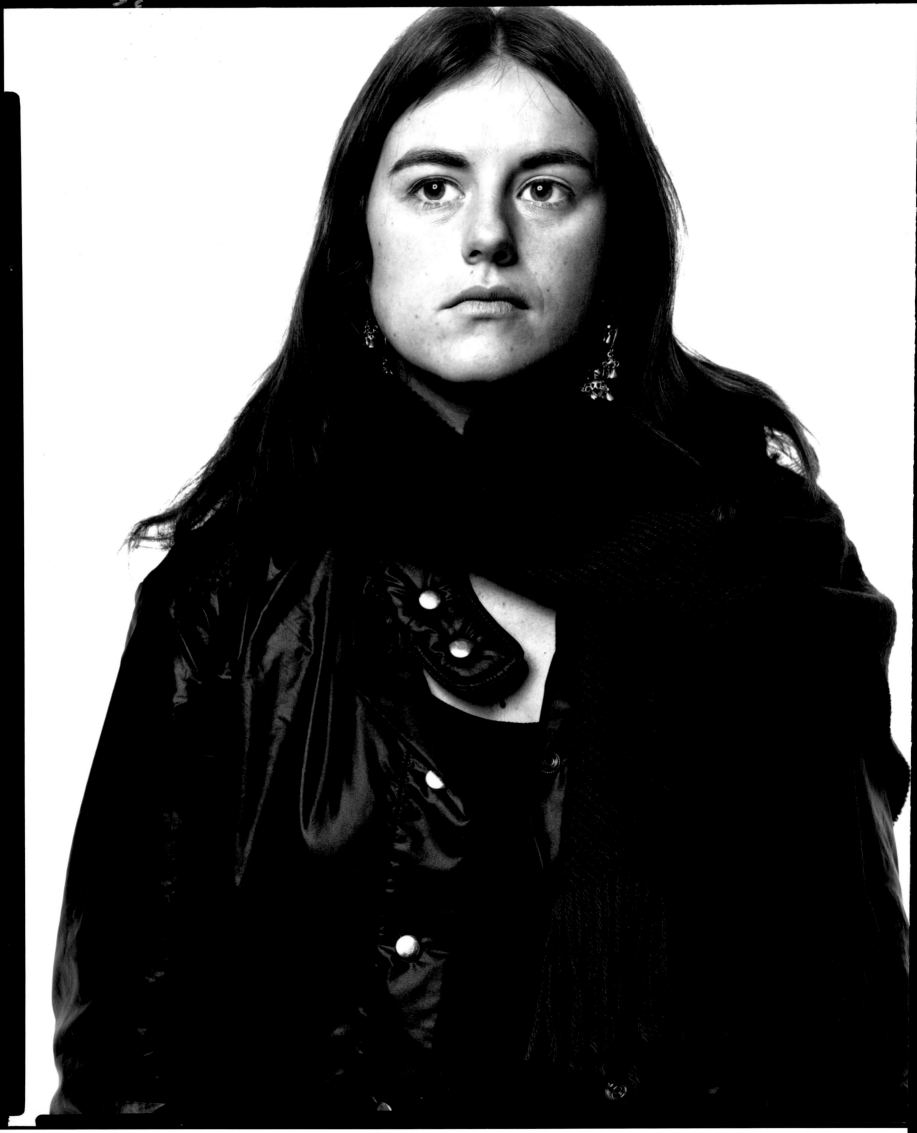

168 Bernardine Dohrn, Weatherman, New York City

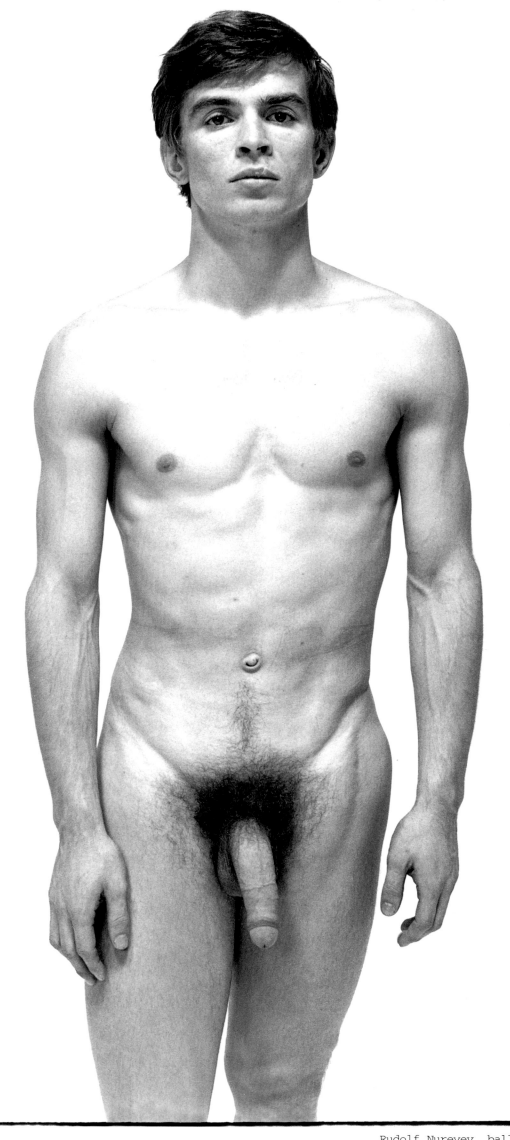

Rudolf Nureyev, ballet dancer, Paris 169

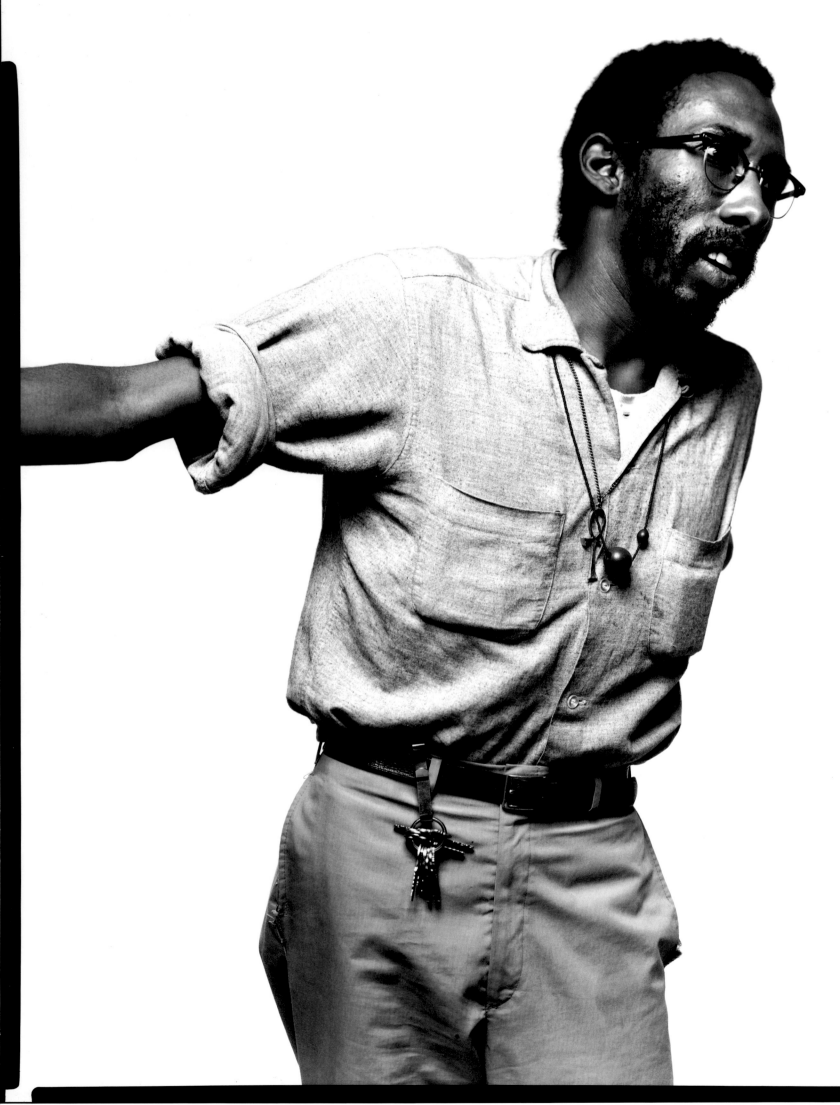

Julius Lester, writer, New York City

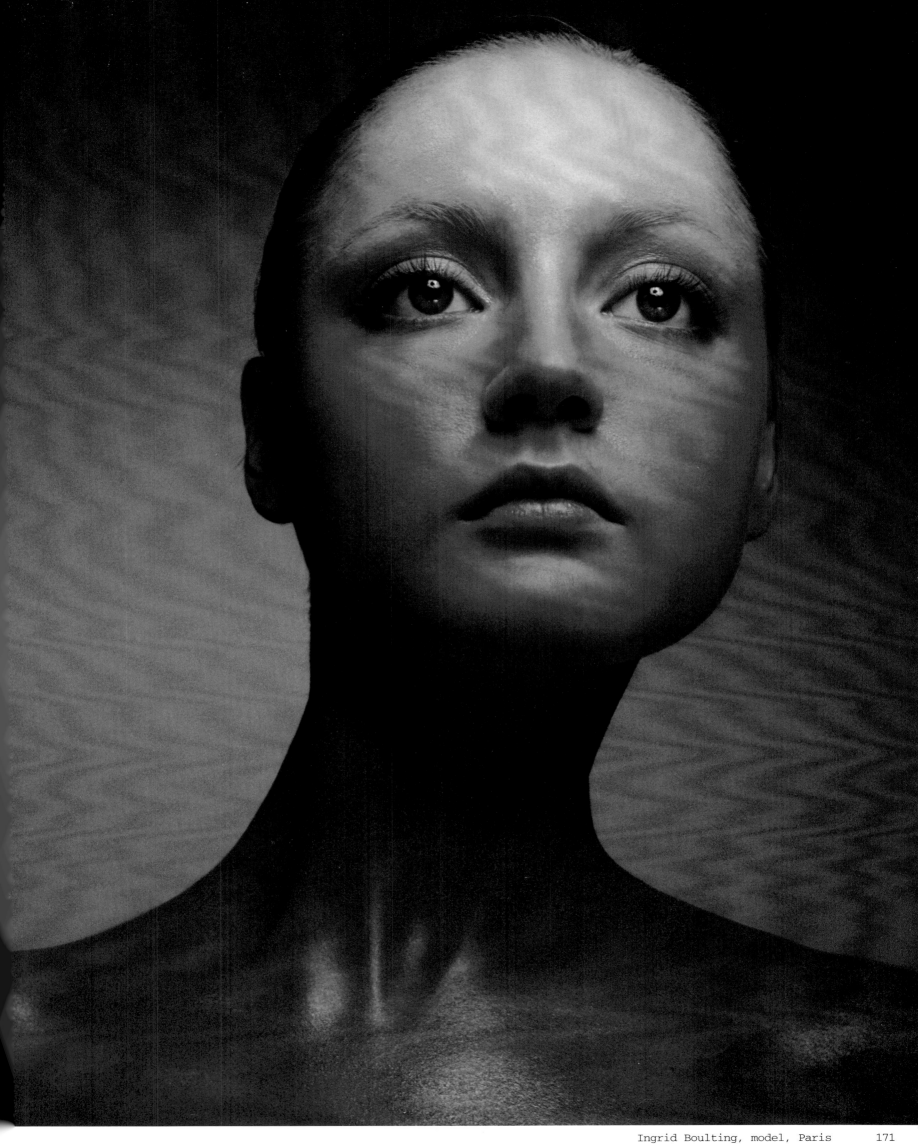

Cape Canaveral,
Florida
September 8, 1963

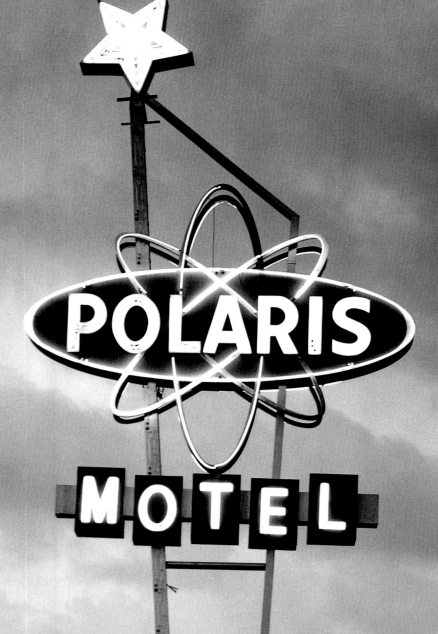

Paul McCartney,
The Beatles
London

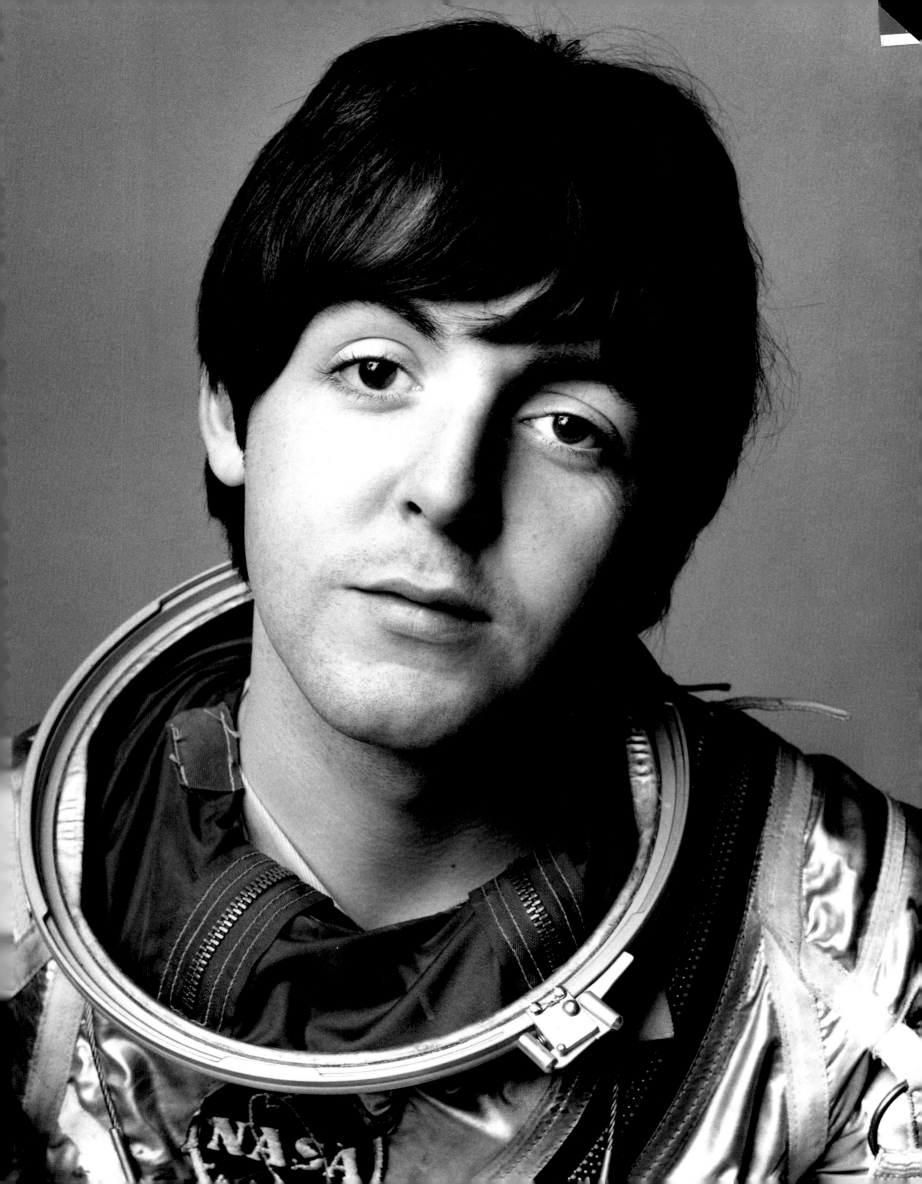

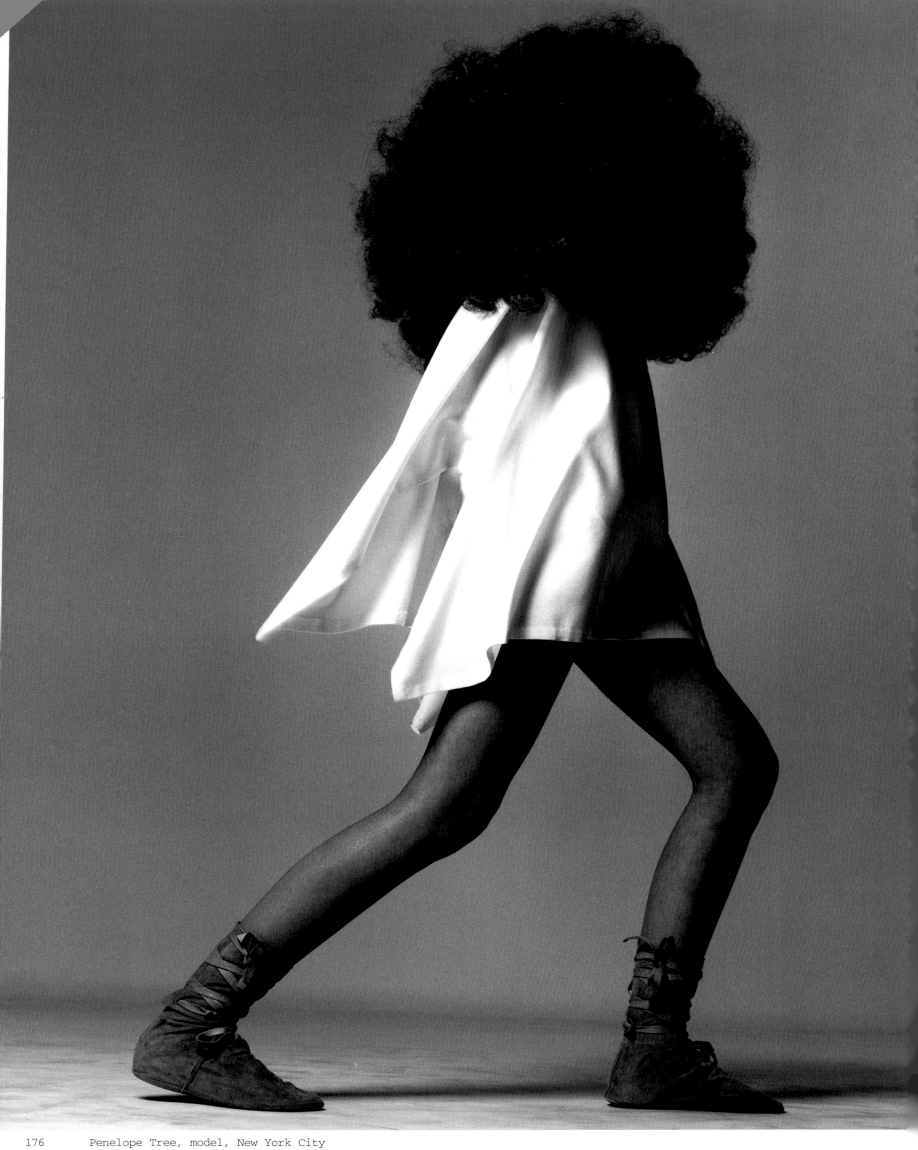

176 Penelope Tree, model, New York City

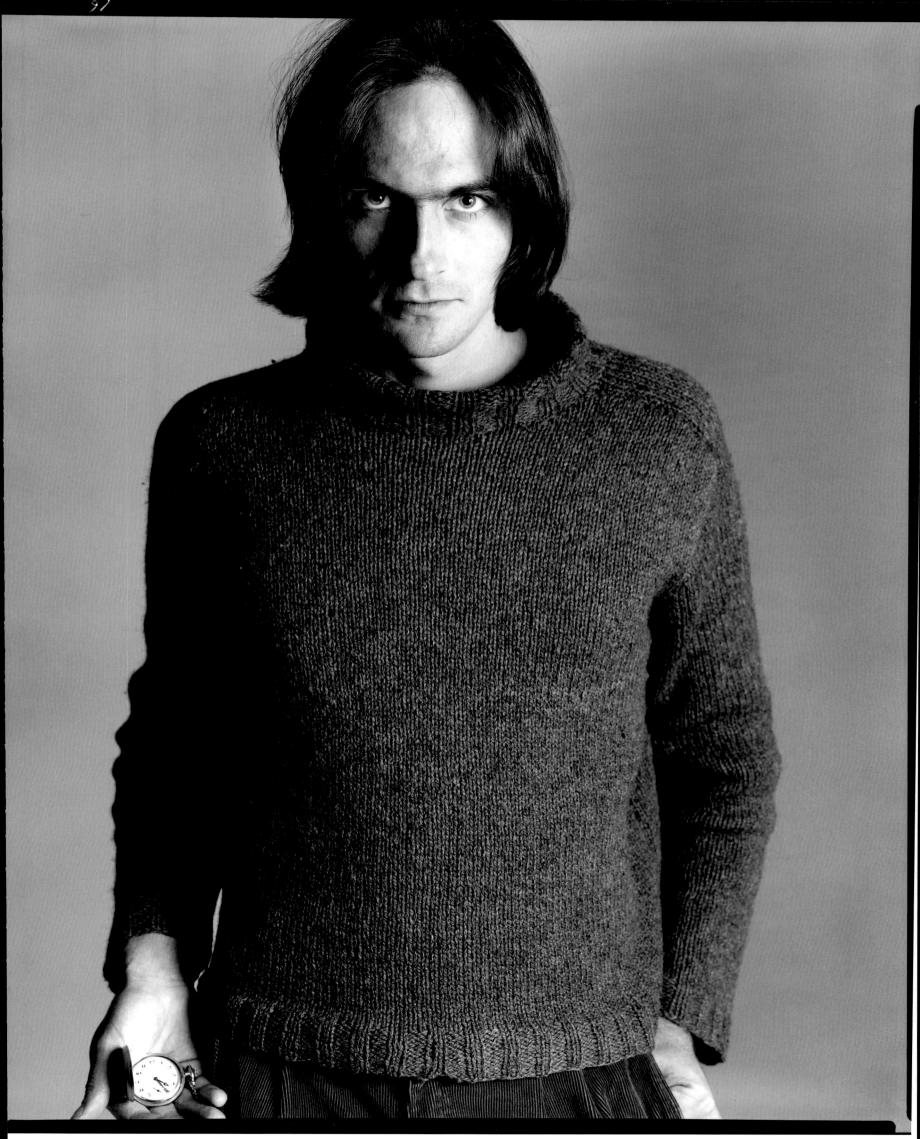

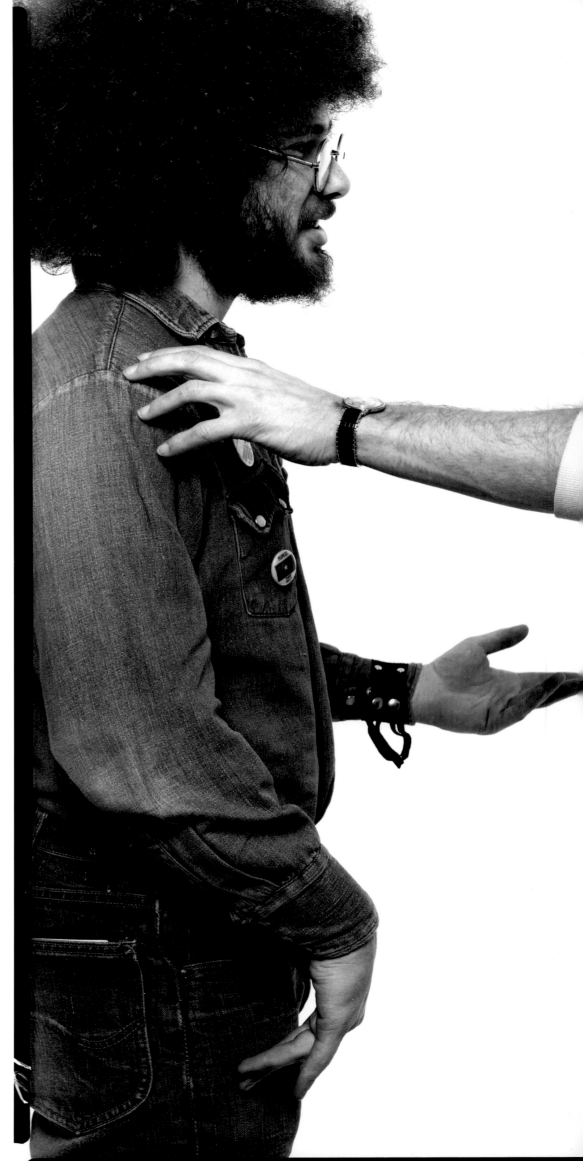

Members of the International Society
for Krishna Consciousness during a
student youth conference,
University of Michigan, Ann Arbor

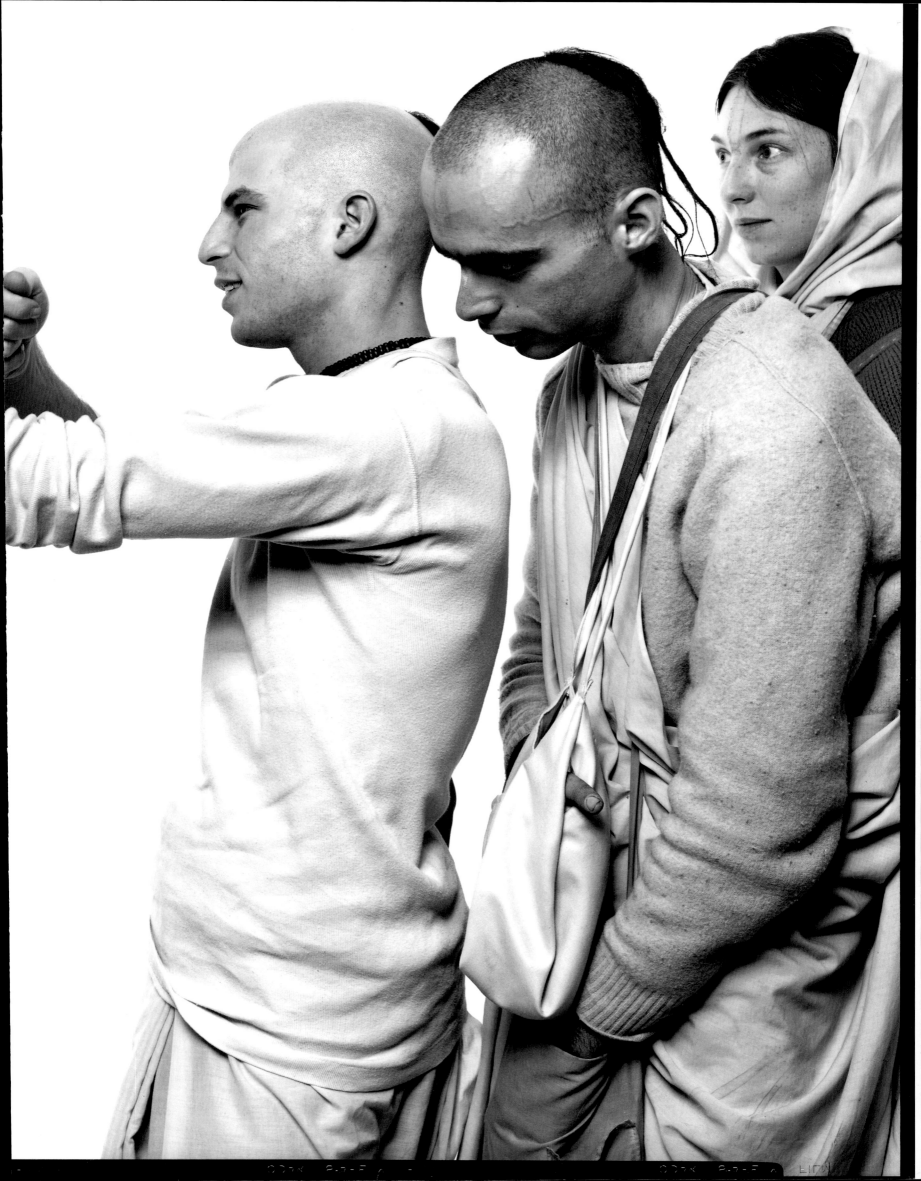

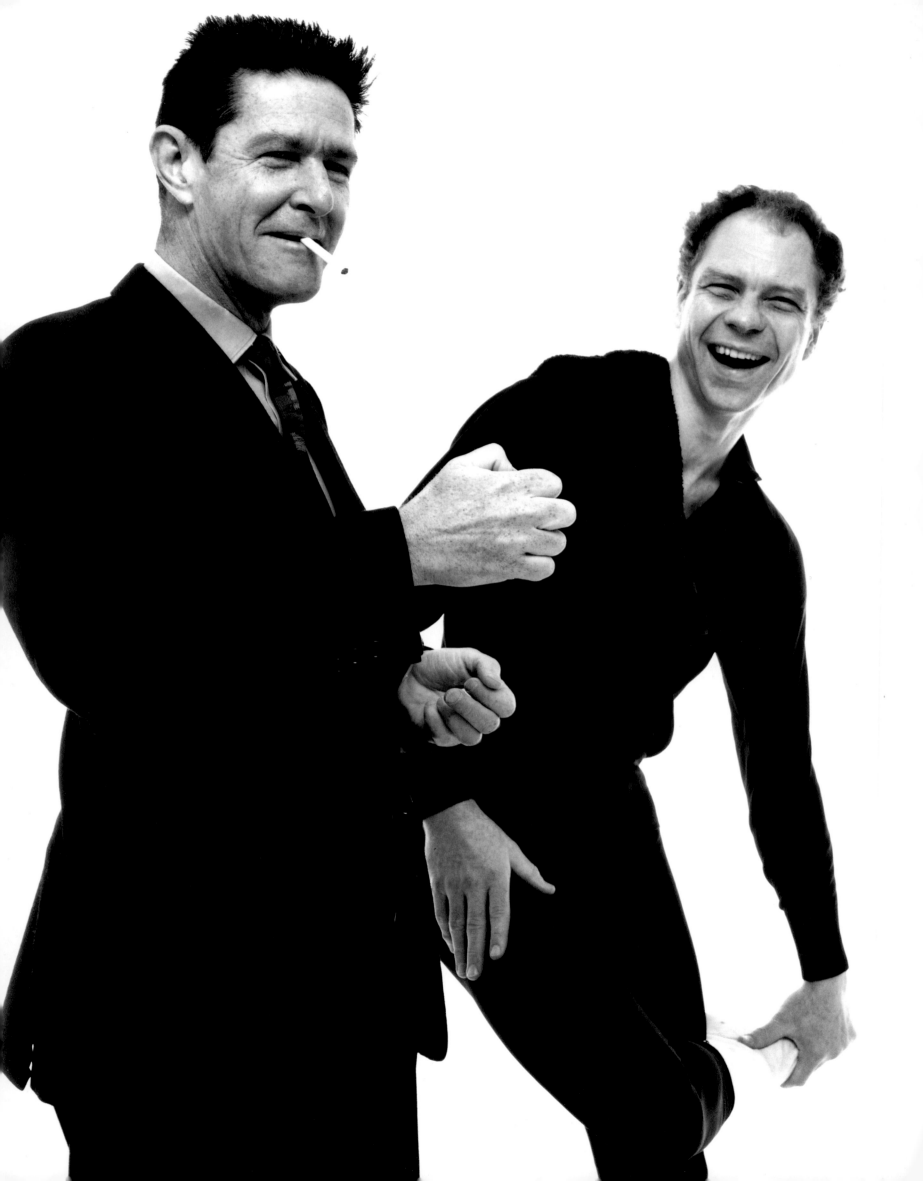

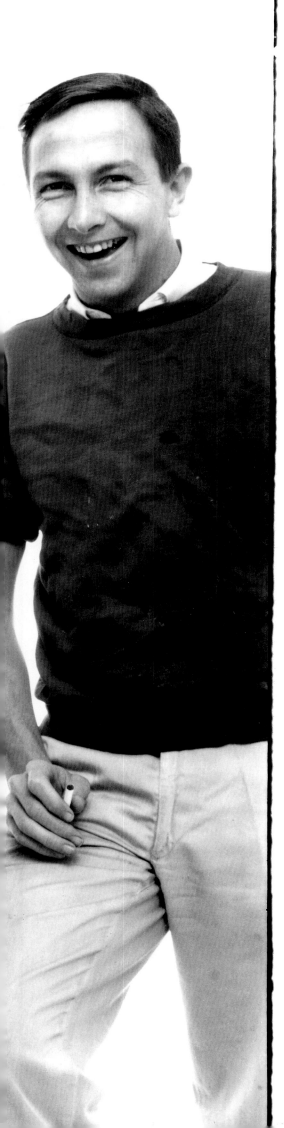

John Cage, musician;
Merce Cunningham, choreographer;
and Robert Rauschenberg, artist
New York City

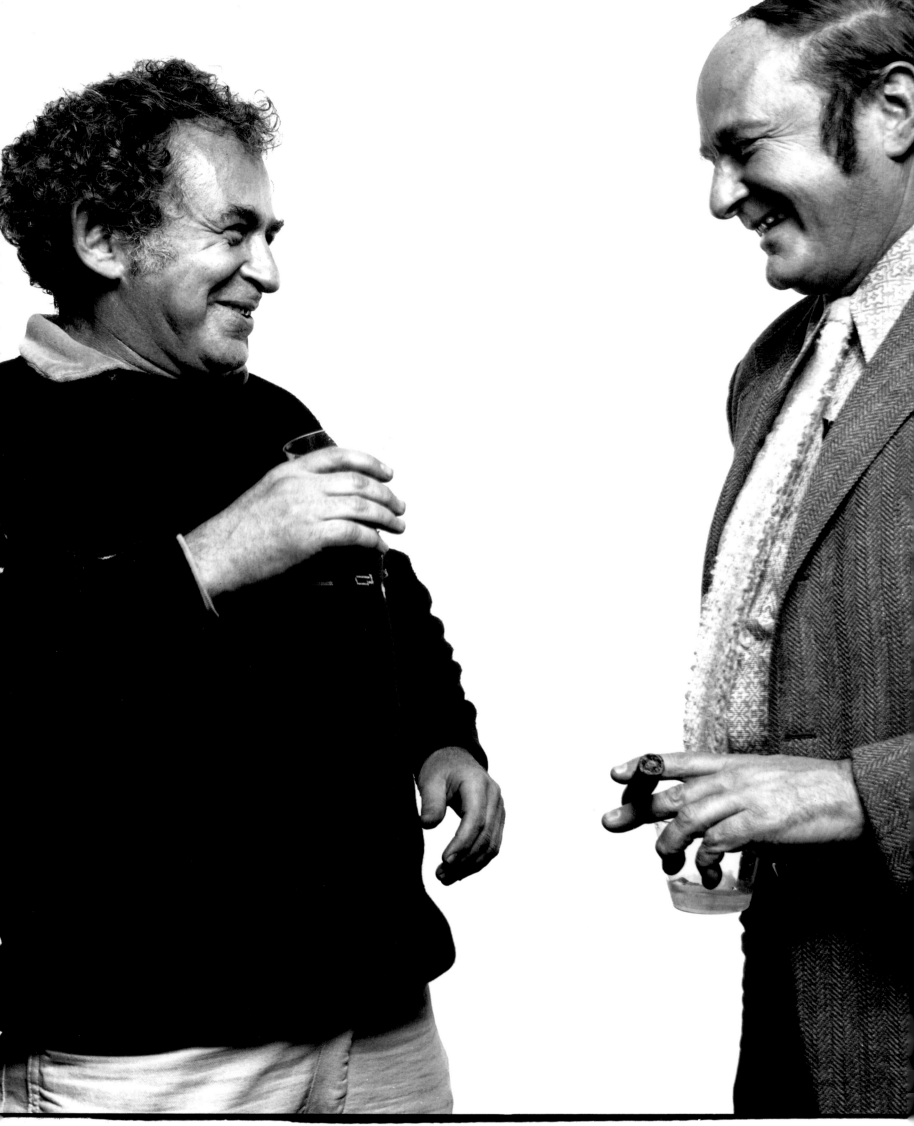

Norman Mailer, writer, and David Dellinger, pacifist, New York City

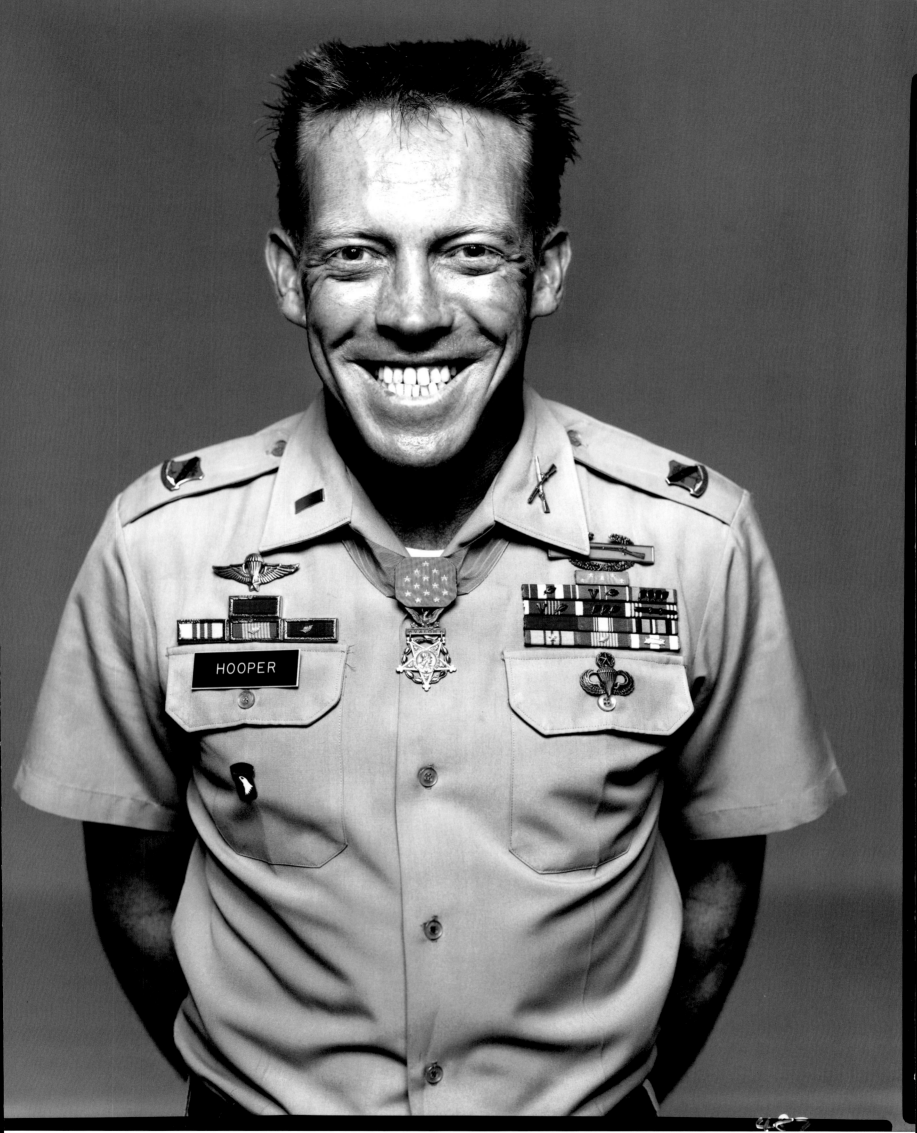

Lt. Joe Hooper, the most decorated American soldier in Vietnam, Saigon 183

Andy Warhol, pop artist, New York City

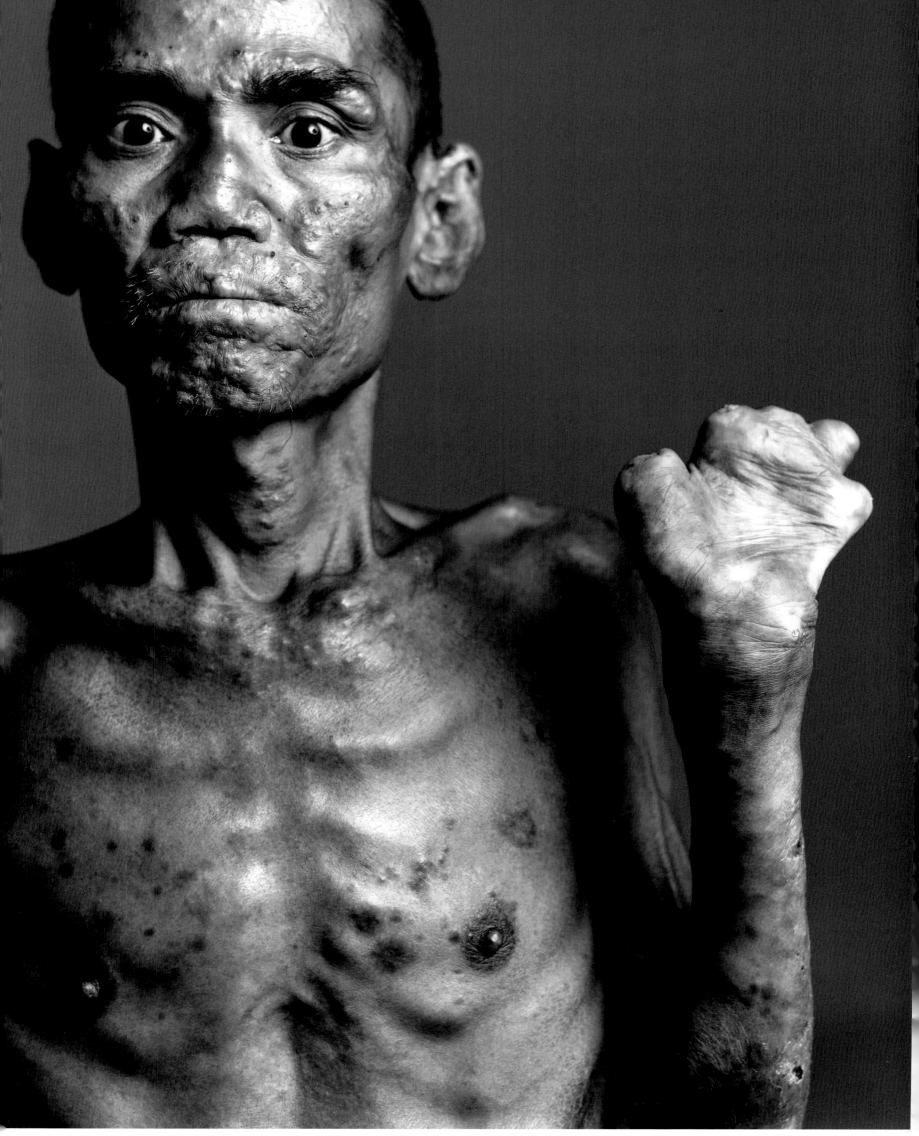

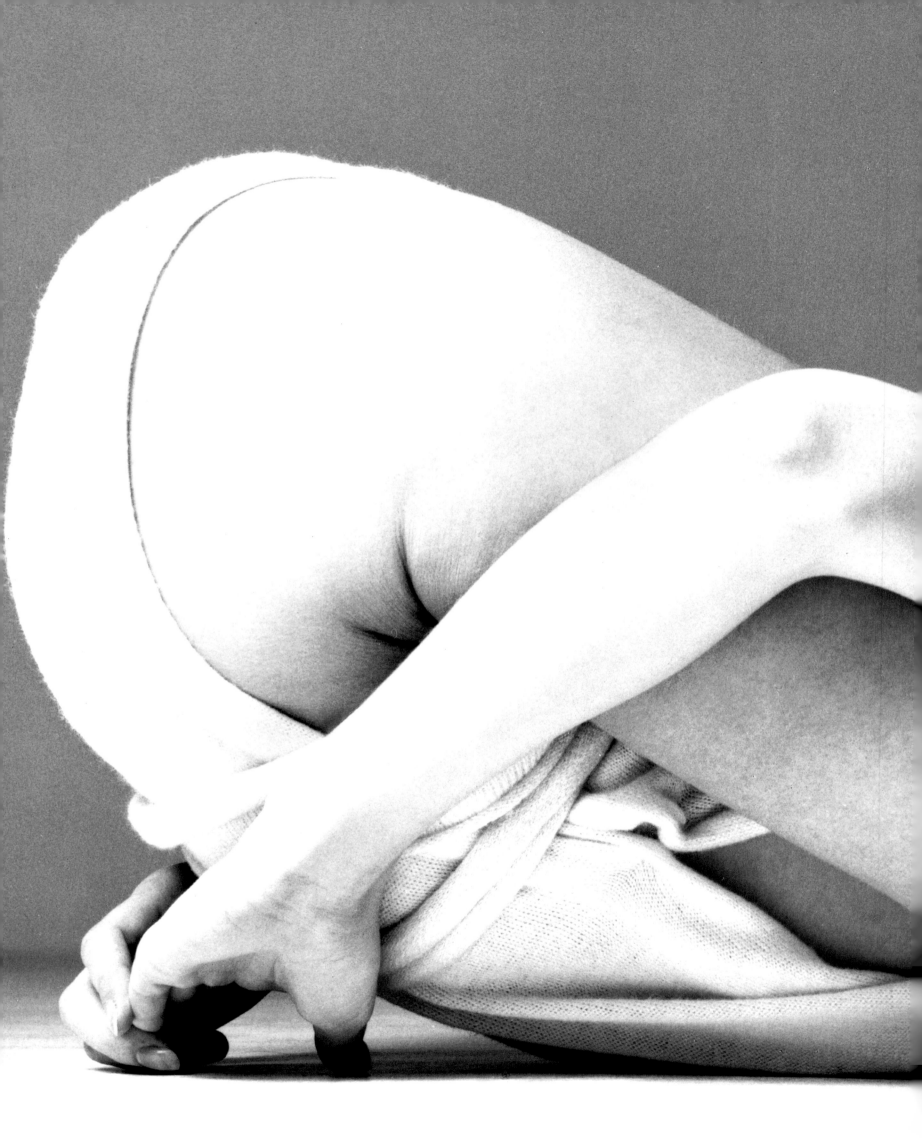

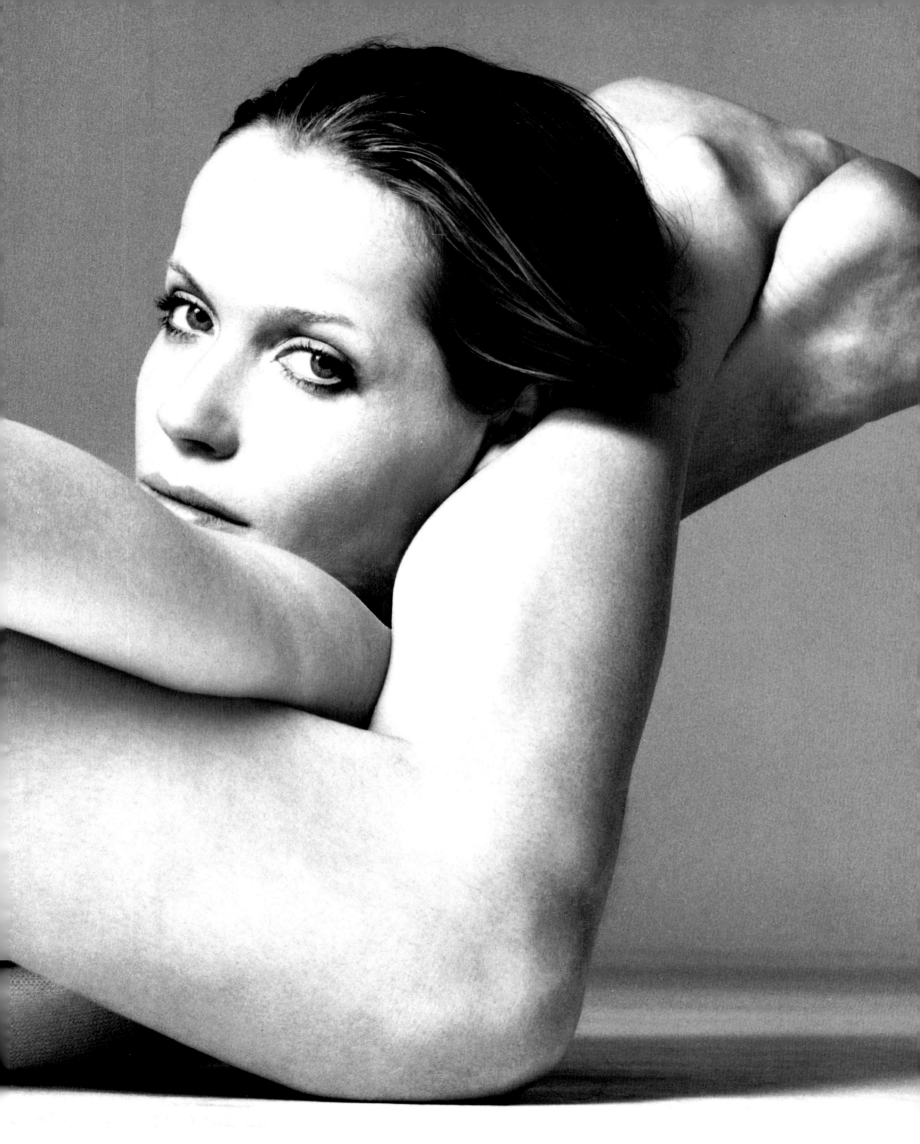

Veruschka, model, New York City 187

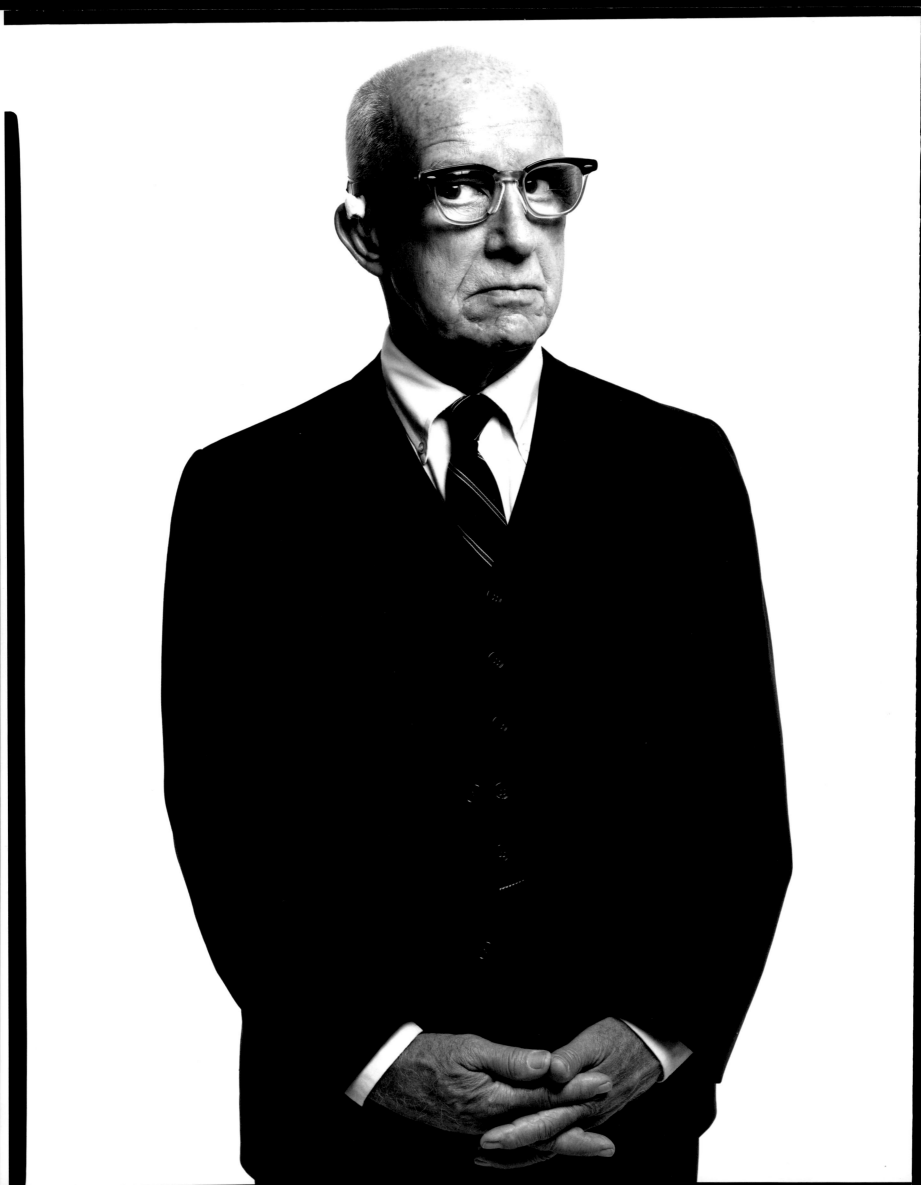

R. BUCKMINSTER FULLER, architect
New York City
October 28, 1969

When I was thirty-two years old I undertook—as earnestly as I
knew how—not to remake my life, but to try to reorganize it to
make it more effective.... I don't think an individual would
make the determination I did on their own. What was really
cataclysmic in my life was that our first child, born just at
the end of World War I, caught first the flu and then spinal
meningitis and infantile paralysis, which in those days were
thought to be absolutely incurable. Despite her being
completely immobilized, nothing happened to her mind at all.
She had all the drives of curiosity any child would have, but
no locomotion. There was no way for her to make an experiment
as a child would. As a consequence, she really showed a very
extraordinary intellectual capability. But in a sense, it went
beyond just intellectual capability. For instance, time and
again, my wife and I would be about to say something—had
already decided what to say—but just before we could say it,
the child would. We were always startled.... And sometimes the
words were not at all the kinds of words she, as a little
child, would use. So that it seemed almost as if telepathy was
being very clearly demonstrated.... She died just before her
fourth birthday, so...that was that.

We were devastated by the loss of this child. And so in 1927,
when our second child was born...we felt...an extraordinary sense
of responsibility. Coincident with this, I lost control of the
business and all the things I'd been developing up to that
time. As a consequence, I was forced...either to commit
suicide—get out of the way—or try to turn my life to some
advantage. It was under these circumstances that I then did
this stock-taking on myself that was so...so powerful. Up to
that time I had been trying...I had become really very good at
finding out what other people said, but the fact is their
different theories were often in conflict. By following them—
not using my own head—I had run into many troubles. It seemed
very clear to me that in my own pains there had been some
place where there was a fork in the road, where I'd taken the
wrong fork—by virtue that it led to the pain—and that if I
traced it all the way back in my life, I might be able to do
things that would help others to avoid such pain. Because I'm
convinced that we're not here really for ourselves. We're
really here for other people.

I made up my mind that words are very treacherous. The ease
with which we can form a word is disproportionate to the
profound effect our words have on others. So not only is it a
very powerful, useful tool, but it is also a very dangerous

one. People use it so carelessly as to do
great harm to one another. Misleading one
another. They become carriers. So I gave
myself...a moratorium on speech. I made up
my mind that I mustn't use this capability
until I really meant to get special results
and not be parroting what somebody else
said. My wife agreed to do this. She met
the public for me. Once in a while
something came up where I really had to
speak but by-and-large for almost a year
and a half I was able to...not make sounds.

During that time I was doing this
fantastic thinking and...I came to some
very fundamental conclusions. I was
convinced from my first child that children
have very much greater capability than they
are credited with. If you could keep them
from being harmed, there might be a
generation that would grow up with such
competence and strength and knowledge that
it might be able to avoid many of the
errors I see my fellow man making today.
I'm absolutely convinced that trying to
persuade human beings to change their
patterns is a preposterous kind of a game,
but I find everybody's doing it. That's
what politics is always trying to do—
reform the man. But anything you can find
in the way of a problem that needs solving,
instead of trying to solve it through
political reform, a law, a persuasion,
there is something you could do physically.
You could rearrange the environment so
people will behave in appropriate ways. As,
for instance...imagine there's a great
river, a torrent. And people keep drowning
in it as they try to get across. The thing
to do is build a bridge over the river.
You won't need a sign to tell people to use
the bridge. They will come. They will
see the bridge, and they will use it to
cross the river.... Well, I saw that there
were a great many bridges to be built.

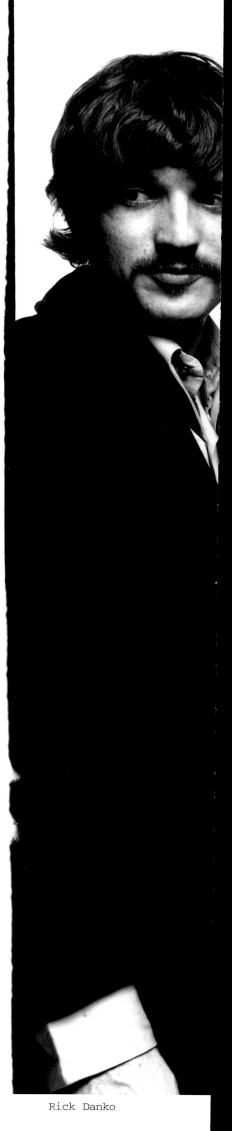

The Band
New York City

Rick Danko

190

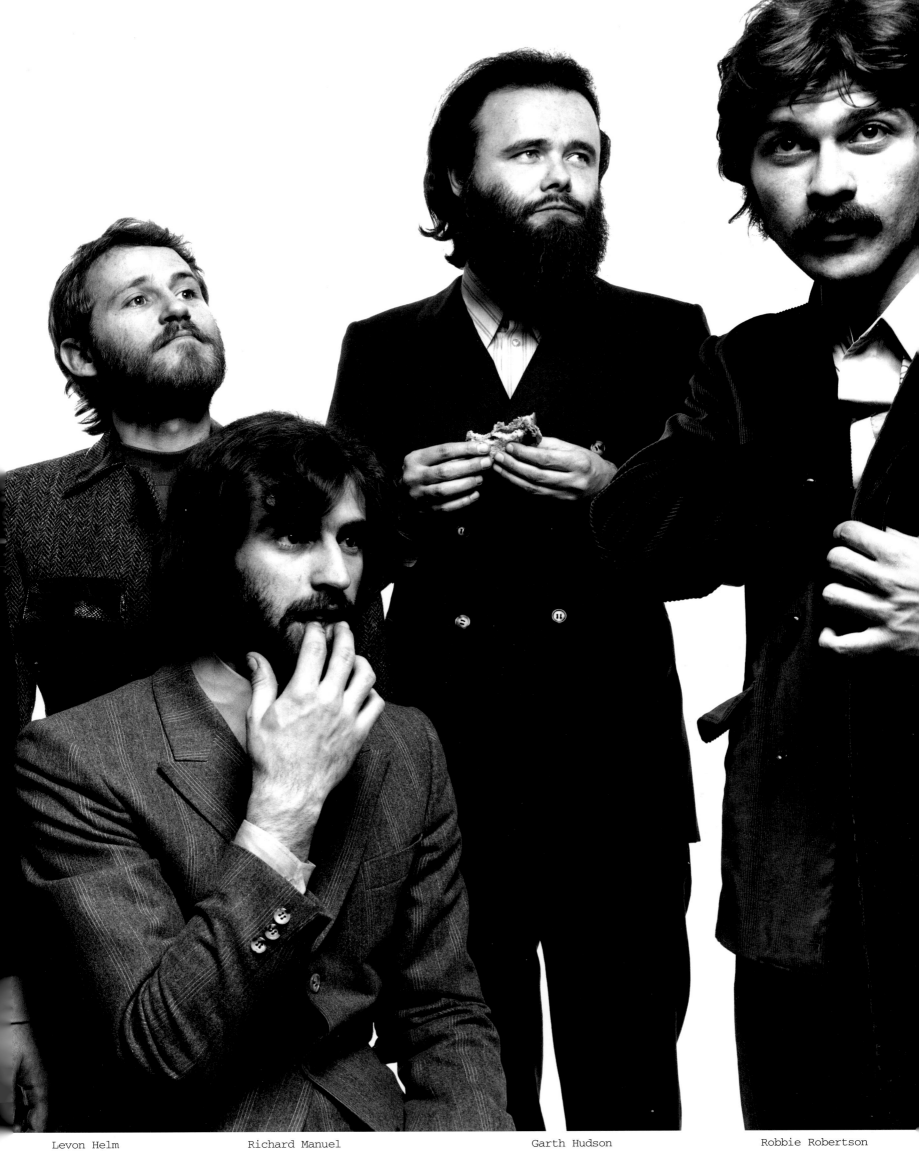

Levon Helm Richard Manuel Garth Hudson Robbie Robertson

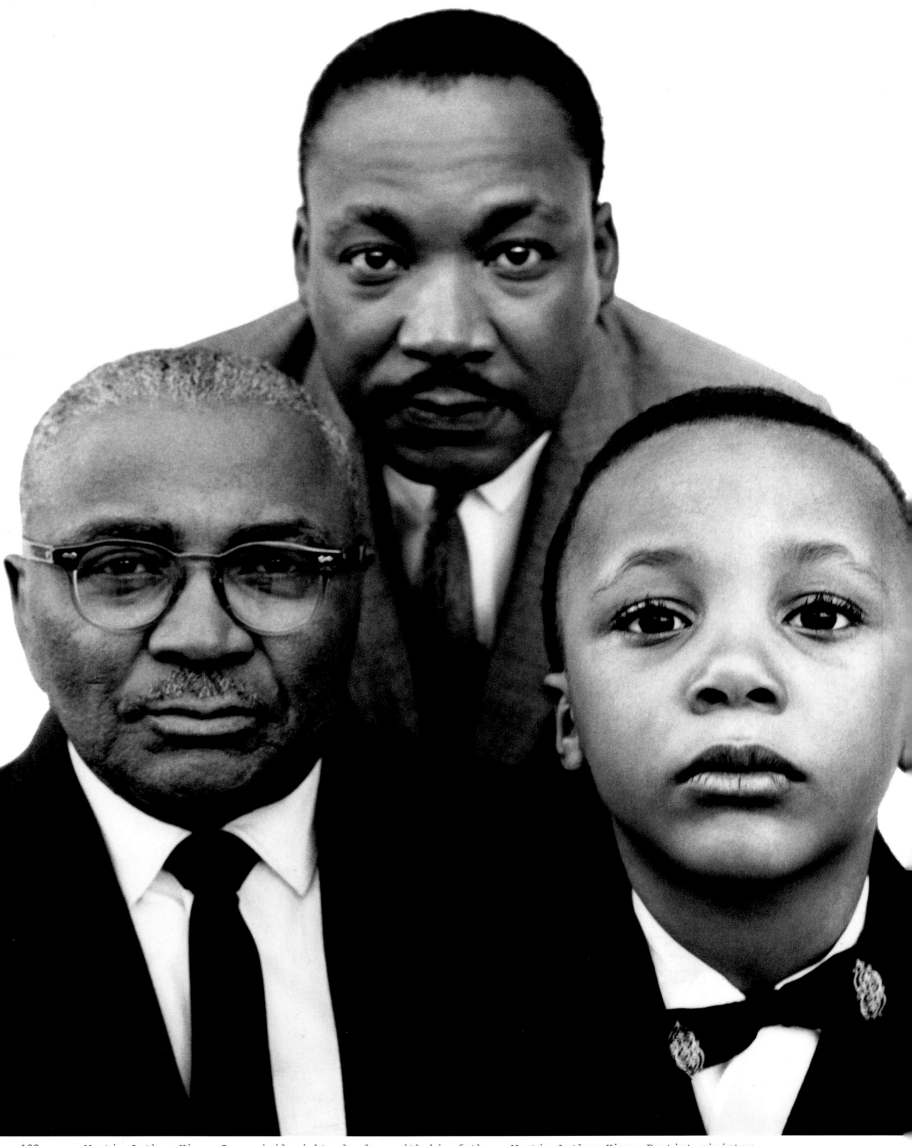

192 Martin Luther King, Jr., civil rights leader, with his father, Martin Luther King, Baptist minister, and his son, Martin Luther King III, Atlanta, Georgia

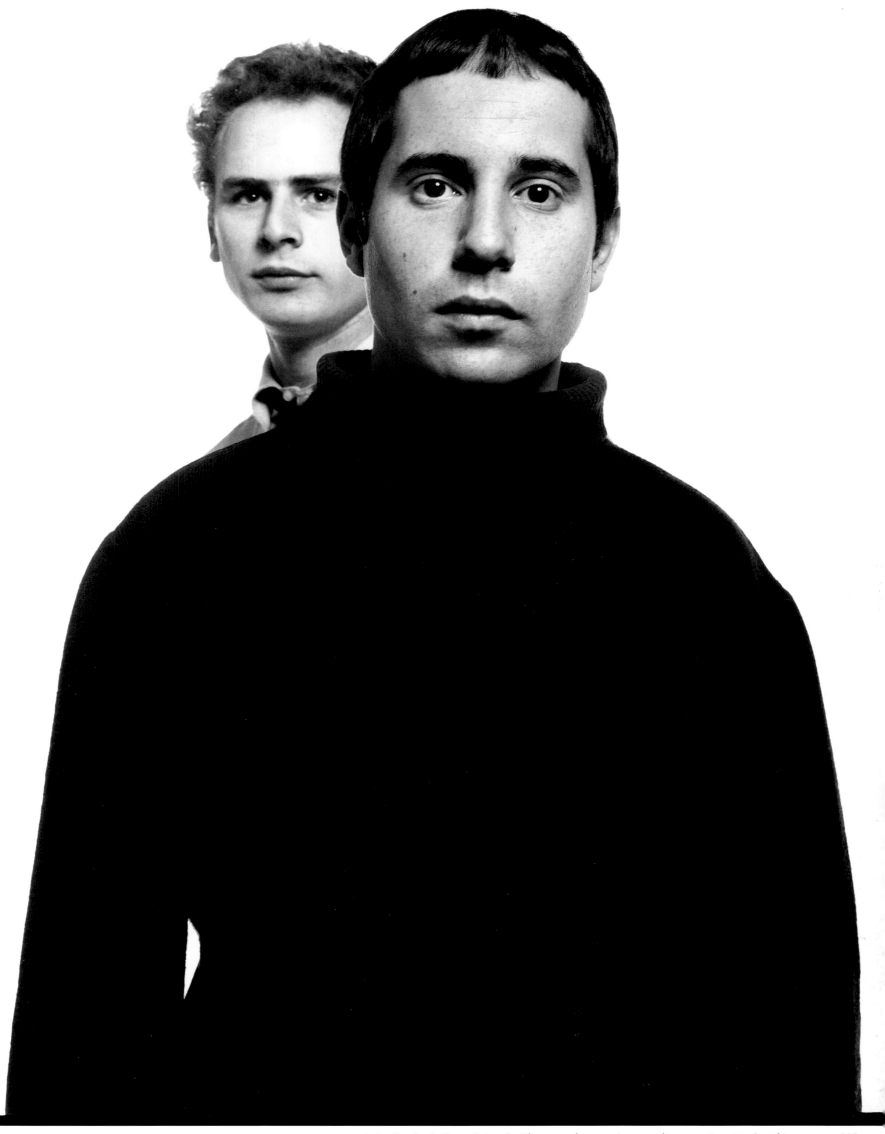

Art Garfunkel and Paul Simon, singers/songwriters, New York City 193

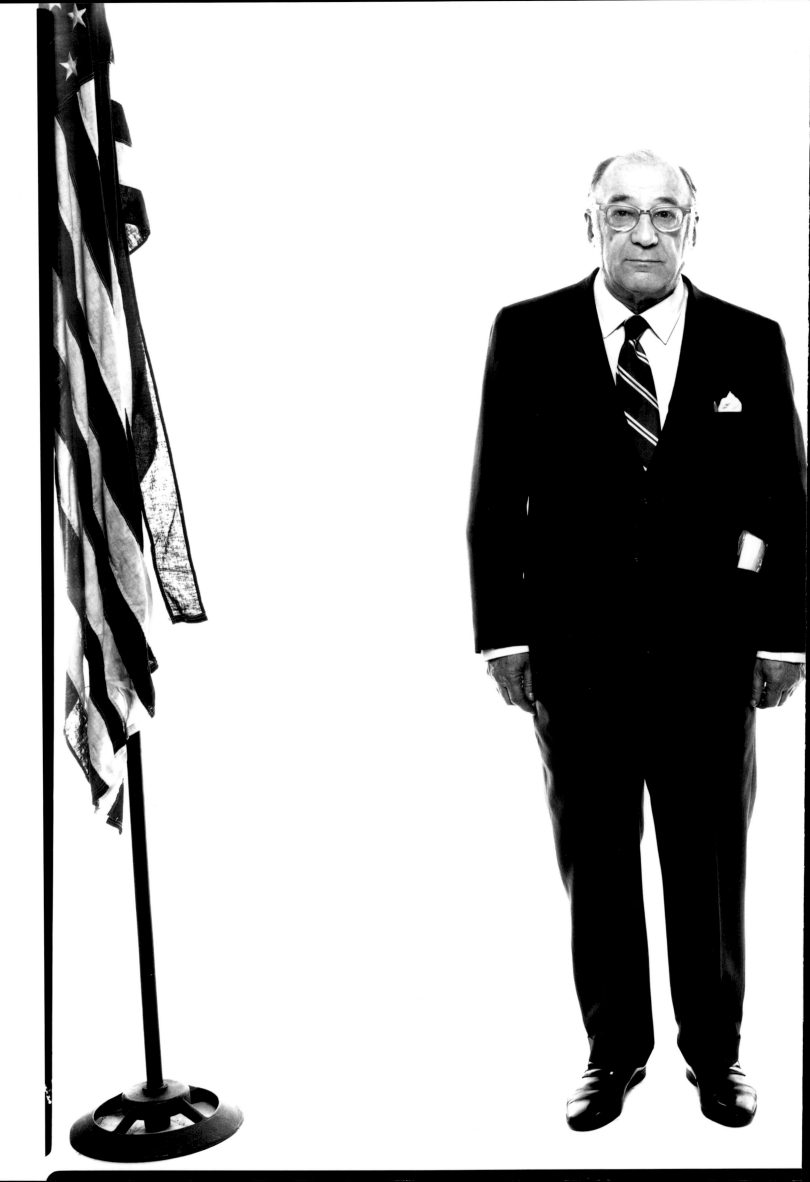

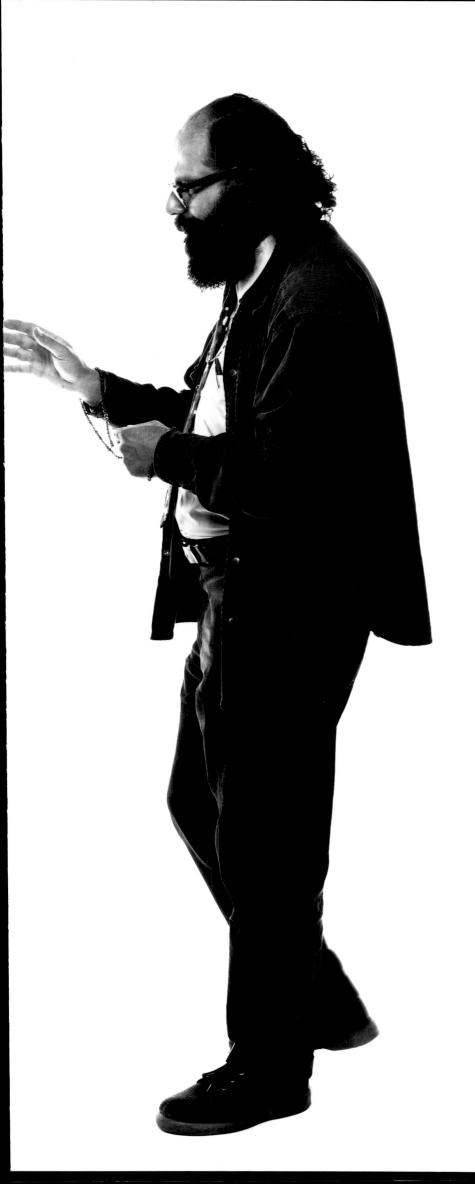

Louis Ginsberg and
his son Allen
Ginsberg, poets
Hoboken, New Jersey 195

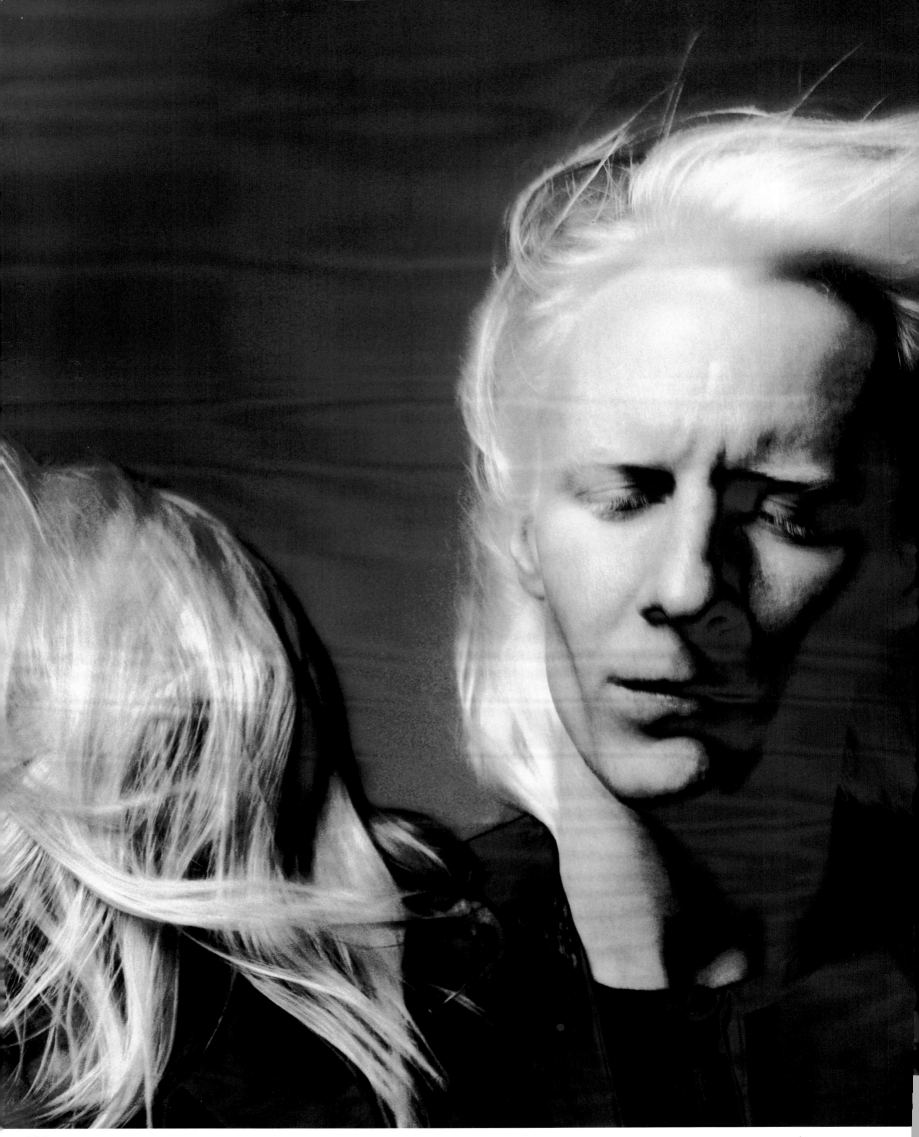

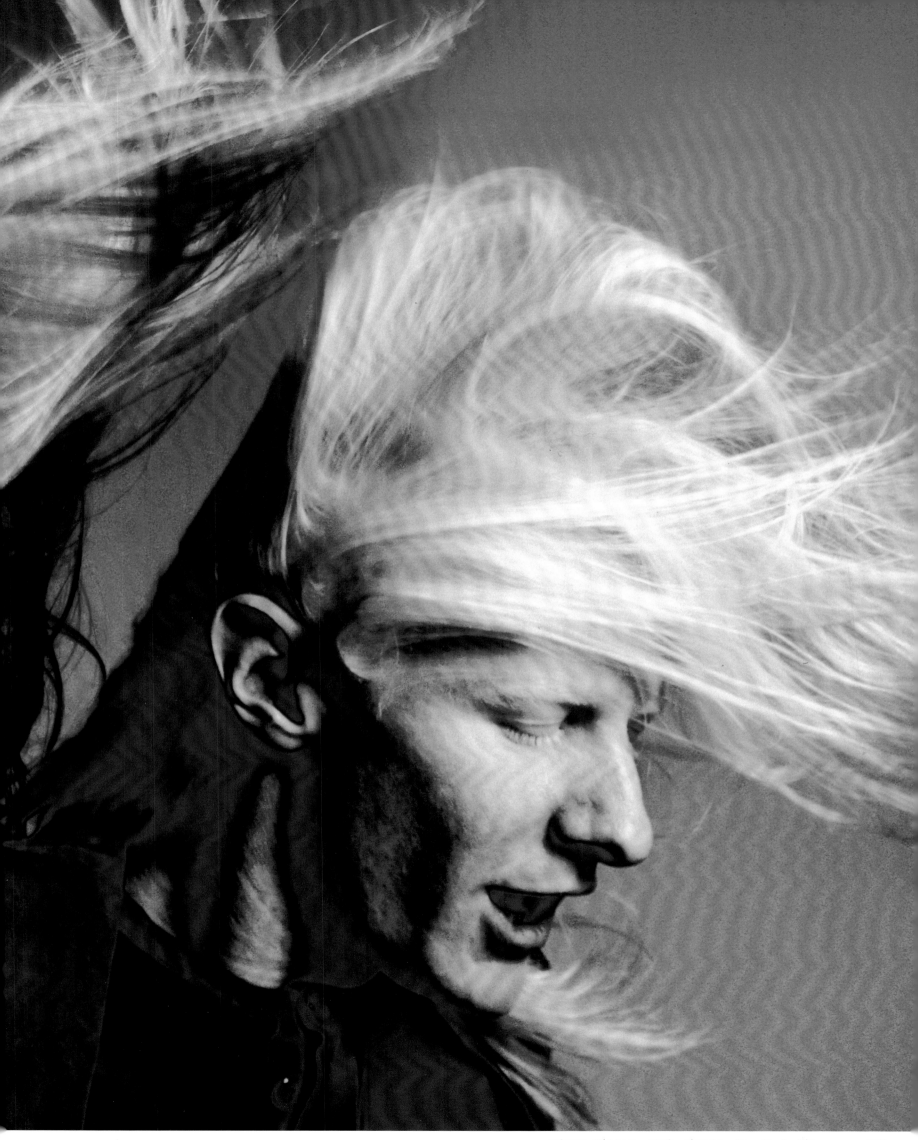

Johnny Winter, rock singer, New York City 197

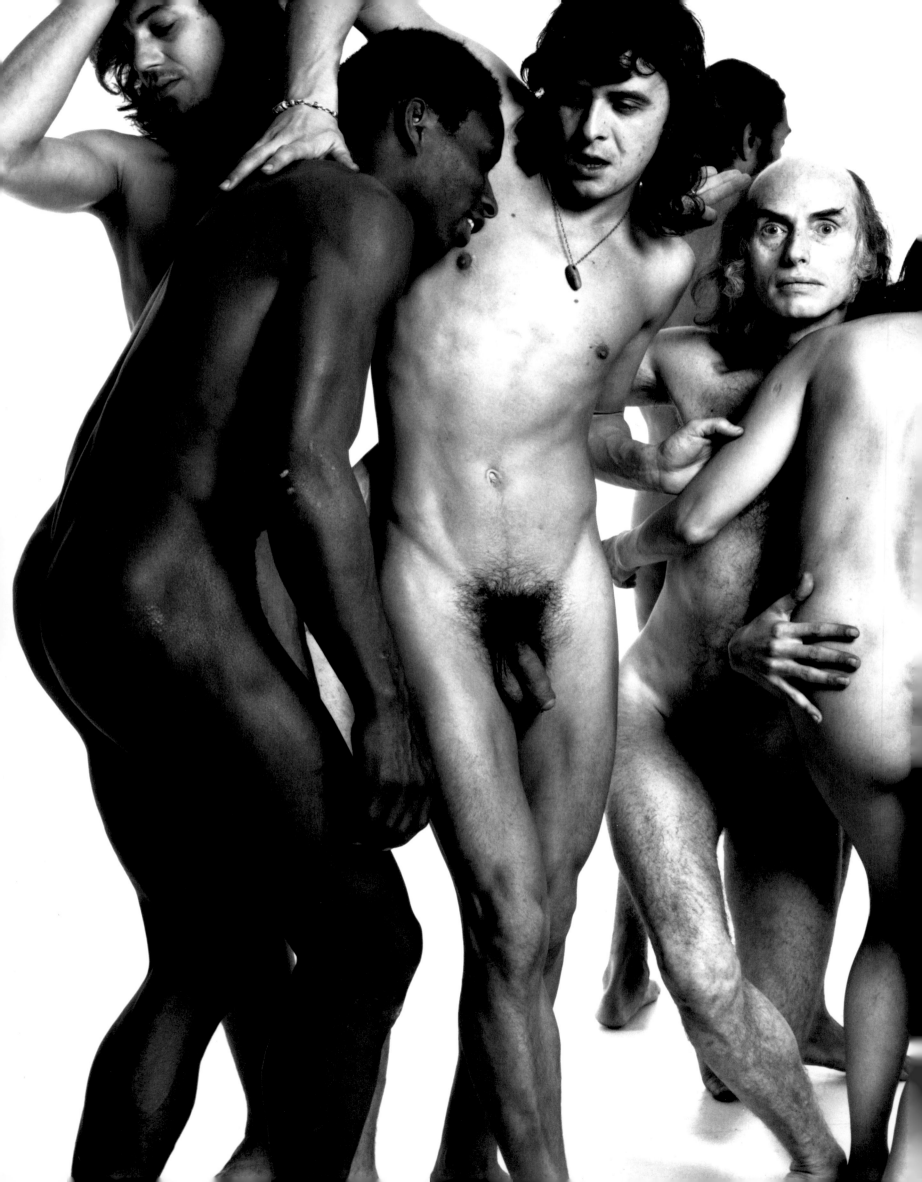

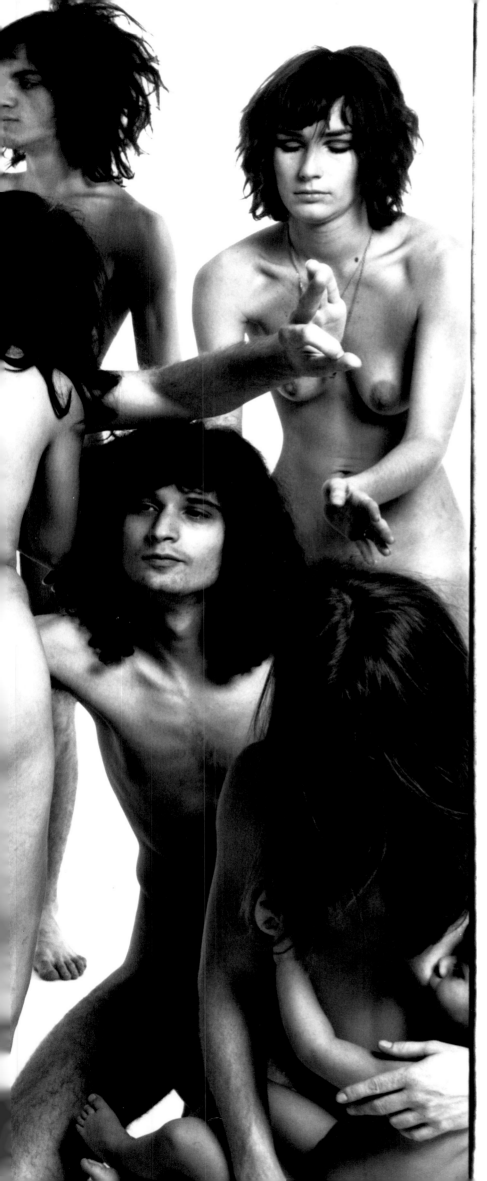

Julian Beck and the Living Theatre
New York City

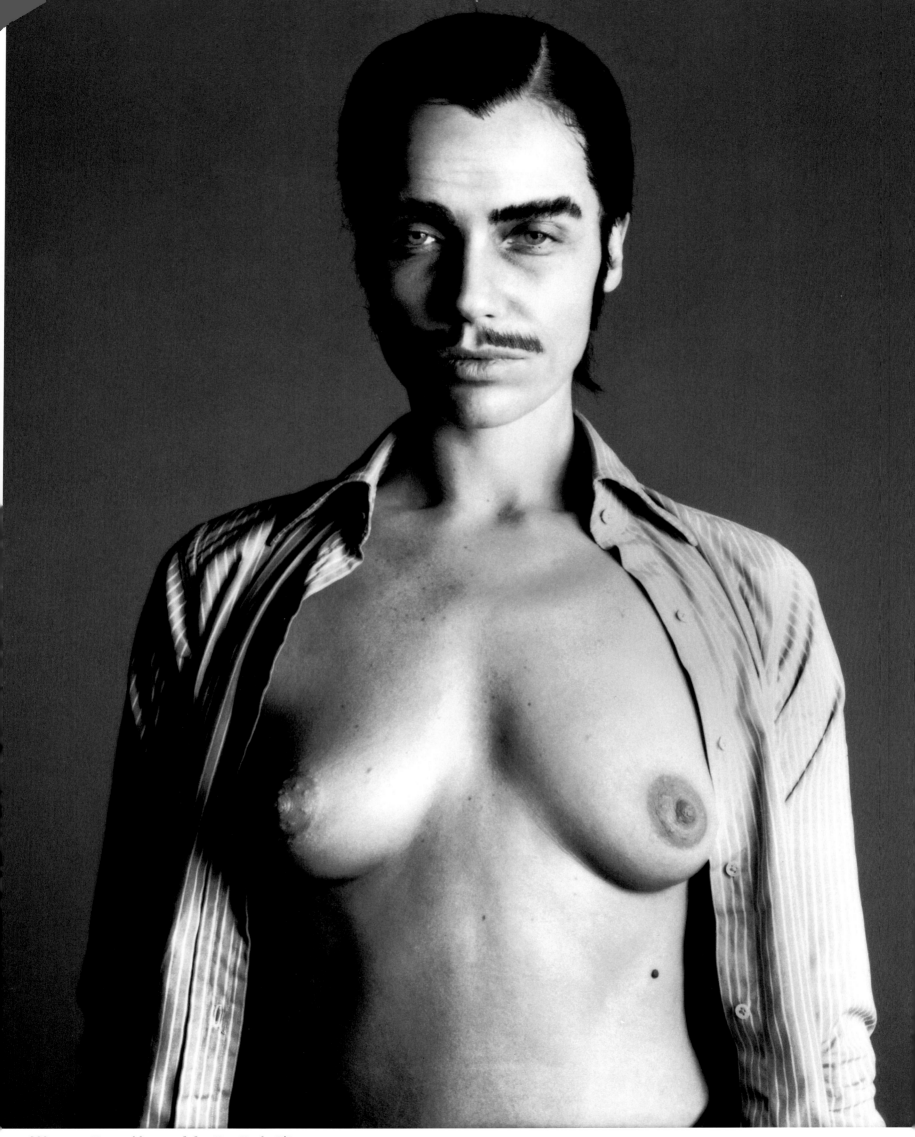

Veruschka, model, New York City

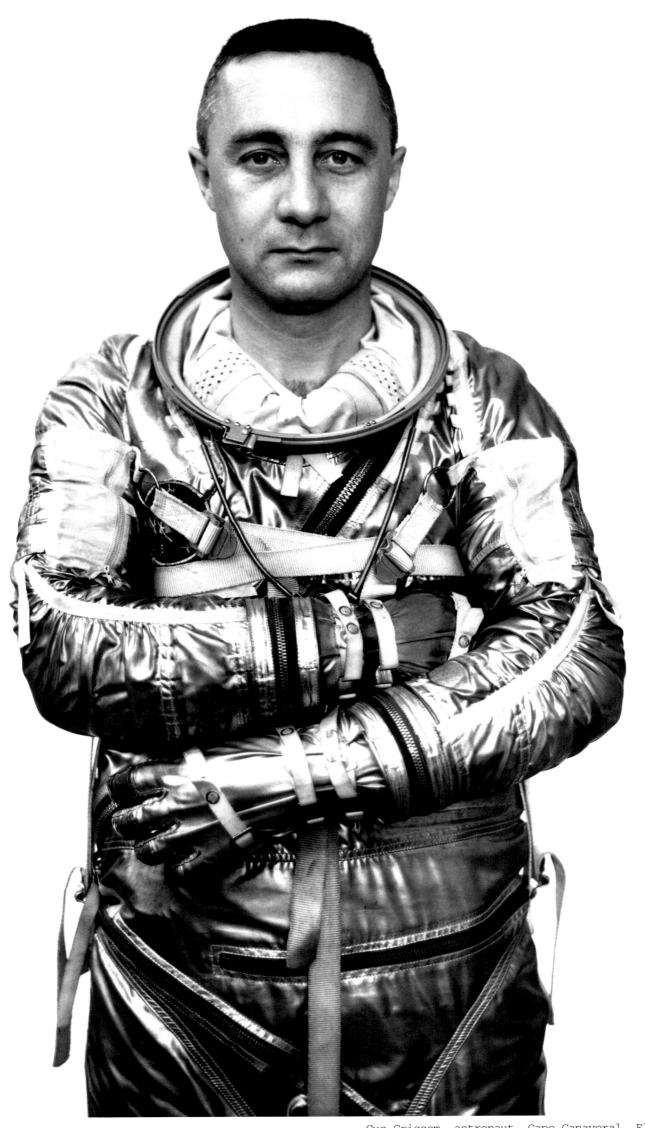

Gus Grissom, astronaut, Cape Canaveral, Florida 201

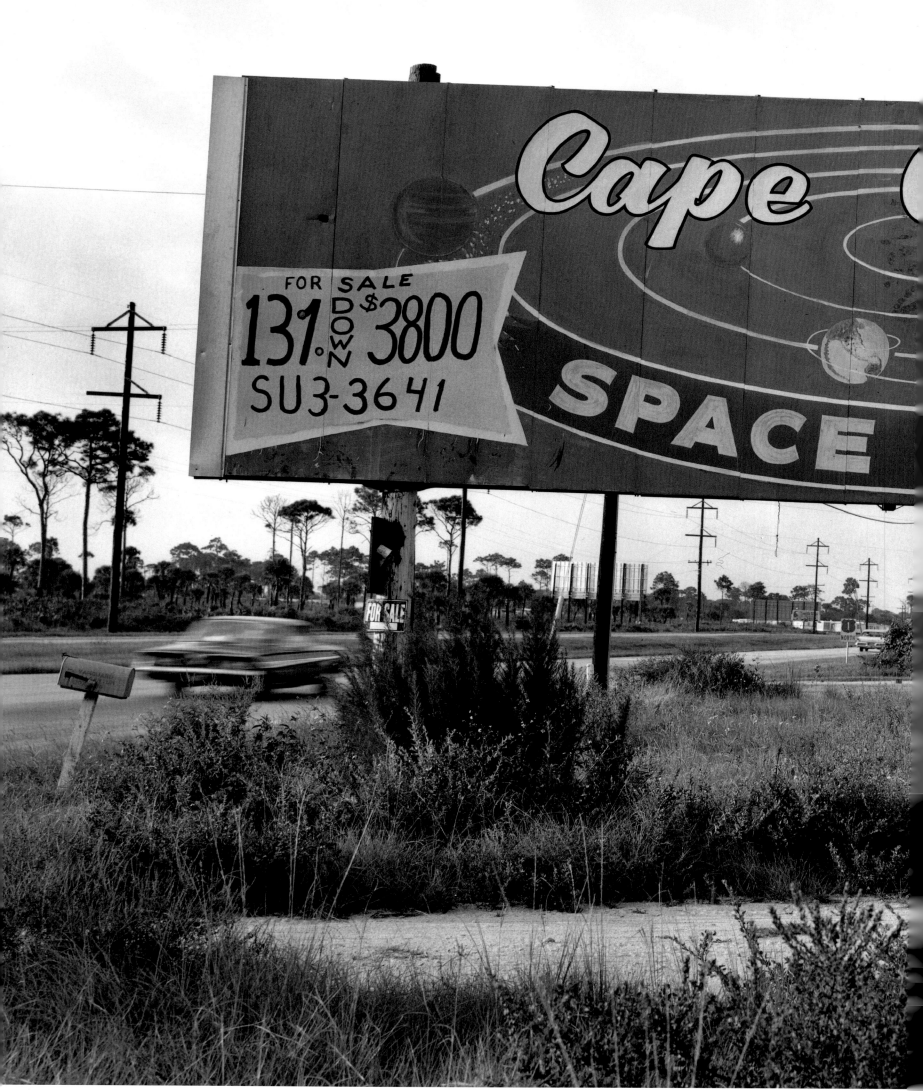

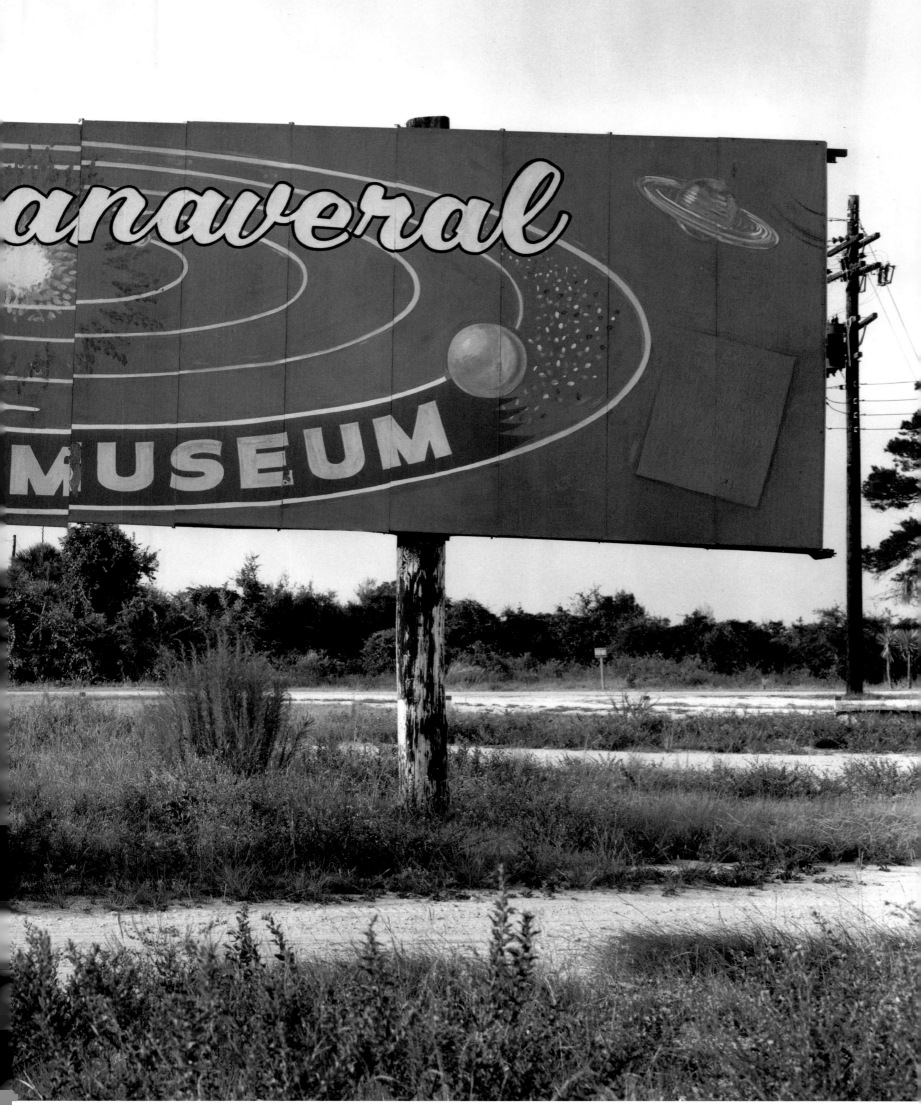

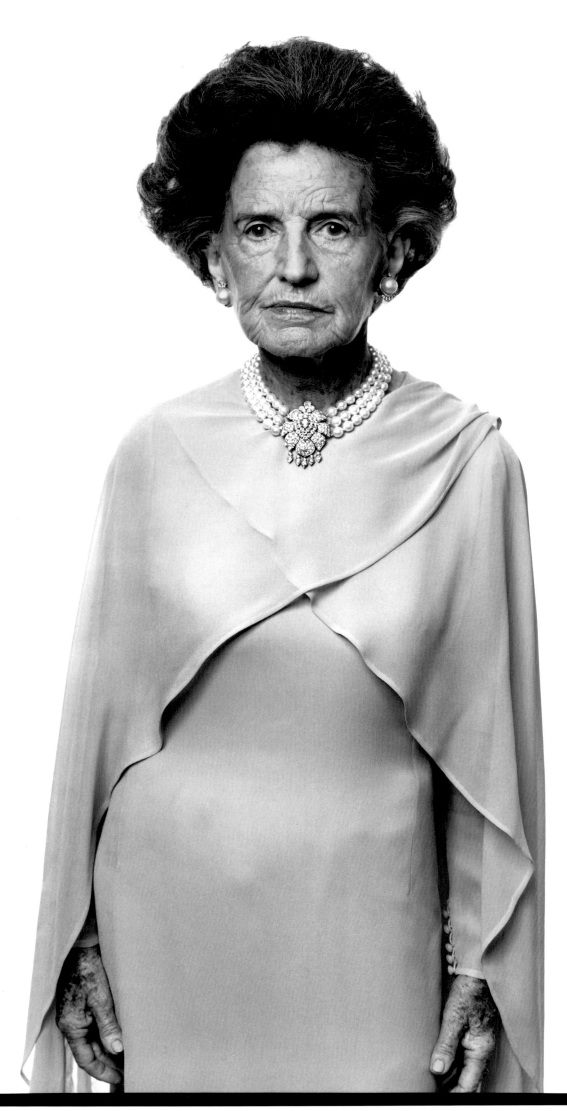

204 Rose Fitzgerald Kennedy, Hyannisport, Massachusetts

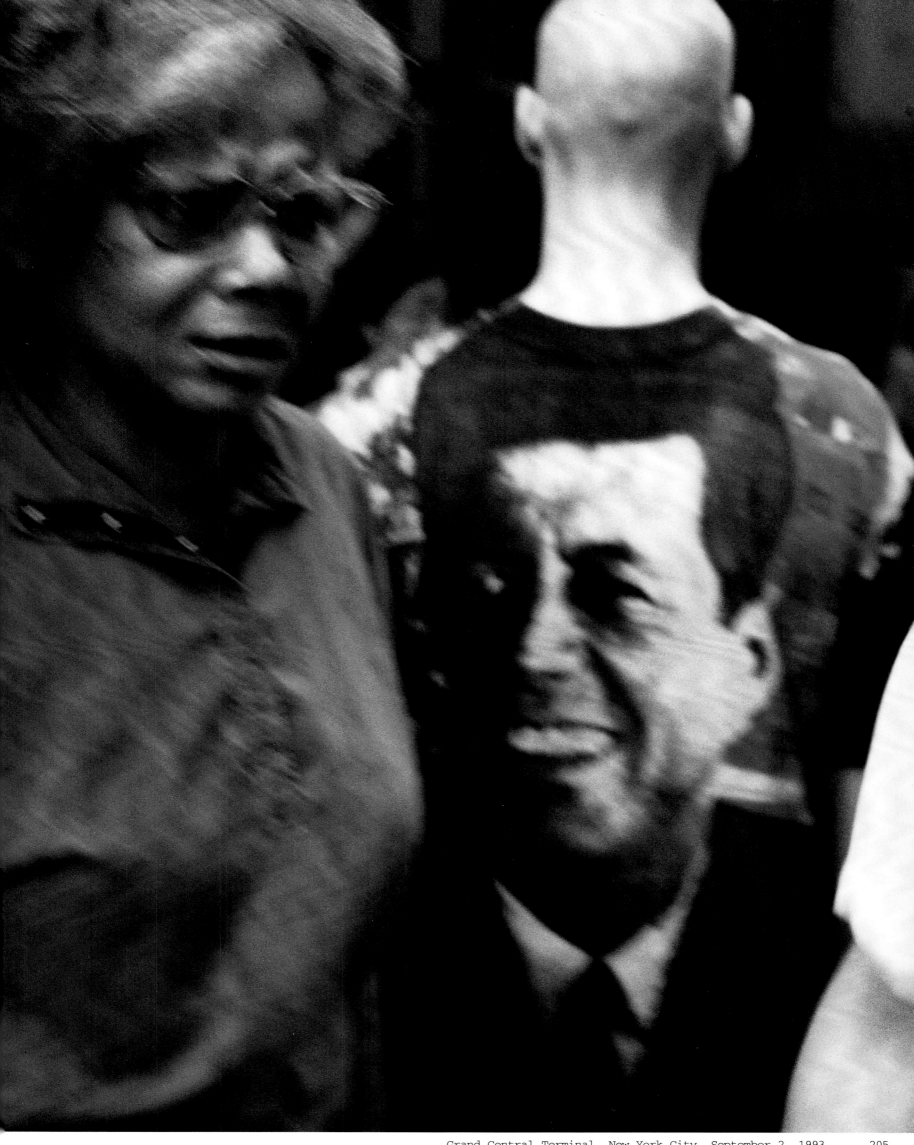

SAUL STEINBERG, artist
East Hampton, New York
August 18, 1969

It's like I can see inside myself...the myself...the myself of
the time when I was a child. It keeps coming out. It's like
somebody inside me is doing pranks for me. I have
somebody in my pouch who is myself many years ago.

I watch, in those moments, the twilight of the
mind...I'm like a Peeping Tom, because I am
trying to figure out...to listen to my automatic
thinking. That is the doodling of the mind. And
it keeps doodling...sometimes making good things.

By comparison, how clumsy the physical life is.
You walk and you do this and...how seldom
something really exciting happens, like.... What
is exciting about us when we lead the physical
life, we lead the animalic life...lovemaking,
swimming,...or having real physical
confrontations.... It takes courage.

DR. EDWARD BARSKY, surgeon, veteran of the
Lincoln Brigade in the Spanish Civil War,
leader of the Joint Anti-Fascist Refugee Committee
New York City
August 28, 1969

Well, I think you're...a little naive about it, ya see? 'Cause
when you go before the Un-American Activities Committee...you're
not just a man—or a woman—picked out of the air. You're
somebody...who has something to do with...something. And that
something should be a matter of principle to you. The
Un-American Activities Committee had no principles. They were just
a bunch of bastards, ya see. They were un-American. So when I was
up there and they asked me questions...I wouldn't answer 'em.

If I hadn't gone to Spain, I wouldn't be here...talking to you,
you know? And I wouldn't have gone to jail and I wouldn't have
lived that kind of a life. And I'm proud and happy that I did

live that kind of life. 'Cause...Spain and the work with the
Joint Anti-Fascist Refugee Committee—I don't know if you
remember that; that was before your time—but that work and the
things around it meant something to me. And you got to have
something in life. Something must mean something to you.

There's another thing, you know...that you learn as you go
through life. It's hard to see it if you just walk up and down
Broadway but, uh...essentially people are courageous. They're
not...cowardly. The masses of people. They are courageous.

I remember in Barcelona when they used to bomb us...every two
hours—on the clock. See...not as big as the bombs they use
today, but they were big enough in those days and, uh...you
walk around...and after an hour or so you get a little tense
because you knew...that in an hour the planes were comin' over.
And I would see young girls—good lookin'...young, ordinary
people—standing in the street...old women, old men...shakin'
their fists and cursing at the planes. But they had that
courage. When your homes are...being invaded...and your liberty
is being taken away—and liberty means something to people—
people do have that courage. It's the best thing they have
in life.

See, if I would dream of going in there and cooperating with
the Un-American Activities Committee...I would have to go out
and hide myself from...anybody I knew...or knew me. I would
feel a traitor to everything...I had done and...betraying
everybody who had supported me. Well, that helps you to...stand
up. And you are not alone. There's a lot of other people
with you. The struggle itself steels you to do what you know
is right.

We knew we were right. It was a very simple thing as far as
we were concerned. It was the simplest thing. You didn't have
to be a magician—or a god—to know that. Why do you have to
think what's right and wrong? You know what's right.

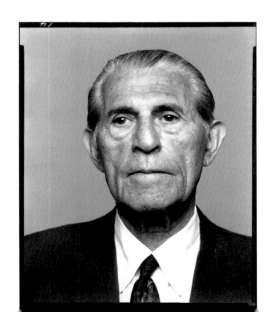

BOB DYLAN, singer/songwriter
Los Angeles
September 11, 1997

I don't have to work very hard at it. It's just there. It's
always been right there. I figure everybody's got a gift for
some kind of thing that they really like to do. And as long as
they keep doing it, and they're true to whatever that is, what
they really like to do—and it's *sufficient*—then as you go on,
I mean I know in my case, I learn more and more about it. I
consider myself just still at the beginning.

I'm still the same. I'm still the same person. I still feel
like the same person. The music I used to listen to, it's still
the same music, a whole list of names of people who aren't
around anymore, you know? Those people, they were there first.
They were like the clue to it. That was the world I came East
to find, which was like a long odyssey in itself, just trying
to get there. And those people I'm speaking of, they knew about
the older people who'd been there in the forties. And the
thirties. That stuff was real obscure, but they knew what it
was and they had the stuff, they had it. I know it rubbed off
on me. In a big way. It all sort of jumbled itself up in my
mind and came out the way it came out. And if I stray from

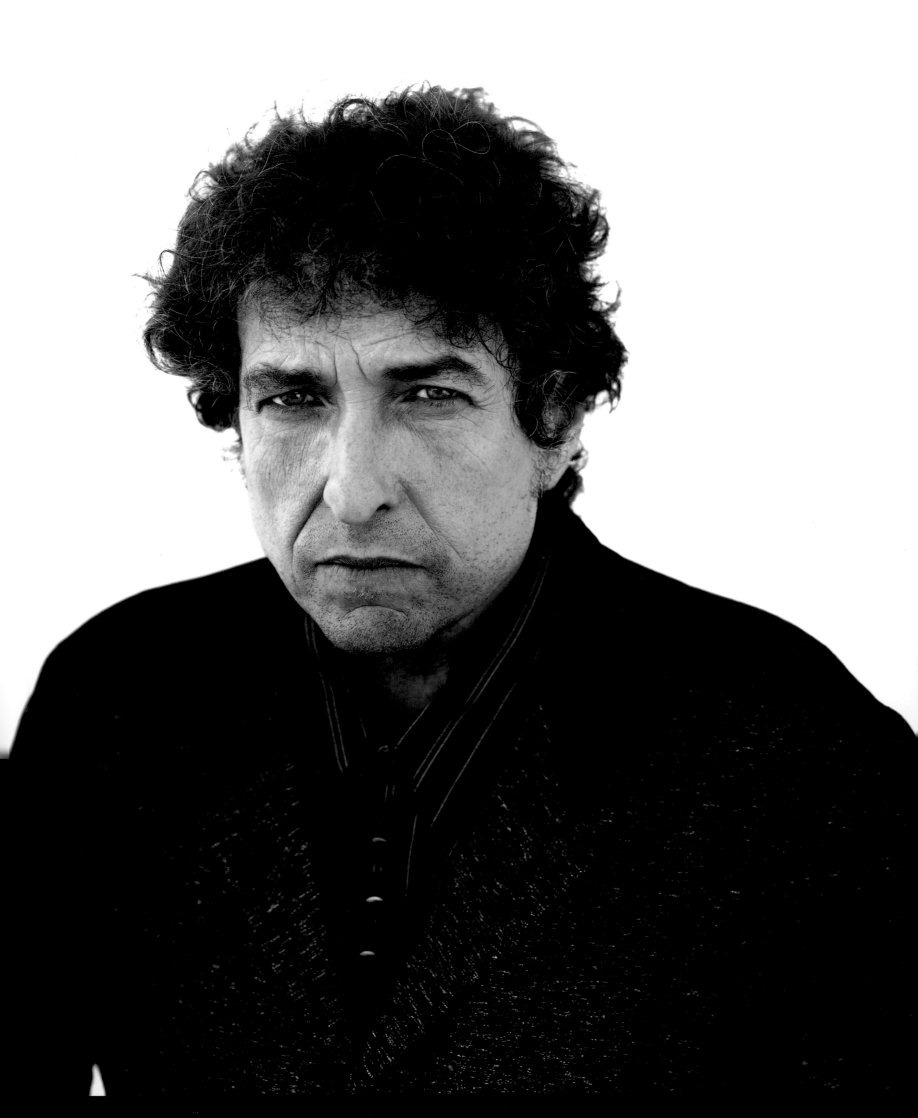

that, or if I don't commit myself to it, thinking something else is happening...but I don't do that anymore. I fully believe that that is the blueprint for my type of creativity. There've never been any new developments. For me. You know what I mean? Because it's an immense deep world. And it never ends. And for me, it's been the be-all and end-all of how I conduct my life.

One of the feelings of it was that you were a part of a very elite, special group of people that was outside and downtrodden. You felt like you were part of a different community, a more secretive one. And this community spread out across America. It spread out across America. New York had plenty of it, but you go to a city like Philadelphia or, same thing, go to St. Louis, go to Columbus or go to, you know, Houston, go to Austin, Atlanta, every little city you went to, if you knew who to call, what to look for, you could find...like-minded people.

That's been destroyed. I don't know what destroyed it. Some people say that it's still there. I hope it is. I hope it is. I know, in my mind, I'm still a member of a secret community. I might be the only one, you know?

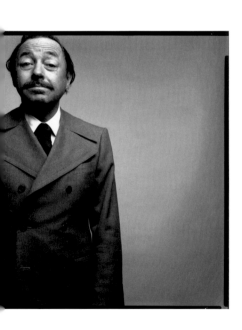

TENNESSEE WILLIAMS, playwright
The Algonquin Hotel, New York
August 26, 1969

I can take my glasses off but I had such terrible insomnia last night, you know, that my eyes have...black...circles under them.... In the South they say, "The blackbirds kissed you last night."

Pain?... I don't think there's much—that pain is much of a creative, uh...impetus. I, uh...I have a very high pain barrier and I, uh, I seldom feel any pain. I'm most likely to feel embarrassment.... Whenever I go out with somebody I, uh...I wonder if I'll be able to talk to them or not.... Is that the sort of thing you mean?... There was one summer I went to Tangiers with, uh...uh, Marion Vaccarro, and...the problem was greatly,

uh...greatly increased. I wouldn't talk to her at all. I simply wouldn't talk to her.... And, uh—you've heard of Jane Bowles...I said to Janie, I said, "Janie, I can't talk this summer." And she said, "Well, Tennessee, you've always been a poor conversationalist."... Janie—Janie was the only person I could talk to.... Not Paul.... Janie and I, we used to go every evening about five o'clock to a lady doctor who'd give us a *piqûre*. You know, a shot...which, uh, whether it was imaginary or not, I felt...it made me feel better. For a little while.

I once was going abroad and, uh...I said to this rather very nice and, uh, you know, fine doctor, I said to him, "I am going abroad and in case I take ill abroad and have to see other doctors, I wish that you would, uh...write down what's wrong with me on a slip of paper so I can show it to them."... And so he wrote down, "Leukemia, with infections."... And, uh, when I came home...I said, uh, "What are we going to do about this leukemia? Is there anything we can do? Shouldn't I be taking blood transfusions or something? To keep my energy up for my work?" And he said, "What makes you think I ever wrote that down?"... I said, "Well, I remember it."

I don't smoke...anymore. I just forgot to.... My, uh, closest friend died of lung cancer due to smoking, uh...four packs a day.... Well, it took courage...for me...going on.... And I still feel...the need of more courage than I have.

ABBIE HOFFMAN, former Yippie
New York City
November 30, 1986
(photographed in 1971)

I always prefer insults to compliments, to tell you the truth.
I don't know, I should be better at that. I should be
better at accepting those kinds of things. I always have the
tendency that it's gonna soften my instincts for...for
evaluating...justice, injustice, society. For inspiring people.
For being a nudge. I'm difficult. I'm difficult. I'm difficult.
I'm difficult for the society and I should be even more
difficult.

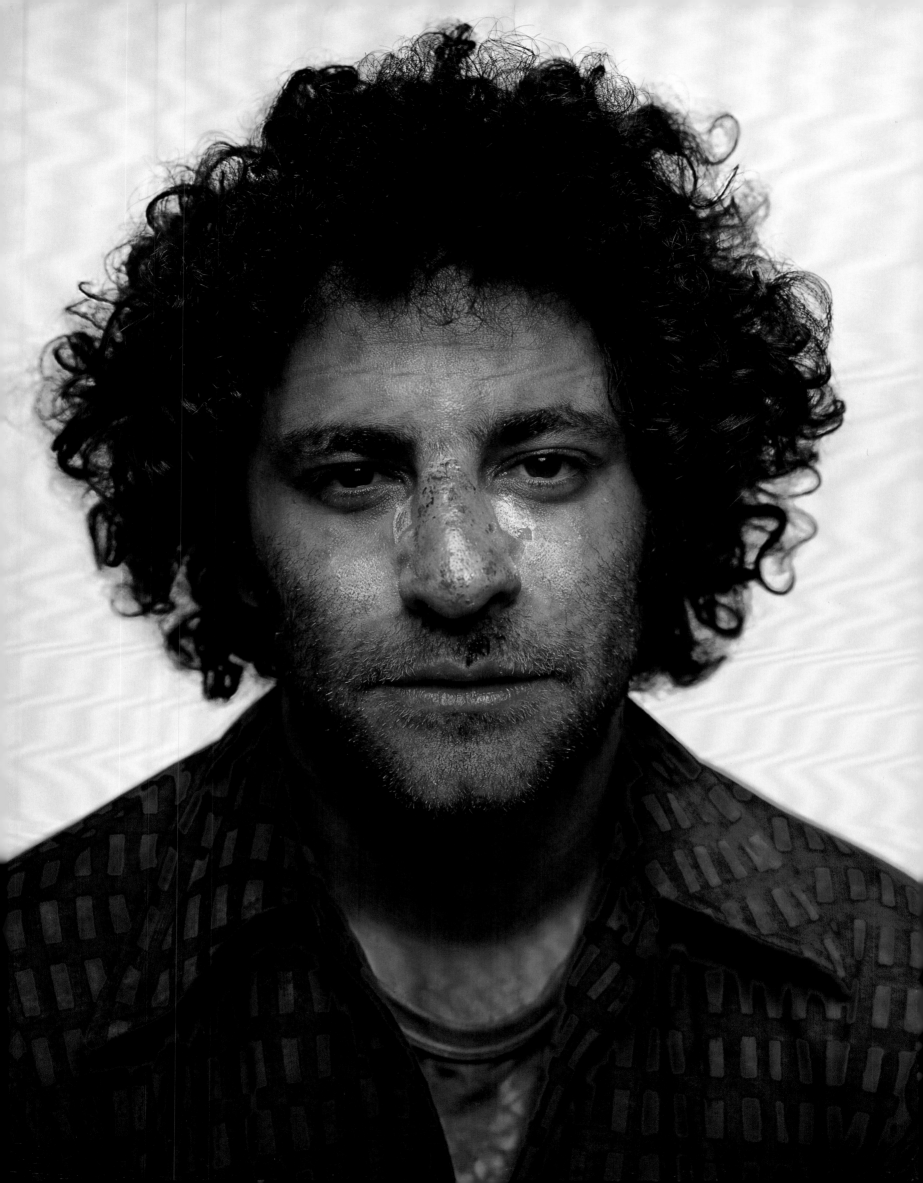

Frank Zappa, musician
Los Angeles
March 31, 1993

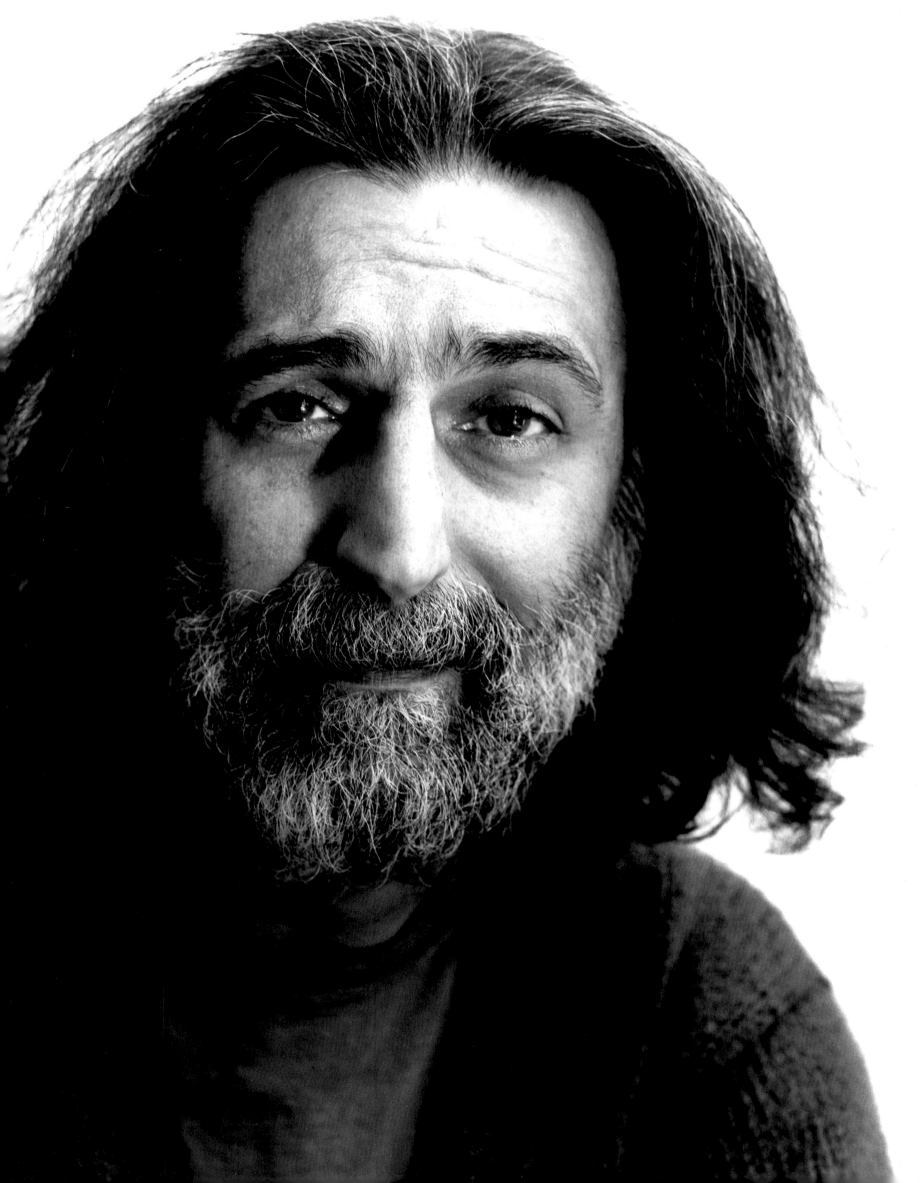

BIOGRAPHIES

Renata Adler (b. 1939) graduated from Bryn Mawr College in 1959. In 1962 she became a writer-reporter on the staff of *The New Yorker* magazine. She was chief film critic for *The New York Times* in 1968–1969. In 1970, her film reviews were collected as *A Year in the Dark*, and a selection of her *New Yorker* pieces was published as *Toward a Radical Middle*. Her story "Brownstone" received the O. Henry Award for Best Short Story in 1973. During the House Judiciary Committee inquiry into the impeachment of Richard Nixon in 1974, she was a consultant on the staff of the special counsel, John Doar, and a speechwriter for the chairman of the committee, Peter Rodino. She received a law degree from Yale in 1979 and has continued to work as a journalist. She has published two novels, *Speedboat* (1976) and *Pitch Dark* (1983), and two books on journalism and ethics, *Reckless Disregard* (1986) and *Politics and Media* (1988).

Edward Albee (b. 1928) wrote *The Zoo Story*, his first play, in 1958. The following year he began to write *The American Dream*, which was produced in New York in 1961. In a preface to the published text of the play, he summed up the theme of his work: "an attack on the substitution of artificial for real values in our society, a condemnation of complacency, cruelty, emasculation and vacuity; it is a stand against the fiction that everything in this slippling land of ours is peachy-keen." In 1962 he received a Tony and the Drama Critics Circle Award for *Who's Afraid of Virginia Woolf?* He has received three Pulitzer Prizes: for *A Delicate Balance* in 1967, *Seascape* in 1975, and *Three Tall Women* in 1994.

Henry Aronson (b. 1934) worked for the NAACP Legal Defense Fund in the mid-1960s. He spent three years in New York as director of the Vera Institute of Justice, where he designed a program that offered criminal defendants job assistance and counseling. In 1970 he moved to Saigon as head of the Lawyers Military Defense Committee, which provided free legal representation for soldiers facing courts-martial. He has a private practice in Seattle, Washington, and manages a commuter rail project for the Puget Sound area.

Joan Baez (b. 1941) gained attention as a folk singer in 1959 when she made an appearance at the Newport Folk Festival. Her first album was released later that year. By 1962 she was the subject of a *Time* magazine cover story. She was active in the civil rights movement—marching with Martin Luther King, Jr., and refusing to allow discrimination policies at her concerts in the South—and in 1965 she helped finance the first march on Washington, D.C., in protest of the war in Vietnam. She married the antiwar activist David Harris in 1968. They have a son, Gabriel, who was born when his father was in jail for resisting the draft. Harris and Baez divorced a few years later. She has continued to perform and record and to support Amnesty International, famine relief, and the reform of immigration policies.

James Baldwin (1924–1987) was born in Harlem, where his stepfather was a storefront preacher. He attended De Witt Clinton High School in the Bronx and wrote for the school magazine, the *Magpie*. By the mid-1940s he had published several essays and book reviews, and he received a small grant that he used in part to buy a one-way ticket to Paris. He lived mostly in Europe after that, although he returned to America intermittently. He published his first novel, *Go Tell It on the Mountain*, in 1953, and his first collection of essays, *Notes of a Native Son*, in 1955. In the early and mid-Sixties he was an important spokesman for the civil rights movement, particularly after his collection of polemical essays, *The Fire Next Time*, appeared in 1963, although he was criticized by black activists in the late Sixties for his refusal to be identified solely as a black writer. Baldwin wrote seven novels and eight major works of nonfiction, as well as plays and a screenplay of *The Autobiography of Malcolm X*. When he died he was at work on a book about Martin Luther King, Jr.

Roger Baldwin (1884–1981) was one of the founders of the American Civil Liberties Union and its director for more than thirty years. Born into an old Boston family and educated at Harvard, he was influenced as a young man by Emma Goldman's ideas about social reform. Under his direction, the ACLU participated in a variety of controversial cases, including the successful challenge of the banning of James Joyce's *Ulysses*. With the aid of volunteer lawyers, Baldwin defended the rights of trade union members and Communists as well as the German-American Bund and the Ku Klux Klan. In describing his life-long commitment to freedom of speech and social reform, he said, "I am dead certain that human progress depends on those heretics, rebels, and dreamers who have been my kin in spirit and whose 'holy discontent' has challenged authority and created the expanding visions mankind may yet realize."

The Band. The Band's first album, *Music from Big Pink*, which was recorded in 1968 in the basement of a house (Big Pink) in West Saugerties, New York, was one of the most influential records of the Sixties. The group was closely associated with Bob Dylan in the late Sixties and mid-Seventies. They disbanded in 1976 after a final concert tour, The Last Waltz, which ended with a gala concert on Thanksgiving Day in San Francisco that was filmed by Martin Scorsese.

Edward Barsky (1895–1975) left his position as assistant surgeon at Beth Israel Hospital in New York in 1937 to head the volunteer medical team of the Abraham Lincoln Brigade, which supported the Republicans against Franco's Fascist forces in the Spanish Civil War. After the war, his work as a leader of the Joint Anti-Fascist Refugee Committee led to an investigation by the House Un-American Activities Committee, and in 1947, when he and others refused to provide the records that were requested of them, Dr. Barsky was convicted of contempt of Congress. He was sentenced to six months in prison. He later rejoined the staff of Beth Israel, where he was a consulting surgeon at the time of his death. In the mid-Sixties he was a member of the Medical Committee for Human Rights, which provided care for student civil rights workers and developed rural health centers and mobile health units in the South.

Jeremy Berge (b. 1943) went to Vietnam as a translator for the Navy. He joined with several antiwar activists there, and began working for the Committee of Responsibility, which arranged medical treatment in the United States for injured Vietnamese children. He also helped establish a residential center for paraplegics in Saigon that was turned over to the Vietnamese when the war ended. Berge received a medical degree from the University of California at Irvine in the late Seventies. He practices in San Francisco, where he specializes in HIV-related diseases.

Black Panther Party. Huey P. Newton and Bobby Seale organized the Black Panther Party for Self-Defense in Oakland, California, in 1966. Their motto was "In order to get rid of the gun it is necessary to pick up the gun." The ideology of the party was largely Newton's creation, and differed significantly from the tenets of Black Power separatist groups like Stokely Carmichael's Student Non-Violent Coordinating Committee (SNCC). Newton's program was based on Marxist-Leninist ideas and encouraged alliances with white radicals. The Panthers established a number of community outreach programs and patrolled inner-city streets, and dozens of party members were involved in violent confrontations with the police. By the early Seventies, the Panthers had been infiltrated by the FBI, and with most of its leaders in prison or in exile, the party gradually disintegrated.

Ingrid Boulting (b. 1947) was born in South Africa and trained with the Royal Ballet in London before becoming a model and actress. She appeared in a number of films, including *The Last Tycoon*, and modeled for British and American *Vogue*, *Harper's Bazaar*, and other magazines. She lives in Ojai, California, where she paints and teaches yoga.

Carl Braden (1914–1974) left a Roman Catholic seminary at the age of sixteen to become a newspaper reporter in Louisville, Kentucky. He worked for many years as a journalist, and in the late Forties became active in a number of civil rights organizations. In 1954 he and his wife, Anne, were arrested and charged with plotting to incite insurrection after they bought a house in a white neighborhood of Louisville and transferred the title to a black family. The black family was harassed and the house firebombed. Carl served eight months of a fifteen-year prison sentence for sedition before an appeals court overturned his conviction. Blacklisted as journalists, the Bradens became field organizers for the Southern Conference Educational Fund (SCEF), an inter-racial organization working to end segregation. In 1958 they were called before the House Un-American Activities Committee to testify about their work. Carl refused to comply, citing his First Amendment rights, but the Supreme Court ruled against him, and he served nine months in prison for contempt of Congress. Throughout the Sixties, the Bradens organized support for most of the major civil rights campaigns. In 1966 they became executive directors of SCEF. A year later they were again arrested in Kentucky and charged with sedition, this time for setting up a community organizing project among poor whites in Appalachia. The case ended when the Supreme Court ruled that the state sedition law was unconstitutional. In 1972 the Bradens resigned as directors of SCEF, in part because of ideological splits within the organization. They continued to build interracial coalitions and to work against racism.

Susan Brockman graduated from Cornell University with a degree in fine arts. In the mid-1960s, while living with the painter Willem de Kooning, she made and exhibited a series of shoebox-size constructions of rooms. She is a photographer, a film editor, and a mixed-media artist, and has produced and directed five films.

David Brothers established a branch of the Black Panther Party in Brooklyn in 1968. He became the deputy chairman of the New York State branch of the party, and is now a community organizer in Brooklyn and a member of the All African People's Revolutionary Party, which he co-founded with Stokely Carmichael.

Kevin Buckley (b. 1940) covered the war in Vietnam for *Newsweek* from 1968 to 1972. He later worked for *New Times* magazine, *Look*, *Geo*, and *Lear's*. In 1991 he published a book about the relationship between the United States and General Manuel Noriega of Panama. He is now the executive editor of *Playboy*.

John Cage (1912–1991) held that the absence of harmony, or even sound, didn't necessarily indicate the absence of music. His compositions included experiments with improvised instruments, including a "prepared" piano that produced sounds that the composer Virgil Thomson described as "a ping, qualified by a thud." Cage's interest in Eastern philosophy and the I Ching led him to introduce elements of chance into his work. His ideas were influential, not only for other composers but also for artists like his friends Jasper Johns and Robert Rauschenberg, and for the choreographer Merce Cunningham, with

whom he collaborated for fifty years and with whom he lived from 1970 until his death.

Denis Cameron (b. 1928) worked as a photojournalist in the Middle East and Asia in the 1960s, and in Cambodia from 1970 to 1975. He lives in London, where he works for a press photo agency. In 1995 he made a documentary on euthanasia, *Tired of Living, Feared of Dying*.

Cape Canaveral is a mosquito-infested area of swamps, savannas, and beaches that juts into the Atlantic Ocean on the east coast of Florida. It is owned by the National Aeronautics and Space Administration and since the late 1950s has been the center of the American space program. On February 20, 1962, John Glenn flew from Cape Canaveral in the Friendship 7 Mercury capsule, and became the first American astronaut to orbit the earth. On July 20, 1969, Neil Armstrong traveled from Cape Canaveral to the moon. In the mid-1970s, when the Apollo space program was terminated, the economy of the area suffered, but interest in Cape Canaveral was revived in 1981, when the first space shuttle was launched. On October 29, 1998, Senator John Glenn returned to space with six other astronauts on a Discovery space shuttle.

Truman Capote (1924–1984) began his writing career in earnest in 1948 with *Other Voices, Other Rooms*, a stylized novel about a teenage boy who lives in a crumbling mansion in Louisiana. It drew to a large extent on Capote's recollections of growing up in the South. In 1966 he published his most influential book, *In Cold Blood*, a "nonfiction novel" about the murder of a family in Kansas. He wrote several volumes of short stories, reportage, and novellas, and worked for many years on an ambitious novel about New York social life, *Answered Prayers*, that was unfinished at his death.

Fannie Lee Chaney (b. 1921) is the mother of James Chaney, a victim of one of the most notorious murders in the history of the civil rights movement. In 1964, James Chaney, a twenty-one-year-old black plasterer from Meridian, Mississippi, was helping to register black voters at a Freedom Summer community center established in Meridian by the Congress of Racial Equality (CORE). He and two colleagues, Michael Schwerner and Andrew Goodman, both of whom were white, were shot and killed as they drove back to Meridian from a nearby town after inspecting the ruins of a Methodist church that had been firebombed. Their bodies were bulldozed into an earthen dam and recovered six weeks later, following one of the largest FBI manhunts in the Bureau's history. Chaney had been savagely beaten. The story of the investigation was the subject of the film *Mississippi Burning* (1988). Although state authorities never pursued murder charges, and the case remained officially "unsolved," nineteen men, including the county sheriff, his deputy, and the Imperial Wizard of the Ku Klux Klan, were arrested by the FBI and charged with violating the civil rights of Chaney, Schwerner, and Goodman. In 1967, the prosecution, led by John Doar of the Justice Department, managed to win a conviction against seven of the defendants. It was the first successful federal prosecution of racial violence in Mississippi. Fannie Chaney, a seamstress who had been active in the civil rights movement prior to her son's murder, moved to New York in 1964 and worked with CORE in Harlem. She participates in the management of the James Chaney Foundation, which was established in 1989. (See the entries for Carolyn Goodman and Anne Schwerner.)

César Chavez (1927–1993) used nonviolent tactics—strikes, fasts, marches, and boycotts—to organize the first union for farm workers in the United States. Born a poor migrant himself, Chavez founded the United Farm Workers Union

in support of a boycott against grape growers in the San Joaquin, Imperial, and Coachella valleys. Seventeen million Americans stopped buying grapes, and in 1975, California passed a collective bargaining act for farm workers. Chavez remained head of the union until his death, lobbying to create more low-cost housing for workers and trying to curtail pesticide poisoning.

Chicago Seven Conspiracy Trial. On March 20, 1969, a grand jury in Chicago indicted eight men for conspiring to cross state lines to incite a riot at the 1968 Democratic convention. The convention had been disrupted by violent clashes between police and demonstrators, who were clubbed and gassed when they gathered to protest the war in Vietnam and to defy officials who had refused to grant them permits to hold their rallies and marches. The leading candidate for the Democratic nomination that year was Hubert Humphrey. He was endorsed by both Mayor Richard Daley of Chicago and by President Lyndon Johnson, who had declined to run for a second term, largely because of widespread opposition to his policies in Vietnam. Another prominent candidate for the nomination, Robert Kennedy, had been assassinated three months earlier. The Democrats refused to endorse a peace plank in their political platform, and nominated Humphrey over the liberal candidate, Eugene McCarthy. Humphrey lost to Richard Nixon in the election in November. The Chicago conspiracy trial defendants were of disparate and not completely compatible political backgrounds, although all of them were opposed to the war in Vietnam and to the racist aspects of American life in the 1960s. Abbie Hoffman and Jerry Rubin were the founders of the Yippie movement. David Dellinger was a pacifist. Tom Hayden and Rennie Davis were founders of the Students for a Democratic Society. Bobby Seale was a member of the Black Panthers. Lee Weiner was a community activist in Chicago. John Froines was an assistant professor of chemistry at the University of Oregon. During the raucous five-month trial, the presiding judge, Julius Hoffman, was openly contemptuous of the defense. Bobby Seale, who had been in Chicago during the convention for only a few hours, and who had never met any of his alleged co-conspirators before he arrived to speak at a rally, was bound and gagged in the courtroom by federal marshals when he protested that his lawyer was not present. His case was severed from the trial of the seven other defendants. In February 1970 the Chicago Seven were found innocent of conspiracy, although Davis, Dellinger, Hoffman, Hayden, and Rubin were found guilty of crossing state lines to incite a riot. In 1972, an appeals court overturned the convictions, citing Judge Hoffman's procedural errors and hostility toward the defendants. Seale's case was declared a mistrial, although he was sentenced to four years imprisonment for contempt of court. This judgment was also overturned on appeal. An official government investigation later termed the events in Chicago during the Democratic convention in 1968 "a police riot."

Shirley Clarke (1919–1997) was the sole female member of the New York–based New American Cinema Group, which she founded with Jonas Mekas and which, like the French New Wave, aimed to create what they defined as independent films: "rough, badly made, perhaps, but alive." Clarke's first feature, *The Connection* (1960), a version of the Jack Gelber play produced by the Living Theatre, was about junkies waiting for their fix. In *The Cool World* (1963) and *Portrait of Jason*, a 1967 documentary, she explored gang membership and male prostitution. Her last film, made in 1986, was a portrait of the composer and saxophonist Ornette Coleman. She taught directing and film and video production at UCLA.

Wendy Clarke (b. 1944), the daughter of Shirley Clarke, is a video artist in California.

William Sloane Coffin, Jr. (b. 1924), a Presbyterian minister, became the chaplain of Yale in 1958. He was an adviser to the Peace Corps, and in 1961 helped organize a Freedom Ride to Montgomery, Alabama, to draw attention to laws permitting racial segregation in restaurants and interstate transportation systems. He was arrested and jailed for disturbing the peace. Coffin was an early opponent of the war in Vietnam and embarked on a course of civil disobedience. He led services at which students turned in their draft cards and he was the spokesman for a delegation that delivered a briefcase containing nearly one thousand draft cards to the Department of Justice in 1967. Early the following year he and four other activists, including Dr. Benjamin Spock, were indicted for conspiring to counsel, aid, and abet draft dodging. Coffin was found guilty, fined, and sentenced to two years in jail, but his conviction was overturned and an effort to retry him was eventually dropped. He left Yale in the early Seventies and became the senior minister of the Riverside Church in Manhattan. He has since retired.

Leonard Cohen (b. 1934) was one of Canada's most promising poets and novelists in the late Sixties, but he became better known as a songwriter. An early work, "Suzanne," remains his most popular song. Its mournful, dreamlike, erotic, slightly alienated lyrics sung in a minor key are typical of his compositions. In 1968 he recorded his first album, *The Songs of Leonard Cohen*, on which he accompanied himself with an acoustic guitar. He has made several subsequent albums. In the 1970s he became a Buddhist, and he lives much of the time in a monastery on Mount Baldy, near Los Angeles.

Alice Cooper (b. 1948) is known as the father of "shock rock." Born Vincent Furnier, the son of a Protestant minister in Detroit, he gained attention for onstage antics that included simulated executions, chopping up baby dolls, performing in heavily made-up drag, and using a live boa constrictor or a chicken as part of the act. By the early Seventies, however, his band was being praised by the critics for its music, and their records frequently appeared on the hit charts. Cooper began performing regularly in Las Vegas and became a TV game-show personality. He continued to tour with his band through the Nineties.

Merce Cunningham (b. 1919) is the leader of the modernist movement in dance. He was born in Centralia, Washington, and was studying dance in Seattle in the late Thirties when he met John Cage. His collaboration with Cage, who became the musical director of the Merce Cunningham Dance Company, led to work that progressively segregated the roles of music and movement, until their only relationship was simultaneity of performance. Robert Rauschenberg, the company's resident designer from 1954 to 1964, and Jasper Johns, who was appointed artistic adviser in 1967, as well as such artists as Frank Stella, Andy Warhol, and Marcel Duchamp, created productions for Cunningham.

Jackie Curtis (1947–1985), whose real name was John Holder, Jr., was a playwright, director, and performer who often took the female lead in his own plays. He grew up on the Lower East Side of New York, where his grandmother, Slugger Ann, owned a bar. He acted in and wrote the screenplay for Andy Warhol's *Women in Revolt* (1971), and wrote and directed the plays *Glamour, Glory and Gold* (1967), *Lucky Wonderful* (1968), and *Heaven Grand in Another Orbit* (1969). The La Mama theater produced his *I Died Yesterday*, based on the story of Frances Farmer, in 1984, and *Champagne* in 1985, the year he died of a drug overdose.

Joe Dallesandro (b. 1948). A self-confessed former hustler, petty thief, and drug addict, Dallesandro took a job as a doorman at the Warhol Factory and made several films there, most notably *The Loves*

of Ondine (1967), *Lonesome Cowboys* (1968), *Flesh* (1968), *Trash* (1970), and *Heat* (1972). He later moved to Europe, where he had a successful career as an actor. He starred in Louis Malle's *Black Moon* (1975) and has worked with Francis Coppola (*The Cotton Club*, 1984) and John Waters (*Cry-Baby*, 1990). He was married three times and has two sons. He lives in California and continues to act in films and on television.

Rick Danko (b. 1943) was born in a small town in Ontario, Canada, where he learned to play guitar, mandolin, and violin when he was a teenager. He was the bass guitarist and vocalist for The Band, and after the group broke up in 1976 he made two solo albums and collaborated with many other musicians, including Ringo Starr.

Dao Dua (? –1990) was born Nam Nguyen Thanh. He was known as Dao Dua, the "coconut monk," because his vegetarian diet consisted largely of coconuts. It was said that Dao Dua studied chemical engineering in Paris when he was a young man. He began studying Buddhism when he returned to Vietnam, and he became a teacher. In the mid-1960s Dao Dua and his followers established a religious community on Phoenix Island, in the middle of the Mekong River. His teachings included ideas from Buddhist, Taoist, and Christian sources, and at the height of the Vietnam War he had attracted some 3,000 followers. Phoenix Island became a haven for Vietnamese peasants and American soldiers fleeing the war. Dao Dua was jailed repeatedly by the Saigon government for preaching pacifism and the peaceful reunification of North and South Vietnam; following the war he was jailed again by the Communist government.

Candy Darling (1944–1974) was born James Lawrence Slattery on Long Island, New York. In his book *POPism*, Andy Warhol says that "Candy was the most striking drag queen I'd ever seen. On a good day, you couldn't believe she was a man." She appeared in Warhol's *Flesh* (1968) and *Women in Revolt* (1971) and was cast in many Off-Off-Broadway plays. She appeared in the film *Klute* (1971) and in Tennessee Williams's *Small Craft Warnings* Off Broadway in 1972. She died of cancer.

Rennie Davis (b. 1941) is the son of an economics professor who was a member of President Truman's Council of Economic Advisors. He grew up on a five-hundred-acre farm in the Blue Ridge Mountains of Virginia. In 1958 he entered Oberlin College in Ohio and became involved in student politics, helping to found the Progressive Student League. He was one of the founders of SDS, and served as a community organizer among the poor in Chicago. In 1967 he visited Hanoi and returned deeply committed to the antiwar movement. He was the national coordinator of the National Mobilization Committee to End the War in Vietnam (Mobe), and one of the key organizers of the antiwar demonstrations at the 1968 Democratic National Convention in Chicago, which led to his indictment as one of the Chicago Seven. In 1971 he was arrested as a leader of the Mayday tribe protest, which sought to shut down the government through massive civil disobedience. In the mid-Seventies Davis became a follower of Guru Maharji Ji. He lives in Boulder, Colorado, and runs a New Age technology company.

Dorothy Day (1897–1980) was a founder of the Catholic Worker movement and a nonviolent radical who battled for social justice for more than fifty years. Day espoused a kind of anarcho-pacifism, promulgated by her monthly newspaper, the *Catholic Worker*. She was born in Brooklyn into a largely agnostic family. When she was in her early twenties she became involved with the Industrial Workers of the World (the Wobblies) and with a group of left-wing intellectuals in

Greenwich Village. She had a daughter with a man with whom she had a common-law marriage, and her desire to have the child baptized led to her conversion to Catholicism. In 1933 she and Peter Maurin, an itinerant French lay preacher, started the Catholic Worker movement, which ran hospices for the poor and established communal farms. Members of the movement lived in voluntary poverty and participated in acts of civil disobedience that often resulted in arrest. Day inspired radical figures in the Church such as Thomas Merton and Daniel and Philip Berrigan. In the mid-Seventies she was arrested in a demonstration in support of César Chavez and the United Farm Workers. She died in a Catholic settlement house on the Lower East Side of New York, where she had lived for many years.

Willem de Kooning (1904–1997) was an abstract expressionist painter of the New York School, a master of the fervid, improvisatory brushstroke. He was born in Rotterdam and immigrated to the United States in 1926, where he worked at a series of odd jobs before being invited in 1935 to paint murals for the Federal Arts Project. Unlike his contemporaries, de Kooning put the human figure at the fore of his work, which oscillated between semi-representational paintings, like the "Woman" series of 1950–1953, and dense, muscular abstractions. The critic Harold Rosenberg first described his vigorous, gestural style as "action painting." In 1962 he began work on a studio in East Hampton, Long Island, where he would spend the remainder of his life, branching out into lithography and sculpture but remaining a painter at heart. Although afflicted with Alzheimer's disease in his last years, de Kooning continued to work. At the time of his death an exhibition of his late work was in progress at the Museum of Modern Art.

David Dellinger (b. 1915) belonged to an earlier generation of radicals than the other members of the Chicago Seven. Clean-shaven, mild of manner, and usually wearing a business suit, he was the descendant of an old Yankee family in Massachusetts and had studied at the Union Theological Seminary in New York after graduating magna cum laude with a degree in economics from Yale in 1936. A longtime pacifist who had gone to prison rather than serve in the military in World War II, he was the founding editor of the radical pacifist magazine *Liberation* and an early opponent of the war in Vietnam. He traveled to Hanoi and became one of the key links between the peace movement and the North Vietnamese. In August 1969 three American prisoners of war were turned over to him. He was a defendant in the Chicago Seven conspiracy trial because of his involvement in organizing the antiwar demonstrations at the 1968 Democratic Convention. The charges against him of inciting to riot were lifted on appeal, and he was never sentenced for the contempt of court charges imposed on him. In 1975 he became the editor of *Seven Days* magazine, and in 1993 he published an autobiography, *From Yale to Jail*.

John Doar (b. 1921) grew up in a small town in Wisconsin and attended Princeton. He received a law degree from the University of California and in 1960 was appointed the First Assistant in the Justice Department's Civil Rights Division. During the following two years he traveled around the South gathering evidence that blacks were being intimidated and prevented from registering to vote. In 1962 he accompanied James Meredith when he attempted to register at the racially segregated University of Mississippi. He co-wrote the Civil Rights Act of 1964 and won a conviction from an all-white jury against Ku Klux Klan members who had murdered civil rights worker Viola Gregg Liuzzo. In 1967 he won a federal case against the Klan members, including a deputy sheriff and an Imperial Wizard, who had murdered three civil rights workers—

James Chaney, Michael Schwerner, and Andrew Goodman. He left the Justice Department in 1968 to become president of the Bedford-Stuyvesant Development Corporation, which was dedicated to restoring inner-city neighborhoods in New York City. In 1973 he was named special counsel to the House Judiciary Committee investigating the impeachment of President Nixon. He practices law in New York.

Bernardine Dohrn (b. 1942) attended law school at the University of Chicago, where she volunteered to help the Southern Christian Leadership Conference organize rent strikes. She was working for the National Lawyers Guild in 1968 when the SDS chapter at Columbia University took over the campus. Dohrn worked on the legal defense of some of the students who were arrested, and soon joined SDS. At the 1968 SDS convention she identified herself as a "revolutionary communist." She was the leader and spokeswoman for the militant Weathermen faction that broke with SDS in 1969 and staged the Days of Rage during the first few days of the Chicago Seven conspiracy trial. A few months later the Weathermen decided to go underground as "urban guerrillas" in an "armed struggle." In March 1970 a bomb factory in a town house in Manhattan exploded, killing three Weathermen. A few days later Dohrn was indicted for her role in the Days of Rage. She was on the FBI's most wanted list during much of the 1970s, while she and her husband, Bill Ayers, another Weatherman, remained in hiding. Conspiracy charges against the Weather Underground were eventually dropped because of illicit government surveillance. Dohrn and Ayers surrendered in 1980, and she was fined $1,500 and placed on three years probation for her involvement in the Days of Rage. Two years later, she served seven months in jail for refusing to cooperate with a grand jury investigating the robbery of a Brink's truck near Nyack, New York, in which former Weathermen killed a bank guard and two police officers. She and Ayers live in Chicago, where she is the head of the Children and Family Justice Center at Northwestern University School of Law. They have two sons and are raising the son of Kathy Boudin, who is in prison for her participation in the Brink's robbery.

Bob Dylan (b. 1941), the most significant popular musician and songwriter of the 1960s, was born Robert Zimmerman in Duluth, Minnesota. He left Minnesota for Greenwich Village in 1961, and the following year legally changed his name and made his first album, *Bob Dylan*, which consisted mostly of folk standards. His next two albums, *The Freewheelin' Bob Dylan* (1963) and *The Times They Are a-Changin'* (1964), established him as the voice of a generation. In 1965 he began using an electric guitar and ushered in folk rock. *Highway 61 Revisited* (1965) and *Blonde on Blonde* (1966) are widely considered to be perhaps the best rock albums of the decade. In 1968, he released *John Wesley Harding*, a spare, acoustic recording that anticipated country rock. He spent several years in semiretirement, and then made an album, *Blood on the Tracks* (1975), that is among his best, and that inaugurated an ambitious tour he called the Rolling Thunder Revue. He has continued to tour regularly, and to record. In 1988 he was inducted into the Rock and Roll Hall of Fame. In 1997 he was the recipient of a Kennedy Center Award for the Performing Arts. In 1998 his album *Time Out of Mind* won a Grammy for album of the year.

Eric Emerson (? –1975), a dancer from New Jersey who began to hang out at the Warhol Factory in 1966, appeared in several Warhol films, including *Chelsea Girls* (1966) and *Lonesome Cowboys* (1968). He was also the lead singer of the Magic Tramps, a glitter-rock band. Early one morning in the spring of 1975 his body was found in the middle of Hudson Street, in Greenwich Village.

Gloria Emerson (b. 1930) reported from South Vietnam from 1970 to 1972. In her earlier posts in Paris and London she covered a wide range of stories, from civil wars in Northern Ireland and Nigeria to French couture. She received a George Polk Award for her reports from Vietnam. She is the author of *Winners & Losers*, a book about the war and its effects on Americans, which won a National Book Award in 1978. She is also the author of *Some American Men* (1985) and *Gaza: A Year in the Intifada* (1991). She taught journalism as an honorary fellow at Princeton University. She has never returned to Vietnam.

Jason Epstein (b. 1928). A prominent editor and book publisher, Epstein founded Anchor Books, the first quality American paperback line. In 1958 he joined Random House and served there in various capacities, including that of editorial director, for over forty years. During a newspaper strike in New York in 1963, he and his then wife, Barbara Epstein, along with their friends Robert Silvers, Elizabeth Hardwick, and Robert Lowell, founded *The New York Review of Books*. Epstein is the author of *The Great Conspiracy Trial* (1970), about the trial of the Chicago Seven.

Bob Fass (b. 1933) invented "free-form radio" in 1963 when he joined WBAI in New York and offered to do a program from midnight to five in the morning. "Radio Unnameable" was born, and soon developed a cult following. Fass talked, entertained guests, and provided a launching pad for Bob Dylan, Arlo Guthrie, Phil Ochs, Patti Smith, and other artists whose voices mingled six nights a week with those of politicians, poets, activists, and anyone who called in with something they wanted to say. Today, Fass lives with his wife and twelve cats on Staten Island and continues to produce "Radio Unnameable."

Jules Feiffer (b. 1929) was born in the Bronx, New York, and attended the Art Students League and Pratt Institute. In 1956 he began publishing cartoons in the *Village Voice*, and two years later published his first book of cartoons, *Sick, Sick, Sick*. His work, which has been nationally syndicated since 1959, is concerned with political satire and social commentary, and has received several prizes, including a special George Polk Award in 1962. In addition to his books of cartoons, he has written novels; screenplays, including *Carnal Knowledge* and *Popeye;* plays, including the Obie Award–winning *Little Murders;* musical revues; and works of nonfiction. In 1986 he was awarded a Pulitzer Prize for editorial cartooning.

Thomas C. Fox (b. 1944) grew up in Milwaukee, Wisconsin, and attended Stanford University on a football scholarship. After graduation he went to Vietnam with the International Voluntary Services. He returned to the United States to study Vietnamese at Yale, and went back to Saigon as a stringer for *The New York Times*. He married a Vietnamese woman, To Kim Hoa, who worked with the Committee of Responsibility, an organization that arranged medical treatment in the United States for injured Vietnamese children. They live in Kansas City, where he is the publisher of the *National Catholic Reporter*. They have three children, one of whom, Catherine, a competitive swimmer, was the first Vietnamese American to win an Olympic gold medal for the United States.

John Froines (b. 1939) is an organic chemist with degrees from Yale and the University of California at Berkeley. He was a community organizer for SDS in the mid-Sixties in New Haven, Connecticut, where he met Tom Hayden and Rennie Davis. His indictment as one of the Chicago Seven included the charge that he taught demonstrators to use incendiary devices. He was acquitted and worked in the antiwar movement until 1973, when he returned to science. He is now a leading expert on toxicology

and exposure assessment and is the director of the Center for Occupational and Environmental Health at UCLA.

The Fugs, the first "underground" rock band, was formed in New York City in 1965 by two poets, Ed Sanders and Tuli Kupferberg, who performed with various back-up musicians in Off-Off-Broadway theaters. The lyrics to their songs were satirical and obscene. They recorded their first album in 1965 and made several subsequent records, including *It Crawled Into My Hand, Honest* (1968) and *Golden Filth* (1970), a compilation of previous work. They disbanded in 1969 but re-formed in 1984 and have continued to record.

R. Buckminster Fuller (1895–1983) was born into a distinguished New England family. He graduated from Milton Academy and went to Harvard, from which he was expelled twice. He served in the Navy during World War I, but resigned in 1919 to be with his young daughter, who had contracted both infantile paralysis and spinal meningitis. She died in 1922. He blamed her death partly on drafty houses, and set about designing houses and developing ideas for improving housing conditions. He developed the concept of what he called synergetic geometry, based on the idea that every aspect of the physical environment is interconnected. In the late Forties he invented the geodesic dome, which was named for the Greek word for the arcs of great circles. The domes took their structural strength from the combined attributes of tetrahedrons and spheres. They brought Fuller wealth and fame. Nearly 300,000 were assembled in his lifetime, including a 250-foot-diameter, twenty-story dome that served as the U.S. pavilion at the Montreal Expo in 1967. Fuller lectured widely on many subjects, including "Spaceship Earth," a term he coined to encourage people to view themselves as passengers on a single-system planet with a common interest in survival. He anticipated current ecological concerns by insisting on building with as little waste of materials as possible. He patented more than two thousand inventions during his lifetime. In 1983 he was awarded the Presidential Medal of Freedom.

Fred Gardner (b. 1941) graduated from Harvard in 1963 and served in the Army. In January 1968 he founded the first G.I. Coffeehouse, the UFO, in Columbia, South Carolina, near Fort Jackson. The UFO (which was a block away from the USO, the official social center for soldiers) was decorated with psychedelic posters and provided music to dance to and a place to read, play cards, or just hang out. It tapped into the growing disaffection among soldiers with the war in Vietnam. The success of Gardner's G.I. Coffeehouse drew the support of the antiwar movement, which began setting up more coffeehouses in towns near military bases. By 1971 there were thirty-four such establishments. Gardner was briefly the stage manager of the FTA Show, an antiwar cabaret organized by Jane Fonda. In the years following the end of the war he had several jobs, including as a writer and a private investigator. Since the mid-1980s he has been the managing editor of the student-run weekly at the University of California at San Francisco Medical Center. He is also involved in the medical marijuana movement.

Art Garfunkel (b. 1942) met Paul Simon when they were sixth-grade classmates in Queens, New York. They started singing together as a team in the mid-Fifties, and recorded as a rock 'n' roll duo, Tom and Jerry. Garfunkel attended Columbia University, where he earned a B.A. in art history and an M.A. in mathematics education. In 1964 he and Simon released their first album as Simon and Garfunkel. It included the hit song "The Sounds of Silence," and their next five albums were best-sellers. In 1970, *Bridge Over Troubled Water* became one of the top-selling pop albums of

all time and won six Grammys. That year Simon and Garfunkel dissolved their partnership. Garfunkel has acted in several films, including *Catch-22* and *Carnal Knowledge*, and has continued to perform and record as a solo artist. In 1982 he and Simon gave a concert together in Central Park in New York. In 1997, Garfunkel's *Songs From a Parent to a Child* received a Grammy nomination. He is married and has a son.

Jean Genet (1910–1986), the celebrated French playwright, novelist, and poet, covered the 1968 Democratic National Convention in Chicago for *Esquire*. He and other writers, including Allen Ginsberg and William Burroughs, addressed about four thousand protestors at a rally at the Chicago Coliseum on August 27, and the next night attempted to lead a nonviolent march that ended in a riot. In 1970, Genet returned to the United States, and lived for two months with members of the Black Panther Party.

Allen Ginsberg (1925–1997) was the leading poet of the Beat Generation of the 1950s, during which he wrote his two best-known poems, "Howl" and "Kaddish." He experimented with LSD; was an early proponent of the sexual revolution; and lived openly as a homosexual. He became a guru to hippies and then to Yippies. He coined the term "flower power" in 1965 and was one of the organizers of the Gathering of the Tribes for a Human Be-In in Golden Gate Park in San Francisco in January 1967. He was arrested that year in New York City at a demonstration against the war in Vietnam. During the 1968 Democratic National Convention in Chicago he tried to calm crowds of demonstrators by chanting Buddhist mantras, and was later tear-gassed. By this time he had begun to preach the superiority of yoga and meditation over drugs. He testified for the defense during the Chicago Seven conspiracy trial. After the war in Vietnam ended, Ginsberg was active in attempts to reform drug laws, protect the environment, and expose government harassment of members of the counterculture. His *Collected Poems* was published in 1985. He received many awards, including the National Book Award in 1973, the Robert Frost Medal for distinguished poetic achievement in 1986, and an American Book Award for contributions to literary excellence in 1990.

Louis Ginsberg (1895–1976) was born in Newark, New Jersey, and attended Rutgers College and Columbia University. He wrote his first poem in high school, won a poetry prize at Rutgers, and continued to write poems all his life. He taught English at Central High School in Paterson, New Jersey, from 1921 to 1961, and when he retired became adjunct associate professor of English at Rutgers. His poems were widely anthologized and he published three collections of poetry. In his later years he frequently gave readings with his eldest son, Allen Ginsberg.

Juan Gonzalez (b. 1947) was a member of the Students for a Democratic Society and a leader of the student strikes at Columbia University in 1968. He was one of the founders of the Young Lords Party. He married another member of the party, Gloria Fontanez, a Puerto Rican who had previously worked as a health care worker. She became the leader of the group after it became the Puerto Rican Revolutionary Workers Organization in 1972, and the objections of former leaders to her violent tactics led to the group's demise. Juan Gonzalez was divorced from Gloria. He is a columnist at the New York *Daily News* and co-host of the Pacifica Radio program "Democracy Now." In 1999 he won a George Polk Award for journalism for his columns on New York's poor and disenfranchised.

Carolyn Goodman (b. 1915) is the mother of Andrew Goodman, a twenty-year-old civil rights worker who was murdered in Mississippi in 1964

during the Freedom Summer voter registration drive. Andrew Goodman had attended private schools in New York and was an anthropology student at Queens College. Prior to volunteering to work at a Freedom School in the South with the Student Nonviolent Coordinating Committee, he had worked as a counselor for inner-city children and had lived with poor coal miners in West Virginia. He had been in Mississippi for only a day when he and Michael Schwerner and James Chaney were murdered by Ku Klux Klan members who stopped their car on a deserted road at night and shot and killed them, then bulldozed their bodies into an earthen dam. (See the entries under Fannie Lee Chaney and Anne Schwerner.) At the end of his funeral service at the Ethical Culture Society in New York, his mother, Mrs. Chaney, and Mrs. Schwerner filed out of the building together, with arms linked. A traditional Jewish graveside service was held at the Mount Judah Cemetery at Cypress Hills, Brooklyn. Carolyn Goodman was a psychologist in New York. She is now the president of the Andrew Goodman Foundation, which was established in 1966.

André Gregory (b. 1934) grew up in New York City. He studied at Harvard and with Martha Graham and Sanford Meisner at the Neighborhood Playhouse in New York, and later with Jerzy Grotowski and Lee Strasberg. In the Sixties he directed and produced plays in Off-Broadway theaters in New York as well as in theaters in Seattle, San Francisco, Philadelphia, and Los Angeles. In 1970 he founded The Manhattan Project, a theatrical company designed to develop new training techniques for American actors. The company's production of *Alice in Wonderland* received an Obie and a Drama Desk Award. Gregory has acted in several plays and films, including *My Dinner with André* (1981), which he co-wrote with his co-star, Wallace Shawn. He directed *Vanya on 42nd Street* in 1990. He is an actor, and he lectures and teaches acting.

Gus Grissom (1926–1967) was born in Mitchell, Indiana. He received a degree in mechanical engineering from Purdue University and enlisted in the Air Force. Grissom flew a hundred combat missions during the Korean War and later became a fighter test pilot. In April 1959 he was one of the first astronauts chosen for the Mercury program, the first American effort to put humans in space. In 1961 he flew the second Mercury mission, during which the spacecraft was lost after splashdown. Grissom commanded the first manned Gemini mission in 1965, and was chosen to command the first manned mission of the new Apollo spacecraft, but on January 27, 1967, twenty-five days before the scheduled liftoff, a fire broke out inside the command module during a test, and Grissom and two other astronauts were asphyxiated. They were the first casualties of the American space program. Two years later Apollo 11 carried Neil Armstrong and Edwin Aldrin to the moon.

James Groppi (1930–1985), the son of a first-generation Italian immigrant, grew up in Milwaukee, Wisconsin. He became a priest in 1959 and in the early Sixties was assigned to a parish in a primarily black neighborhood of Milwaukee. He became involved in civil rights activities, and went to Mississippi to assist with voter registration programs. In 1965 he marched with Martin Luther King, Jr., in Montgomery, Alabama. When he returned to Milwaukee he increased his civil rights activities, in connection with which he was arrested more than a dozen times. One of his primary activities was a successful campaign to pass an open-housing ordinance. He later worked for welfare reform and Native American rights, and actively protested the war in Vietnam. His relationship with the Church was often strained. He was married in 1976 and subsequently excommunicated. He became a bus driver in Milwaukee and the president of the bus drivers' union.

Nancy Grossman (b. 1940) grew up on a dairy farm in New York State and attended Pratt Institute. Her work includes collage, painting, drawing, assemblage, wood carving, and bronze. She had exhibited primarily figurative drawings and paintings before 1969, when a show of carved heads encased in leather and adorned with industrial metal hardware gained attention. She has subsequently exhibited her two- and three-dimensional works widely and has received many awards.

Pablo Guzman (b. 1950) was a founder of the Young Lords Party and its minister of information. He left the group in 1975 and became a journalist. He is now an Emmy-award winning news reporter at WCBS-TV in New York.

George Harrison (b. 1943) was the lead guitarist for the Beatles. He also sang and composed many of the group's best-known songs, including "While My Guitar Gently Weeps" and "Here Comes the Sun." He became interested in Eastern religions, and played a sitar on the *Rubber Soul* album (1965). In 1970, following the breakup of the Beatles, Harrison recorded a three-record set, *All Things Must Pass*, which was the number one album on the charts for six weeks. In 1971 he organized two highly successful concerts to benefit the starving population of Bangladesh. He continued to record, and in the late Eighties joined Bob Dylan and others on the best-selling *Traveling Wilburys* album.

Tom Hayden (b. 1939) grew up Catholic in a largely Protestant working-class neighborhood outside of Detroit. He attended the University of Michigan at Ann Arbor, where he was the editor of the student newspaper and where, in 1962, he drafted a manifesto for the fledgling Students for a Democratic Society (SDS). Known as the Port Huron Statement (it was introduced at an SDS convention in Port Huron, Michigan), it became a classic document in the history of the New Left. The manifesto attacked the cold war, racism, and bureaucracy and advocated "participatory democracy" and a decentralized government. Hayden became the first president of SDS and helped establish the Economic Research and Action Project (ERAP), which set up grassroots community organizations in poor areas of the North. He directed an ERAP group in Newark, New Jersey, and after the Newark riots in 1967 came to believe that the problems of the inner cities were connected to the politics of war. He made several trips to Southeast Asia to establish contact between the North Vietnamese and the American peace movement. In 1968 he and Rennie Davis were project directors for the National Mobilization Committee to End the War in Vietnam (Mobe), which organized demonstrations during the Democratic National Convention in Chicago. Both men were indicted as conspirators and were members of the Chicago Seven. In 1972, after his conviction for inciting to riot was reversed on appeal, Hayden and Jane Fonda traveled across the United States working for the Indochina Peace Campaign. They were married in 1973. In 1975 Hayden failed in an attempt to become the Democratic candidate for U.S. senator from California, but in 1982 he won a seat in the state assembly, representing the Santa Monica district. In 1989, Hayden and Fonda were divorced. In 1992 he won the state senate seat representing the region stretching from Malibu to the San Fernando Valley and including Beverly Hills and Hollywood. In 1996 he was a delegate to the Democratic National Convention in Chicago.

Levon Helm (b. 1942) was born in Arkansas, where he learned to play the guitar when he was eight. He was for many years the drummer for The Band, and after the group disbanded in 1976 he made solo records as well as collaborating with other musicians. He published his autobiography, *This Wheel's on Fire*, in 1993.

Ho Chi Minh (1890?–1969) was born Nguyen That Thanh in the village of Kim Lien in central Vietnam, which was then part of French Indochina. He adopted the nom de guerre Ho Chi Minh (He Who Enlightens) in the early 1940s, when he was in China training Vietnamese nationalist guerrilla forces. Ho had been exposed to anticolonial revolutionary activities from an early age. He left Vietnam in 1912 and traveled around the world, living for a time in New York and Boston before settling in Paris, where he became convinced that the liberation of Vietnam from colonialist rule lay through Communism. He was one of the founders of the French Communist Party and was its adviser on colonial affairs. Ho signed his writings during this period "Nguyen the Patriot." He spent two years in the Soviet Union in the mid-Twenties studying revolutionary techniques, and was the director of the Asian bureau of the Communist International in Shanghai in the late Twenties and early Thirties. By this time he had begun recruiting Vietnamese political refugees for a guerrilla force intended to liberate Vietnam, and he was sentenced to death in absentia by French authorities. In 1930 he established the Communist Party of Indochina. His forces infiltrated northern Vietnam, where they staged an abortive peasant revolt. During most of the Thirties Ho moved clandestinely through Southeast Asia, coordinating revolutionary activities. After the outbreak of World War II, when much of the area was occupied by the Japanese, he went to south China, where he founded the Vietnamese Independence League, popularly known as the Viet Minh. Late in 1944 he returned to Vietnam and organized his guerrillas into formal military units. During the latter stages of the war the Viet Minh worked closely with the United States, rescuing downed American fliers and furnishing intelligence information to the Office of Strategic Services. In August 1945 they seized Hanoi, and in September Ho Chih Minh proclaimed the Democratic Republic of Vietnam. He was elected president in nationwide elections the following year. A liberal constitution was adopted, modeled to an extent on that of the United States. The French were unwilling to give up Vietnam entirely, however, and in December 1946 Ho called for a "national war of resistance." In 1954, following the defeat of the French at Dien Bien Phu, an international conference in Geneva declared a cease-fire and divided Vietnam at the seventeenth parallel. The final declaration of the conference provided for elections to settle the future of the country, although the United States and the anti-Communist government of South Vietnam refused to agree to this. In 1960, a new constitution gave Ho Chih Minh almost unlimited powers in the Democratic Republic of Vietnam in the north. Citing the continued refusal by the South Vietnamese to permit the elections specified in the Geneva agreement, Ho supported the Vietcong Communist resistance. The United States sent military aid and advisers to assist the South Vietnamese government, which until 1963 was headed by Ngo Dinh Diem, and over the years the military commitments on both sides multiplied and the war escalated. Ho Chih Minh continued to contend that Vietnam was a single nation and that the United States was violating the Geneva agreement by supporting Diem and preventing reunification. He demanded the withdrawal of American troops from Vietnam and recognition of the Vietcong as a legitimate power in South Vietnam. Supplies from Hanoi were sent south through jungle routes that were known as the Ho Chi Minh Trail. A few weeks before his death in September 1969, Ho again rejected American peace proposals.

Abbie Hoffman (1936–1989) grew up in Worcester, Massachusetts, and attended Brandeis University and the University of California at Berkeley, where he studied psychology. He was the publicity director for the Worcester branch of the National

Association for the Advancement of Colored People and, later, chairman of the local chapter of the Congress of Racial Equality. He then became field secretary for the Student Nonviolent Coordinating Committee. In 1964 he was arrested for taking part in the Freedom Summer in Mississippi, and in 1966 he moved to the East Village in New York City, where he opened Liberty House, a store that sold handbags, dolls, and dresses made by a cooperative owned and run by blacks in the South. He was soon involved in hippie culture and specialized in staging "happenings," like the event in the spring of 1967 in which dollar bills were thrown onto the floor of the New York Stock Exchange. Later that year he led anti-war protestors who surrounded the Pentagon and attempted to levitate it. He helped found the Yippie movement, and during the protests that took place at the 1968 Democratic convention in Chicago he was arrested for having the word "fuck" on his forehead. In his testimony at the trial of the Chicago Seven he explained that he was "tired of seeing my picture in the paper and I know if you got that word, they aren't going to print your picture in the paper and it also summed up my attitude about what was going on in Chicago." Hoffman was released on bail following his conviction in the Chicago trial. In 1971 he and his wife Anita had a son who they named america. In 1972 an appeals court overturned the Chicago Seven convictions, but the following summer Hoffman was arrested for participating in the sale of three pounds of cocaine to undercover agents. He spent six weeks in prison before raising bail, and in late February 1974, before his trial began, he disappeared. He had plastic surgery to alter his appearance and lived for a while in Mexico and Canada, eventually moving to a remote hamlet in northern New York, the home of his companion, Johanna Lawrenson. He lived there as Barry Freed, a writer and activist in the campaign to protect the St. Lawrence River from destructive dredging by the Army Corps of Engineers. In 1980, explaining that his cover was about to be blown, he appeared on television with Barbara Walters and identified himself. He was sentenced to three years in prison on the drug charges and for jumping bail. When he got out of prison, he became a lecturer on college campuses. He was the author of several books, including *Revolution for the Hell of It* (1968) and *Soon to Be a Major Motion Picture* (1980). He committed suicide in 1989.

Tom Hompertz met Andy Warhol in 1967 when Warhol gave a lecture in San Diego, California. Hompertz was a surfer, and he appeared in a movie Warhol was working on, *San Diego Surf*. It was never released. He had a part in *Lonesome Cowboys*, which was filmed in Arizona in December 1967 and January 1968.

Joe Hooper (1940–1979) was the most decorated soldier of the Vietnam War. A staff sergeant, he received thirty-seven citations, including the Medal of Honor, two Silver Stars, and eleven Purple Hearts. After retiring from the Army, Hooper suffered increasingly from alcoholism and post-traumatic stress syndrome. He died as the result of a fall suffered in a Louisville, Kentucky, hotel room while attending the Kentucky Derby.

Garth Hudson (b. 1937) learned to play the accordian and organ when he was growing up in London, Ontario, and is a classically trained musician. He formed a rock group in Detroit in the early Sixties and then became the keyboard player for The Band. Since the breakup of the group he has played with other musicians and produced records.

Richard Hughes (b. 1943) graduated from Carnegie-Mellon University in Pittsburgh and received a conscientious objector deferment from his draft board. He went to Vietnam as a free-lance journalist, and took up the cause of the indigent children who lived on the streets of

Saigon. He established "Shoeshine Boys" shelters where they could live and learn trades. Hughes raised funds to support the shelters and was assisted by Asian Christian Services volunteers. By the time the war ended there were eight such shelters in Saigon and Danang. Hughes was forced to leave Vietnam in 1976. He returned to the United States, where he works as an actor. He successfully campaigned for the release from prison in Saigon of two Vietnamese colleagues who had worked closely with him on the Shoeshine Boys project.

Anjelica Huston (b. 1951), the daughter of the director John Huston, grew up in a Georgian mansion in Ireland. When she was sixteen her father cast her as the lead in his film *A Walk with Love and Death*, but she did not seriously pursue a career as an actress until the 1980s. She was a model in the early Seventies. In 1985 she won an Academy Award for best supporting actress for her role as a mafia princess in *Prizzi's Honor*, which was directed by her father. She has appeared in many films and in 1996 directed *Bastard Out of Carolina*, a film made for cable television based on the novel by Dorothy Allison.

Lauren Hutton (b. 1943) grew up in Florida and moved to New York City in the mid-Sixties. She became a model, and with the support of Diana Vreeland, the editor of *Vogue*, established one of the most successful fashion careers of the period. She appeared on more than two dozen *Vogue* covers. She has acted in many films, produced TV documentaries, and hosted and produced a cable television interview program and a series about the arts. She continues to work as a model.

The International Society for Krishna Consciousness was founded in the United States in 1965 by Bhaktivedanta Swami Prabhupada, a follower of a religion that regards the Hindu god Krishna as the supreme deity. Members of the group were known as Hare Krishnas because of the first two words of their principal mantra. During its early years, the organization was supported through the sale of incense. George Harrison gave them a mansion near London and recorded "My Sweet Lord," which featured their mantra. The group's head office is in Los Angeles, and they claim a million members worldwide.

Peter Jay (b. 1940) served as a volunteer in the Peace Corps in Peru in the early Sixties. He became a reporter for *The Washington Post* in 1965 and was the paper's bureau chief in Saigon from 1970 to 1972. When he returned from Vietnam he was awarded a Nieman Fellowship at Harvard. He was for many years a columnist for the *Baltimore Sun* and is now a freelance journalist and a farmer.

Jay Johnson (b. 1948) and his twin brother, Jed, met Andy Warhol in 1968, after Jed delivered a telegram to the Factory on Union Square. They became part of the Factory group, and Jed was Warhol's companion and housemate for most of the Seventies. Jay became a model. Jed became an interior designer, and in 1984, Jay joined his brother's company, Jed Johnson and Associates. Jed was killed in the crash of TWA Flight 800 in 1996, and Jay became president of the company.

Janis Joplin (1943–1970) grew up in Port Arthur, Texas. In the early Sixties she began singing folk music in coffeehouses in Beaumont and Houston, and in 1966 moved to San Francisco, where she joined the band Big Brother and the Holding Company. Joplin developed a raucous, blues-based singing style, and her appearance with Big Brother at the Monterey International Pop Festival in 1967, where she sang a version of Big Mama Willie Mae Thornton's "Ball and Chain," received both critical and popular acclaim. The following year the band's album *Cheap Thrills* rose to number one on the charts. Joplin left Big Brother and formed

two successive bands, the Kozmic Blues Band and the Full-Tilt Boogie Band. She died of a heroin overdose while she was recording *Pearl*, which was the number one best-selling rock album for nine weeks in 1971. Joplin was inducted into the Rock and Roll Hall of Fame in 1995.

Larry Josephson (b. 1939), who was a ham radio operator when he was a teenager in Los Angeles, volunteered to work as an audio engineer at WBAI in New York in 1964. In the spring of 1966 he was given his own show, "In the Beginning," which was slotted early in the morning. Instead of sunny, happy, morning radio, Josephson came on "pissed off, half-asleep, and late." He described himself as "the angry music man," and is widely credited with influencing the style of Howard Stern and other contemporary radio hosts. In 1977, Josephson established the Radio Foundation, which produces public radio programs.

Lothar B. Kalinowsky (1899–1992) was born in Berlin. He fled Germany in 1933 and went first to Italy and then to New York, where he practiced psychiatry and neurology for more than forty years. He was a leading proponent of electroshock therapy and the author of an influential textbook, *Shock Treatments and Other Somatic Procedures in Psychiatry* (1946).

Nicholas Katzenbach (b. 1922), a former Rhodes scholar and professor of law at the University of Chicago, accepted a job in the Justice Department in 1961, shortly after John F. Kennedy was inaugurated as president. He was the deputy attorney general when riots broke out at the University of Mississippi following James Meredith's attempt to register as a student there, and Katzenbach directed the U.S. marshals trying to restore order. In 1963 he escorted two black students onto the campus of the University of Alabama, despite Governor George Wallace's attempts to block their enrollment. He became the attorney general in 1964, following Robert F. Kennedy's resignation to run for the U.S. Senate, and played a key role in getting the 1964 Civil Rights Act passed in Congress and in drafting voting rights legislation in 1965. He was made undersecretary of state in 1966. After his resignation in 1969 he served as a senior vice president and general counsel for IBM.

Florynce Kennedy (b. 1916) was born in Kansas City, Missouri. In 1944, when she was twenty-eight, she entered Columbia University, and in 1951 received a law degree. She handled the estates of Billie Holiday and Charlie Parker, and was an early civil rights activist. In 1966 she founded the Media Workshop to confront racism in media and advertising. She was a founding member of the National Organization for Women, and in 1972 formed the Feminist Party to support Shirley Chisholm, a black congresswoman from Brooklyn, New York, who was a candidate for president. She also represented Valerie Solanas, the woman who shot Andy Warhol. She was for many years a popular lecturer at colleges and universities. Her autobiography, *Color Me Flo: My Hard Life and Good Times*, was published in 1976.

Rose Kennedy (1890–1995) was the daughter of John "Honey Fitz" Fitzgerald, a politician who became mayor of Boston. As a young woman she was active in settlement social work. In 1914 she married Joseph Kennedy, who earned a fortune in banking, real estate, liquor distribution, film production, and the stock market, and served as ambassador to Great Britain in the late Thirties. They had nine children. Her eldest son, Joseph Kennedy, Jr., died in World War II. One of her daughters, Kathleen Kennedy, died in a plane crash in 1948. Two of her sons, President John F. Kennedy and Senator Robert Kennedy, were assassinated. In 1952 Pope Pius XII named her a papal countess in recognition of her exemplary

Catholic life and her contribution to charities. She had thirty grandchildren and forty-one great-grandchildren.

Martin Luther King (1897–1984) was born Michael King in Stockbridge, Georgia. The son of an impoverished sharecropper, he became a Baptist preacher when he was fifteen. He received a degree in theology from Morehouse College in 1930 and a year later became pastor of the Ebenezer Baptist Church in Atlanta. The previous pastor had been his father-in-law, A. D. Williams. He attended a Baptist convention in Germany in 1934, and on his return changed his name to Martin Luther King. He was a leader of the Atlanta branch of the National Association for the Advancement of Colored People, and in 1957 joined the board of the Southern Christian Leadership Conference, which was led by his son, Martin Luther King, Jr. The elder King's endorsement of John Kennedy in the 1960 presidential race is considered a crucial element in JFK's victory over Richard Nixon. After his older son was assassinated in 1968, his younger son, A.D., became co-pastor of Ebenezer Baptist Church. A.D. drowned in 1969. Reverend King's wife was murdered by a deranged gunman in 1974 as she played the organ in the church. King retired a year later.

Martin Luther King, Jr. (1929–1968), was ordained as a Baptist minister during his final year at Morehouse College in Atlanta. After receiving a doctorate in theology from Boston University in 1955, he became the pastor of a congregation in Montgomery, Alabama. He was active in the non-violent civil rights movement there, and in 1957 founded the Southern Christian Leadership Conference. In 1960 he became co-pastor, with his father, of the Ebenezer Baptist Church in Atlanta. He was arrested several times during demonstrations protesting segregation policies, and a widely quoted letter that he wrote while in jail in Birmingham, Alabama, was influential in encouraging President Kennedy to introduce major civil rights legislation. On August 28, 1963, King gave his famous "I have a dream" speech during a huge civil rights demonstration in Washington, D.C. He received the Nobel Peace Prize the following year. By 1966 his political philosophy was challenged by Black Power leaders, who derided his insistence on nonviolent protest and alliances with white groups. King became involved in the movement against the war in Vietnam, and in 1967 announced the formation of the Poor People's Campaign. Early in April 1968 he was in Memphis, Tennessee, to support a sanitation workers' strike when he was assassinated. In 1986, Dr. King's birthday was made a federal holiday.

Martin Luther King III (b. 1957), the second child of Martin Luther King, Jr., and Coretta Scott King, is president of the Southern Christian Leadership Conference, which was founded by his father.

Henry Kissinger (b. 1923) was born into a cultured, devoutly Jewish family in Bavaria. They immigrated to the United States in 1938, and Kissinger attended school in New York City and served in the U.S. Army. He received a doctorate from Harvard in 1954 and taught government there for many years. His first book, *Nuclear Weapons and Foreign Policy* (1957), was influential in the diplomatic community, and he became an adviser at the highest levels of government. He was President Johnson's emissary in secret meetings in Paris with North Vietnamese diplomats that led to the opening of peace talks in 1968. He became President Nixon's principal foreign policy adviser, and shared the Nobel Peace Prize in 1973 with Le Duc Tho, the chief negotiator for North Vietnam, after they successfully concluded a cease-fire agreement. He was secretary of state from 1973 to 1977. Following his retirement from government service he founded Kissinger Associates, a consulting firm.

Paul Krassner (b. 1932) attended City College in New York and wrote for *Mad* magazine and *The Steve Allen Show*. He founded *The Realist* in 1958 and was its publisher and editor until 1974. He then suspended publication until 1985, when the magazine began to appear again. The most notorious piece published in *The Realist* was probably "The Parts Left Out of the Kennedy Book," which appeared in 1967. It purported to be a censored chapter of William Manchester's biography of President Kennedy and claimed, as Krassner later put it, that "an act of presidential necrophilia had taken place." Krassner was one of the founders of the Yippie movement, and he edited Lenny Bruce's autobiography, *How to Talk Dirty and Influence People*. In the late Seventies he was the editor of *Hustler* magazine, and later hosted radio shows and wrote for television and magazines. He performs stand-up comedy and is the author of *Confessions of a Raving, Unconfined Nut: Misadventures in the Counterculture* (1993) and *The Winner of the Slow Bicycle Race: The Satirical Writings of Paul Krassner* (1996).

William Kunstler (1919–1995) graduated from Columbia Law School in 1948 and opened a private practice in New York. In the Fifties he began representing civil rights clients, and in the early Sixties the American Civil Liberties Union asked him to serve as a pro bono counsel to the Freedom Riders in Jackson, Mississippi, who were challenging racially segregated facilities in the South. He became what he called "a special trial counsel" to Martin Luther King, Jr., and represented Nathan Schwerner, the father of Michael Schwerner, one of three civil rights workers murdered near Philadelphia, Mississippi, in 1964. In addition to his civil rights clients, he represented Lenny Bruce, Jerry Rubin, Abbie Hoffman, Father Daniel Berrigan, and the Black Panther Party. He was the lead defense attorney in the Chicago Seven conspiracy trial, at the end of which Judge Julius Hoffman charged him with 160 counts of contempt, although an appeals court overturned virtually all of the citations. In 1989 he successfully argued against the constitutionality of a Texas law punishing flag burning. His books include his autobiography, *My Life as a Radical Lawyer* (1994).

Tuli Kupferberg (b. 1923) is a poet and one of the founders of The Fugs. He wrote many of the group's songs, including "Kill for Peace." He made solo albums in the late 1960s and has continued to record his own work intermittently, as well as to work with Ed Sanders on Fugs albums. He is the author of several books, including *Teach Yourself Fucking: Cartoons and Collages* (1999), and is the producer and host of a cable television program, *The Revolting News Show*.

R. D. Laing (1927–1989) was born in Glasgow, Scotland, and received a medical degree from Glasgow University in 1951. He was trained as a psychoanalyst but became an outspoken critic of traditional approaches to madness. His first book, *The Divided Self*, which was published in 1960, established him as a leader of the English "antipsychiatry" movement. Early in his career he questioned the belief in a genetic or biological origin of schizophrenia, suggesting that it was a response to extreme internal conflicts, often within the family. He experimented with the therapeutic use of mescaline and LSD and established a therapeutic community, Kingsley Hall, in London, where patients and the medical staff lived and worked democratically. His books include *The Self and Others* (1961), *Sanity, Madness, and the Family* (1964), *The Politics of Experience* (1967), and *The Politics of the Family* (1969).

Jonathan Larsen (b. 1940) received a master's degree from Harvard in 1963 and became a correspondent for *Time* magazine. He was *Time's* bureau chief in Saigon in 1970 and 1971, and then an editor at *Time*, *New Times*, and *Life*, and a Nieman fellow at Harvard. From 1989 to 1994

he was editor in chief of the *Village Voice*. He was divorced from his first wife, Wendy Wilder Larsen, and is married to the editor Jane Amsterdam. He serves on the editorial board of the *Columbia Journalism Review* and is the chairman of the editorial board of the *Amicus Journal*, which is published by the Natural Resources Defense Council.

Wendy Wilder Larsen (b. 1940) received a master's degree from Harvard in 1963. In 1967 she married the journalist Jonathan Larsen, and accompanied him to Vietnam when he was the bureau chief for *Time* magazine in 1970 and 1971. She taught English literature in Saigon, and in 1986 co-wrote, with Tran Thi Nga, *Shallow Graves*, a verse novel that describes Larsen's experiences in Vietnam and Tran Thi Nga's life story. She contributes to several periodicals, is a member of the program committee of the Museum of Modern Art, and is on the board of the Poets and Writers organization and the Open Space Institute.

Jonathan Lear (b. 1948) was a sophomore history major at Yale in 1967 when he covered the March on Washington to protest the war in Vietnam for the *Yale Daily News*. Shortly thereafter he joined the staff of the *New Journal*, an alternative political and cultural magazine, and in 1968 became its editor. He graduated from Yale in 1970 and went to Cambridge, where he got a degree in philosophy. He became a member of the Yale faculty in 1985 and began training as a psychoanalyst. In 1996 he joined the Committee on Social Thought at the University of Chicago. His books include *Open Minded: Working Out the Logic of the Soul* (1998), and *Love and Its Place in Nature: A Philosophical Interpretation of Freudian Psychoanalysis* (1990).

Gerald Lefcourt (b. 1942) graduated from Brooklyn Law School in 1967. He worked briefly for the Legal Aid Society, and then joined five other lawyers to form a group called the Law Commune, which pooled fees and drew salaries according to need. In April 1969, Lefcourt took on the case of a group of men and women, most of them members of the Black Panther Party, who had been indicted for conspiring to blow up department stores, railroads, police stations, and the New York Botanical Gardens. Twenty-one people were implicated in the case, and the accused were known as the Panther 21, although only thirteen people were tried. The trial lasted for eighteen months, but the jury took only two hours to acquit the defendants of all 156 charges. Lefcourt has had a private law practice in New York since 1971. He is a past president of the National Association of Criminal Defense Lawyers and a recipient of the Thurgood Marshall Lifetime Achievement Award.

John Lennon (1940–1980) was, along with Paul McCartney, the principal songwriter for the Beatles. His compositions include "Strawberry Fields Forever," "Lucy in the Sky with Diamonds," and "A Day in the Life." In 1963 he married Cynthia Powell, a classmate at the Liverpool College of Art, and they had a son, Julian. They were divorced and in 1969 he married the conceptual artist Yoko Ono. The following year the Beatles broke up. He recorded many songs with his wife, including the anthem "Give Peace a Chance." Lennon took a five-year hiatus from music starting in 1975, when his son Sean was born, and resumed recording in 1980. He was working on the posthumously released *Double Fantasy* album when he was murdered in New York by a deranged fan.

Julius Lester (b. 1939) was born in St. Louis, Missouri. His father was a Methodist minister. In 1960 he graduated from Fisk University in Nashville and soon became active in the civil rights movement. He worked as a photographer for the Student Non-Violent Coordinating

Committee during voter registration drives in the South. In 1968 he began producing a show on WBAI Radio in New York called "The Great Proletarian Cultural Revolution," and became embroiled in a controversy when he broadcast an anti-Semitic poem written by a teenager. That year he also published his first book, *Look Out Whitey! Black Power's Gon' Get Your Mama!* In 1971 he became a tenured professor of Afro-American Studies at the University of Massachusetts at Amherst. In 1982 he converted to Judaism, and he is now a professor of Judaic and Near Eastern Studies. He is the author of many books, including novels and collections of poems and folktales, and contributes essays and reviews to numerous magazines and newspapers.

The Living Theatre. Inspired by Antonin Artaud, Paul Goodman, and Wilhelm Reich, and aiming to create "a revolution disguised as theater," Julian Beck and his wife, Judith Malina, founded the Living Theatre in 1949. Their work was politically and artistically confrontational. In "The Rite of Universal Intercourse," for instance, a section of the four-and-a-half-hour production of *Paradise Now,* naked actors piled on top of one another, undulating and embracing. The audience was invited to join them, and the evening often climaxed with spectators and actors running into the street in various forms of undress. The group's commitment to anarchy and pacifism led to conflict with the U.S. government, and in 1963 the IRS seized the Theatre's New York loft in lieu of back taxes. For twenty years the group lived in exile in Europe, where they were hailed as cultural icons and occasionally arrested. Their communal lifestyle and "outrageous" performances came under intense critical and police scrutiny during a tour of the United States in 1968. In the early 1980s, Beck worked as a character actor in Hollywood films to support the group. He died of colon cancer in 1985, at the age of sixty.

Don Luce (b. 1934) grew up on a dairy farm in Vermont and received a master's degree in agriculture from Cornell University in 1958. He became the director of the International Voluntary Services (IVS) in Vietnam in 1960, and resigned in 1967 to protest the American government's defoliation policies and the bombing of refugees. In 1969 he was the co-author of *Vietnam: The Unheard Voices.* His apartment in Saigon had become a refuge for dissident Vietnamese students, and in 1970 he introduced one of them to Tom Harkin, a visiting American congressional aide who was looking for the infamous "tiger cages" where opponents of the South Vietnamese government were tortured. The student drew a map of Con Son prison showing where the tiger cages were located, and Luce and Harkin convinced two congressmen to conduct an inspection there. Luce was expelled from Vietnam for this. He worked as the director of the Asian Resource Center until 1991, when he became the director of the IVS. He now works with the homeless and mentally ill at a community mission in Niagara Falls, New York, and goes back to Vietnam almost every year, where he is in charge of the IVS AIDS Program.

Paul McCartney (b. 1942) was the bass guitar player and, with John Lennon, lead vocalist and principal songwriter for the Beatles. His compositions include "Penny Lane," "Eleanor Rigby," "Let It Be," and "Yesterday." Following the breakup of the Beatles in 1970, he formed another band, Wings, with which he toured and recorded until 1980. His wife, Linda Eastman, sang and played keyboards for Wings. He made a series of successful solo albums after Wings disbanded, and in 1991 his first classical composition, *Liverpool Oratorio,* was performed. He was knighted in 1997 and inducted into the Rock and Roll Hall of Fame in 1999.

David McReynolds (b. 1929) graduated from UCLA in 1953 with a degree in political science. In 1957 he joined the staff of *Liberation* magazine, and three years later went to work for the War Resisters League (WRL), a pacifist group formed in 1923. Throughout the Sixties the WRL organized antiwar demonstrations, assisted in the burning of draft cards, promoted acts of civil disobedience at Army induction centers, and aided men who resisted the draft. In 1969, McReynolds published a collection of political writings, *We Have Been Invaded by the 21st Century,* which included an essay in which he gave an account of his homosexuality. He continued to work as a leader of the WRL, which trains people in methods of civil disobedience, publishes pacifist literature, and organizes community groups. He retired in 1998.

Norman Mailer (b. 1923) grew up in Brooklyn and attended Harvard, where he received a degree in engineering in 1943. He served as an infantryman in the Philippines, and when he was discharged from the Army he wrote his first novel, *The Naked and the Dead* (1948), which became a best-seller. He continued to write novels, but he also published essays, including "The White Negro," in 1957, which defined the persona of the existentialist "hipster." In 1960 he wrote a report on the Democratic convention, "Superman Comes to the Supermarket," in which he explored the idea of John F. Kennedy as a heroic character. His report on the march on the Pentagon in 1967 was published as *The Armies of the Night* (1968), and his essays on the Republican and Democratic conventions in 1968 were brought together in *Miami and the Siege of Chicago.* He received a Pulitzer Prize for *The Armies of the Night,* and another one in 1979 for *The Executioner's Song.* He has written ten novels, several volumes of short stories, three plays, a book of poetry, and many volumes of nonfiction.

Gerard Malanga (b. 1943) was central to the running of Andy Warhol's Factory from 1963 until 1968. He assisted in the preparation of silk screens, was a liaison between Warhol and other people, and acted in such films as *Harlot* (1964), *Vinyl* (1965), and *Bufferin* (1966). He was known for his dance with a bullwhip, which he performed on a tour with the Velvet Underground band in the late Sixties. He was a co-founder of *Interview* magazine, and the first archivist of photographs for the New York City Parks Department. He has published twelve volumes of poetry and a book of photographs.

Malcolm X (1925–1965) was born Malcolm Little in Omaha, Nebraska. His father was a Baptist preacher with black nationalist views who was killed in a streetcar accident when Malcolm was six. His mother was declared legally insane eight years later. He was placed in reform schools and foster homes and was sent to prison for theft in 1946. He became known as Malcolm X after he joined the Temple of Islam, later the Nation of Islam, a black nationalist sect led by Elijah Muhammad. He was the group's national representative and second in command, and his forceful oratory brought him a large personal following. Malcolm X was particularly critical of the nonviolent strategy for reform advocated by Martin Luther King, Jr., but he also became increasingly estranged from Elijah Muhammad, and in 1964 broke with the Nation of Islam to form his own group. He repudiated black separatism and attempted to establish ties with civil rights activists. He was assassinated by members of the Nation of Islam. The year after his death *The Autobiography of Malcolm X* was published. It became a best-seller.

Richard Manuel (1943–1986) learned to play the piano as a boy in Ontario, Canada. He was the lead singer, pianist, and a songwriter for The Band. The group disbanded in 1976, but four of its members, including Manuel, reunited in 1983. He committed suicide three years later, after a performance in Florida.

Harry Mattison (b. 1948) worked as an assistant to Richard Avedon, and later was a photojournalist in Central and South America, the Middle East, and South Africa. In 1982 he was one of several foreign journalists targeted for assassination by a right-wing death squad in El Salvador. In 1983 he was awarded the Robert Capa gold medal by the Overseas Press Club. In the late Eighties and early Nineties he spent several years documenting life in an inner-city community in Washington, D.C., and subsequently worked for the Honduran Human Rights Commission. He is married to the poet and human rights activist Carolyn Forche.

Taylor Mead was born in Detroit and studied acting at the Pasadena Playhouse in California. In 1964 he received an Obie for his performance in Frank O'Hara's play *The General Returns from One Place to Another.* He was an early Warhol "superstar," and appeared in a number of Warhol's films, including *Tarzan and Jane Regained…Sort of* (1963), *Taylor Mead's Ass* (1964), *Nude Restaurant* (1967), and *Lonesome Cowboys* (1968). In the Seventies he acted in *Hamlet* with Rip Torn and with Al Pacino in Brecht's *The Resistible Rise of Arturo Ui.* He lives in New York and works primarily in films.

James Meredith (b. 1933) grew up on his family's farm in rural Mississippi. He served for nine years in the U.S. Air Force, and in 1961 applied for admission to the then all-white University of Mississippi. When his application was rejected he filed a suit in federal court saying that he had been rejected because he was black. A court of appeals ruled in his favor, and President Kennedy issued an executive order authorizing the secretary of defense to use armed force if necessary to get Meredith into the school. His appearance on campus in September 1962 sparked riots that left two people dead. In 1966, during a one-man "march against fear" across Tennessee and Mississippi that was designed to encourage black voter registration, Meredith was shot by a would-be assassin. He has lectured widely on civil rights, worked in a brokerage house on Wall Street, and made several attempts to run for public office. In 1989 he was hired to work on the staff of Jesse Helms, the conservative senator from North Carolina. In 1991 he supported the gubernatorial bid in Louisiana of David Duke, the former head of the Ku Klux Klan.

Franklin Millspaugh (b. 1936) helped organize a chapter of SDS at the University of Illinois, where he earned a B.A. in engineering. He moved to New York City and began working at WBAI, an alternative radio station in New York. As the station manager from 1966 to 1970, he recognized the importance of free-form radio and made it the centerpiece of his programming. He has worked with several public radio and television stations and is on the national board of directors of Pacifica Radio.

Dale Minor (b. 1932) was on the staff of WBAI in the Sixties. He was a correspondent for the Pacifica Group, of which WBAI is part, and wrote about the civil rights movement, the Six-Day War, and the war in Vietnam. He covered the Democratic National Convention in Chicago in 1968 and then left Pacifica to write *The Information War* (1970), which is primarily about Vietnam. He was a producer at CBS News for many years, and in 1993 joined the Cronkite Ward Company, which produces the "Great Books" program for the Discovery Channel.

The Mission Council was established in July 1964 by the U.S. ambassador to South Vietnam, Maxwell Taylor, to formalize weekly meetings in Saigon with agency heads and the chief embassy officers. Ellsworth Bunker became the ambassador in 1967, at a time when President Johnson hoped that American involvement in the war would soon

end. Instead, American participation expanded greatly. The chief military officer in Vietnam during this period was General Creighton Abrams, who commanded U.S. forces between 1968 and 1972. The idea behind the establishment of the Mission Council was to increase the embassy's influence, but in fact the war was largely managed in Washington, and in any case the various members of the Mission Council were often at odds with one another.

Paul Morrissey (b. 1939) was introduced to Andy Warhol in 1965 by Gerard Malanga, a mutual friend, and he soon became a key figure in the making of Warhol's films. After Warhol was shot in 1968, Morrissey became the official director of the films and Warhol acted as producer. Morrissey is best known for *Flesh* (1968), *Trash* (1970), and *Heat* (1972). He is the director of several subsequent films, including *Andy Warhol's Frankenstein* (1974), *Forty-Deuce* (1982), *Beethoven's Nephew* (1985), and *Spike of Bensonhurst* (1988).

Louise Nevelson (1899–1988), a pioneer environmental sculptor, was born in Kiev and raised in Rockland, Maine, where her father was in the lumber business. She moved to New York City in 1920 and studied at the Art Students League. She subsequently studied with George Grosz and Hans Hofmann, and in the Thirties worked as an assistant to Diego Rivera when he was preparing his murals for Rockefeller Center. She worked in relative obscurity until the late Fifties, when she was included in a group show at the Museum of Modern Art. The Sixties brought her international fame. She represented the United States at the 1962 Venice Biennale; had shows in Europe, India, Japan, and Iran; and in 1967 was the subject of a major retrospective at the Whitney Museum of American Art. She had several important corporate and civic commissions in the Seventies, including the Louise Nevelson Plaza in lower Manhattan.

Huey P. Newton (1942–1989) was born in Monroe, Louisiana. His father, a poor sharecropper and Baptist preacher, named him after the populist governor of Louisiana, Huey P. Long. He was raised in the Oakland, California, ghetto. In 1966 he and Bobby Seale formed the Black Panther Party for Self-Defense, and the following year Newton was wounded during a gunfight in which a policeman was killed. His arrest precipitated a vociferous "Free Huey" movement, and the Black Panthers gained many new members. A poster of Newton seated in a wicker chair with a spear in his left hand and a rifle in his right was a ubiquitous Sixties icon. Newton was found guilty of manslaughter but released following a successful appeal. In 1971 the party broke into rival factions, and in 1974, Newton fled to Cuba after he was indicted for assault and the murder of a young prostitute. He returned to the United States in 1976 to face the charges, which were dropped. In 1980 he earned a Ph.D. in social philosophy from the University of California at Santa Cruz. He was shot and killed in Oakland by a crack dealer.

Nguyen Ngoc Luong was Gloria Emerson's translator in South Vietnam in the early Seventies. When the war ended, he refused offers to come to the United States. He is a musician.

Rudolf Nureyev (1938–1993) was the first important defector to the West from a Soviet ballet company. He left the Kirov Ballet when it was on tour in Paris in 1961, and soon established what would be a long association with the Royal Ballet Company, and a legendary partnership with the ballerina Margot Fonteyn. He was noted for his charismatic stage presence and extraordinary balletic technique. He did much to popularize ballet in the West and raise the standards of male dancing. Nureyev performed with many companies as a guest artist and appeared in both classical and contemporary ballets as well as in modern dance works. He also staged several ballets, and was the director of the Paris Opera Ballet from 1983 to 1989.

Denise Oliver (b. 1946) joined the Young Lords Party in 1969 and was soon given the rank of minister. In 1971 she left the party to join the Eldridge Cleaver faction of the Black Panthers, which had split with Huey P. Newton, who was seen as too moderate.

Peter Orlovsky (b. 1933) was born into a poor family on the Lower East Side of New York. His father was a Russian immigrant. He was forced to leave home when he was seventeen, and worked at menial jobs before being drafted into the Army. He was sent to San Francisco as a medic, and it was there in 1954 that he met the poet Allen Ginsberg, who became his lover and lifelong companion. In 1957, while they were living in a hotel in Paris, Orlovsky wrote his first poems. In 1970 he moved to a farm in upstate New York. In 1974 he joined the faculty at the Jack Kerouac School of Disembodied Poetics at the Naropa Institute in Boulder, Colorado. He has published three volumes of poetry, including *Clean Asshole Poems and Smiling Vegetable Songs* (1978).

Brigid Polk (b. 1939) was a name used by Brigid Berlin, one of Andy Warhol's closest confidantes. The daughter of a Hearst Corporation president, she had been raised on Fifth Avenue but was estranged from her family by the time she got involved with Warhol. She appeared in a number of his films, most notably *Chelsea Girls* (1966). She lives in New York, where she is working on her memoirs.

Steve Post (b. 1944) grew up in the Bronx, New York. He got a job as the bookkeeper at WBAI and volunteered to do errands for Bob Fass in exchange for watching him produce "Radio Unnameable." He was given his own free-form program, "The Outside," in 1965. It consisted of music interspersed with Post's personal observations, dialogues with friends like the satirist Paul Krassner, and phone calls from the audience. "The Outside" ran on weekend nights for seven years, and for ten years after that Post filled WBAI's morning slot. He hosts a daily "personality and music" program on WNYC.

A. Philip Randolph (1899–1979) was one of the founders of the civil rights movement. The son of an itinerant African Methodist Episcopal preacher, he went to school in Florida and moved to New York when he was twenty-one, where he joined the Socialist Party and became a propagandist for black unionism. He is best known for his nonviolent battle to unionize railroad sleeping car porters. In 1937, as president of the first black union, he successfully fought the Pullman Company for pay increases and shorter hours. He was instrumental in forcing President Truman to racially integrate the U.S. military, and he served as one of the AFL-CIO's first black vice presidents. In 1963 he organized the March on Washington for Jobs and Freedom.

Robert Rauschenberg (b. 1925) was born in Port Arthur, Texas. He was drafted into the Navy and in 1948 went to Paris to study under the G.I. Bill, and then to Black Mountain College in North Carolina and the Art Students League in New York. His first paintings in the early 1950s were a series of all-white and all-black surfaces underlaid with wrinkled newspaper. Much of his early work anticipated the pop art movment. In the mid-Fifties he became associated with the Merce Cunningham Dance Company, first as a designer of costumes and sets and later as a technical director. He also produced theatrical pieces in collaboration with John Cage. In 1964 he was the third American to win first prize for painting at the Venice Biennale. In 1998 the catalog for a retrospective of his work at the Guggenheim Museum called the period since 1950 "the Rauschenberg era."

Robbie Robertson (b. 1944) was the lead guitarist and chief songwriter for The Band. After the breakup of the group in 1976, he became interested in film, and produced and starred in *Carny* (1980). He wrote scores for several films by Martin Scorsese, including *Raging Bull*, *The King of Comedy*, and *The Color of Money*. His albums include *Robbie Robertson* (1987), *Storyville* (1990), and *Contact from the Underworld of Redboy* (1998).

George Lincoln Rockwell (1918–1967) was born in Bloomington, Illinois. He enlisted in the Navy in 1941 and served as an aviator during World War II. After the war he was a commercial photographer, painter, advertising executive, and publisher. He trained naval fighter pilots during the Korean War, and in the early Fifties became convinced that Adolf Hitler's National Socialism was the "new religion." In 1958 he founded the National Committee to Free America from Jewish Domination, and the next year established what would become the American Nazi Party, which remained small throughout the Sixties, although it gained much media attention. In 1966 he renamed his party the National Socialist White People's Party and shifted the focus of propaganda from anti-Semitism to harangues against blacks. He was assassinated in Arlington, Virginia, by a man he had expelled from the party a few months earlier.

Jada Rowland (b. 1943) starred in the soap opera *The Secret Storm* from 1954, when the program was first broadcast, to its close in 1974. Her character, Amy Ames, who was nine years old at the show's inception, experienced two decades of dramatic situations, including teen pregnancy, sexual frigidity, insanity, artificial insemination, and blackmail. In addition to roles in another soap, *As the World Turns*, and the series *The Doctors*, and the short-lived *The Hamptons*, she also appeared on the Broadway stage. In the mid-Eighties she began painting, and is the illustrator of thirteen children's books, including *Miss Tizzy* (1993).

Jerry Rubin (1938–1994), the son of a Cincinnati truck driver and Teamster's Union official, helped organize an antiwar teach-in at the University of California at Berkeley in 1965 that led to the formation of the Vietnam Day Committee, an early and militant voice against the war in Vietnam. In 1966 he ran for mayor of Berkeley on a platform advocating community control of the police and legalization of marijuana. He received 22 percent of the vote. He was a founder of the Yippies, and called his indictment as a co-conspirator in the trial of the Chicago Seven "the Academy Award of protest." In the 1970s, after his conviction for crossing state lines with the intention of starting a riot was overturned on appeal, he became involved in the est movement. In 1976 he published his autobiography, *Growing Up (at 37)*. In 1978 he married Mimi Leonard, a former debutante who worked for ABC-TV in New York. They had two children and were later divorced. In the 1980s he promoted "networking" salons and staged a number of "Yippie vs. Yuppie" debates with Abbie Hoffman. He moved to Los Angeles in 1991, where he marketed Wow, a powdered nutritional drink. He died in November 1994, after having been struck by a car while jaywalking across Wilshire Boulevard.

Ed Sanders (b. 1939) founded *Fuck You: A Magazine of the Arts* in New York in 1962. He wrote editorials for the magazine that supported sexual liberation and the legalization of marijuana and opposed the war in Vietnam. In 1964 he opened the Peace Eye Bookstore on the Lower

East Side, and the following year co-founded The Fugs with Tuli Kupferberg. He was the author of many of the group's songs about politics, drugs, and sex, including "Wet Dream." After a hiatus between 1970 and 1984, he and Kupferberg reformed the Fugs and have continued to record. In 1971, Sanders published *The Family: The Story of Charles Manson's Dune Buggy Attack Battalion*, which became a best-seller. He is the author of many books of poetry, fiction, and essays. He was a visiting professor of language and literature at Bard College in 1979 and 1983 and a Guggenheim fellow in 1983–1984.

Robert Scheer (b. 1936) was born in the Bronx, New York. He studied economics and Chinese in a graduate program at the University of California at Berkeley, and in 1964 traveled to Vietnam on a ticket supplied by Paul Krassner of *The Realist*, who had raised the funds from a sale of red, white, and blue "Fuck Communism" posters. Soon afterward he joined the staff of *Ramparts*, one of the most influential leftist journals of the late Sixties and Seventies. After the magazine's demise in 1975, Scheer wrote for *Esquire*, *Cosmopolitan*, and *Playboy*. From 1976 to 1993 he was a national correspondent for the *Los Angeles Times*, where he is now a contributing editor and syndicated columnist. He is the author of several books, including *Thinking Tuna Fish, Talking Death: Essays on the Pornography of Power* (1988).

Anne Schwerner (1912–1996) was a high school biology teacher in New Rochelle, New York. She was the mother of twenty-four-year-old Michael Schwerner, one of three civil rights organizers who were murdered by the Ku Klux Klan in Mississippi in 1964. Her son was a graduate of Cornell and a field secretary for the Congress of Racial Equality. In January 1964 he and his wife, Rita, established a community center in Meridian, Mississipppi, where they held voter registration classes and taught black children to read and write. In June the Schwerners and a black colleague, James Chaney, went to Oxford, Ohio, to help train volunteers for the voter registration drive that was to be known as Freedom Summer. Michael Schwerner and Chaney returned to Mississippi along with Andrew Goodman, a student they had met in Ohio, to investigate an attack by the Ku Klux Klan on a Methodist church that was to host a Freedom School. The church had been firebombed and members of the congregation beaten. Schwerner, Chaney, and Goodman were murdered late at night as they drove back to Meridian from the church. (See entries for Fannie Lee Chaney and Carolyn Goodman.)

Bobby Seale (b. 1937) grew up in Oakland, California. He served in the Air Force and studied engineering in college before founding the Black Panther Party with Huey Newton. In the summer of 1968 he went to Chicago to address the antiwar demonstrators gathered at the Democratic convention and was later indicted as one of the Chicago Eight, which became the Chicago Seven when his case was separated from the others. He was sentenced to four years in jail for contempt of court, but the sentence was overturned on appeal. In 1973 he ran an unsuccessful grassroots campaign for mayor of Oakland. He is the author of *Seize the Time* and *Barbeque'n with Bobby Seale*. He teaches black studies at Temple University in Philadelphia.

Robert Shaplen (1917–1988) grew up in Philadelphia and received a master's degree in journalism from Columbia University in 1938. He began his career as a reporter for the *New York Herald Tribune*, and covered World War II in the Pacific for *Newsweek*. He joined the staff of *The New Yorker* in 1952, and from 1962 to 1978 was the magazine's Far East correspondent. His books include *Time Out of Hand: Revolution and Reaction in Southeast Asia* (1969) and *The Road from War: Vietnam 1965–1970* (1970).

Jeff Shero (b. 1942) joined the Students for a Democratic Society (SDS) at the University of Texas at Austin in 1962, and three years later became the group's national vice president. In 1967 he moved to New York City and founded *Rat*, an underground newspaper. *Rat* published papers stolen from offices at Columbia University during the student takeover of buildings in 1968, as well as a survival guide for protestors at the Democratic National Convention in Chicago and articles by Allen Ginsberg, William Burroughs, and the Yippies. In the early 1970s, Shero was arrested while in possession of two hundred false I.D.'s intended for draft dodgers. In 1972 he changed his name to Jeff Nightbird. He became an antidrug activist and in 1989 was a consultant on Oliver Stone's film *Born on the Fourth of July*. He wrote a column for the Austin, Texas, *New Statesman* until 1997, and is writing a novel about Cuba.

Alvin Shuster (b. 1930) went to work at the Washington bureau of *The New York Times* when he was seventeen. He became a reporter in 1952. In 1966 he received a fellowship at Harvard, and later spent three years as the London bureau chief of the *Times*, and eighteen months in Vietnam as the chief of the Saigon bureau. He returned to London in 1972 and became the bureau chief in Rome in 1975. In 1977 he went to work as an editorial writer and foreign editor at the *Los Angeles Times*, where he is now a senior consulting editor.

Anita Siegel (b. 1939) grew up in Brooklyn, New York. For several years in the 1960s she shared a loft in Manhattan with the artist Nancy Grossman. She is a sculptor and collage artist whose work has appeared frequently on the op-ed pages of *The New York Times*.

Paul Simon (b. 1941) grew up in Queens, New York. He met Art Garfunkel when they were in elementary school, and when they were sixteen, calling themselves Tom and Jerry, they recorded a hit song, "Hey, Schoolgirl." Their follow-up record flopped and they split up and went to college. Simon got a degree in English literature and dropped out of law school. In 1964 he and Garfunkel recorded an album that contained the song "Sounds of Silence," which, in a remixed single, went to number one on the charts and established them in the vanguard of folk-rock groups. For the next five years they were one of the most successful acts in pop music. Simon wrote the songs, and the two harmonized on a series of hit singles and albums, including *Parsley, Sage, Rosemary and Thyme* and "Mrs. Robinson," composed for the soundtrack of *The Graduate*. Their last album, *Bridge Over Troubled Water* (1970), won six Grammys and eventually sold nine million copies. Simon's solo career has included several Top Ten hits, including "Mother and Child Reunion" (1972), "Love Me Like a Rock" (1973), and "Fifty Ways to Leave Your Lover" (1975). In 1981 he and Art Garfunkel reunited for a free concert in Central Park that drew an estimated 400,000 fans. In 1986 he released his biggest-selling solo album, *Graceland*, recorded with South African musicians, and in 1990 worked with Brazilian musicians on *The Rhythm of the Saints*. He played a free solo concert in Central Park in New York in 1991 and released a live album of the show. In 1999 he and Bob Dylan toured together.

Sigrid Spaeth (1936–1996) was born in Trier, Germany, and came to the United States in the Fifties. She was a painter and a designer of book jackets.

Dr. Benjamin Spock (1903–1998) published a handbook on raising children in 1946 that had sold nearly fifty million copies by the time he died. The first edition, which was titled *The Common Sense Book of Baby and Child Care*, opened with the

advice "Trust youself," and went on to encourage demonstrative familial love and to discourage the kind of ascetic, regimented behavior that earlier experts had advocated. Dr. Spock was the preeminent childrearing guide for the parents of the Sixties' generation. Spock grew up in New Haven, Connecticut, and attended Yale and then the Columbia University medical school. He was a resident in pediatrics and also in psychiatry. He opened a private pediatrics practice in New York and served as a psychiatrist in the Navy during World War II, while he was working on his first book. He gave up his practice in 1947 and taught child development, first at the University of Pittsburgh and then at Case Western Reserve University in Cleveland until 1967, when he retired. He was a prominent opponent of the war in Vietnam and the draft, and from 1962 to 1967 was co-chairman of SANE, the National Committee for a Sane Nuclear Policy. In 1968 he was convicted of conspiracy to aid and abet violation of the draft, but the conviction was overturned on appeal. In the 1970s he ran for president, and later vice president, as the candidate of the People's Party, a coalition of left-wing organizations. In 1976 he divorced his first wife, Jane, whom he had married in 1927 and with whom he had two sons. His second wife, Mary Morgan, collaborated with him on *Spock on Spock: A Memoir of Growing Up with the Century* (1989). He was the author of many articles and eleven other books.

Ringo Starr (b. 1940) was the drummer for the Beatles. He was also the lead vocalist on many of their songs, including "With a Little Help from My Friends" (1967). After the breakup of the group in 1970, he played on the *Plastic Ono Band* album recorded by John Lennon and Yoko Ono, as well as on George Harrison's *All Things Must Pass*. He has made many solo albums and appeared in films and on televison. In 1989 he formed a group called the All Starr Band, and has toured extensively with various incarnations of it.

John Steinbeck IV (1946–1991) was the son of the writer John Steinbeck. He was born in New York, where his father had moved from California. He was drafted into the Army when he was eighteen and completed a tour of duty in Vietnam, part of which he spent as a combat reporter for the Armed Forces Radio. He later returned to Southeast Asia to work as a freelance journalist. In 1967 he published an article in the *Washingtonian* magazine, "The Importance of Being Stoned in Vietnam," which claimed that 75 percent of the American soldiers in Vietnam smoked marijuana. This was shocking at the time. Two years later he published the book *In Touch*, about his experiences in Vietnam, including his embrace of Buddhist philosophy, and about his arrest on charges related to marijuana possession. At the time of his death from cardiac arrest following back surgery, he was writing his autobiography, *Legacy*, which dealt with the influence of heredity on addictive behavior, and with what he believed to be a link between his father's addiction to alcohol and his own.

Saul Steinberg (1914–1999) was born in Romania and educated in Bucharest and Milan, where he received a doctoral degree in architecture. He began publishing drawings in an Italian magazine while he was in architecture school, and in 1941, in the midst of World War II, used a fake passport to flee Italy for the United States. His first drawing appeared in *The New Yorker* in October 1941, inaugurating a relationship with the magazine that would last for more than half a century. He served in the U.S. Navy during the war, and was given the assignment of drawing cartoons that would inspire anti-Nazi resistance. After the war his drawing style became more abstract and philosophical, and in the late 1960s and 1970s he began drawing architectural fantasies and caricatures of New York street life. In 1978 the Whitney

Museum of American Art exhibited a retrospective of his work. During his career at *The New Yorker* he drew 85 covers and published 642 drawings in the magazine. He published several books, including *The Art of Living* (1949), *The Labyrinth* (1960), *The New World* (1965), *The Inspector* (1973), and *The Discovery of America* (1993).

Louise Stone (b. 1941) is the widow of Dana Stone, a combat photographer captured by the Viet Cong and executed by the Khmer Rouge in 1971. She grew up in Cynthiana, Kentucky, and attended Randolph Macon Woman's College in Lynchburg, Virginia. She met Dana, a former logger from Vermont, in 1962, and they were married in Bangkok in January 1968, just before the Tet offensive. Early in 1970 they walked across Cambodia together. In April of that year Dana, who was working for CBS News, and his friend Sean Flynn, who was working for *Time*, rode rented motorcycles across the Cambodian border and were captured by the Viet Cong. They were never heard from again. Louise Stone searched for her husband in Vietnam and Cambodia for more than a year. When she returned to the United States, she lived for a time with John Steinbeck IV and his family in Greenwich Village in New York. In the late 1970s she returned to Kentucky to live on her father's horse farm. In the early 1980s she developed multiple sclerosis. In 1988 the photographer Tim Page came across a declassified U.S. intelligence report about the disappearance of Dana Stone and Sean Flynn. Two years later he flew to Cambodia, recovered their remains, and reconstructed what had happened to them. The Viet Cong had handed them over to the Khmer Rouge, who held them in captivity for nearly a year before killing them. Page went to Kentucky to explain this to Louise Stone, but found her too ill to communicate. She was living in a room covered with her husband's photographs.

Sly Stone (b. 1944) was born Sylvester Stewart in Dallas, Texas. When he was four he sang with a gospel family group. His father taught him and his younger brother, Freddie, to play the guitar when they were young, and he also learned to play the piano. The family moved to the San Francisco area in the 1950s and Sly and his brother continued to study music. Sly worked as a disk jockey, a songwriter, and a record producer before forming his first band in the late Sixties. In 1967 he started the band that made him famous, Sly and the Family Stone, playing what was called "psychedelic rock." Their first album was a flop, but after that they were often on the charts with ecstatic dance music mixed with political statements. Their song "I Want to Take You Higher," recorded in 1969, became a Sixties anthem. After 1970, Sly had problems with drugs, although his 1971 album *There's a Riot Goin' On* was number one on the charts.

Students for a Democratic Society (SDS). Created in 1960 as the youth auxiliary of the social-democratic League for Industrial Democracy (LID), SDS soon became the flagship organization of the New Left. The nucleus of its leaders, including Tom Hayden, were students from the University of Michigan at Ann Arbor. They nearly broke with LID in 1962 after preparing a manifesto of their beliefs, the Port Huron Statement, that was deemed insufficiently anti-Communist by the parent organization. SDS was grounded in ideas about "participatory democracy," which were implemented in grassroots projects aimed at organizing the poor in northern cities. In 1965 they led the first of several mass rallies in Washington, D.C., to protest U.S. involvement in Vietnam. By 1968 the group had become increasingly militant, and led the siege of Columbia University by student activists who barricaded themselves in buildings for a week, until they were dispersed, or arrested, by New York City policemen. The Columbia protest sparked similar disruptions in schools all over the country. In 1969, riven by extremist factions, most prominently the Weathermen, SDS broke up.

James Taylor (b. 1948) grew up in a large, wealthy family in Chapel Hill, North Carolina. He joined a rock band in 1966 and made his first album two years later. In 1970, his second album, *Sweet Baby James*, received five Grammy awards and has become one of the best-selling albums of all time. One of the songs on it, "Fire and Rain," which is about a friend's suicide and Taylor's own drug problems, is a classic of the acoustic singer/songwriter genre. His double album *Live* was a platinum seller in 1993.

Gary Thiher (b. 1945) co-founded a branch of SDS at the University of Texas at Austin. After he graduated, he moved to New York, where he worked at the alternative newspaper *Rat* as an editor, writer, and layout designer. In the early 1970s he lived on a "quasi-commune" in Arkansas, and later worked as a building contractor. He has completed a doctoral dissertation in philosophy at the University of Missouri.

Norman Thomas (1884–1968) was the Socialist Party candidate for president six times (his last campaign was in 1948). An ordained Presbyterian minister, he became a Christian pacifist during World War I and, with Roger Baldwin, founded the American Civil Liberties Union. He joined the Socialist Party in 1918, and became its leader after the death of Eugene Debs in 1926. Anti-Communist, antiwar, anticapitalist, and pro–civil rights, his political evangelicalism was still potent rhetoric for young Americans of the 1960s, when he denounced U.S. involvement in Vietnam as "an immoral war ethically and a stupid war politically."

Tiger Cages were cramped cells in which people who were considered enemies of the South Vietnamese government were tortured and starved. The existence of the tiger cages was revealed in 1970 by a young American congressional aide, Tom Harkin, who was given a map of Con Son prison that showed where the tiger cages were located—behind a secret door. During a tour of the prison, Harkin slipped away from a group of visiting Americans and took photographs of the prisoners in the cages and recorded their voices. The photographs were printed in *Life* magazine. Harkin lost his job, but the cages were subsequently closed and most of the prisoners freed. Harkin is now a U.S. senator. In 1995 he returned to Vietnam and met several of the former prisoners he had helped free.

Penelope Tree (b. 1949) was born into a distinguished Anglo-American family. Her mother, Marietta Peabody FitzGerald Tree, was a representative to the United Nations Commission on Human Rights. Penelope was discovered by Richard Avedon and Diana Vreeland, the editor of *Vogue* magazine, at Truman Capote's masked ball in 1966, and she became one of the most prominent models of the period. She retired when she was twenty-two. She is the mother of two children and has worked as a childbirth educator, a television researcher, and a travel writer.

William Turnage (b. 1942) went to school at Yale, where he worked for the chaplain, William Sloane Coffin, Jr. He studied history at Oxford and went back to Yale to take courses in environmental studies. He was the photographer Ansel Adams's business manager for seven years, during which time they collaborated on conservation projects in California. In 1978 he became the executive director of the Wilderness Society, and in 1985 left to manage the Ansel Adams Trust.

Tina Turner (b. 1938) was born Anne Mae Bullock near Brownsville, Tennessee. She met the rhythm-and-blues musician Ike Turner at a club in St. Louis in 1956, and soon became his lead singer. He changed her name to Tina and they were married in 1958. The Ike and Tina Turner Revue was a major crossover act in the late Sixties and early Seventies, and established Tina as one of the most flamboyant, erotic performers in rock music. In 1976, however, after years of marital abuse, Tina left Ike and the band. She emerged as a major star in her own right in 1984 with the album *Private Dancer*, and has continued to tour and record.

Twiggy (b. 1949) was born Leslie Hornby in a working-class suburb of London. In 1966 she became a model. Her career prefigured those of the "supermodels" of the Eighties and Nineties, and in 1967 she appeared on the cover of *Newsweek* as a pop culture phenomenon. She was five feet six inches tall and weighed only ninety-two pounds. When asked if her figure was the thing of the future, she replied, "It's not really what you call a figure, is it?" She made her acting debut in 1970 in Ken Russell's film *The Boy Friend*, for which she won a Golden Globe award. In 1983 she was nominated for a Tony for her work on Broadway in *My One and Only*. She continues to appear on stage and television and in films. She starred Off Broadway in *If Love Were All* in 1999.

Veruschka was born Vera von Lehndorff, the daughter of a Prussian count executed for his involvement in an attempt to assassinate Hitler. She studied painting and design in Hamburg in the late 1950s and began modeling in Milan and Paris in 1961. In 1966 she appeared in Antonioni's film *Blow-Up* and was photographed for *Vogue* in leopard-skin body paint. A few years later she began to collaborate on body painting with the artist Holger Trülzch, and in 1986 they published *Veruschka: Trans-figurations*. She lives in New York, where she is at work on a book of photographs of herself.

Luchino Visconti (1906–1976), the hereditary Duke of Modrone, got his start in film when his friend Coco Chanel introduced him to the French director Jean Renoir, who hired him as an assistant. He was an aristocrat and a supporter of the Communist Party, and his films deal with both tragic peasants and decadent members of the upper class. In 1947 he made *La Terra Trema*, the saga of an impoverished Sicilian fisherman's family, using real Sicilian villagers instead of actors. The second part of his "Sicilian trilogy" was *Rocco and His Brothers* (1960), followed by *The Leopard* (1963), an epic about the landed gentry of Sicily. Many of his films, like *The Damned* (1969) and *Death in Venice* (1970), are described as "operatic," and he directed and staged both plays and operas, including several starring his friend Maria Callas.

Viva was born Janet Sue Hoffmann in upstate New York. In the late Sixties she became a close friend of Andy Warhol's and a central figure in the Factory. She appeared in a number of Warhol's films, including *The Loves of Ondine* (1967), *Lonesome Cowboys* (1968), and *Blue Movie* (1968). Viva was married to the French filmmaker Michel Auder and has two daughters. She is the author of two autobiographical novels, *Superstar* (1970) and *Baby* (1975), and is at work on her memoirs. She lives in Malibu, California, where she paints landscapes.

George Wallace (1919–1998) grew up in a small rural town in Alabama, became a lawyer and a state legislator and judge, and in 1962 was elected governor with the backing of the Ku Klux Klan. The following year he stood at the door of an administration building at the University of Alabama to defy a federal court order that permitted two black students to enroll in the previously segregated school. He ran for president of the United States as an independent in 1968 and won 13 percent of the popular vote. He appeared to be even more popular during the campaign preceding the Democratic primaries in 1972, but he was shot before the elections. His spine was severed

and he was paralyzed for life. He ran for president again in 1976 but dropped out during the primaries. He retired as governor in January 1987. Wallace spent the last years of his life attempting to revise his reputation as a racist.

Andy Warhol (1928–1987) was the emblematic pop artist of the Sixties. In the Fifties he had a successful career as a commercial illustrator, and a small parallel career in the world of fine art. His first solo exhibition, in 1952, was of drawings based on the writings of Truman Capote. Then in the early Sixties he began producing silk-screened images derived from the consumer culture, most notably the Campbell's soup cans he exhibited in 1962. Warhol became famous, and his reputation increased with startling speed. In 1964 he rented a loft on 47th Street in New York that he painted silver. This was the first "Factory," and for several years it was where the art world met the drug and homosexual subcultures, and where celebrities, intellectuals, musicians, hustlers, and drag queens gathered. Warhol produced a remarkable number of paintings and films during this period. Early in 1968 the Factory was moved to a more antiseptic loft on Union Square, which became the offices for Andy Warhol Films, Inc. On June 3, Valerie Solanas, a woman Warhol knew slightly, shot him several times in the stomach with a 32-caliber revolver. She was the founder and sole member of an organization called S.C.U.M., the Society for Cutting Up Men. Warhol's liver, lungs, esophagus, stomach, and spleen had been punctured by bullets and he almost died. He turned his filmmaking enterprise over to an assistant, Paul Morrissey, and by the early 1970s was engaged primarily in producing commissioned portraits. He was also involved in video and television projects. He died following gallbladder surgery in New York early in 1987. After his death, the Andy Warhol Foundation for the Visual Arts was established, and under its aegis the Andy Warhol Museum, the nation's largest single-artist museum, opened in Pittsburgh in 1994.

WBAI, a listener-sponsored FM radio station in New York City, went on the air in 1960 and immediately embraced the emerging counterculture and the New Left. Airtime was devoted to the civil rights and antiwar movements, including on-site reporting from demonstrations and rallies. A nightly news program called "The War Report" provided extensive coverage of the day's events in Vietnam. The early morning hours were devoted to underground music no commercial station would play. In the 1970s, WBAI programmed coverage of the feminist and gay liberation movements and in the 1980s provided information on the involvement of the U.S. government in Central America and Iran. WBAI is part of the Pacifica Foundation, which has sponsored noncommercial radio stations since 1949. The concepts pioneered by Pacifica influenced the development of National Public Radio and public-access television.

Weathermen. In June 1969 radical members of the Students for a Democratic Society disrupted the group's annual convention with a statement advocating armed struggle against the American empire. The radicals called themselves Weathermen, after the lyrics in a Bob Dylan song: "You don't need a weatherman to know which way the wind blows." In the subsequent months, SDS broke into factions and essentially collapsed. On October 8, 1969, the second anniversary of the death of Che Guevara and two weeks after the Chicago Seven conspiracy trial opened, about three hundred Weathermen gathered in Lincoln Park in Chicago and launched the Days of Rage: four days of smashing windows and clashing with police. A few months later the Weatherbureau broke into cells and began to move underground. In March 1970 a Greenwich Village town house they were using as a bomb factory exploded, killing three members. The

Weather Underground, as it was now known, carried out some twenty bombings while in hiding over the next decade. Most of the surviving members surrendered in the late Seventies. In 1981 the group made headlines one last time, in connection with a botched armored car robbery in which three people died.

Ken Weaver (b. 1940) played drums, performed monologues, and improvised rants for The Fugs from 1965 to 1969. After the group broke up, he moved to the West Coast, where he held a variety of jobs. In 1983 he published *Texas Crude*, a book about slang, and received a B.A. in Russian from the University of Arizona. He subsequently worked as a translator for government agencies, including the CIA.

Lee Weiner (b. 1939) became a member of the Congress of Racial Equality in the early Sixties and helped organize a number of civil rights demonstrations. In 1968, while working as a community organizer in Chicago, he joined his friends Abbie Hoffman, Jerry Rubin, and Rennie Davis in planning the antiwar protests that led to the Chicago Seven conspiracy trial. Weiner was acquitted of conspiracy and of the charge that he suggested blowing up a parking garage as a diversionary tactic for demonstrators. During the mid-Seventies he worked in the Carter administration as a consultant for the Vista program. He lives in New York City and works for the Anti-Defamation League.

Leonard Weinglass (b. 1933) graduated from Yale Law School in 1958. He has represented defendants in many civil rights and criminal cases, including Abbie Hoffman, Tom Hayden, and Rennie Davis in the Chicago Seven conspiracy trial; eight Vietnamese students who were threatened with deportation from the United States as a result of their antiwar activities; members of the Symbionese Liberation Army who were charged with kidnapping Patty Hearst; and Kathy Boudin, a member of the Weather Underground, who was charged with murder in connection with the robbery of a Brink's truck during which three people were killed. He is the author of *Race for Justice: Mumia Abu-Jamal's Fight Against the Death Penalty* (1995), a book about a former Black Panther who is on death row in Pennsylvania.

Tennessee Williams (1911–1983) was born Thomas Lanier Williams in Columbus, Mississippi, and moved to St. Louis, Missouri, when he was a child. His eccentric family life provided material for much of his work, starting with plays he wrote for an amateur theatrical group in St. Louis in the late 1930s. His first artistically and commercially successful play was *The Glass Menagerie* (1945), and during the next decade and a half he established himself as a major dramatist with *A Streetcar Named Desire* (1947), *Summer and Smoke* (1948), *The Rose Tattoo* (1953), *Cat on a Hot Tin Roof* (1955), *Suddenly Last Summer* (1958), *Sweet Bird of Youth* (1959), and *The Night of the Iguana* (1961). Many of his plays were also made into successful films. He published his memoirs in 1972, and continued to write plays until his death.

Edgar Winter (b. 1946) played keyboards and saxophone with his older brother, Johnny Winter, when they were teenagers in Texas, and was part of a jazz group. He collaborated with his brother on the album *Second Winter* in 1969, and later formed his own bands, Edgar Winter's White Trash and The Edgar Winter Group.

Johnny Winter (b. 1944) is an albino blues-rock guitarist who grew up in Beaumont, Texas, where he organized his first band when he was fourteen. He spent several years playing in bars in Texas, and in 1968 signed a million-dollar recording contract. He had several hit records before briefly retiring because of a heroin addiction. In 1973 he recorded

a new album, *Still Alive and Well*, and later produced records for Muddy Waters and played in Waters's band.

Holly Woodlawn (b. 1946) inspired Lou Reed's song "Walk on the Wild Side." She was raised as Howard Ajzenberg in Puerto Rico and Miami, and ran away to New York when she was fifteen. Her appearances in Andy Warhol's films *Flesh* (1968) and *Trash* (1970) established her as a Warhol superstar. She also appeared in *Women in Revolt* (1971) and other independent films, and on stage in *Women Behind Bars*. Her autobiography, *A Low Life in High Heels*, was published in 1991.

Yippies. Created in December 1967 by a group of counterculture activists—most prominently Abbie Hoffman, Jerry Rubin, and Paul Krassner—the Yippie movement was named as a play on the word "hippie." Yippie became an acronym for Youth International Party as an afterthought. The goal of the Yippies was to hasten a cultural revolution through guerrilla theater, ridicule, and media manipulation. At the 1968 Democratic National Convention in Chicago, some three thousand Yippies participated in a Festival of Life that was broken up by the police and turned into chaos and violence. As a consequence, Abbie Hoffman and Jerry Rubin were indicted for conspiring to incite a riot and were tried as members of the Chicago Seven.

Young Lords Party. A radical, largely Puerto Rican activist group founded in 1969, the Young Lords were committed to Puerto Rican independence and opposed racism, *machismo*, and capitalism. The party ran community programs in New York City in an appropriated church, pressured the city to improve local garbage collection, "liberated" medical supplies to test the poor for TB and lead poisoning, and commandeered a run-down South Bronx hospital to protest its condition. The Party's newspaper, *Palante,* and a regular show on WBAI radio attracted new members as well as provoked opposition. In 1972 the party was renamed the Puerto Rican Revolutionary Workers Organization, but disputes over leadership led to attrition. Within five years the group had effectively disbanded.

Frank Zappa (1940–1993) was a composer, band leader, guitarist, and producer with a broad range of musical interests. He became known as the leader of the experimental rock group Mothers of Invention in the mid-1960s, but as he explained to an interviewer shortly before his death, "I never had any intention of writing rock music. I always wanted to compose more serious music…but I knew no one would play it." The Mothers of Invention released their first album, *Freak Out!*, in 1966. Each cut was part of what Zappa called "an overall satirical concept," and the band's live performances included dadaistic theatrical effects and scatological humor. Zappa was an important influence on progressive and experimental rock music. He made more than sixty albums, and his classical chamber and orchestral compositions were performed in Europe and America. He established his own record company in the 1970s. In the 1980s he was a prominent defender of First Amendment rights, and testified before Congress against the censorship of song lyrics. He died of prostate cancer.

CHRONOLOGY

1960

February: Four black students from the North Carolina Agricultural and Technical College at Greensboro stage a "sit-in" at the segregated lunch counter of a local Woolworth's. Sit-ins throughout the South ensue. In a speech at a rally in Durham, Martin Luther King, Jr., the leader of the Southern Christian Leadership Conference, says, "What is new is that American students have come of age. You now take your honored places in the worldwide struggle for freedom."

April: The Student Non-Violent Coordinating Committee (SNCC) is founded at a meeting in Raleigh, North Carolina, sponsored by the Southern Christian Leadership Conference.

May: The U.S.S.R. downs a U-2 spy plane over Soviet territory and captures the pilot, Francis Gary Powers.

President Eisenhower signs the Civil Rights Act of 1960, which had been passed in the Senate largely through the efforts of Senate Democratic leader Lyndon B. Johnson, despite strong opposition from other Southern political leaders.

The Food and Drug Administration approves Enovid, the first birth control pill.

June: A. Philip Randolph, the head of the Negro American Labor Council, and Martin Luther King, Jr., call for pickets at the Democratic and Republican national conventions to protest what they term the inadequacy of the 1960 Civil Rights Act.

September: John F. Kennedy and Richard M. Nixon participate in the first televised debates between presidential candidates.

October: Paul Goodman publishes *Growing Up Absurd,* in which he notes that "among all young people it is perhaps just the young people in the South, whites and Negroes both, who most find life worth living these days, because something real is happening."

The British psychiatrist R. D. Laing publishes *The Divided Self,* which he describes as showing "that *schizophrenia* was one position, one way of seeing things, and that *normality* was another."

November: John F. Kennedy is elected president in one of the closest elections in United States history. He receives 49.7 percent of the popular vote to Nixon's 49.5 percent. Kennedy, who is forty-three, is the second-youngest and first Roman Catholic president.

Richard Wright, the author of *Black Boy* (1945) and *White Man, Listen!* (1957), dies in Paris at the age of fifty-two.

December: The National Liberation Front (NLF), an alliance of opponents to the regime of Premier Ngo Dinh Diem in South Vietnam, is formed. There are nine hundred American military personnel stationed in South Vietnam.

1961

January: Bob Dylan leaves Minnesota for New York and becomes a fixture in Greenwich Village coffeehouses.

The United States breaks off diplomatic relations with Cuba, two years after Fidel Castro took power.

In his inaugural speech as the thirty-fifth president of the United States, John F. Kennedy declares, "Ask not what your country can do for you, ask what you can do for your country."

March: President Kennedy issues an executive order establishing the Peace Corps, which will send volunteers to help develop agricultural and educational programs in poor countries.

April: Soviet cosmonaut Yuri Gagarin becomes the first man to orbit the earth.

An invasion force of some fifteen hundred anti-Castro Cuban exiles, trained by the CIA, lands at the Bay of Pigs. They are defeated in less than three days by Castro's forces. President Kennedy assumes responsibility for the fiasco.

May: The Congress of Racial Equality (CORE) organizes "Freedom Rides" to the South to test the enforcement of the Supreme Court's ruling that it is unconstitutional to apply state segregation laws to interstate transport. Busloads of interracial Freedom Riders are set upon by white mobs at several stops, and the scale of the violence prompts Attorney General Robert Kennedy to dispatch a protective force of six hundred U.S. marshals.

June: The Soviet ballet star Rudolf Nureyev defects to the West.

August: The parliament of the German Democratic Republic votes to build a wall sealing off the border between East and West Berlin.

September: The U.S.S.R. breaks a three-year moratorium on nuclear testing.

October: Joseph Heller publishes *Catch-22,* a satirical novel about a World War II bomber group.

December: American pilots begin flying combat missions in attack aircraft in Vietnam. On December 22, the first American soldier is killed. There are 3,200 American military personnel in South Vietnam.

1962

February: The Military Assistance Command Vietnam (MACV) headquarters is established in Saigon to control the buildup of U.S. advisers and support personnel.

Marine Lieutenant Colonel John Glenn becomes the first American to orbit the earth.

April: The United States explodes a nuclear device near Christmas Island in the Pacific Ocean.

May: The Nazi official Adolf Eichmann, who was the director of Jewish affairs for the Central Office of Reich Security in Germany during World War II, is hanged in Israel for his role in the Holocaust.

June: Students for a Democratic Society (SDS) holds its first national convention at an AFL-CIO camp near Port Huron, Michigan. The group's manifesto, the Port Huron Statement, which endorses the labor, civil rights, peace, and student movements, is prepared from a draft written by Tom Hayden.

The Supreme Court rules in *Engel* v. *Vitale* that the practice of reading prayers in New York public schools is unconstitutional.

August: Marilyn Monroe dies of an overdose of sleeping pills in her Hollywood home at the age of thirty-six.

The United States national debt reaches $300,000,000,000.

September: James Meredith, a black man whose right to be admitted to the University of Mississippi at Oxford has been upheld by the United States Supreme Court, is escorted to Oxford by 170 U.S. marshals. Riots break out and two men are killed, but Meredith is successfully enrolled in the previously segregated school.

Rachel Carson publishes *Silent Spring,* about the effect of pollution caused by pesticides. It is an influential critique of a culture that tampers with the ecosystem without understanding the consequences.

October: U.S. aerial surveillance discovers that sites for Soviet nuclear missiles are being built in Cuba, and on October 22 President Kennedy threatens a retaliatory nuclear strike against the Soviet Union if missiles are used. A naval blockade of Cuba is established and the U.S. military is put on alert. During negotiations between President Kennedy and Premier Khrushchev, an American U-2 reconnaissance plane is shot down while flying over Cuba. On October 28 Khrushchev agrees to dismantle and remove the missiles under UN supervision. Kennedy agrees to remove American missiles based in Turkey and lift the naval blockade of Cuba.

November: The Esalen Institute, which is devoted to "the exploration of unrealized human capacities," is founded in Big Sur, California.

Former vice-president Richard Nixon, who has been defeated by Edmund Brown in the California gubernatorial race, holds a press conference to announce his departure from politics, saying, "You won't have Nixon to kick around anymore."

The New Yorker publishes James Baldwin's essay "Letter From a Region in My Mind." It will appear the following year in *The Fire Next Time.*

December: There are 11,300 American military personnel in South Vietnam.

1963

February: Betty Friedan publishes *The Feminine Mystique.*

March: The first major exhibition of pop art, "Six Painters and the Object," opens at the Guggenheim Museum in New York with works

by Jasper Johns, Robert Rauschenberg, Roy Lichtenstein, Jim Dine, James Rosenquist, and Andy Warhol.

April: Martin Luther King, Jr., who has remarked that when he is in Birmingham, Alabama, he feels that he is "within a cab ride of being in Johannesburg, South Africa," writes "Letter from a Birmingham Jail" after he is arrested and incarcerated during a civil rights campaign.

May: After two bombings in Birmingham aimed at civil rights leaders, the first full-scale urban riot of the decade breaks out.

Bob Dylan's first album of original songs, *The Freewheelin' Bob Dylan*, is released. It includes "Blowin' in the Wind."

June: A Buddhist monk commits suicide by self-immolation in Saigon to protest the anti-Buddhist policies of the South Vietnamese government.

Two black students attempt to register at the University of Alabama in spite of Governor George Wallace's pledge to prevent the desegregation of the school. Wallace personally blocks the entrance to the registration center, and defies Attorney General Nicholas Katzenbach's demand that he comply with federal court orders. The students register after National Guard units are sent to the campus.

Medgar Evers, a leader of the National Association for the Advancement of Colored People, is shot to death in the driveway of his Jackson, Mississippi, home by Byron De La Beckwith, a white supremacist.

August: The United States, the Soviet Union, and Great Britain sign a nuclear test-ban treaty.

Some 200,000 people, a third of them white, participate in the March on Washington for Jobs and Freedom. They gather at the Lincoln Memorial, where Bob Dylan and Joan Baez appear and Martin Luther King, Jr., gives his "I Have a Dream" speech.

September: In Birmingham, a bomb explodes during Sunday services at the Sixteenth Street Baptist Church, killing four black schoolgirls.

November: A group of South Vietnamese military commanders overthrow Ngo Dinh Diem in Saigon. Diem and his brother, Ngo Dinh Nhu, his chief of security, are murdered. There are 16,300 American military personnel in South Vietnam.

President Kennedy is assassinated in Dallas, Texas, on November 22, and Vice-President Lyndon B. Johnson is sworn in as president. Lee Harvey Oswald, who has been charged with the murder, is shot and killed in the basement of the Dallas municipal jail by a local nightclub owner, Jack Ruby, on November 24.

1964

January: President Johnson announces a "War on Poverty" in his State of the Union address.

Stanley Kubrick's satirical film about nuclear war, *Dr. Strangelove or: How I Learned to Stop Worrying and Love the Bomb*, is released.

February: The Beatles arrive in New York for their first U.S. tour and make their American television debut on *The Ed Sullivan Show*, which is watched by more than 73 million viewers.

In Miami, twenty-two-year-old Cassius Clay defeats Sonny Liston for the heavyweight boxing championship. Following his victory, Clay pro-

claims himself a Black Muslim and takes the name Muhammad Ali.

June: Marshall McLuhan publishes *Understanding Media*, in which he claims that "the medium is the message."

Herbert Marcuse publishes *One-Dimensional Man*, a neo-Marxist study of the nature of capitalist societies. He encourages the countercultural rebellions of the Sixties, and his books for a time become intellectual bibles for New Left students.

Three civil rights workers—Michael Schwerner, Andrew Goodman, and James Chaney—are murdered in Mississippi by the Ku Klux Klan during the Freedom Summer voter registration project.

July: President Johnson signs the Civil Rights Act of 1964, which bans segregation in all public facilities in the United States. The Equal Employment Opportunity Commission is established.

The first northern ghetto riot breaks out in Harlem after a fifteen-year-old boy is shot by an off-duty policeman. Riots soon erupt in Rochester, New York; Paterson, New Jersey; Philadelphia, Pennsylvania; and other cities.

August: Responding to reports of an attack on a U.S. destroyer by North Vietnamese torpedo boats in the Gulf of Tonkin, in international waters, President Johnson orders the first United States air strikes against North Vietnam. Congress passes the Gulf of Tonkin resolution, authorizing Johnson to take "necessary measures to repel any armed attack against the forces of the United States and to prevent further aggression."

September: The Warren Commission releases its report on the assassination of John F. Kennedy, finding that Lee Harvey Oswald acted alone, and that there was no international or national conspiracy.

October: The Reverend Martin Luther King, Jr., wins the Nobel Peace Prize.

November: Lyndon Johnson receives 61 percent of the popular vote and defeats Barry Goldwater in the presidential election.

December: Students demonstrate at the University of California at Berkeley, where the dean of students has declared that on-campus political advocacy for off-campus causes is forbidden. Mario Savio, the leader of the Free Speech Movement, and a veteran of Freedom Summer in Mississippi, encourages the students to hold a sit-in at Sproul Hall protesting the university's "depersonalized, unresponsive bureaucracy." Police arrest eight hundred nonviolent demonstrators.

There are 23,300 American military personnel in South Vietnam.

1965

February: Malcom X is assassinated while he is giving a speech at the Audubon Ballroom in New York City. Three members of the Nation of Islam, the organization he had broken with the previous year, are arrested for the murder.

March: The United States begins sustained bombing of North Vietnam. The first American ground combat units are deployed in South Vietnam.

Martin Luther King, Jr., conducts a voting rights campaign in Selma, Alabama, that concludes with a four-day march to Montgomery. Outside Montgomery, four Klansmen chase down and kill Viola Gregg Liuzzo, a white civil rights worker who was driving in a car with a black passenger.

The Supreme Court rules in favor of conscientious objection, stating unanimously that any person who sincerely believes in a Supreme Being, whether or not the belief conforms to a belief held by accepted religions, can be exempted from military combat training and service.

April: The first national antiwar march takes place in Washington, D.C. It attracts 20,000 demonstrators.

A new military government assumes power in South Vietnam with the appointment of Premier Nguyen Cao Ky.

July: Martin Luther King, Jr., leads some 20,000 marchers to Chicago's City Hall to protest the continued segregation of public schools. It is the largest civil rights demonstration in the city's history.

August: The Voting Rights Act of 1965 goes into effect. It eliminates many of the devices that Southern officials had used to prevent blacks from voting.

Riots involving 30,000 blacks erupt in the Watts ghetto in Los Angeles. Twenty thousand National Guardsmen and police are called in. Thirty-five people are killed and four thousand arrests are made over the course of five days.

A federal law goes into effect that makes destroying a draft card a criminal offense.

September: President Johnson signs the Federal Aid to the Arts Act, establishing the National Endowment for the Arts (NEA) and the National Endowment for the Humanities (NEH).

October: Antiwar rallies are held across the country, countered by demonstrations in support of the war. Several antiwar protesters burn their draft cards. In Berkeley, Allen Ginsberg coins the term "flower power."

December: On Christmas Eve, the United States suspends the bombing of North Vietnam. Over 184,000 American military personnel are in South Vietnam.

1966

January: The United States resumes bombing North Vietnam.

In San Francisco, the writer Ken Kesey and the Merry Pranksters hold the Trips Festival, the first official hippie gathering. Twenty thousand people attend.

February: Muhammad Ali, who has become eligible for the draft, remarks, "I ain't got no quarrel with them Vietcong."

July: Bob Dylan is injured in a motorcycle accident near his home in Woodstock, New York. He spends the next year and a half in seclusion, playing country rock music with The Band at home.

August: The comedian Lenny Bruce, whose satirical attacks on bourgeois morality have led to obscenity charges, is found dead of a heroin overdose in his Hollywood, California, home at the age of thirty-nine.

The Beatles give their final concert at Candlestick Park in San Francisco.

September: Former Harvard professor Timothy Leary, who advocates the use of psychedelic drugs such as LSD, founds the League for Spiritual Discovery, "a legally incorporated religion dedicated to the ancient sacred sequence of turning on, tuning in, and dropping out."

October: The Black Panther Party is founded in Oakland, California.

The National Organization for Women (NOW) is founded in Washington, D.C.

December: More than 385,000 American military personnel are in South Vietnam.

1967

January: Lester Maddox, a strict segregationist, is sworn in as governor of Georgia.

The first Human Be-In, presided over by Allen Ginsberg and Timothy Leary, with music by the Grateful Dead and the Jefferson Airplane, takes place in Golden Gate Park in San Francisco.

Astronauts Gus Grissom, Edward White II, and Roger Chaffee are killed when a fire breaks out during a test launch of their Apollo spacecraft at Cape Canaveral.

March: United States Senator Robert Kennedy of New York gives a speech calling for a halt in the bombing of North Vietnam and the opening of peace negotiations. U.S. aircraft begin bombing major North Vietnamese industrial sites and electric power plants.

The Quotations of Chairman Mao is published in the West. Within two years, 350 million copies will be sold.

April: Muhammad Ali is stripped of his heavyweight boxing title by the World Boxing Association after he refuses to be inducted into the Army on the grounds that he is a conscientious objector and a minister of the Nation of Islam. His boxing license is revoked.

The U.S. Supreme Court rules that state laws forbidding interracial marriages are unconstitutional.

The Monterey International Pop Festival takes place in California, ushering in the Summer of Love. The Who, Otis Redding, Jimi Hendrix, the Jefferson Airplane, and Janis Joplin and Big Brother and the Holding Company perform.

June: The Beatles' *Sgt. Pepper's Lonely Hearts Club Band* is released. It is number one on the charts in the United States for nineteen weeks.

Muhammad Ali is convicted of draft evasion and sentenced to five years in prison. He appeals.

July: A four-day race riot breaks out in Newark, New Jersey. The National Guard fires on protestors, leaving twenty-six people dead and 1,300 injured. A week later the worst race riot in the history of the United States takes place in Detroit. Federal troops are called out. Two thousand people are reported injured, forty-three are killed, and five thousand arrests are made.

August: George Lincoln Rockwell, the forty-nine-year-old leader of the American Nazi Party, is shot to death in Arlington, Virginia, by a former aide.

September: In the first election since the 1963 coup, Nguyen Van Thieu is elected president of South Vietnam and Nguyen Cao Ky vice-president.

October: Thurgood Marshall becomes the first black justice on the Supreme Court.

Che Guevara, Fidel Castro's chief lieutenant during the Cuban revolution, is killed in Bolivia.

Seven white segregationists are found guilty of conspiring to violate the civil rights of Andrew Goodman, Michael Schwerner, and James Chaney, who were murdered during Freedom Summer. The prosecution is led by John Doar of the U.S. Department of Justice.

Over six hundred demonstrators out of a crowd of 50,000 people are arrested during the March on the Pentagon in Washington, D.C., to protest the war in Vietnam.

Hair, a "tribal love-rock musical," opens in New York.

November: *Rolling Stone* magazine is founded in San Francisco.

Senator Eugene McCarthy announces that he will run against President Johnson in the 1968 elections and calls for a negotiated settlement in Vietnam.

December: In New York, Dr. Benjamin Spock and Allen Ginsberg are among some five hundred people arrested for attempting to shut down a draft induction center.

Mike Nichols's film *The Graduate* is released, starring Dustin Hoffman and Anne Bancroft, with a soundtrack by Simon and Garfunkel.

Over 485,000 American military personnel are in South Vietnam.

1968

January: Fred Gardner founds the first G.I. Coffeehouse in Columbia, South Carolina.

The Vietcong and the North Vietnamese launch ground attacks on over one hundred cities and towns throughout South Vietnam during the Tet holiday truce. Several key installations in Saigon are attacked.

March: President Johnson authorizes sending 13,500 more troops to Vietnam. Eugene McCarthy wins 42 percent of the vote in the New Hampshire Democratic primary. Robert Kennedy announces that he also will seek the Democratic presidential nomination. Johnson announces a partial halt to the bombing of North Vietnam and declares that he will not seek reelection.

April: Stanley Kubrick's *2001: A Space Odyssey* is released.

Martin Luther King, Jr., is assassinated on the balcony of a Memphis, Tennessee, motel room by James Earl Ray. Riots in over a hundred towns and cities ensue. Forty-six people are killed and three thousand injured.

President Johnson signs the Housing Rights Act, which makes racial discrimination against those seeking to rent or buy a house illegal.

A student occupation of five Columbia University buildings and a campus-wide strike led by Students for a Democratic Society (SDS) shuts down the school.

May: The Reverend Ralph Abernathy leads the Poor People's March on Washington against poverty and hunger. Three thousand marchers camp in a makeshift Resurrection City near the Lincoln Memorial.

William Styron's novel *The Confessions of Nat Turner*, about a slave revolt in 1831, wins the Pulitzer Prize.

Peace talks between the United States and North Vietnam open in Paris.

In Catonsville, Maryland, nine Roman Catholics, including the priests Daniel and Philip Berrigan, raid the Selective Service office and burn hundreds of draft records. They are arrested.

June: On June 3, Andy Warhol is shot by Valerie Solanas, the founder of the Society for Cutting Up Men (S.C.U.M.).

On June 5, Senator Robert F. Kennedy is assassinated in Los Angeles after winning the California presidential primary. He dies on June 6. His assailant, Sirhan Sirhan, is indicted for murder on June 7.

The war in Vietnam is now the longest war in U.S. history.

July: Huey Newton, co-founder of the Black Panthers, goes on trial for the murder of a policeman in Oakland, California.

August: The Republican National Convention opens in Miami Beach. Richard Nixon receives the nomination for president, with Spiro Agnew as his running mate.

Over ten thousand antiwar demonstrators show up at the Democratic National Convention in Chicago, but they are outnumbered by law enforcement officers gathered together by Mayor Richard Daley. Twelve thousand city policemen joined by four thousand state policemen and four thousand National Guardsmen clash violently with the demonstrators for days. People are beaten, clubbed, and gassed. Vice-President Hubert Humphrey receives the Democratic nomination. His running mate is Senator Edmund Muskie.

October: President Johnson announces a complete halt to the bombing of North Vietnam.

November: Richard Nixon becomes president by the narrowest electoral margin—less than one percent—since his own defeat by John Kennedy in 1960.

December: The President's Commission on the Causes and Prevention of Violence issues the Walker Report, which calls the Chicago police department's actions at the Democratic National Convention an organized "police riot."

Norman Thomas, the co-founder of the American Civil Liberties Union and the leader of the U.S. Socialist Party from 1926–1955, dies at the age of eighty-four.

César Chavez of the United Farm Workers leads a nationwide table grapes boycott. Thousands of college students travel to California to help the farmworkers. Seventeen million Americans stop buying grapes.

Abbie Hoffman publishes *Revolution for the Hell of It.*

Over 536,000 American military personnel are in South Vietnam.

1969

March: President Nixon orders secret bombing raids on Communist camps in eastern Cambodia.

The Chicago Eight (Abbie Hoffman, Jerry Rubin, David Dellinger, Tom Hayden, Rennie Davis, John Froines, Lee Weiner, and Bobby Seale) are charged with conspiring to incite riots during the 1968 Democratic National Convention.

April: American troop strength reaches a peak level of 543,000.

May: In Berkeley, California, the "People's Park"—a three-acre vacant lot near the University of California campus that had been claimed by residents of the neighborhood and turned into a garden and community center—is bulldozed by

police, who put a fence up around it. When a crowd of students protests, the police turn on them with tear gas and shotguns. At least fifty demonstrators are shot, and one person dies. The governor of California, Ronald Reagan, sends three thousand National Guardsmen in to restore order.

Norman Mailer's *The Armies of the Night*, an account of the 1967 March on the Pentagon, wins a Pulitzer Prize.

June: Nixon announces the withdrawal of 25,000 American troops from Vietnam.

On the night of Judy Garland's funeral, patrons of the Stonewall Inn, a gay bar in Greenwich Village, forcefully resist a police raid. The gay liberation movement is born during the ensuing five days of violence.

July: The Apollo 11 lunar mission, manned by Neil A. Armstrong, Edwin "Buzz" Aldrin, Jr., and Michael Collins, puts the first man on the moon.

The film *Easy Rider,* directed by Dennis Hopper and starring Hopper, Peter Fonda, and Jack Nicholson, opens in New York.

August: Charles Manson and members of his "family" are arrested in Los Angeles for the cult murders of the actress Sharon Tate and six other people.

The Woodstock Music and Arts Fair, a rock concert held over three days on a farm near Bethel, New York, is attended by 400,000 people.

September: Ho Chi Minh, who declared the independence of Vietnam in 1945, dies at the age of seventy-nine.

October: The trial of the Chicago Eight is disrupted by demonstrations, including the Weathermen's "Days of Rage" (October 8–11). The National Guard is called in to keep order. On October 29, Judge Julius Hoffman orders Bobby Seale bound and gagged.

A Moratorium against the war in Vietnam is observed by millions of Americans on October 15.

November: Bobby Seale is sentenced to four years in prison for contempt of court and his trial for conspiracy is separated from that of the other members of the Chicago Eight.

A second Moratorium against the war culminates with a demonstration (the Mobilization) at the Washington Monument in Washington, D.C., on November 15. Over 250,000 people gather for the largest antiwar protest in American history.

Press reports describe the massacre in March by American soldiers of between two hundred and five hundred unarmed South Vietnamese villagers at My Lai, a rural hamlet.

December: The first draft lottery since 1942 takes place.

Fred Hampton, the chairman of the Illinois branch of the Black Panthers, is shot and killed in a predawn raid by fourteen heavily armed police officers. Mark Clark, another Panther, is also killed. The Illinois ACLU charges that the police action was entirely premeditated and demands an investigation.

Hell's Angels security guards stab a teenage boy to death during a Rolling Stones concert attended by more than 300,000 people at the Altamont Speedway in California.

1970

January: The U.S. Air Force uses B-52 bombers over northern Laos.

Nixon's national security adviser, Henry Kissinger, holds secret negotiating sessions in Paris with Vietnamese Communists.

February: The Chicago Seven are acquitted of conspiracy charges, although five of the defendants are convicted of incitement to riot.

March: A Greenwich Village town house being used as a bomb factory by the Weathermen explodes, killing three people.

April: Paul McCartney confirms rumors that the Beatles have broken up.

May: Twenty thousand American and South Vietnamese troops cross the Vietnamese border to launch a military invasion of Cambodia, which Nixon publicly downplays as an "incursion." After *The New York Times* reports that the Nixon administration has been secretly bombing the region since March, 100,000 protestors demonstrate in Washington.

At Kent State University in Ohio, during a rally protesting the invasion of Cambodia, students set fire to the ROTC building and the National Guard shoots at demonstrators, killing four. Four hundred colleges and universities close down for the rest of the spring term as some two million students go on strike.

June: The U.S. Supreme Court's decision in *Welsch* v. *United States* rules that the claim of conscientious objector status on solely moral grounds is constitutional.

U.S. ground troops are withdrawn from Cambodia.

August: An attempted escape and kidnapping by black militants in a San Rafael, California, courtroom leaves the judge and three kidnappers dead. A warrant is issued for the arrest of former UCLA faculty member and activist Angela Davis on suspicion of helping to organize the escape.

Kate Millett publishes *Sexual Politics*.

September: A federal court rules that Muhammad Ali cannot be denied a boxing license.

Jimi Hendrix dies of a drug overdose in London at the age of twenty-seven.

October: Janis Joplin dies of a drug overdose in Hollywood, California, at the age of twenty-seven.

Muhammad Ali is licensed to box again.

Angela Davis is arrested in New York City in connection with the courtroom shoot-out and attempted kidnapping in California in August.

1971

February: South Vietnamese troops, aided by U.S. air and artillery, invade Laos. The mission fails within five weeks, incurring heavy casualties.

March: Lt. William Calley is convicted for the 1968 murder of twenty-two civilians at My Lai in South Vietnam and receives a life sentence, of which he will serve three years.

May: Antiwar demonstrations in Washington climax in the Mayday protest, in which 30,000 demonstrators attempt to halt government activities by blocking city traffic.

June: *The New York Times* publishes the first excerpts of *The Pentagon Papers,* an exhaustive, top secret government study of America's involvement in Vietnam since World War II that includes evidence of covert operations, coverups,

and lies. A former Defense Department official, Dr. Daniel Ellsberg, admits leaking the documents to the *Times* and surrenders to federal authorities in Boston.

Citing financial problems, music promoter Bill Graham shuts down two of rock music's most influential concert halls, the Fillmore East in New York City and the Fillmore West in San Francisco.

The Supreme Court overturns the 1967 conviction of Muhammad Ali for draft evasion.

July: The Doors' lead singer, Jim Morrison, dies of heart failure in Paris at the age of twenty-seven.

1972

March: The North Vietnamese launch a massive invasion of South Vietnam.

May: The United States mines Haiphong harbor in Vietnam and expands the bombing of North Vietnam.

Alabama governor George Wallace, campaigning at a rally for the presidential primary in Laurel, Maryland, is shot by Arthur Bremer. The injury leaves Wallace permanently paralyzed from the waist down.

June: Angela Davis is acquitted of murder, kidnapping, and conspiracy for her role in the 1970 courtroom shooting.

The Democratic National Committee Headquarters at the Watergate apartment complex in Washington, D.C., is broken into. Police apprehend five men with cameras and electronic surveillance equipment. One of them, James McCord, is an ex-CIA agent working for the Republican National Committee and the Committee to Re-elect the President.

July: South Dakota senator George S. McGovern wins the presidential nomination at the Democratic National Convention in Miami Beach.

November: Richard Nixon is re-elected with 60.7 percent of the popular vote, the greatest Republican landslide in history.

December: In Paris, peace talks break down between the United States and North Vietnam. Nixon orders renewed bombing of Hanoi and Haiphong.

1973

January: The Supreme Court decision on *Roe* v. *Wade* upholds a woman's right to have an abortion during the first trimester of a pregnancy.

Former president Lyndon Johnson dies at the age of sixty-four.

Nixon halts the bombing of North Vietnam. In Paris, a final peace agreement is signed by representatives of the United States, North Vietnam, South Vietnam, and the Provisional Revolutionary Government. The agreement calls for a cease-fire, the release of prisoners of war, and the holding of elections. Withdrawal of the remaining 23,400 American troops in South Vietnam begins.

October: Secretary of State Henry Kissinger and Le Duc Tho, North Vietnam's representative at the Paris peace talks, are awarded the Nobel Peace Prize. Le Duc Tho declines the award.

INDEX

ACKNOWLEDGMENTS

THE PROJECT

Civil Rights Movement
Atlanta, Georgia; Jackson, Louisiana;
Algiers, Louisiana; Santa Monica, California

Marguerite Lamkin, *Project Coordinator*
Marvin Israel, *Editor*
James Baldwin, *Writer*
David Baldwin, *Researcher*
Jim Houghton, *Photographic Assistant*

Antiwar Movement
New York, New York; Chicago, Illinois;
Ann Arbor, Michigan; New Haven, Connecticut;
Milwaukee, Wisconsin

Gideon Lewin, Peter Waldman, Larry Hales,
Photographic Assistants

Vietnam
Saigon; Fire Base Charlie, DMZ; Mekong River

Henry Aronson, Gloria Emerson,
John Steinbeck IV, *Project Advisors*

Larry Hales, *Photographic Assistant*
Mark Godfrey, *Technical Assistance*
Allen Hurlburt, *Clearances*

Space Exploration
Langley Field, Virginia; Cape Canaveral, Florida

Earl Steinbicker, *Photographic Assistant*
Suzy Parker, *Researcher*

The Arts
New York, New York; Montauk, New York;
East Hampton, New York; Hoboken, New Jersey;
Port Arthur, Texas; Los Angeles, California;
London, Paris, Bahamas, Ireland

Marvin Israel, Bea Feitler, *Art Directors*

Diana Vreeland, Alexander Liberman,
Polly Mellen, Babs Simpson, *Editors*

THE BOOK

Avedon Studio
Norma Stevens, *Managing Editor*

Bill Bachmann, Brian Heatherington,
Editorial Assistants

Sebastian Kim, Grant Delin, Ian Colletti,
Jim Macari, Jos Schmid, *Technical Assistants*

Marc McClish, John Delaney,
Master Printers

Bob Bishop, Mike Bishop, Scott Norkin,
Margot Frankel, *Art Production*

Eastman Kodak
George Fisher, *Chief Executive Officer*
Patrick T. Siewert, *President, Kodak Professional*
Audrey Jonckheer, *Communications Director,*
Kodak Professional

and Ray DeMoulin, David Biehn,
Kathleen Moran

Random House
Peter Olson, *Chief Executive Officer*
Ann Godoff, *Publisher*
Sharon DeLano, *Editor*
Katherine Rosenbloom, *Production Manager*

and Harold Evans

Biographies by Sharon DeLano
Alex Abramovich, Sarah Smith,
Marcus Ryu, *Biographical Research*

Chronology by Jana Martin

The Wylie Agency
Andrew Wylie
Jeffrey Posternak

Meridian Printing
Dennis Glass, *Chairman*
Daniel Frank, *Project Director*
Mike Page, *Pre-Press Manager*
John Del Barone, Kevin Reph, *Pressmen*

Designed by Ruth Ansel
and Gregory Wakabayashi

All rights reserved under International and Pan-American Copyright
Conventions. Published in the United States by Random House, Inc.,
New York, and Eastman Kodak Company, Rochester, New York, and
simultaneously in Canada by
Random House of Canada Limited, Toronto.

Random House and colophon are registered trademarks of Random
House, Inc.

The quotation from Abbie Hoffman on page 212 comes from Nancy
Cohen's film *My Dinner with Abbie*.

Library of Congress Cataloging-in-Publication Data

Avedon, Richard.
The sixties / Richard Avedon and Doon Arbus.
p. cm.
ISBN 0-679-40923-8
1. Celebrities' portraits. 2. Portrait photography.
3. Nineteen sixties. 4. Avedon, Richard.
I. Arbus, Doon. II. Title.
TR681.F3A934 1999
779' .2' 09046—dc21 99-24954

Random House website address: www.atrandom.com
Printed in the United States on acid-free paper

First Edition